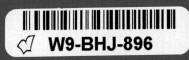 W9-BHJ-896

MATISSE

IN THE COLLECTION OF
THE MUSEUM OF MODERN ART

MATISSE

IN THE COLLECTION OF
THE MUSEUM OF MODERN ART

including remainder-interest and promised gifts

JOHN ELDERFIELD

with additional texts by William S. Lieberman and Riva Castleman

THE MUSEUM OF MODERN ART, NEW YORK

This publication and the exhibition it accompanies
were made possible by a generous grant
from the Robert Wood Johnson Jr. Charitable Trust.

TRUSTEES OF THE MUSEUM OF MODERN ART

William S. Paley, *Chairman of the Board;* Gardner Cowles, *Vice Chairman;* David Rockefeller, *Vice Chairman;* Mrs. John D. Rockefeller 3rd, *President;* Mrs. Bliss Parkinson, *Vice President;* Neal J. Farrell, *Treasurer;* Mrs. Douglas Auchincloss, Edward Larrabee Barnes, Alfred H. Barr, Jr.,* Mrs. Armand P. Bartos, Gordon Bunshaft, Shirley C. Burden, William A. M. Burden, Thomas S. Carroll, Frank T. Cary, Ivan Chermayeff, Mrs. C. Douglas Dillon,* Gianluigi Gabetti, Paul Gottlieb, George Heard Hamilton, Wallace K. Harrison,* Mrs. Walter Hochschild,* Mrs. John R. Jakobson, Philip Johnson, Mrs. Frank Y. Larkin, Ronald S. Lauder, John L. Loeb, Ranald H. Macdonald,* Donald B. Marron, Mrs. G. Macculloch Miller,* J. Irwin Miller,* S. I. Newhouse, Jr., Richard E. Oldenburg, John Parkinson III, Peter G. Peterson, Gifford Phillips, Nelson A. Rockefeller,* Mrs. Albrecht Saalfield, Mrs. Wolfgang Schoenborn,* Martin E. Segal, Mrs. Bertram Smith, James Thrall Soby,* Mrs. Alfred R. Stern, Mrs. Donald B. Straus, Walter N. Thayer, R. L. B. Tobin, Edward M. M. Warburg,* Mrs. Clifton R. Wharton, Jr., Monroe Wheeler,* John Hay Whitney*

Honorary Trustee

EX OFFICIO

Edward I. Koch, *Mayor of the City of New York;* Harrison J. Goldin, *Comptroller of the City of New York*

Copyright © 1978 by The Museum of Modern Art
All rights reserved
Library of Congress Catalog Card Number 78-56155
Clothbound ISBN 0-87070-470-2
Paperbound ISBN 0-87070-471-0
Designed by Christopher Holme
Type set by Boro Typographers, Inc., New York, N.Y.
Printed by Lebanon Valley Offset Co., Inc., Annville, Pa.
Bound by Sendor Bindery, Inc., New York, N.Y.
The Museum of Modern Art
11 West 53 Street, New York, N.Y. 10019
Printed in the United States of America
Second Printing 1978

frontispiece: Matisse modeling *La Serpentine* (pp. 61, 62), Issy-les-Moulineaux, autumn 1909. Photograph by Edward Steichen

CONTENTS

Matisse in New York City, c. 1930

ILLUSTRATIONS

Page numbers marked with an asterisk indicate works reproduced in color.

PREFACE

This book documents the works by Henri Matisse in the Collection of The Museum of Modern Art and is part of a continuing program of publications on aspects of the Museum Collection. The works recorded and illustrated here are either already at the Museum or fall into the categories of remainder-interest gifts (works that are the property of the institution but remain with the donors for their lifetime) or promised gifts (works that have been formally committed as future gifts or bequests). The entire group of works—which includes paintings, sculptures, drawings, cutouts, prints, illustrated books, a stained-glass window, and a set of chasubles—contains a number of Matisse's greatest masterpieces; it affords an overview of virtually every period in his long and varied career, and it constitutes the single most important collection of his art in private or public hands, only the combination of the Russian Museum Collections in Moscow and Leningrad being of comparable importance.

The Matisse collection is the result of the efforts of many curators and the generosity of many Trustees and friends of the Museum. It is mainly due, however, to the work of Alfred H. Barr, Jr., first Director of the Museum and, later, until his retirement in 1967, Director of Museum Collections. Mr. Barr was aided by a number of his colleagues, but particularly by William S. Lieberman, now Director of the Department of Drawings, who is also responsible for acquiring a majority of the drawings and prints by Matisse owned by the Museum. Since joining the Museum in 1968, William Rubin, now Director of the Department of Painting and Sculpture, has been instrumental in adding a number of important paintings and cutouts to the Collection.

In 1931, the third year of the Museum's existence, Mr. Barr organized a major retrospective exhibition of Matisse's work, the Museum's first large European one-man show and the first important Matisse exhibition at an American museum. The following year the Collection received its first Matisses: a group of twelve prints, including the portfolio *Dix Danseuses* of 1927 (p. 126), the gift of Mrs. Saidie A. May. Before then, however, *Interior with a Violin Case* of 1918–19 (p. 119) had been left to the Museum as part of the magnificent bequest of Lillie P. Bliss, a Founder of the Museum and its Vice-President at the time of her death in 1931. This painting, together with a selection of prints, formally entered the Collection in 1934.

Another of the Museum's Founders, Abby Aldrich Rockefeller, purchased for the Collection a number of highly important Matisses in the 1930s. The *Gourds* of 1916 (p. 113) and the drawing *The Plumed Hat* of 1919 (p. 121) were thus acquired in 1935. To these were added, in 1936, the *Bather* of 1909 (p. 59), and in 1939, *The Blue Window* of 1913 (p. 91) (this work having been confiscated by the Nazis from the Folkwang Museum, Essen) and *La Serpentine* of 1909 (p. 61), the latter being part of a gift of thirty-six modern sculptures made that year.

In the years immediately following World War II, two of Matisse's very greatest works entered the Collection. In 1946, James Thrall Soby, then Chairman of the Committee on the Museum Collections, proposed the acquisition of the *Piano Lesson* of 1916 (p. 115); it was purchased through a fund set up by Mrs. Simon Guggenheim in 1938, which was continuously replenished until her death in 1969, and which made possible some of the Museum's most important painting and sculpture acquisitions. *The Red Studio* of 1911 (p. 87), selected by Mr. Barr in 1949, was also purchased through this fund. In 1948, Matisse himself donated a set of his *Jazz* prints of 1947 (p. 150), and these were immediately shown in a special exhibition directed by Mr. Lieberman, whose efforts brought a large number of prints into the Collection in the following years. The addition by purchase of approximately ninety prints by Matisse in 1951 to those received earlier from Abby Aldrich Rockefeller firmly established the core of that part of the Collection. Subsequent purchases and generous gifts from the many donors listed on p. 21 soon made it the most comprehensive Matisse print collection in public hands.

In 1949, A. Conger Goodyear, first President of the Museum, gave to the Collection the *Still Life* of 1899 (p. 25). In 1950, the drawing *Dahlias and Pomegranates* of 1947 (p. 152) entered the Museum, and in 1951, the sculpture *Reclining Nude I* of 1906–07 (p. 50). Thus, when Mr. Barr opened his second major Matisse retrospective exhibition in 1951, accompanied by publication of his classic study, *Matisse: His Art and His Public,* the Museum had acquired seven paintings, two sculptures, three drawings, and around one hundred prints by Matisse. It was in the years following this exhibition and publication that the pace of Matisse acquisitions rapidly increased. In 1952, Edward Steichen gave to the Museum the drawing *Standing Nude* of 1901–03 (p. 32), which he had received from the artist. The same year, Mr. Barr proposed the purchase of the following sculptures: *Seated Figure, Right Hand on Ground* of 1908 (p. 63), the Backs I, III, and IV, and the Jeannettes I, III, IV, and V. At that time *Back II* was unknown; it was added to the Collection in 1956 and the set of reliefs (pp. 73–79) thus completed. The gift of *Jeannette II* by Sidney Janis in 1955, one in a sequence of his highly important gifts to the Museum, likewise completed that set of works (pp. 66–71). The book-cover designs for Mr. Barr's *Matisse: His Art and His Public* (p. 160) and for the catalog of the 1951 exhibition organized by Mr. Barr (p. 161) had been commissioned from Matisse by Monroe Wheeler, then Director of Exhibitions and Publications and a Trustee of the Museum. These were formally accessioned in 1953. In the same year, Mr. Barr proposed the acquisition of the paper cut-out maquettes for a set of red vestments (pp. 154–55), which Matisse had designed for use in the Vence chapel, and which Mr. Barr had seen in his Nice studio the previous year. These were purchased through Bliss Bequest funds, as was a set of white vestments used at the consecration of the Vence chapel but which proved to be too heavy for regular use. In 1954, in part through the efforts of Bertha M. Slattery, a friend of the Museum, funds were raised to commission the fabrication of the remaining five chasubles Matisse had designed for the chapel, and these were acquired in 1955 thanks to gifts from Mrs. Charles Suydam Cutting, Gertrud A. Mellon, William V. Griffin, and Philip Johnson. The complete set was presented in the exhibition "Vestments by Matisse in the Collection of The Museum of Modern Art" at the end of that year. Meanwhile, *Life* magazine donated to the Museum in 1953, at Matisse's suggestion, the stained-glass window *Nuit de Noël* (p. 158)—which Matisse had designed for the magazine in 1952—together with the paper cut-out maquette for this work (p. 159).

In 1955, two of the Museum's most important Matisse paintings entered the Collection as gifts. *Goldfish and Sculpture* of 1911 (p. 85) was donated by Mr. and Mrs. John Hay Whitney, who in 1968 were to promise to the Collection Matisse's 1904 study for *Luxe, calme et volupté* (p. 37). *The Moroccans* of 1915–16 (p. 111) was the first in a series of magnificent gifts and remainder-interest gifts from the Florene May Schoenborn and Samuel A. Marx Collection, a collection that was exhibited at the Museum in 1965–66 under the rubric "The School of Paris." *The Rose Marble Table* of 1917 (p. 117) was purchased in 1956, and the following sculptures were acquired in this same period: *Tiari* of 1930 (p. 137) and *The Serf* of 1900–03 (p. 31), the latter proposed by Mr. Lieberman. To these were added in 1960 *Venus in a Shell I* of 1930 (p. 139), the gift of Pat and Charles Simon.

Before Mr. Barr's retirement in 1967, an additional eight paintings, one sculpture, and a number of drawings and prints were added to the Collection. These included *Lemons against a Fleur-de-lis Background* of 1943 (p. 147), earlier selected from the collection of Loula D. Lasker by Mr. Barr; *Music (Sketch)* of 1907 (p. 53), given by Mr. Goodyear in honor of Mr. Barr; and *The Pink Blouse* of 1922 (p. 123), given anonymously on a remainder-interest basis. In 1964, another anonymous donor gave, in the form of remainder-interest gifts, three crucial paintings from Matisse's great "experimental" period of the teens, *Woman on a High Stool* of 1914 (p. 93), *Goldfish* of 1914–15 (p. 101), and *Variation on a Still Life by de Heem* of 1915 (p. 105), which consolidated the Museum's holdings in this period as by far the strongest of any collection in the world. In 1967, Mrs. Bertram Smith, a Trustee of the Museum, promised to the Collection, through her friendship with Mr. Barr and Mr. Lieberman, *Still Life with Aubergines* of 1911 (p. 83), to which was later added an important group of further promised gifts including the Matisse *Landscape at Collioure* of 1905 (p. 41) and *Standing Nude, Arms on Head* of 1906 (p. 51).

In 1969, the collection of Nelson A. Rockefeller was exhibited at the Museum, at which time Governor Rockefeller promised to the Collection *View of Collioure and the Sea* of 1911 (p. 81) and the lithograph *Odalisque in Striped Pantaloons* of 1925 (p. 125). In 1968, William Rubin proposed the acquisition of the great 1952–53 cut-out, *Memory of Oceania* (p. 168). It was also through the efforts of Mr. Rubin that the Museum was promised in 1970, by Mr. and Mrs. David Rockefeller, the important Fauve painting, *Girl Reading* of 1905–06 (p. 45), and acquired in 1975 three great Matisses from different periods of his career: the early *Male Model* of 1900 (p. 29), *View of Notre Dame* of 1914 (p. 95), and the large en-

vironmental cutout of 1952, *The Swimming Pool* (p. 163), this last purchased through funds generously provided by Mrs. Bernard F. Gimbel. To these were added, in 1976, an additional Fauve painting, *View of Collioure with the Church* of 1905 (p. 40), the promised gift of Kate Steichen, and the Museum's earliest Matisse, *Lemons and Bottle of Dutch Gin* of 1896 (p. 24), the fractional gift of Mr. and Mrs. Warren Brandt. The most recent painting acquisition at the time of writing is *The Italian Woman* of 1916 (p. 109), the gift of Governor Rockefeller in 1977.

Since Mr. Barr's retirement, many drawings and prints as well as paintings and sculptures have been added to the Collection, principally through the efforts of Mr. Lieberman, and recently, in the case of some prints, the efforts of Riva Castleman, Director of the Department of Prints and Illustrated Books. The more than a dozen drawings acquired since 1967 include an important Fauve portrait, *Jeanne Manguin* of 1906 (p. 47), two 1914 drawings of Yvonne Landsberg (p. 97), two 1945 self-portraits by Matisse (pp. 148–49), and the superb late work *The Necklace* of 1950 (p. 153), part of a magnificent bequest of 267 drawings from the Joan and Lester Avnet Collection. In addition, the Museum has acquired a number of drawings that specifically relate to paintings or sculptures in the Collection. These include *The Back* of 1909 (p. 72), *Girl with Tulips* of 1910 (p. 65), and *Study after Dance* of 1909 (p. 57) and *Study for The Back II* of 1911 (p. 74), the last two being gifts of Pierre Matisse. The most important recent addition to the print collection has been the gift of the Louis E. Stern collection in 1964, containing nearly all of Matisse's illustrated books.

Of course, not all periods of Matisse's work are equally well represented in the Museum Collection, despite its considerable size. This attests less to the want of trying to fill the lacunae that do exist than to the astonishing variety of Matisse's art. However, the collection as it stands—containing twenty-six paintings, sixteen sculptures, six cutouts, nineteen drawings, nearly two hundred prints, plus design objects of various kinds—shows the quality, range, and depth of Matisse's achievement more fully than any other single collection and offers a remarkable overview of the development of his artistic career, as this publication demonstrates.

There need be no excuse for yet another book on Matisse. Despite the large number of publications on the artist that do exist, very few deal seriously and in detail with his individual works. There is still no catalogue raisonné, although Matisse's daughter, Mme Marguerite Duthuit, has long been preparing one; neither is there a standard

biography of the artist. As a result, Alfred Barr's great book, *Matisse: His Art and His Public,* remains today, over a quarter of a century after its publication, the indisputably most important single work on Matisse. I am deeply indebted both to the book itself and to the documentation collected by Mr. Barr while he was preparing it and which is conserved in the Archives of The Museum of Modern Art. I am also particularly indebted to Mme Marguerite Duthuit, who graciously consented to discuss with me a number of the works in the Museum Collection, and additionally answered by letter questions both from Riva Castleman and from myself. Similarly, Pierre Matisse was most helpful in clarifying a number of details to the benefit of this catalog.

To my coauthors go many thanks for their contributions. William S. Lieberman, Director of the Department of Drawings, discusses the drawings in the Museum Collection (excepting those I have treated in conjunction with paintings or sculptures). Riva Castleman, Director of the Department of Prints and Illustrated Books, has contributed texts on the prints. (While all paintings, sculptures, and drawings in the Museum Collection are reproduced, only a selection of the very extensive print holdings could be incorporated.) All texts by my coauthors are followed by their initials. The notes and the reference photographs for each commentary appear in the back of the book under the full catalog entry or entries for the work or works discussed. The page number of that full entry is given at the end of the short caption accompanying the reproduction of each work.

Among the scholars who have been helpful in elucidating both historical and interpretive questions, my thanks go especially to Pierre Schneider and Lawrence Gowing, who discussed the Museum's Matisses with me prior to the writing of the catalog, and John Hallmark Neff and Jack D. Flam, who offered a number of useful suggestions in the course of my work. Pierre Schneider generously allowed me to read the sections of his forthcoming book on Matisse that relate to the Museum's works, and John Neff gave me access to his important dissertation on Matisse and Decoration. Thanks are also due to George Braziller, who allowed me to reprint here certain passages in my entries on the cutouts originally written for the book *The Cut-Outs of Henri Matisse,* of which he is the publisher.

At The Museum of Modern Art, both Monique Beudert, Curatorial Assistant in the Department of Painting and Sculpture, and my secretary, Diane Gurien, worked assiduously on this publication and on the exhibition it accompanies. Judith Cousins, Researcher of the Collection, was indispensable in gathering documentation on

Matisse. William Rubin, Director of the Department of Painting and Sculpture, offered advice and encouragement throughout the project. Monawee Allen Richards of the Department of Drawings and Alexandra Schwartz of the Department of Prints and Illustrated Books prepared the catalog information on the Museum's holdings in these areas of the Collection. Jean Volkmer, Senior Conservator of Paintings, undertook the challenging task of making X-ray photographs of *The Moroccans,* and Kate Keller made infra-red photographs of this work and of *The Red Studio.* Antoinette King, Senior Paper Conservator, gave me the benefit of her detailed technical knowledge of the cutouts, and Richard Tooke and his staff in the Department of Rights and Reproductions were most helpful in arranging and supplying photographs for the catalog.

It was once again a very great pleasure to work with Francis Kloeppel, who edited the catalog and thus improved it. Christopher Holme was responsible for its handsome design and for overseeing its production, while Martin Rapp, Director of Publications, took a keen interest in this and other publication ventures associated with the project. To these, and to Clive Phillpot, Librarian of the Museum, who prepared the list of the Museum's publications on Matisse, go my many thanks.

Finally, The Museum of Modern Art is very deeply obliged to the Robert Wood Johnson Jr. Charitable Trust for a generous grant which made possible both the exhibition and this publication.

JOHN ELDERFIELD
July 1978

Matisse drawing from a model in his apartment on Place Charles-Félix, Nice, c. 1928

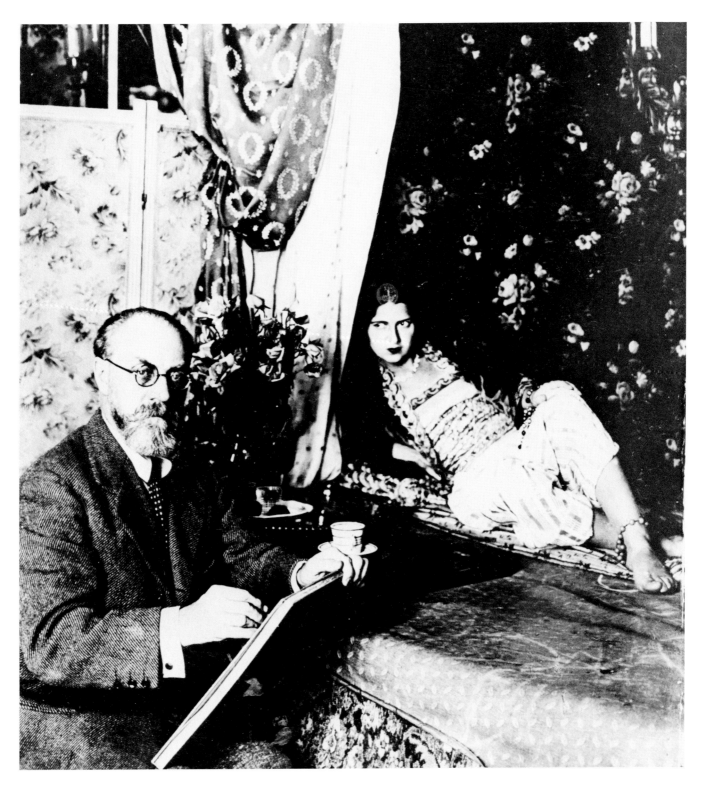

EXHIBITIONS OF MATISSE'S WORK

AT THE MUSEUM OF MODERN ART

This list includes all one-man exhibitions of Matisse at The Museum of Modern Art, as well as other exhibitions in which a significant number of his works were included.

"Painting in Paris from American Collections," Jan. 19–Feb. 16, 1930. 11 works. Directed by Alfred H. Barr, Jr.

"Memorial Exhibition: The Collection of the Late Miss Lizzie P. Bliss," May 17–Sept. 27, 1931. 2 paintings, 2 lithographs. Directed by Alfred H. Barr, Jr.

"Henri Matisse: Retrospective Exhibition," Nov. 3–Dec. 6, 1931. 70 paintings, 13 sculptures, 54 drawings, 5 monotypes, 2 woodcuts. Directed by Alfred H. Barr, Jr.

"Modern Works of Art: Fifth Anniversary Exhibition," Nov. 20, 1934–Jan. 20, 1935. 5 works. Directed by Alfred H. Barr, Jr.

"Summer Exhibition: The Museum Collection and a Private Collection on Loan," June 4–Sept. 24, 1935. 6 works. Directed by Alfred H. Barr, Jr.

"Modern Paintings and Drawings: Gift of Mrs. John D. Rockefeller, Jr.," Jan. 15–Feb. 15, 1936. 4 works.

"Modern Painters and Sculptors as Illustrators," Apr. 27–Sept. 2, 1936. 3 illustrated books. Directed by Monroe Wheeler.

"Art in Our Time: 10th Anniversary Exhibition," May 10–Sept. 30, 1939. 8 works. Painting and Sculpture section directed by Alfred H. Barr, Jr.

"20th Century Portraits," Dec. 9, 1942–Jan. 24, 1943. 8 works. Directed by Monroe Wheeler.

"Modern Drawings," Feb. 16–May 10, 1944. 17 works. Directed by Monroe Wheeler.

"Art in Progress: 15th Anniversary Exhibition," May 24–Oct. 22, 1944. 5 works. Painting and Sculpture section directed by James Thrall Soby.

"The Museum Collection of Painting and Sculpture: First General Exhibition," June 20, 1945–Jan. 13, 1946. 6 works. Directed by Alfred H. Barr, Jr.

"Matisse: Jazz—Gift of the Artist," Oct. 1–31, 1948. Installed by William S. Lieberman.

"The Abby Aldrich Rockefeller Print Room: Master Prints from the Museum Collection," May 10–July 10, 1949. 7 works. Directed by William S. Lieberman.

"Selections from Five New York Private Collections," June 26–Sept. 9, 1951. 3 works. Directed by Andrew Carnduff Ritchie.

"Henri Matisse," Nov. 13, 1951–Jan. 13, 1952. 74 paintings, 29 sculptures, 24 drawings, watercolors, prints, and illustrated books, 14 paper cutouts. Directed by Alfred H. Barr, Jr.

"Les Fauves," Oct. 7, 1952–Jan. 4, 1953. 32 works. Directed by John Rewald.

"Sculpture of the Twentieth Century," Apr. 29–Sept. 7, 1953. 6 works. Directed by Andrew Carnduff Ritchie.

"Paintings from the Museum Collection: 25th Anniversary Exhibition," Oct. 19, 1954–Feb. 6, 1955. 6 works. Installed by Alfred H. Barr, Jr., and Dorothy C. Miller.

"Etchings by Matisse," May 4–31, 1955. 31 works. Directed by William S. Lieberman.

"Paintings from Private Collections: A 25th Anniversary Exhibition," May 31–Sept. 7, 1955. 14 works. Directed by Alfred H. Barr, Jr.

"Vestments by Matisse in the Collection of The Museum of Modern Art," Dec. 20, 1955–Jan. 15, 1956. 10 vestments, 7 maquettes.

"The Prints of Henri Matisse," June 26–Oct. 7, 1956. 64 works. Directed by William S. Lieberman.

"The Last Works of Henri Matisse: Large Cut Gouaches," Oct. 17–Dec. 4, 1961. 42 works. Directed by Monroe Wheeler.

"The School of Paris: Paintings from the Florene May Schoenborn and Samuel A. Marx Collection," Nov. 2, 1965–Jan. 2, 1966. 6 works. Directed by Monroe Wheeler, installed by Alicia Legg.

"Chasubles Designed by Henri Matisse," Dec. 18, 1965–Jan. 9, 1966. 4 works.

"Henri Matisse: 64 Paintings," July 19–Sept. 25, 1966. 64 works. Directed by Monroe Wheeler.

"Twentieth Century Art from the Nelson Aldrich Rockefeller Collection," May 28–Sept. 1, 1969. 7 works. Directed by Dorothy C. Miller.

"Four Americans in Paris: The Collections of Gertrude Stein and Her Family," Dec. 19, 1970–Mar. 1, 1971. 76 works. Directed by Margaret Potter, installed by William S. Lieberman.

"Matisse: 6 Acquisitions," July 21–Sept. 30, 1971. 6 works. Directed by William S. Lieberman.

"Matisse: Jazz," Feb. 22–Mar. 5, 1972. Directed by Riva Castleman.

"The Sculpture of Matisse," Feb. 24–May 1, 1972. 93 works. Directed by Alicia Legg.

"Seurat to Matisse: Drawing in France," June 13–Sept. 8, 1974. 13 works. Directed by William S. Lieberman.

"Exhibition of Matisse Chasubles," Nov. 9, 1974–Jan. 5, 1975. 5 chasubles. Directed by Arthur Drexler.

"Modern Masters: Manet to Matisse," Aug. 4–Sept. 28, 1975. 11 works. Directed by William S. Lieberman.

"The 'Wild Beasts': Fauvism and Its Affinities," Mar. 24–June 1, 1976. 28 works. Directed by John Elderfield.

"Between World Wars: Drawing in Europe and America," Aug. 20–Nov. 19, 1976. 3 works. Directed by William S. Lieberman.

"Matisse/Gaudí: Ecclesiastical Designs," Nov. 15, 1976–Jan. 9, 1977. 7 works. Directed by J. Stewart Johnson.

"European Master Paintings from Swiss Collections," Dec. 17, 1976–Mar. 1, 1977. 3 works. Directed by William Rubin.

"Matisse: The Swimming Pool," Mar. 11–Aug. 1, 1977. Installed by Alicia Legg.

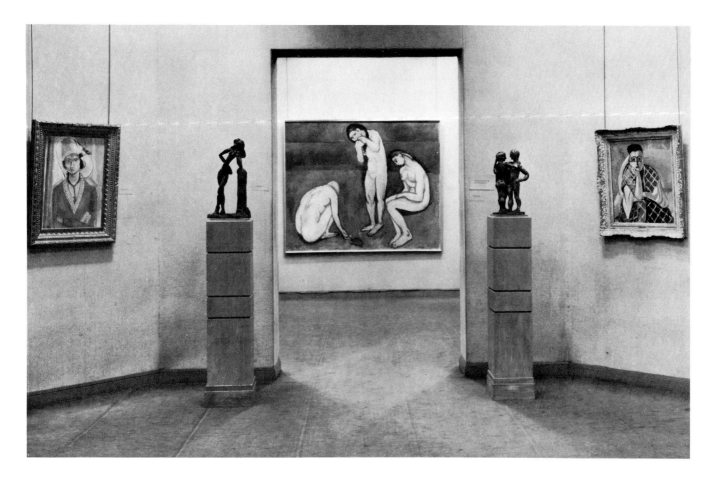

"Henri Matisse: Retrospective Exhibition," November 3–December 6, 1931

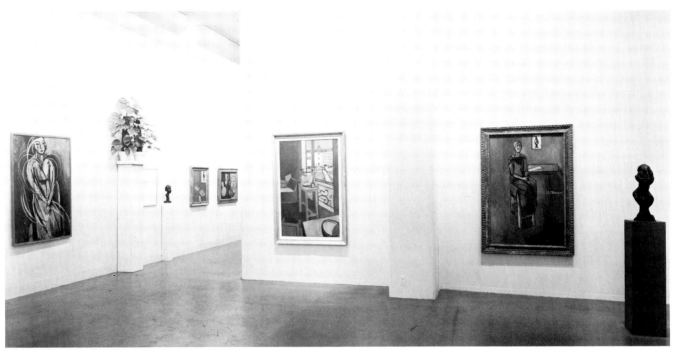

"Henri Matisse," November 13, 1951–January 13, 1952

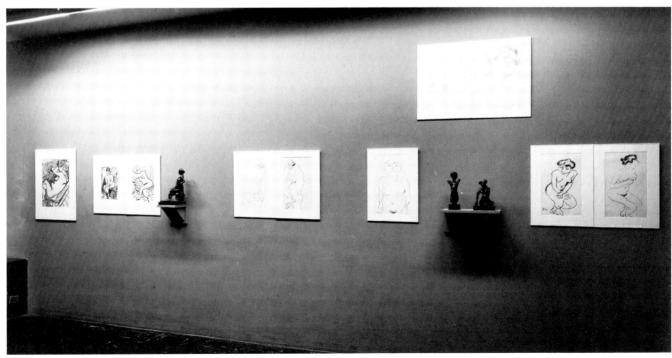

"The Prints of Henri Matisse," June 26–October 7, 1956

16

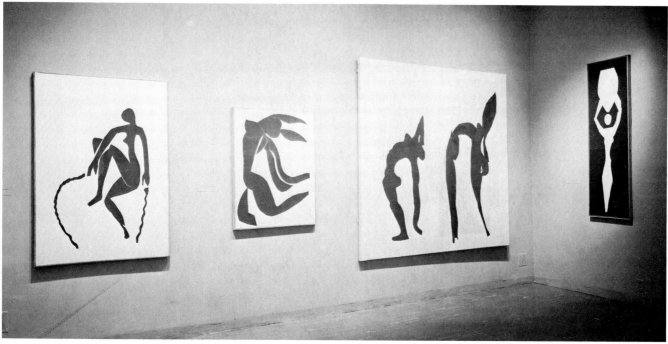

"The Last Works of Henri Matisse: Large Cut Gouaches,"
October 17–December 4, 1961

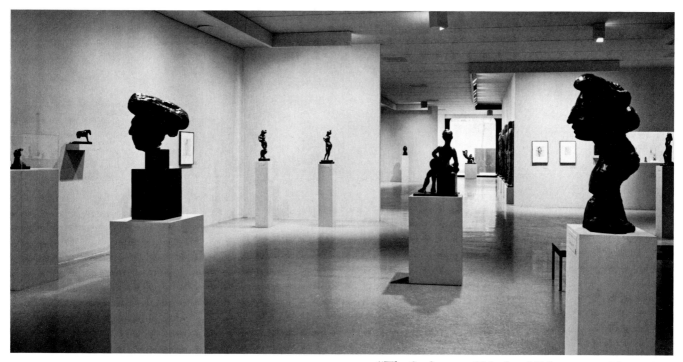

"The Sculpture of Matisse," February 24–May 1, 1972

17

PUBLICATIONS ON MATISSE

ISSUED BY THE MUSEUM OF MODERN ART

MONOGRAPHS

Henri Matisse: Retrospective Exhibition. By Alfred H. Barr, Jr. 1931. 124 pp., ills.

Contents: Introduction by Alfred H. Barr, Jr.; "Notes of a Painter" (1908) by Matisse; bibliography; catalog of exhibition, Nov. 3–Dec. 6, 1931.

Matisse: His Art and His Public. By Alfred H. Barr, Jr. 1951. 592 pp., ills. (23 col.).

Four statements by Matisse. Bibliography. Published at the time of the exhibition Nov. 13, 1951–Jan. 13, 1952, and commenced with the "intention of revising and bringing up to date the catalog" of 1931.

Dust jacket designed by Matisse.

Reprint edition by Arno Press, New York, 1966 (but black-and-white plates for color).

First paperbound edition 1974 (original color plates in black and white, but 8 extra color plates inserted).

Henri Matisse. Introduction by Alfred H. Barr, Jr. 1951. 32 pp., ills.

Chronology and catalog of exhibition, Nov. 13, 1951–Jan. 13, 1952.

Covers designed by Matisse.

Etchings by Matisse. Introduction by William S. Lieberman. 1955. 30 pp., ills.

Prints selected from the collection of the Abby Aldrich Rockefeller Print Room of The Museum of Modern Art for exhibition, May 4–31, 1955.

Jazz. By Henri Matisse. 1960. 52 pp., ills. (15 col.).

Published and printed for the Members of The Museum of Modern Art by R. Piper & Co. Verlag, Munich, in connection with exhibition, June 17–Sept. 19, 1960.

Derived from the 1947 Paris publication of Editions Verve.

The Last Works of Henri Matisse: Large Cut Gouaches. By Monroe Wheeler. 1961. 64 pp., ills. (13 col.).

Includes bibliography and catalog of exhibition, Oct. 17–Dec. 4, 1961, organized in collaboration with The Art Institute of Chicago and San Francisco Museum of Art.

Henri Matisse: 64 Paintings. By Lawrence Gowing. 1966. 63 pp., ills. (8 col.).

Bibliography and chronology. Includes catalog of exhibition, July 19–Sept. 25, 1966.

The Sculpture of Matisse. By Alicia Legg. 1972. 56 pp., ills.

Includes "Sculptures by Matisse Seen in His Paintings" and catalog of exhibition, Feb. 24–May 1, 1972.

GENERAL BOOKS AND CATALOGS

Painting in Paris from American Collections. Foreword by Alfred H. Barr, Jr. 1930. Pp. 33–34. 6 ills. of Matisse's work.

Catalog of exhibition, Jan. 19–Feb. 16, 1930.

Memorial Exhibition: The Collection of the Late Miss Lizzie P. Bliss. 1931. P. 31. 3 ills. of Matisse's work.

Catalog of exhibition, May 17–Sept. 27, 1931.

The Lillie P. Bliss Collection. Edited by Alfred H. Barr, Jr. 1934. Pp. 54–55, 80–81. 4 ills. of Matisse's work.

Catalog of exhibition, May 14–Sept. 12, 1934.

Modern Works of Art: Fifth Anniversary Exhibition. By Alfred H. Barr, Jr. 1934. Pp. 31, 37. 5 ills. of Matisse's work.

Includes catalog of exhibition, Nov. 20, 1934–Jan. 20, 1935.

Modern Painters and Sculptors as Illustrators. By Monroe Wheeler. 1936. Pp. 62–63. 2 ills. of Matisse's work.

Includes catalog of exhibition, Apr. 27–Sept. 2, 1936.

Third revised edition, 1946. Pp. 60–61. 2 ills. of Matisse's work.

Art in Our Time. An exhibition to celebrate the tenth anniversary of The Museum of Modern Art and the opening of its new building, held at the time of the New York World's Fair. 1939. Passim. 7 ills. of Matisse's work.

Catalog of exhibition, May 10–Sept. 30, 1939.

Reprint edition by Arno Press, New York, 1972.

Painting and Sculpture in The Museum of Modern Art. Edited by Alfred H. Barr, Jr. 1942. Pp. 59–60, 84. 4 ills. of Matisse's work.

————. ————. 1948. Pp. 38, 40–45, 250, and passim. 8 ills. of Matisse's work.

————. ————. 1958. Pp. 41–42.

————. Edited by Alicia Legg. 1977. Pp. 62–63.

20th Century Portraits. By Monroe Wheeler. 1942. Pp. 14–15, 140. 4 ills. of Matisse's work.

Includes catalog of exhibition, Dec. 9, 1942–Jan. 24, 1943.

What Is Modern Painting? By Alfred H. Barr, Jr. 1943. Pp. 22–23 and passim. 1 ill. of Matisse's work. (Introductory Series to the Modern Arts. 2.)

Last revised edition (9th), 1966. Pp. 24–25, 42, and passim. 3 ills. (1 col.) of Matisse's work.
Foreign-language editions.

Modern Drawings. Edited by Monroe Wheeler. 1944. Pp. 93–94 and passim. 8 ills. of Matisse's work.
> Includes catalog of exhibition, Feb. 16–May 10, 1944.
> Second revised edition, 1945.

Art in Progress. A survey prepared for the 15th anniversary of The Museum of Modern Art, New York. 1944. Pp. 40–41, 222. 3 ills. of Matisse's work.
> Includes catalog of exhibition, May 24–Oct. 22, 1944.

Les Fauves. By John Rewald. 1952. Pp. 5–14, 41–44, 46–47. 10 ills. of Matisse's work.
> Includes catalog of exhibition, Oct. 7, 1952–Jan. 4, 1953.

Sculpture of the Twentieth Century. By Andrew Carnduff Ritchie. 1952. Passim. 5 ills. of Matisse's work.
> Published on the occasion of exhibition 1952–53 at Philadelphia Museum of Art, The Art Institute of Chicago, and, Apr. 29–Sept. 7, 1953, The Museum of Modern Art. (Separate catalog published 1952. 47 pp. 1 ill. of Matisse's work.)
> Reprint edition by Arno Press, New York, 1972.

Masters of Modern Art. Edited by Alfred H. Barr, Jr. 1954. Pp. 47–55, 227, 228. 11 ills. (4 col.) of Matisse's work.
> Published on the occasion of the 25th anniversary of the Museum.
> Second edition 1955.
> Third edition, revised, 1958.
> Foreign-language editions.

Paintings from Private Collections. A 25th-anniversary exhibition. Introduction by Alfred H. Barr, Jr. 1955. Pp. 14–15.
> Includes catalog of exhibition, May 31–Sept. 7, 1955.
> (Illustrations of works exhibited, including several by Matisse, with installation shots, in *The Museum of Modern Art Bulletin,* XXII, 4, Summer 1955.)

The School of Paris. Paintings from the Florene May Schoenborn and Samuel A. Marx Collection. Preface by Alfred H. Barr, Jr. Introduction by James Thrall Soby. Notes by Lucy R. Lippard. 1965. Pp. 10–15. 6 ills. (4 col.) of Matisse's work.
> Catalog of exhibition, Nov. 2, 1965–Jan. 2, 1966, in collaboration with The Art Institute of Chicago, City Art Museum of St. Louis, San Francisco Museum of Art, Museo de Arte Moderno, Mexico.

De Cézanne a Miró. Una exposición organizada bajo los auspicios del International Council of The Museum of Modern Art, New York. 1968. Pp. 28–29, 2 ills. (1 col.) of Matisse's work.
> Published on the occasion of exhibition 1968 at the Museo Nacional de Bellas Artes, Buenos Aires; Museo de Arte Contemporaneo de la Universidad de Chile, Santiago; and Museo de Bellas Artes, Caracas.

What Is Modern Sculpture? By Robert Goldwater. 1969. Passim. 3 ills. of Matisse's work.

Twentieth Century Art from the Nelson Aldrich Rockefeller Collection. 1969. Pp. 16–22 and passim. 9 ills. (2 col.) of Matisse's work.
> Foreword by Monroe Wheeler. Preface by Nelson A. Rockefeller. "The Nelson Aldrich Rockefeller Collection" by William S. Lieberman, pp. 11–35. Includes catalog of exhibition, May 28–Sept. 1, 1969.

Four Americans in Paris. The Collections of Gertrude Stein and Her Family. 1970. Passim. 21 ills. (1 col.) of Matisse's work.
> Contents include: "Matisse, Picasso, and Gertrude Stein" by Leon Katz, pp. 51–63. "Portraits: Henri Matisse" by Gertrude Stein, pp. 99–101.
> Includes catalog of exhibition, Dec. 19, 1970–Mar. 1, 1971.

An Invitation to See. 125 paintings from The Museum of Modern Art. Introduction and comments by Helen M. Franc. 1973. Pp. 42, 68–69, 74, 116, 132. 5 col. ills. of Matisse's work.

Seurat to Matisse: Drawing in France. Selections from the Collection of The Museum of Modern Art. Edited by William S. Lieberman. 1974. P. 98. 8 ills. of Matisse's work.
> Includes catalog of exhibition, June 13–Sept. 8, 1974.

The Meanings of Modern Art. By John Russell. 12 vols. 1974–75. Passim. 37 ills. (9 col.) of Matisse's work.

Modern Masters: Manet to Matisse. Edited by William S. Lieberman. 1975. Pp. 84–105. 11 ills. (2 col.) of Matisse's work.
> Includes catalog of exhibition shown at Sydney and Melbourne in Australia in 1975, then at The Museum of Modern Art, Aug. 4–Sept. 28, 1975. Notes on each painting from disparate sources.

Prints of the Twentieth Century: A History. By Riva Castleman. 1976. Pp. 87–90 and passim. 4 ills. (1 col.) of Matisse's work.

The "Wild Beasts": Fauvism and Its Affinities. By John Elderfield. 1976. 168 pp., with frequent references to Matisse throughout. 51 ills. (6 col.) of Matisse's work.
> Published on the occasion of exhibition, Mar. 24–June 1, 1976.

European Master Paintings from Swiss Collections: Post-Impressionism to World War II. By John Elderfield. Foreword by William Rubin. 1976. Pp. 72–77. 3 ills. (1 col.) of Matisse's work.
> Published on the occasion of exhibition, Dec. 17, 1976–Mar. 1, 1977.

Painting and Sculpture in The Museum of Modern Art 1929–1967. By Alfred H. Barr, Jr. 1977. Pp. 566–67, 604, 608, 652, 654, and passim. 34 ills. of Matisse's work.

A Treasury of Modern Drawing. The Joan and Lester Avnet Collection in The Museum of Modern Art. By William S. Lieberman. 1978. Pp. 32, 116. 1 ill. of Matisse's work.
> Catalog of the collection published on the occasion of exhibition, Apr. 28–July 4, 1978.

Publications of the Museum that have only one or two references, entries, illustrations, etc., pertaining to Matisse have generally been excluded.

CLIVE PHILLPOT
Librarian, The Museum of Modern Art

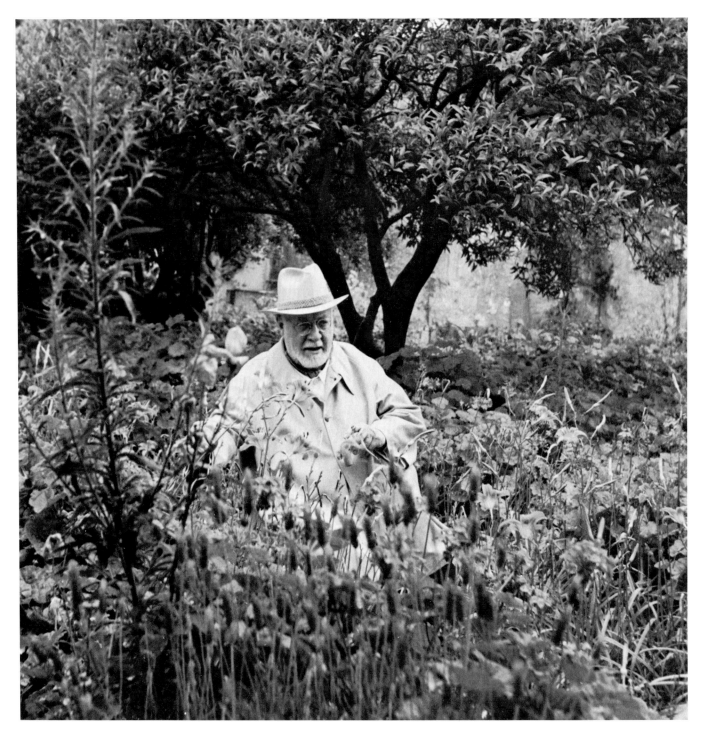

Matisse in Tériade's garden, Saint-Jean-Cap-Ferrat, 1951

DONORS OF WORKS BY MATISSE
in the Collection of The Museum of Modern Art

DEPARTMENT OF PAINTING AND SCULPTURE

Lillie P. Bliss
Mr. and Mrs. Warren Brandt
Mrs. Charles Suydam Cutting
Mrs. Bernard F. Gimbel
A. Conger Goodyear
William V. Griffin
Mrs. Simon Guggenheim
Sidney Janis
Philip C. Johnson
Loula D. Lasker
Mr. and Mrs. Samuel A. Marx
Mrs. Gertrud Mellon
Abby Aldrich Rockefeller
Mr. and Mrs. David Rockefeller
Nelson A. Rockefeller
Mr. and Mrs. Sam Salz
Pat and Charles Simon
Alexander Smith, Inc.
Mrs. Bertram Smith
Kate Rodina Steichen
Time, Inc.
Mr. and Mrs. John Hay Whitney
Two anonymous donors

DEPARTMENT OF DRAWINGS

Joan and Lester Avnet
Lillie P. Bliss
Mrs. Bernard F. Gimbel
Philip C. Johnson
The Lauder Foundation
Carol Buttenweiser Loeb Memorial Fund
Pierre Matisse

Mr. and Mrs. Pierre Matisse
John S. Newberry
Abby Aldrich Rockefeller
Edward Steichen
The Tisch Foundation, Inc.
An anonymous donor

DEPARTMENT OF PRINTS AND ILLUSTRATED BOOKS

Larry Aldrich
Mr. and Mrs. R. Kirk Askew, Jr.
Mr. and Mrs. Walter Bareiss
Mr. and Mrs. Armand P. Bartos
Lillie P. Bliss
Mrs. W. Murray Crane
Frank Crowninshield
Peter H. Deitsch
Mr. and Mrs. E. Powis Jones
M. Knoedler & Co., Inc.
Henri Matisse
Saidie A. May
Frank Perls
James William Reid
John Rewald
Victor S. Riesenfeld
Abby Aldrich Rockefeller
Mrs. John D. Rockefeller 3rd
Nelson A. Rockefeller
Derald and Janet Ruttenberg
Mrs. Bertram Smith
Louis E. Stern
Curt Valentin
Two anonymous donors

MATISSE

IN THE COLLECTION OF
THE MUSEUM OF MODERN ART

Lemons and Bottle of Dutch Gin. *Paris, early 1896. Oil on canvas, 12¼ x 11½ in (31.2 x 29.3 cm). (Full Catalog entry and Notes, p. 173)*

Still Life. *Paris, early 1899. Oil on canvas, 18⅛ x 15 in (46 x 38.1 cm). (C&N, p. 173)*

The first original paintings that Matisse made were still lifes.[1] It was as a still-life painter that Matisse first made his reputation—at the Salon de la Nationale of 1896—and as a still-life painter that he first began to assimilate modernism and provoked a storm of criticism at the same Salon a year later. The painting of 1897 that created the controversy, *La Desserte* (fig. 1), formed the basis for the work with which Matisse finally established his characteristic decorative style a decade later, the *Harmony in Red* of 1908 (fig. 2). Still life clearly exerted a special fascination for Matisse, and was one of his most important modes of expression throughout his career.

In an artistic career spanning sixty-four years, Matisse worked as a painter, sculptor, draftsman, printmaker, muralist, designer, and creator of paper cutouts. Not only did

he recognize that each of these media had its own unique properties, which he sought to express; he was also keenly aware of the specific pictorial and iconographic meanings that different genres—still life, landscape, figure painting, and so on—traditionally and innately allowed. Even in the early years he began to interweave different genres; he never, however, obliterated their meanings, for they were as much the raw materials of his art as were the formal properties of each of the media he used—and he was as self-conscious about the one as the other.

When viewed as a whole, Matisse's art reveals a number of constantly recurring themes that were explored in different ways, in wholes and in fragments, throughout his career. Each was initiated by his work in a specific genre, which was then enriched by its alliance with others to produce a set of motifs which, though by no means original or unique to Matisse, obviously held special meaning for him. Thus, the addition of family members to the early

still-life subjects produced domestic interiors; the exploration first of landscape and then of the model blended in the creation of pastoral figure compositions. The motif of the window allowed a passage between the interior and exterior worlds. The patterns of landscape, and often pastoral figures too, were transposed to the interior—to produce a kind of interior pastoral, which was sometimes the artist's studio, sometimes his home. The themes multiply and compound as the art develops. They also interweave, like the arabesques in his paintings; hence the almost disjointed impression produced by the totality of Matisse's oeuvre when viewed chronologically.

This impression is also an attribute of the fluctuations of Matisse's style. Matisse's stylistic self-consciousness—his constant questioning of his own work, his unwillingness to be satisfied with any single solution, no matter how successful—strikes us as characteristically modern.[2] The extent to which it dominates his art is nevertheless unusual. It derives from the same keen awareness of the separate components of his art that made him realize how useful the traditional generic distinctions could be for him. In the course of finding himself as an artist, he began systematically to explore the separate formal components of painting, and just as he interwove genres to produce a set of personal motifs, so he eventually began to reassemble for himself the stylistic vocabulary of painting in a number of different ways, some more realistic and analytic, some more synthetic and abstract. And just as the motifs of his art interweave, so do the styles. Although, of course, there was a general stylistic momentum in the development of his art —for the variety of approaches were all directed to a few basic goals—there was no coherently unfolding logic of style. Matisse alternated in approach from period to period, even from painting to painting, and even at times combined different styles in a single work. Moreover, since there was no coordination between the stylistic and thematic paths of his art (style, that is to say, did not follow subject matter, or vice versa), the variations of style add yet a further dimension to each of the recurrent themes that Matisse explored.

As new stylistic variations were formulated and older ones revived, they were all applied to the same set of subjects, revealing them in new and different ways. "Thus I have worked all my life," Matisse said in his last years, "before the same objects, which continued to give me the force of reality by engaging my spirit with everything that these objects had gone through for me and with me."[3] This meant not only a constant advance—a constant search for new pictorial means—but also a constant return. "My painting is finished," he once said, "when I rejoin the first emotion that sparked it."[4] Each painting he made "rejoined" in a different way the initial themes of his career.

The first of these themes to be established was one that itself spoke of beginnings. Although in some respects still life is a very neutral subject, it is also, at least as Matisse interpreted it in his early paintings, a subject that evokes domesticity and the closed, secure world of the bourgeois family, the familiar world of childhood, serviced by mothers, servants, and then by wives. Insofar as it is a neutral subject, it allows the artist to impose his control on the objects he chooses to paint, and by extension on the environment of which they are tokens.[5] Matisse could readily, as he put it later, "animate with my own feelings"[6] such inherently passive things. Still life eventually provided him with the means of presenting in condensed form often highly generalized and complex iconographic schemes. It would be wrong, however, to see much more in the lemons and the glass of transparent liquid in *Lemons and Bottle of Dutch Gin* of 1896 than an early use of objects that continued to fascinate him. Although the confrontation of Dutch realist setting and the already quite radiant fruit and glass may be viewed in retrospect as the source for what the objects often later evoke—a feeling of sensual release from immediate reality to something more basic and eternal even than the family—here they still belong to the bourgeois world.[7] If these objects relate at all to another world, it is through the light that enters the interior to heighten their color and luster (more than their volume), thus drawing them apart from the surrounding gloom. Even in Matisse's earliest work, it is light that transforms and idealizes material things.

The still life was painted in Matisse's twenty-sixth year, when he was still a student in Gustave Moreau's studio and was making copies in the Louvre. A third of the twenty copies he made between 1893 and 1900 were still lifes.[8] His first was after the Dutch seventeenth-century painter David de Heem's *Desserte* (fig. 85). Five were copies after Chardin, with whose work Matisse had first become impressed in 1892 at Lille, and whom he said later he studied more than any other artist.[9] Both Chardin's work and that of the Dutch masters underwent a revival toward the end of the nineteenth century;[10] Matisse likely found confirmation for his enthusiasms in the Moreau studio. He sought, he said, "the gradations of tone in the silver scale, dear to the Dutch masters, the possibility of learning how to make light sing in a muted harmony, by gradating the values as closely as possible."[11] "Matisse found in Chardin's great still life [*Pyramid of Fruit*]," said a fellow student, "a knowledge of values that enabled him to replace them by color."[12] That, however, was yet to happen. The dark still life of 1896 is clearly indebted both to Chardin

and to Dutch painting. The piled-up fruit and the division of foreground into light and dark areas with the projecting knife in the center generally relate to Chardin's *Pyramid of Fruit,* which Matisse copied in 1893.[13] However, the picture also seems to reveal a knowledge of contemporary painting. Not only does it reflect something of Moreau's love of luminous, glittering objects, but its obliquely arranged composition, the advancement of objects close up to the picture plane, the suppression of depth between spatially separated objects (such as the glass and the fruit behind it), and the use of such deliberated devices as the contrast of the dark and light sides of the knife across the divided ground suggest an initial compositional response to the Manets, Cézannes, and Impressionist paintings Matisse had started to look at that year in the Vollard and Durand-Ruel galleries.[14]

Matisse's full introduction to modern painting came only later in 1896 and in the following year. It was with domestic still lifes like *Lemons and Bottle of Dutch Gin* that Matisse achieved his success at the Salon de la Nationale in the spring of 1896 and was elected an Associate of the Salon. By the time of the following Salon he had begun overtly to investigate Impressionism; hence the hostile reaction to his *La Desserte* mentioned above. This is an expanded still life (the family ambience is made explicit by the addition of the maid) that brings to a summation the first period of still-life work. Matisse then turned primarily to landscape painting, only to return consistently to still life in the winter of 1898–99, toward the end of an extended marriage trip that had taken him to London, Corsica, and Toulouse. During this trip, Matisse's art had finally become liberated from the constraints of naturalism to achieve a spontaneous, indeed at times reckless, interpretation of Impressionism with flecked, cascading brushstrokes and intense colors. In the later Toulouse paintings, notably the still life *Buffet and Table* (fig. 3), this had been submitted to the discipline of Neo-Impressionism, but back in Paris in February 1899 Matisse returned to a more instinctive style of which The Museum of Modern Art's *Still Life* (p. 25) is a characteristic example.[15] It was in the works of this period that Matisse finally transformed the still-life motifs from which he had begun and made the "transition from painting in values to painting in color."[16] The style established early in 1899 is often described as proto-Fauve.[17]

As was to happen again—when Matisse's Neo-Impressionism of 1904–05 was liberated in the Fauvism of 1905–06—he reacted against a self-imposed discipline to achieve an important stylistic breakthrough. It was not, however, simply a repudiation of the preceding phase. The style of 1899 (like that of 1905) synthesized the earlier

discipline and the period of sheer spontaneity which preceded it to create something that was neither Impressionist nor Neo-Impressionist though built upon these manners. "Matisse preferred a largeness and freshness of conception which could not be achieved with so formalized a technique [as Neo-Impressionism]," Meyer Schapiro has written. "At the same time he desired a structure and expressive movement which he could not find in Impressionism. He gradually simplified his themes and his methods of painting, willfully omitting the whole complexity of detail in a given surface and expressing his perception of its color by a single broad area of intense color."[18] This new broadness and simplification of method may be seen in the 1899 *Still Life*. Although it seems to reveal the influence of the still lifes of Bonnard or Vuillard, compositionally it is not in fact markedly different from some of the still lifes made before the encounter with Impressionism. The high viewpoint, the screened-off background (screened, here for the first time, by the *toile de Jouy* fabric to reappear so often later), and the organization of the table with the back edge roughly parallel to the top of the picture frame and the side edge sloping in a sharp diagonal down the surface may be seen in paintings of 1895 and 1896.[19] New is the sense of continuity across the surface provided by the side-by-side juxtaposition of heavily impastoed zones of paint, which already gives to Matisse's work a patterned character, emphasized by the heavily applied contours and stripes and arcs of intense color that function as highlights to divide areas of a similar tone.

Since his first Impressionist-derived paintings in 1896, Matisse had abandoned the toned grounds of his first series of still lifes and begun to free his touch from the description of objects as such to emphasize the way in which objects were made visible by light. His experience of Neo-Impressionism had taught him to use units of color as the abstract, nonimitative modules of painterly construction. In works like the 1899 *Still Life*, Matisse concerns himself with rendering the light falling on objects so as to express them in two-dimensional and coloristic terms. His colleague Jean Puy recalled that this indeed was Matisse's ambition at the time.[20] This, however, does not entirely explain the furnacelike heat of the paintings of this period. Puy notes that Matisse used such bold colors and so emphasized the materiality of his painting "in order to produce the maximum resonance on the eye." This "resonance," which becomes characteristic of Matisse's paintings, is of course antinaturalistic, for as he said the question was not of representing the objects set up as a still life. "This spectacle creates a shock in my mind. That is what I have to represent."[21] When he started to teach, he distinguished between the Impressionist method

of "considering color as warm and cool" and an opposite method, "seeking light through the opposition of colors."[22] Before 1900, he had already learned that the light produced by contrasts seemed more exact to inner experience, and more lasting, than that which represented the flux of the world. He knew he had discovered his "true path," he said later—except that he was carried forward by an impulse he found "quite alien" in its very recklessness.[23] Looking for a new discipline, he turned to Cézanne. The broadness of touch in the 1899 *Still Life* may already refer to Cézanne's work, though it could as easily derive from Nabi sources. Within a year, however, Matisse's Cézannism is unmistakable.

Male Model. *Paris, 1900. Oil on canvas, 39⅛ x 28⅝ in (99.3 x 72.7 cm). (C&N, p. 174)*

Matisse turned away from Impressionism for reasons similar to Cézanne's a generation before: art was not a record of nature itself but of the artist's feelings before nature. "A Cézanne is a moment of the artist, while a Sisley is a moment of nature," he told Pissarro, probably in 1899.[1] That year he bought one of Cézanne's Bathers compositions (fig. 4). The *Male Model* of 1900, one of a number of studies of the nude made in the Académie Carrière,[2] is openly based on Cézanne's methods.

It is typical of the early Matisse that in turning to a new style he also turned to a new subject. Having gone back to still lifes in the winter of 1898–99, when establishing his own domestic setting after his marriage, he then returned to being a student and put aside still life for the figure. There are very few figure studies before 1900. Once established, however, this subject became his major preoccupation. "What interests me most is neither still life nor landscape, but the human figure," he wrote in the famous "Notes of a Painter" of 1908. "It is that which best permits me to express my so-to-speak religious attitude toward life."[3] He continued by making reference to his works depicting the Italian model Bevilaqua, which include both the *Male Model* and the sculpture *The Serf* of 1900–03: "I do not insist upon all the details of the face, on setting them down one by one with anatomical exactitude. If I have an Italian model who at first appearance suggests nothing but a purely animal existence, I nevertheless discover his essential qualities, I see amid the lines of his face those which suggest the deep gravity which persists in every human being. A work of art must carry within itself its complete significance and impose that upon the beholder even before he recognizes the subject."[4]

The face of the *Male Model* is indeed especially summary in treatment—not only by virtue of its composition from a few angular Cézannist planes, but because Matisse (again taking his cue from Cézanne's work) has allowed the color of the background to penetrate into part of the head and neck.[5] This serves to embed the upper part of the figure within the ground of the painting, and to bring that potentially deepest of spaces around the head forward to the surface. Although there is an overall coloristic contrast between the highlighted beige and orange figure and the darker, complementary-hued ground—a contrast which prefigures that of paintings like *Dance* (p. 55)[6]—this is sublimated to the contrast between volume and flatness afforded by figure and ground, and to the reconciliation of this contrast by painterly means. The ground to the left of the figure is as emphatically worked as any other part of the picture, and thus identified with the literal surface of the work and with the side of the figure nearer to the eye. To the right, its treatment is more restrained, and it seems aligned with the farther side of the figure. As is often to happen in subsequent figure paintings, different parts of a more or less monochromatic ground seem to occupy different positions in space.[7] Here, this device serves to join the mass of the figure to the surface and creates a feeling of space opening in depth, as the eye follows the stance of the model diagonally into the work.

Crucial to this effect is the way in which Matisse has created a false "shadow" on the surface down the figure's left side. This is one of the sources for the broad arbitrary bands of contrasting color that set off the contours of figures in *Luxe, calme et volupté* (p. 37) and a number of subsequent paintings.[8] The device seems to have been an outgrowth of Matisse's early charcoal *académies*, partially influenced by Carrière's vaporous paintings, where the edges of highlighted forms grade off into areas of dark space.[9] Matisse transformed this technique in a series of pen-and-ink drawings made between 1900 and 1903, such as *Standing Nude* (p. 32), where emphatic pen scumblings surrounding the figure help to fix it to the white ground.[10] (Something analogous may be observed in the etching *Standing Nude*, 1902–03, p. 33.) In the drawing, volumes are indicated by areas of blank paper; concavities and spaces by strokes of the pen—which led Matisse's fellow students to say of works of this kind that he was making a "negative" (in the photographic sense) of what he saw.[11] In drawings like *Standing Nude* and paintings like the *Male Model*, Matisse shows himself already fascinated by the ambiguity of figure and ground and the pictorial tension he can create through this ambiguity. Although the drawing is certainly indebted to van Gogh,[12] Matisse learned most in this respect from the art of Cézanne.

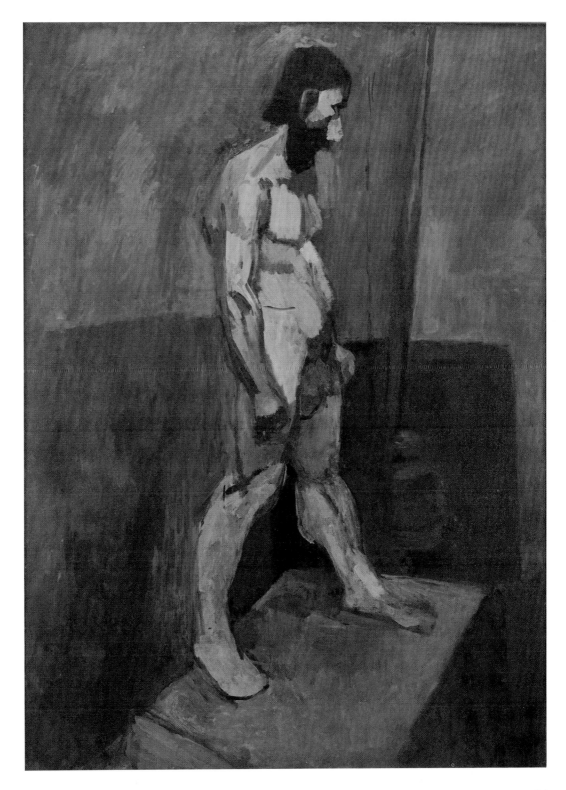

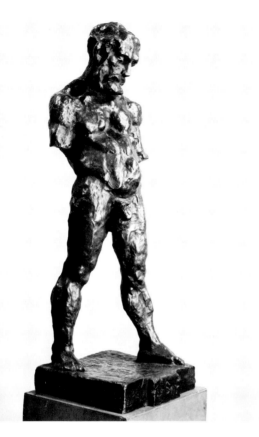

The blue tonality of the *Male Model* may well owe something to Cézanne's Bathers compositions (although it has been attributed to Symbolist influences and compared in this regard to Picasso's almost contemporaneous Blue Period work).[13] Matisse, however, was less interested in Cézanne's color than in his architectonic structure established by "the harmonies of forces" within the work.[14] Although Derain and Puy have referred to paintings like this as proto-Fauve,[15] Matisse's color is certainly less vivid than in the preceding still lifes. Having almost dissolved volumes in painterliness and intense color in his still lifes, Matisse turned to the figure to learn from Cézanne how volumes could be accommodated to the flat surface of the painting, how volumes could be created from a cumulative mass of broad flat touches of pigment that both belonged to the surface and denoted space. Construction in color was applied to the construction of colored mass. The weight and gravity of the figure and its sober, impassive expression and immobile pose closely relate it to Cézanne's studies of the nude, as well as illustrating Matisse's conviction (as given in the 1908 "Notes of a Painter") that "Expression, for me, does not reside in pas-

sions flaring up in a human face or manifested by violent movement. The entire arrangement of my picture is expressive . . ."[16] Hence, the linked succession of planes on the torso both describes the muscularity of the figure and possesses an intrinsic interest at least equivalent to that of the subject itself. Matisse is true "not only to direct observation but to the emotion governing the observation."[17] The rhythms of painting itself embody the "expression" of the work. This too is Cézannist. Like Cézanne, Matisse was seeking a *logique* as well as an *optique* on which to base his art.

In 1900, he was doing so in a highly deliberated manner. Although the *Male Model* appears to be a very spontaneous painting, we know from Puy that Matisse made measurements from the model, used a plumb line, and was very rational and calculating in making his works of this period.[18] (We can, in fact, see inscribed on the canvas to the right of the figure the vertical guideline against which the pose was matched.) A number of the constructional rules he passed on to his students are well demonstrated in this painting.[19] Also evidence of Matisse's calculating mood from around 1900 is the fact that he began to work simultaneously in different media, developing similar subjects in painting, drawing, prints, and sculpture. Matisse's daughter, Mme Marguerite Duthuit, has explained that Matisse would turn to printmaking in periods of experimentation when he felt the need to explore a major theme in different techniques.[20] Matisse himself was explicit about the role of sculpture in his art as a whole: "I took up sculpture," he said, "because what interested me in painting was a clarification of my ideas. I changed my method and worked in clay in order to have a rest from painting, where I had done all I could for the time being. That is to say it was done for the purposes of organization, to put order into my feelings and find a style to suit me. When I found it in sculpture, it helped me in my painting. It was always in view of a complete possession of my mind, a sort of hierarchy of my sensations, that I kept on working in the hope of finding an ultimate solution."[21]

Matisse's first important sculpture, *The Serf* (p. 31), was begun in the same year as the *Male Model*, when Matisse was taking evening classes in sculpture at the Ecole Communale de la Ville de Paris and going to Bourdelle's studio for technical advice.[22] It is also based on Bevilaqua, holding the same pose as in the painting. Interestingly, Bevilaqua had been one of Rodin's models, having posed for

above left and opposite: **The Serf.** *Paris, 1900–03. Bronze, 36⅜ in (92.3 cm) h., at base 13 x 12 in (33 x 30.5 cm). (C&N, p. 174)*

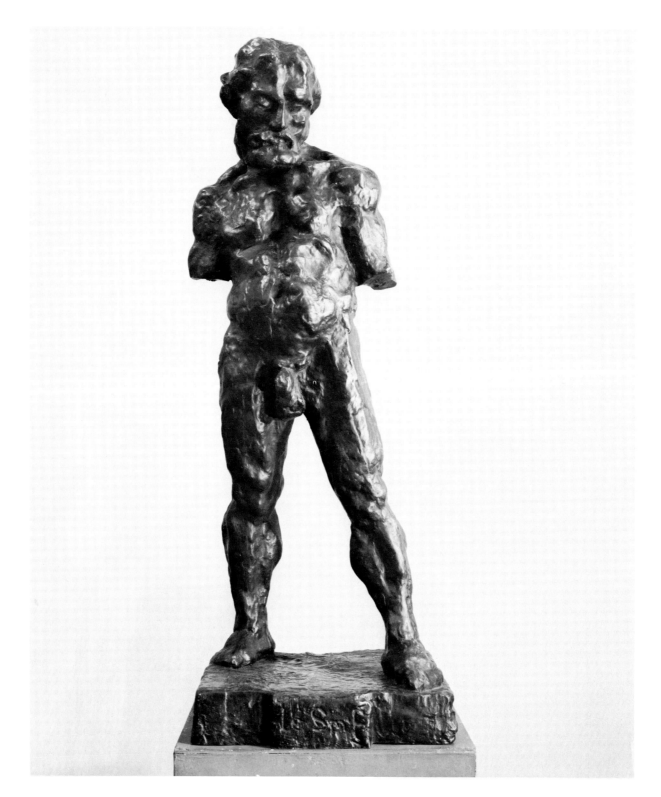

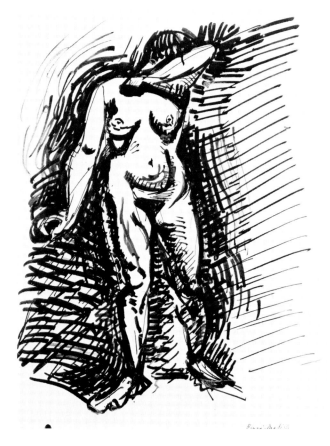

Study for **Madeleine I.** *1901. Pencil, 11¾ x 9¼ in (29.6 x 23.4 cm). (C&N, p. 174)*

Standing Nude. 1901–03. Brush, pen and ink, 10⅜ x 8 in (26.4 x 20.3 cm). (C&N, p. 175)

the legs of *The Walking Man,* a work often paired with *The Serf* to demonstrate that Rodin was the sculptural counterpart to Cézanne in his influence on Matisse.[23] Wanting to incorporate the figure into his art, and turning to sculpture as the most direct way to approach the figure, Matisse, who "never avoided the influence of others,"[24] could hardly do so without making reference to Rodin's work. However, of all Matisse's sculptures, only *The Serf* is Rodinesque, and that only superficially so, being "a development within Rodin's sense beyond Rodin."[25] It transposes in fact certain aspects of Matisse's Cézannism—and with them the self-referential qualities developing in his painting—to a sculptural motif that is indebted to Rodin in stance and gesture; and it revises Rodin's heroic monumentality to create something far more aesthetically contained.

While it would be wrong to see Matisse's sculpture as being painterly—everything is felt as volume—the sense of volume created from an improvised accumulation of touches of material characteristic of the *Male Model* is also evident in *The Serf.* Even the mixture of loose brushwork and planar faceting in the painting finds an equivalent in the alternation between gestural modeling and planes sliced with the sculptor's knife. As in the painting, the surface possesses an intrinsic interest independent not of volume and mass, but of the expression of specific anatomical detail. Unlike Rodin, Matisse did not work clay as an analogy of flesh, but as a "plastic volume material."[26] He avoids, therefore, both a mimetic surface and depicting the effect of internal anatomy upon the surface. It may be an oversimplification to say that Rodin's works are primarily figures and Matisse's primarily sculptures,[27] but the

volumes of *The Serf* are indeed read primarily as blunt architectural masses and not, as in Rodin's work, as parts of an anatomical whole apparently capable of the same muscular activity as that of the spectator who is invited to empathize physically with them. *The Serf* is far more distanced a work and its organization far more responsive to the abstract and visual effects of volumes. As in the *Male Model,* the broadly modeled torso and head visually lift weight off the legs, aided in this respect by the sliced light-receptive planes around the thighs. The overall broadness of touch also allows the sculpture to carry at a distance, something Matisse emphasized to his students as particularly necessary to sculpture, and which he also found telling in Cézanne's paintings.[28] He constantly stressed the importance of achieving "a clear image of the whole,"[29] and even in 1898 recognized that his "work discipline was already the reverse of Rodin's" because of this: "Already I could only envisage the general architecture of a work of mine, replacing explanatory details by a living and suggestive synthesis."[30]

Matisse's concern for the architectonic whole did not mean, however, that he was negligent of the expressive whole, the expression of the character of the subject. The interminable amount of time he spent before the model (the sculpture took an astonishing five hundred sittings)[31] is attributable not only to the fact that Matisse had just turned to figural subjects and was trying to "find a style to suit me," but to Matisse's struggle to find a style that expressed the essential character of his subject. In seeking to realize the "essential character" of what he saw, Matisse separates himself from Rodin's expression of character through "the passions mirrored upon a human face or betrayed by a violent gesture."[32] It had, he told his students, to "exist in the complete work, otherwise you have lost your concept on the way."[33] Hence, Matisse avoided the illusion of movement in Rodin's *Walking Man* as "unstable and not suited to something durable like a statue" (he is nearer to the Rodin of the Balzac studies in this respect)[34] and avoided the kind of facial animation characteristic of Rodin's work. The absence of forearms in *The Serf* may indicate Matisse's indebtedness to Rodin's conviction that a complete scupture does not require anatomical completeness.[35] However, *The Serf* originally had arms, as is shown by an early photograph of the plaster (fig. 8), which were apparently broken off when the sculpture was sent to the foundry.[36] As Albert Elsen has pointed out, the close attachment of arms to body visible in the photograph raises questions about the likelihood of accidental damage.[37] Certainly, the arm sections that remain were trued off with a knife; and the sculpture seems to benefit from the absence of lower arms, which overly

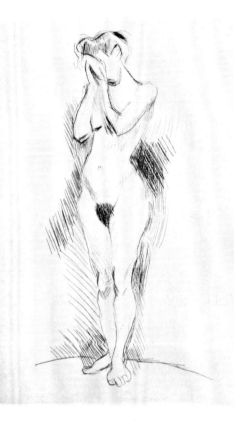

Standing Nude, Hands on Her Face. *1902–03. Etching and drypoint, 5⅞ x 3¹³⁄₁₆ in (14.9 x 9.7 cm). (C&N, p. 177)*

broadened the figure, drawing attention to the out-of-scale head, and tended to concentrate expression in the closed fists. The "essential character" of the figure is better expressed in the armless version.

In his first major sculpture, Matisse already cuts himself off from the tradition of the rhetorical. Only the title refers to the heroic tradition of the past, and this is belied by the heavy posture and gouged, gestural surface. As Matisse's subsequent sculptures make increasingly evident, he belongs more to the informal tradition of painter-sculptors like Daumier and Degas. If this is, as Meyer Schapiro suggests, "an exaggerated Hellenistic Hercules," it is one "whose musculature represents innumerable mean labors, not a potential heroic or athletic prowess."[38] In later sculptures, such an intrinsically powerful subject was itself deemed inappropriate, and Matisse turned from

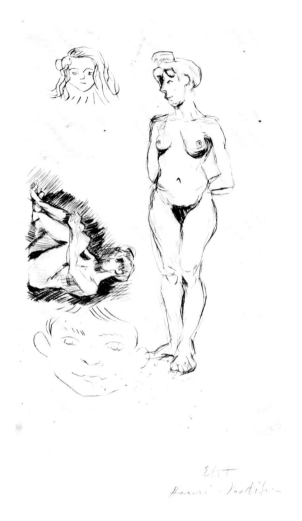

Two Studies of a Nude Model; Studies of the Artist's Children, Jean and Marguerite. *1902–03. Drypoint, 5⅞ x 4 in (14.9 x 10 cm). (C&N, p. 177)*

the heavy masculinity of *The Serf* to female subjects as better suited to his purposes. The 1901 drawing for *Madeleine I* (fig. 9) shows that well before *The Serf* was finished Matisse was beginning to explore more graceful, harmonious, and tranquil forms. By the time *The Serf* was finished "the heroic is eschewed in favor of the informal. The 'sketch' replaces the monument. Rather than a display of power, the work becomes a display of sensibility."[39]

Self-Portrait as an Etcher. *1903. Etching and drypoint, 5 5/16 x 7⅞ in (15.1 x 20.1 cm). (C&N, p. 177)*

The enthusiasm and energy that Matisse brought to his early explorations of new media are nowhere more evident than in his first attempts at printmaking. Working upon small copper plates with no particular intention of producing a perfected, public composition, Matisse nevertheless completed a self-portrait that is one of the most important examples of his draftsmanship in his pre-Fauve years. This print, together with at least three bold ink self-portraits,[1] was probably begun in 1900. In an upper corner of the composition, and with the plate turned on its side, the artist has made two small sketches of himself, one scowling and the other watching dubiously from under his hat. Instead of pursuing either of these subjects Matisse chose, probably for the first time, to represent himself in the act of drawing.

The artist at work was a concept that fascinated Matisse and found expression in his work at different periods in his life. The early years of the twentieth century were devoted to the exploration of various subjects, and Matisse and his friends, the artists Manguin and Marquet, not only worked from shared models, but sketched and painted each other while doing so. Since Matisse through most of his life worked directly from a model, he continually found himself in the picture if a mirror was near the model.[2] The device of the reflected image, the primary means of self-portraiture, was one that Matisse used with charming effect in two monotypes made during World War I and in many pen-and-ink drawings of models in the 1930s. Occasionally this oblique view of the artist is subtly inserted into a painting, but the presence of the artist himself in the composition is a secondary and surprising discovery. Matisse rarely portrayed himself in prints, producing only a heavily shaded lithograph in 1936 and several linear lithographs of his head alone between 1945 and 1952.

In two of the early self-portrait drawings Matisse has filled most areas with crosshatching, a means of forming contours and planes that is a traditional etching technique and seems to have engaged the artist only at the moment when he created his copperplate. With the exception of his self-portrait drawings, the etching has little in common with Matisse's work outside the print media. The central placement of the figure, nearly symmetrically formed, with vast spaces covered with sweeping lines surrounding it, is compositionally uncharacteristic of Matisse's work. He was consistently and innately a master of composition, and his penetrating self-portrait, a composition with considerable strength derived from its nearly head-on form, is a

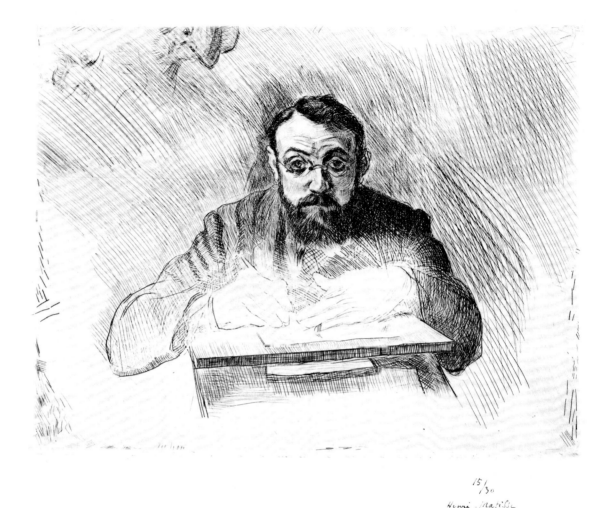

15/30

Henri Matisse

work of exploration. He worked through several states of this print, ultimately reducing the size of the plate.

The other prints of this time consist entirely of small sketches, usually several to a plate, of models and heads (of his children). These are all drypoints scratched directly onto the plate. The pose of one nude has a general resemblance to that shown in certain 1904–05 studio paintings by Matisse, Marquet, and Manguin[3]—although the stance is more solid, perhaps because of the resistance of the medium. These small *académies* are the building blocks that form the early foundations for the great idyllic painting of 1904–05, *Luxe, calme et volupté* (fig. 10).

The small drypoints indicate the informal manner in which Matisse approached printmaking. The small plates were similar to sketch pads devoted to notations for other projects. Matisse was also exploring the possibilities of the tools and materials, scratching here and there as he sought the exact angle for his stylus or the weight and density of lines needed to create certain desired effects. Two deft sketches of his children Marguerite and Jean on a plate where the model is shown in two poses also confirm the notational nature of Matisse's early efforts at drawing upon copper plates. The generally small plate used in these works—it is quite easily taken up in one hand—becomes the chosen format when, a decade later, Matisse returns to this medium. For the moment, however, the plates of the early 1900s may be placed most appropriately within the context of preparatory studies which, perhaps through a stroke of fate only, determined the artist's future approach to drypoints, etchings, and monotypes. R. C.

Study for **Luxe, calme et volupté.** *Saint-Tropez, late summer, 1904. Oil on canvas, 12¾ x 16 in (32.2 x 40.5 cm). C&N, p. 177)*

On June 1, 1904, Matisse's first one-man show opened at the Ambroise Vollard Gallery in Paris. The catalog preface by Roger Marx, the first formal article on Matisse's work, praised him for eschewing easy success for "the challenge of a struggle and the bitter honor of satisfying himself."[1] As soon as the exhibition closed, on June 18, Matisse left Paris for Saint-Tropez to spend the summer near Paul Signac, who had a villa there. By the end of the summer, Matisse had taken on again the challenge of Neo-Impressionism while making preparatory studies for a major painting, *Luxe, calme et volupté* (fig. 10), that turned out to be virtually a manifesto for the thematic direction of his future art.

Matisse had first become acquainted with Neo-Impressionist theory in 1898–99, at which time he briefly flirted with the style.[2] From 1901 he had exhibited at the Neo-Impressionist–dominated Salon des Indépendants, of which Signac was President, and he was certainly aware of the increased visibility in Paris of Neo-Impressionist paintings after 1900, and especially after 1903 when the Druet Gallery opened.[3] Matisse must have come to know Signac fairly well by early 1904 and have wanted to know him better, for it was apparently he who suggested the visit to Signac, and was originally to have brought Marquet with him.[4] Signac, although only seven years Matisse's senior, had been active in the Paris art world since helping to found the Indépendants in 1884, and clearly adopted the position of mentor to the newly emerging Matisse. He arranged accommodations for Matisse and his family, and they stayed in Saint-Tropez until shortly before the opening of the Salon d'Automne on October 15.

Despite Matisse's having invited himself chez Signac, there is no reason to suggest—and the early Saint-Tropez paintings bear this out[5]—that he did so in order to take up Pointillism again. Signac, however, seemed to have assumed that such was Matisse's intention, and after the early part of the summer passed without a single *point* appearing in Matisse's painting, the two men apparently quarreled.[6] The specific source of disagreement was Matisse's *The Terrace, Saint-Tropez* (fig. 11)—a view of Signac's boathouse with Mme Matisse in a Japanese kimono—the brushstrokes of which Signac found so excessively broad as to constitute "treason." Matisse, so the story goes,[7] was highly disturbed by this reprimand and therefore was taken for a walk along the beach by his wife, who posed there with her son Pierre for *By the Sea* (fig. 12), the first of the studies leading to *Luxe, calme et volupté.*

If this account is correctly remembered, Matisse must have felt some justification in Signac's criticisms and have thought it worth trying Neo-Impressionism in a more deliberated manner than before. He later told Alfred Barr that in his first so-called Neo-Impressionist period of 1898–99 he used only the divided brushstroke but not the full methods of the style.[8] Neo-Impressionism was still attractive to him in 1904 because he was continuing to seek a more synthetic and structured view of nature, separated from the empirical standpoint of Impressionism as well as from the specifics of the Impressionist style. "The simplification of form to its fundamental geometric shapes, as interpreted by Seurat, was the great innovation of that day," he wrote. "This new technique made a great impression on me. Painting had at last been reduced to a scientific formula; it was the secession from the empiricism of the preceding eras. I was so intrigued by this extraordinary method that I studied Neo-Impressionism."[9] In the summer of 1904, he seemed determined to follow Neo-Impressionist procedures virtually to the letter. Although *By the Sea*, like the full compositional study for *Luxe, calme et volupté* which followed, is in a highly casual version of the Neo-Impressionist style, it is quite close in treatment to the kind of studies from nature the Neo-Impressionists also made before returning to the studio to work in a more systematic style.[10] The composition is in fact already systematic, the line of the horizon dividing the painting in a Golden Section and that of the shoreline exactly bisecting the lower rectangle, with a pine tree closing the right-hand side of the work. Matisse subsequently made a separate drawing of the pine (fig. 13), whose spokelike branches seemed to fascinate him, then another drawing (fig. 14) laying out the whole general composition of *Luxe, calme et volupté*. The bathers added to the original mother and child were apparently the subject of a number of studies that Matisse made from a model he shared with Signac.[11] Once their poses were established to Matisse's satisfaction, the small oil study for the final painting (p. 37) completed the summer's work. *Luxe, calme et volupté* itself was painted back in Paris in the winter of 1904–05, on the basis of a cartoon drawn after the Saint-Tropez study.[12]

Luxe, calme et volupté is not an entirely successful painting, as Matisse soon acknowledged;[13] in this respect the study benefits from the spontaneity absent in the finished work. It is, however, a highly compelling work and a highly important one in Matisse's oeuvre, both for its deliberated and synthetic treatment and for its subject. Both are conservative, yet both opened the way to the breakthrough in his art that Matisse was soon to achieve.

Maurice Denis criticized *Luxe, calme et volupté* for being "the diagram of a theory."[14] The geometric quality

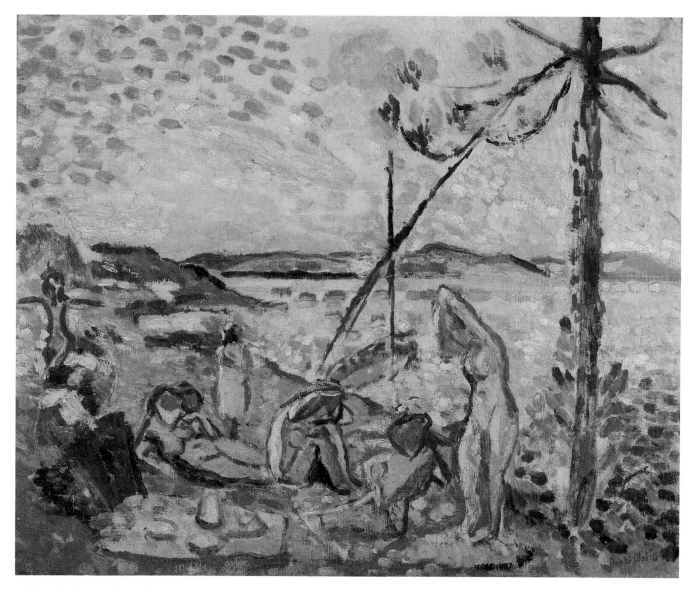

of the design no less than the methodical facture likely provoked the comment. In the oil study for the painting, Matisse broadened the format of *By the Sea* and at the same time let the work be dominated by 30°, 60°, and 90° angles, in keeping with the theories of Charles Henry, which had considerable influence on Signac's art.[15] It is reported that Matisse used a plumb line to fix the position of the tree in the study.[16] He may also have used it, if not in the study then in the cartoon for the final painting, to line up a number of salient parts of the design, such as the positions of the figures to the lower right corner, and to relate the angles at which different elements are placed to

a common focal point, as with the way the angles of the two clouds meet at the junction of horizon and picture edge. The mast and sail of the ship meet on a line that exactly bisects the painting diagonally, while the meeting of mast and shoreline produces a perfect square to the lower right of the composition. There are enough exact coincidences of forms to assure us that it was indeed highly calculated work.

In touch, the study seems far less calculated and fairly close to Matisse's spontaneous Neo-Impressionist–type paintings of 1898–99, except that whereas he previously used both dots and dashes of color, he now stays closer to

the rectangular-module brushstroke of Signac and Cross, though using it in freer form. The codification of method in the finished work confirms this. It is significant that Matisse never used the minute *pointillisme* of Seurat, which causes individually stated pure hues to combine optically in an allover grayness of effect, but opted for the larger constructional units of Signac and Cross and hence for the greater visibility of individual colors. He also followed these artists in leaving areas of blank canvas around individual colors to hold them optically to the same plane; this was to be particularly influential for his work the following summer (see p. 43). Here it introduces a tintlike lightness of effect that was also to be important later.[17] In both study and final painting, however, it is significantly compromised by the agitated, vibrato color juxtapositions. The color scheme established in *By the Sea* carries through the following two works, although of course it is refined as the facture becomes more precise. In conscientious Neo-Impressionist fashion, Matisse divides and separately states local color, complementary-colored shadows, and reflected color. Hence, the red and orange beach, modified by pinks reflected from the sky, gives way to complementary green and blue in the shadows cast by the figures. The tree changes from red-purple to blue-purple as it silhouettes against the sky, from which it picks up orange reflections. The sky itself is given in descending zones of pink and yellow intermixed with their complementaries, while the sea receives color from all the adjacent areas that modify its local blue.

Matisse probably attempted too detailed a rendering of the effects of light and shade on local color, given the large size of his brushstrokes. He wrote later that Henri-Edmond Cross, Signac's neighbor at Le Lavandou, had noted with approval that he "had achieved contrasts as strong as the dominants,"[18] but felt himself that "my dominant colors, which were supposed to be supported by contrasts, were eaten away by these contrasts."[19] "The breaking up of color led to the breaking up of form, of contour. Result: a jumpy surface . . . [which] destroys the calm of the surface and of the contour."[20] In fact, he tried to rescue the identity of the objects shown by resorting to outlining, as Cross often did,[21] only to find himself worried by the conflict of drawing and color thus produced, a conflict that appeared time and again, and was resolved in different ways, in the future development of his art. "Have you found in my picture of the *Bathers,*" he wrote to Signac (who then owned the work) on July 14, 1905, "a perfect accord between the character of the drawing and the character of the painting? In my opinion, they seem totally different, one from the other, absolutely contradictory. The one, drawing, depends on linear or sculptural plasticity; the other, painting, depends on colored plasticity."[22] "If only I had filled in the compartments with flat tones such as Puvis uses."[23] He was writing the following summer, the Fauve summer at Collioure, and beginning to prepare for the *Bonheur de vivre.*

The reference to Puvis de Chavannes undoubtedly relates to the fact that there had been a major retrospective of Puvis's work at the 1904 Salon d'Automne, just before Matisse began the final version of *Luxe, calme et volupté.* It has often been noted that the composition of the painting is highly reminiscent of Puvis's *Doux Pays* (fig. 15).[24] It is also reminiscent of a number of Cross's Bathers compositions that Matisse could have known,[25] and of Cézanne's and Gauguin's Bathers—indeed of a wide variety of nude bathing scenes that filled both progressive and academic salons.[26] The theme is an old one, going back to the Giorgionesque pastoral through rococo *fêtes champêtres* and paintings of the Isle of Cythera. Matisse's painting, however, is not totally removed from the contemporary world and therefore also suggests comparison with modern secularized versions of the Golden Age theme, from Manet's *Déjeuner sur l'herbe* to Seurat's *Grande Jatte.* It is, in fact, a *déjeuner sur la plage:* a group of female bathers have joined Matisse's wife and son to picnic on the beach at Saint-Tropez. It is a highly improbable state of affairs, clearly never happened, and deserves some explanation.

What Matisse has done is to draw together the three major themes of his previous painting: still life and the family, that is to say, things personal and domestic; landscape, the world of observed nature; and the figure, here evoking the timeless and the ideal. They are grouped together under a motto taken from Baudelaire's *L'Invitation au voyage* and speak of an invitation to a world of harmony and sensual pleasure, a world of the imagination if not of art itself:

Là, tout n'est qu'ordre et beauté,
Luxe, calme et volupté.

In the first stanza of the poem, the narrator invites his mistress to the miraculous delights of a distant land that echoes her temperament. Although in the poem that land is Holland, and although the second stanza describes an interior with objects of an intimacy that recalls Matisse's Dutch-inspired domestic still lifes,[27] the family taking tea in *Luxe, calme et volupté* necessarily seems anomalous in this escapist setting. While the family motif may be interpreted as reminder of origins in the mythical representation of the past that constitutes the Golden Age theme, it cannot but appear a sobering reminder of reality, even of the personal or sexual restraints of bourgeois domesticity. (After all, Baudelaire's poem calls for "love at leisure.")

Matisse was later to compare "the tyranny of Divisionism" to living "in a house too well kept, a house kept by country aunts. One has to go off into the jungle to find simpler ways that won't stifle the spirit," he said.[28] It has been suggested that the juxtaposition of naked bathers and fashionably dressed figure may refer to a practice whereby the girls of a bordello were taken on weekend bathing trips by their madam.[29] There is certainly a curious sexual aura to the painting, only emphasized by the somewhat bewildered standing child and by the phallic zeppelin of a cloud that floats over the whole scene.

As the eye travels from left to right across the composition, the scene is transformed with the appearance of the nude figures who successively recline, crouch, and rise to stand before the abstracted landscape. We are in the third stanza, the harbor scene, of Baudelaire's poem. The world of a *Déjeuner sur l'herbe* gives way to a world of the *Doux Pays* complete with ship in the harbor of the ideal land. The land is Saint-Tropez, then an unspoiled paradisal landscape entirely appropriate for the setting of a Golden Age. The landscape itself is an image of youth and innocence in an aging civilization. The theme of the painting is a conservative one not only because it has a long history, but because it looks back nostalgically to a preindustrial past, asserting both the equilibrium and the spontaneity of a simpler, less complicated society. It restates in mythical form the rural nostalgia expressed earlier by nineteenth-century peasant subjects and the assertion of instinctive pleasures expressed earlier in subjects of leisure and recreation.[30] Signac's *Au temps d'harmonie* of 1893–95 (fig. 16) had pictured a future utopia of leisure;[31] Matisse's belongs half to the present and half to the past. In the case of both paintings, however, the contrast between the realities of contemporary life and the lives of those depicted in the works is part of their implicit meaning. The pastoral mode to which they belong is not a window on the world, but a mirror reflecting its artist and his audience, their doubts and feeling of loss of innocence in a civilized world. As such, it prospered within the wave of antimodern feeling around the turn of the century that found its most sustained focus in the Symbolist movement, to which *Luxe, calme et volupté* is linked by virtue of its Baudelairean theme, of Matisse's awareness of Cross's paintings inspired by Symbolist poetry, and by his own contact with Neo-Symbolist writers in 1904.[32] The Golden Age was originally a classical theme. When the Symbolists left the realist modern world, however, they went beyond the confines of a simply classical past to learn from exotic and primitive cultures as well. *Luxe, calme et volupté* is classical in its motifs but instinctive in its feeling, as comparison with Puvis's calmer *Doux Pays* serves to show.

Not being a window on the world, painting of this sort enjoyed greater pictorial license. If what is presented is outside common experience, a special order of its own must be created for it. The otherworldly, far from precluding the methodical, even the scientific, actually required it. The mood of *Luxe, calme et volupté* is not all given with its subject but produced in the insistent abstract rhythms and frozen units of color—in a style that was a totally accepted one but is still curiously personal for all that. "Matisse had discovered within the Post-Impressionist apparatus, which had been devised to deal directly with the world," Lawrence Gowing has written, "the possibility of quite a different and opposite purpose. The pictorial means themselves held qualities of tranquil profusion and delight. They offered an escape."[33] Poesie is built into the very rhythms of the work and the instinctive in its vibrato tones. Moreover, as with the Baudelaire poem, where the distant land echoes something near and present (the temperament of the poet's mistress), the forms of Matisse's painting in speaking of escape do not offer a mere evasion of reality: "the escapist vision enhances the experience of the here and now."[34]

As noted earlier, Matisse was not satisfied with his finished painting. Cross wrote of "the anxious, the madly anxious" mood of Matisse that summer of 1904 and told him, "You won't stay with us long."[35] Matisse possibly chafed against Neo-Impressionism even before making the final version of *Luxe, calme et volupté*, for after showing conservative earlier paintings at the Salon d'Automne, he participated, along with Bonnard, Vuillard, and Laprade, in an exhibition entitled "Intimistes, Première Exposition," at the Henry Graves Galleries—hardly the action of a committed Neo-Impressionist.[36] If this does indeed suggest that Matisse's loyalties were wavering in the autumn, Signac's one-man show at the Druet Gallery in December seems to have won him back. "Carried away by this luminous Signac exhibition," wrote Jean Puy, "Matisse was a thoroughgoing pointillist for a whole year."[37] This is an exaggeration. Matisse did complete his Neo-Impressionist apprenticeship and exhibited *Luxe, calme et volupté* (to very mixed reactions) at the Salon des Indépendants of 1905.[38] Before the year was out, however, he had repudiated the style and was working on a new figure composition, the *Bonheur de vivre* (fig. 19), in which he "tried to replace the 'vibrato' by a more expressive and more direct accord."[39] It was necessary he said, to pass from scientific method to "signs coming from feeling . . . it is necessary to cross this barrier to reexperience light, colored and soft, and pure, the noblest pleasure."[40] What crossed the barrier, indeed broke it down, was Fauvism, in the summer of 1905.

View of Collioure with the Church. *Collioure, summer 1905. Oil on canvas, 13 x 16¼ in (32.9 x 41.3 cm). (C&N, p. 179)*

Landscape at Collioure. *Collioure, summer 1905. Oil on canvas, 15⅜ x 18¼ in (39 x 46.2 cm). (C&N, p. 179)*

After the Salon des Indépendants of 1905, Matisse and his family traveled south once again, this time to the small Mediterranean port of Collioure, not far from the Spanish border. The stir created by *Luxe, calme et volupté* at the Indépendants had confirmed Matisse's position of leadership among his younger friends from the Gustave Moreau studio and the Académie Carrière,[1] and one of them, André Derain, came down to join the Matisses in June. The paintings produced that summer and exhibited in the autumn Salon gave the Matisse circle a name, *les fauves.*

The landscapes Matisse painted that summer were wilder, more reckless than any subsequently produced in his career—though less so than some of the Corsican paintings of the summer of 1898. In both of these summers Matisse responded impetuously to the intense light of the south, threw off the constraints of linear design, and pursued color for its own sake. Color without line meant landscape. It was therefore in landscape painting that Matisse's crucial breakthroughs in the use of color occurred. The first works of the Collioure summer, however, give little

indication of the breakthrough to come. They are painted in a more ordered and sophisticated version of the Neo-Impressionist style of the previous year.[2] We know that Matisse and Derain discussed questions of color theory and technique and that Derain, not Matisse, was probably the first to chafe at the Divisionist style.[3] Just as was the case at Saint-Tropez the year before, Matisse found himself changing his style at least partly because of the example of an artist of lesser stature. Derain had abandoned Divisionism by the end of July. "He goes on, but I've had my fill of it completely," he wrote of Matisse in a letter to Vlaminck, announcing his decision to return to the mixed-technique style he had been developing earlier, where large Nabi-derived color areas, Neo-Impressionist infilling, and van Gogh-like brushstrokes combined.[4] Although Matisse's encouragement and advice undoubtedly helped to liberate the younger painter, Derain's more willful temperament offered an example to the "anxious, the madly anxious" Matisse. "He's going through a crisis just now, in connection with painting," wrote Derain in another letter from Collioure.[5] When resolved it produced paintings of an uninhibited directness and spontaneity that make Derain's look calculated in comparison.

Henri Matisse

It would seem that Matisse made remarkably few paintings that summer, probably around twenty, and most of them very small. *View of Collioure with the Church* demonstrates how the break with Neo-Impressionism came.[6] Although the horizontal brushstrokes that cover much of its surface are Neo-Impressionist in derivation, they are laid on in such a spontaneous and summary fashion and so separated one from the next as to repudiate entirely the ordered framework of that style. Matisse had not been able to make the Divisionist formulas produce

the sense of light he was seeking. When asked later what had produced Fauvism, he talked of a need for direct and utterly personal expression. "The artist, encumbered with all the tehniques of the past and present, asked himself: 'What do I want?' This was the dominating anxiety of Fauvism. If he starts within himself, and makes just three spots of color, he finds the beginning of a release from such constraints."[7] He thus put aside a priori rules both of composition and color relationships for an additive accumulation of separately stated strokes of color that find their

structure in the forms of the motif and in the intuitive understanding of how each newly added stroke modifies the one painted before. This picture is not as casual as it first seems, but is built around an ascending steplike format suggested by the lines of the roofs, to which the other horizontals, and their colors, are all adjusted.

Matisse made a detailed pen-and-ink drawing of the motif (fig. 17), which was visible from the window of the apartment where he was staying (fig. 18), though certainly not painted or drawn from there.[8] (It also can be seen, in highly abbreviated outline, in a lithograph of the winter 1906–07, p. 43.) Comparison of painting and drawing shows how the freedom of the former depends so crucially on the destruction of contour. Although the dabs of pigment that carry around the silhouetted church and tower may be interpreted as contours, they are little different in character from the thick lines of paint elsewhere in the picture. Color is released from the constraints of fixed contours by making painting and drawing one. Unlike the autonomous allover brushstrokes of 1870s Impressionist paintings, to which Fauvist ones are sometimes compared, Matisse's brushstrokes are responsive to the separate identities of the objects he sees. The substance of objects is corrupted in the visual flux, but the visual flux is fixed: the abrupt drawing in paint presumes and does not destroy the existence of the objects from which it derives. The picture may seem "painterly," *malerisch,* in effect, but it shows little real "painting" in the traditional sense, little blending of wet paint. All the parts are put down separately and isolated one from the next. The realistic image seems to have been consumed and dismembered. The reality presented in the picture, however, is visibly a constructed one. "Construction by colored surfaces" was Matisse's description of the Fauvist method.[9]

He soon found the regular direction of brushstrokes in *View of Collioure with the Church* too confining, and in a group of tiny marines began to intermix dots, dashes, and squiggles of thick paint to far more excited effect.[10] In architectural and interior subjects these were combined with larger, and therefore seemingly flatter, areas of color to create his most developed form of the mixed-technique Fauvist style, before it was extended further in Paris in the autumn.[11] It was in landscape that the simplification of painting to the basic constructional unit of the brushstroke found its most clear-cut expression. *Landscape at Collioure* (p. 41) is a veritable flurry of brushstrokes whose varying directions are all that tell us we are seeing a path through trees with a hill in the far distance. There is possibly a strip of blue water beyond the end of the path as it disappears over the brow of the hill,[12] but color is no guarantee of identity here, for the trees too are liberally dosed

with blue, while their trunks are arbitrarily broken into swirls and dashes of scarlet and maroon paint that also appear on the path and on the hill above. These broken tree trunks are indebted to Derain's earlier paintings as well as to Cézanne's.[13] The arabesques they begin to form on the right may well owe something to Cross's work;[14] the overall spontaneity makes certain reference to the work of van Gogh, some of whose Saint-Rémy paintings of olive trees had been exhibited at the Indépendants that spring. Matisse's painting, however, is far more lyrical and informal than any of these sources. Although a highly exuberant work, it is not a statement of total abandon. In the group of paintings showing glades of trees near Collioure, of which *Landscape at Collioure* was probably the first,[15] there began the process through which the Fauvist impulse was finally tamed. These works provided the setting for the calm and harmonious *Bonheur de vivre* (fig. 19).

In the mature Collioure paintings, color speaks for itself with a directness previously unknown in Western painting, and speaks directly too of the emotional response to the natural world that required changing the color of this world the better to render that emotion. As with Impressionist painting, the stress is on the very immediacy of sensation, on "the instantaneity and mosaic aspect of the most primitive moment of vision."[16] In a radical divergence from Impressionist painting, however, not only is color released from contours, theoretical rules, and the representation of the substance of things, but it is also released from "the obligation to render tonal distinctions . . . It is as if all the connecting tonal tissue of painting has been surgically removed to reveal its irreducible chromatic structure."[17] The Impressionists leveled tonal relationships so that color would have a freer rein and would not have to compete for its brilliance against the brilliance of black against white. Because of this, however, shifts of color read also and coincidentally as shifts of value or tone, and thus provide an illusion of atmospheric light and space, an illusion maintained by the balance of warm and cool colors on which Impressionist paintings are based.[18] Matisse later compared this method with another, dedicated to "seeking light through the opposition of colors."[19] It was an idea prefigured by Gauguin and the Symbolists, and may have been suggested by conversations that Matisse and Derain had that summer with Gauguin's friend de Monfreid.[20] The red-green opposition that Matisse settled on could easily have been suggested by Gauguin's work. It became the very hallmark of Matisse's Fauvist art as he replaced the contrasts of tones with the fiercest contrasts of opposing hues. He wanted, he said, "to place side by side, assembled in an expressive and

The Harbor of Collioure. *1907.
Lithograph, 4⁵⁄₁₆ x 7⁵⁄₈ in (10.9 x 19.4
cm). (C&N, p. 180)*

structural way, a blue, a red, a green."[21] Oppositions of
these hues, far from carrying the eye into an atmospheric
space, affirm the planarity of the surface as a taut, stretched
membrane, very different from the softer, more pliant sur-
face of Impressionist paintings. And the light such con-
trasts produce, even when the colors are separated by
areas of blank canvas, is of the most vibrant, dazzling kind.
When Matisse later ran off a list of Fauvist characteristics
it was light-producing color he emphasized most: "Con-
struction by colored surfaces. Search for intensity of color,
subject matter being unimportant. Reaction against the
diffusion of local tones in light. Light is not suppressed,
but is expressed by a harmony of intensely colored sur-
faces."[22]

In the absence of tonal tissue, Matisse gives us the col-
ored skeleton of a painting, and a loosely articulated one
at that. The eye is not helped in movement from part to
part of the *Landscape at Collioure*. It must jump from one
contrasting hue to the next, and jump across unpainted
parts of the canvas to do so. At Collioure Matisse made
some watercolors, which mark one of the very few times he
used this medium. It has been correctly observed that here
"there is no attempt to force the fragile medium to com-
pete with the artist's color experiments in oil."[23] Never-
theless, his responsiveness to the white sheet of the paper

may have encouraged him to open the interstices between
colors in his oils to a radical new degree—just as the ex-
perience of watercolor helped to liberate Cézanne's late
oils, which, together with Neo-Impressionist sketches, may
also have influenced the "unfinish" of Matisse's Collioure
works. From Cézanne, Matisse inherited the wish to make
paintings seem to breathe as if, like the world, they were
alive. This meant that he refused to specify and exactly de-
fine the spaces between objects. The links had to be left
open in order to charge the fixed image with a feeling
of potential movement and free it from the temporal mo-
ment from which it derived.[24] In the Fauve works, the un-
painted breathing spaces between colors served this pur-
pose. It is in these spaces, moreover, and not simply in the
colors themselves, that the vibrant sense of light is trans-
mitted. The colors of the south, as Signac observed, are
dominated by the whiteness of intense light. "Just be-
cause they are in the Midi people expect to see reds, blues,
greens, yellows," he wrote. "It is on the contrary the North
. . . Holland for example . . . that is *colored* (local colors),
the south being *luminous*."[25] The reds, blues, greens, and
yellows of Matisse's *Landscape at Collioure* generate lumi-
nosity in the intervals left between them. Fauvism, Ma-
tisse insisted, was more than merely bright color. "That is
only the surface; what characterized Fauvism was that we

rejected imitative colors, and that with pure colors we obtained stronger reactions—more striking simultaneous reactions; and there was also the *luminosity* of our colors . . ."[26]

The *Landscape at Collioure* is not, however, only a celebration of the light of the south or of Matisse's delight in the semitropical landscape. He evokes not the specifics of the landscape, as did Derain that summer, but rather a timeless idealized setting far more arbitrary and therefore more abstract in its relation to the observed world. While Derain looked outward to the open spaces of coast and mountains, Matisse was attracted by something more private and enclosed. The landscape now in Copenhagen (fig. 20), which followed this one, accentuates the sense of enclosure. No longer a scene, it has become a setting—to be filled, that autumn in a third painting (fig. 21), with a group of pink-and-violet nudes.[27] This can certainly not be mistaken for a simple delight in landscape. Collioure had provided the ideal location for a celebration of *bonheur de vivre,* a more stable form of contentment discovered within the transitory flux of the Fauvist world. Matisse had rebelled against Neo-Impressionism because it could provide neither the sense of light nor the calm he was seeking. In the crucial summer at Collioure he discovered not only a new kind of light, but a new confidence in the contrasting colors that provided it. In Paris that autumn and winter, his work on the *Bonheur de vivre* began a move toward the more deliberately harmonic. Even then, however, Fauvism was by no means over. Other paintings from that same winter show it in a more agitated form than ever prevailed at Collioure.

Girl Reading [La Lecture]. *Paris, winter 1905–06. Oil on canvas, 28⅝ x 23⅜ in (72.7 x 59.4 cm). (C&N, p. 181)*

Girl Reading shows Matisse's daughter Marguerite in the family's Paris apartment at 19 Quai Saint-Michel in the winter of 1905–06. Matisse had rented space in the former Couvent des Oiseaux on the Rue de Sèvres to paint the *Bonheur de vivre;* the works painted at home show nothing of the calming simplification of that picture. He sent the *Bonheur de vivre* as his single submission to the 1906 Salon des Indépendants; the other paintings went with earlier works to his second one-man show, at the Galerie Druet, which opened the day before the Indépendants on March 19.[1]

Matisse's ability to work all but simultaneously in different and virtually opposite styles is hardly ever more evident than in 1906. In 1906 it is partly to be attributed to his uncertainty in a period of transition, but not entirely so. It is evidence of a basic duality in his art between the analytic and synthetic, between nature and imagination. On the one hand, the directness of his response to the observed world was crucial and precious to him. On the other, the very immediacy of the effects he created was often disturbing, and he wanted something more: something more condensed, detached, and controlled. And yet that too was not without its dangers. A synthetic statement could also be an "ephemeral and momentary" one: "When the synthesis is immediate, it is premature, without substance . . ."[2] Perhaps he found the synthetic achievement of the *Bonheur de vivre* a premature one; he did not begin to capitalize on its achievement until the end of the year. *Girl Reading* extends the analytic side of Matisse's art.

Matisse's simultaneous pursuit of different manners of painting is also evidence of the same kind of stylistic self-consciousness that allowed him to mix different techniques of painting in a single work, as he does in this one. The mixed-technique style of Fauvism, of which this is a supreme example, expresses the radical nature of Matisse's art as much as does its liberated color.[3] Although painters have, of course, traditionally varied their methods of handling from section to section of a painting, overt technical discontinuity has usually been the sign of an immature or eclectic art. Matisse may well have been guided to mix techniques by the example of the Nabis, who worked across the full range of Impressionist-based styles, though only rarely within a single work and then without overtly dissonant results. Matisse's adoption of a mixed-technique style was a repudiation of the traditional concept of pictorial coherence, which Impressionism reformulated for modern painting. The regularized, allover brushstrokes of Impressionist pictures had identified, in a way more fully than ever before, pictorial coherence and uniformity of facture. This identity became crucial for much subsequent painting. Matisse's readiness to break with this most basic of conventions shows not only great daring, but a high degree of consciousness as to the pictorial autonomy of the various individual components of his art. In Fauvism, Matisse dissected painting into its constituent parts. His analysis of the world was an analysis of painting at the same time.

As Pierre Schneider has observed, not only is *Girl Reading* another of Matisse's explorations of the family theme, but it looks back specifically to the subject of *La Liseuse* of 1895 (fig. 22), showing an absorbed reader in an *intimiste* setting reminiscent of Vuillard and of the Dutch paintings in which Matisse was interested in his early years.[4] The paintings shown on the back wall and the still-life group to the upper left relate it to the earlier picture.

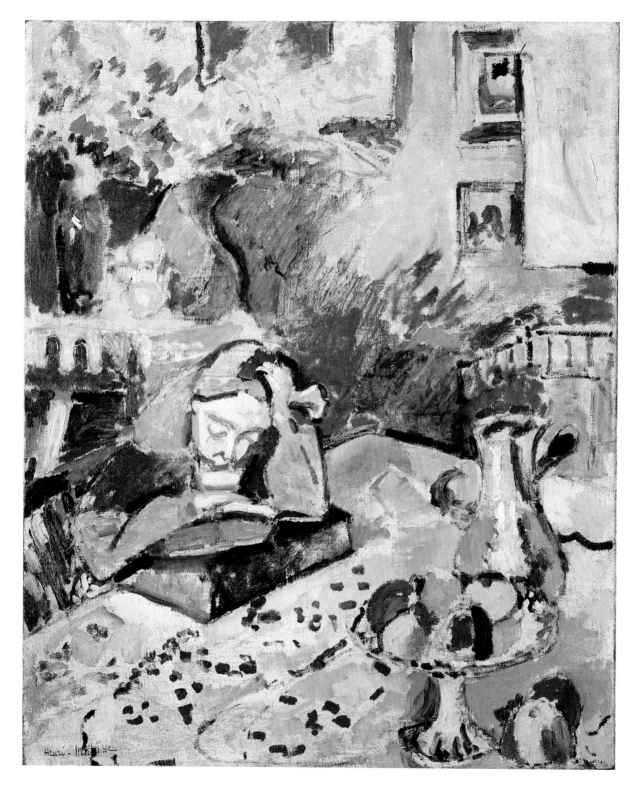

Marguerite Reading. *1906. Pen and ink, 15⅝ x 20½ in (39.6 x 52.1 cm). (C&N, p. 181)*

while the foreground still life of chocolate pot and compotier of fruit appears in a number of early works, as do books.[5] Here, however, the interior seems consumed in flames. Only a few sparks of color on the table remain of Matisse's Neo-Impressionist heritage; nothing, certainly, of its rigid control. *Girl Reading* is a paradigm of the mixed-technique Fauvist style, with its juxtaposed lines, spots, and patches of color, larger areas of brushed and scumbled paint, and liberal areas of blank canvas that both separate colors and function (in the foreground) as colored areas themselves. Not only does the bare canvas surface serve color by providing breathing space between contrasting hues; it is as much a part of the materials of painting as what is placed upon it. Art encompasses the painted and unpainted alike. And more than that: the surface itself is the final arbiter of pictorial coherence. The paint is clearly on top of the surface, is always responsive to it, and never visually penetrates it. Matisse accepts, as he must, the sharp tonal contrasts that some of the contrasts of hue provide, but since the painting is full of contrasts, the eye can never linger long enough with one of them to find its way behind the picture plane and stay there. According to his friend and student Hans Purrmann, if there was anything Matisse truly abhorred it was "holes" in a picture; he would take his friends on critical tours of the Louvre looking for pictures with "holes."[6]

In *Girl Reading,* even the sharpest contrasts of tone read also and coincidentally as contrasts of hue. Moreover, since the painting is dominated by contrasts of the tonally similar reds and greens (as were the Collioure paintings), the flatness of the painted surface is continually affirmed. Even the excited handling cannot disturb that. What it does disturb, however, is the specificity of moment the picture describes. The combination and contrast of different techniques causes the picture to resonate with temporal rhythms that evoke the impermanence, flux—even the very materialization, and then corrosion—of the space presented to our eyes.[7] It is a Bergsonian world of perpetual change, perceived as a set of "distinct and so to speak, solid colors, set side by side," and held together by a "colorless substratum . . . perpetually colored by that which covers it."[8] Within this uncertain world there is but one point of of stasis, the girl reading. Engrossed in her book, she is oblivious of all the Fauvist excitement, of the fact that the room seems to be on fire.[9] Her absorption in quite another world serves to insulate her from her surroundings. Her preoccupation with the invented, aesthetic world shuts out things topical and temporary and provides "a soothing, calming influence on the mind."[10] For a book to "give up its riches," Matisse wrote, the reader must "shut himself away with it—similarly the picture enclosed in its frame and forming with other paintings an ensemble on the wall of an apartment or a museum, cannot be penetrated unless the attention of the viewer is concentrated especially on it."[11] Only the harmonious, self-contained world of art offers an escape from the "succession of moments that constitutes the superficial existence of beings and things, and is continually modifying and transforming them."[12] When we look at Matisse's post-Fauvist interiors, like *The Red Studio* (p. 87), where the introspective calm only the girl shows here is extended to the whole room, we see that the only things to have survived the conflagration of Fauvism are works of art.[13]

The closest that Matisse's drawings came to the fully developed Fauve style of *Girl Reading* was in his portraits and figure studies made with a brush, reed pen, and black ink. *Jeanne Manguin,* a portrait of the wife of one of Matisse's Fauve colleagues, is the greatest of these works. Probably dating from 1906,[14] it shares with *Girl Reading* a mixed-technique style of lines, spots, and summary shading. Although the costume of the figure is allowed to dominate the work—in order to give free rein to Matisse's bravura inventions—and although the modish pose seems almost to be parodying those of conservative bourgeois portraits,[15] it is nevertheless a highly sympathetic treatment of the subject, whose features are given in a dozen amazingly expressive short lines. Very few works of this style exist. The greater proportion of extant drawings from 1906 show a more exclusively linear emphasis and therefore associate themselves more with the synthetic pole of

Jeanne Manguin. *1906. Brush and ink, 24½ x 18½ in (62.2 x 46.9 cm). (C&N, p. 181)*

Matisse's art. Of these, *Marguerite Reading,* made in the summer of 1906 during a second visit to Collioure, prepares for a second, companion canvas to *Girl Reading.*[16] The highly economical line, virtually unsupported by shading and "surrounded by silence which seems to emanate from the paper's blank whiteness,"[17] is more fully expressive of the character of the sitter than any previous line drawing Matisse had made. It shows that he was taking up again the condensed, synthetic approach initiated by the *Bonheur de vivre* and applying it to the test of recording the observed, not the invented, world. Even at this stage, however, he seemed still to distrust his own facility. In painting, the analytic and the synthetic remained as opposite poles.

Nude. *1906. Lithograph, 11 3/16 x 9 15/16 in (28.4 x 25.3 cm). (C&N, p. 182)*

Seated Nude Asleep. *1906. Woodcut, 18¾ x 15 in (47.5 x 38.1 cm). (C&N, p. 182)*

Matisse's first woodcuts and lithographs were exhibited in March 1906 in his second one-man show, held at the Galerie Druet. The boldness and refinement displayed in these works go far beyond what he had so far attempted in printmaking, and in the case of most of the lithographs he begins to incorporate the flowing, uninterrupted line that characterizes much of his subsequent drawing. The woodcuts are the only prints by Matisse that are dynamically in the Fauve manner. A nearly uniform width of line is used to describe forms of the nude and chair as well as to activate the entire composition with radiating and punctuating strokes. This followed the style of primitive carving that the Fauve artists found of interest and also enabled Matisse to create compositions for woodcut in brush and ink that could be directly carved with few complications. Mme Matisse was an artisan of some skill (she is known to have been quite expert at needlework, creating tapestries after Derain's portrait of her in 1905),[1] and she executed

the careful work of gouging.[2] Each block of the three that were completed was printed in an edition of fifty. The drawing for at least one of the woodcuts still exists.

In drypoint and etching Matisse drew directly upon the copper plates, but he rarely created lithographs directly on the stone. With one exception, these earliest lithographs derive from drawings on transfer paper, executed from the same model and, most likely, at the same time as the drawings for the woodcuts. Using a crayon instead of a brush, Matisse smoothly follows the contours of his model, exaggerating only slightly the angles and volumes. These transfer lithographs were printed upon the presses of Auguste Clot on narrow rectangular sheets of a creamy Japan paper. The paper format is unusual and must have been a conscious choice of the artist, for the single-figure lithographs of 1914 are also on paper of this sort and shape. The Japanese print, so important stylistically in the late nineteenth century, continued to have its

Pensive Nude in Folding Chair. *1906. Lithograph, 14¾ x 10⅝ in (37.4 x 26.9 cm). (C&N, p. 182)*

Seated Nude. *1906. Woodcut, 13½ x 10⅝ in (34.2 x 26.9 cm). (C&N, p. 182)*

impact upon younger artists, who were influenced by its more fundamental features, such as form and material. The narrow sheet confined linear forms in a way that emphasized their often foreshortened or cropped contours.

The more densely worked lithograph *Nude* is Matisse's first attempt at working directly upon the lithographic stone. It is a generalized version of the pose seen in the woodcut *Seated Nude,* and is full of emendations as the artist sought to clarify the volumes of the figure. This strange work was long assumed to be a transfer lithograph, for the pose is in an opposite direction from that in the woodcut; however, the drawing for the smaller woodcut is identical to the woodcut, indicating that the block was cut from the reversed drawn image.[3] Zervos dated the lithograph 1907 rather than 1906, placing it stylistically closer to the condensed figures of *Reclining Nude I,* 1906–07, and *Le Luxe I,* 1907.[4] Certainly, its different format and its printing on China paper (the same paper of the many

color lithographs printed by Clot for Toulouse-Lautrec and Vuillard in the 1890s) would seem to indicate that it was completed at another time (or under other circumstances) than the transfer prints.

While the lithographs bear important relationships to the work Matisse later did as a draftsman and printmaker, the woodcuts are the definitive images of the moment. The impetus to make woodcuts and woodcarvings was felt both by the Fauves and the first members of Die Brücke at nearly the same time. In fact, Derain, Vlaminck, Kirchner, Heckel, and Schmidt-Rottluff all created woodcuts in 1905–06 (and Picasso's brief Fauvist moment is found in his *Head of a Woman,* executed upon a wood plank in 1906). Among the results of this shared investigation were the woodcuts that may well have been the outcome of a clever suggestion by the art dealer and publisher Ambroise Vollard. According to the late Frank Perls, who owned the woodblock for *Seated Nude Asleep,* Vollard had asked

Matisse and Vlaminck to take rubbings or prints from a Gauguin woodblock (or carving).[5] Although this event is undocumented, it is known that Vollard had both Gauguin woodcarvings and ceramics and that, inspired by the latter, Matisse, Derain, and Vlaminck went to André Metthey's at Vollard's invitation to make ceramics.[6]

All three artists were involved in Vollard's exhibiting program and could well have been encouraged to contribute woodcuts to yet another of Vollard's print albums (the existence of a Picasso woodcut of this period, though no edition was made until 1933, would indicate some single inspiration behind this effluence of woodcutting). The woodblock for *Seated Nude Asleep,* in fact, was purchased from the estate of Ambroise Vollard.[7] It is characteristic of Matisse's casual involvement with the print media at this time that he, unlike his colleagues, chose to create his images from drawings, rather than gouge directly into the wood. Vallotton's treatment of decorative patterns in his well-known woodcuts, which Barr felt suggested "that the artist had really conceived them as ink designs,"[8] may also have influenced Matisse. There is at least one other drawing of this period that may have been meant for a woodcut.[9] A nearly contemporary drawing (fig. 23) of a seated nude holding a book, used to illustrate *Les Jockeys camouflés* by Pierre Reverdy (1918) and probably reduced in scale, stylistically links the woodcuts and lithographs. The figure, seen from above, is foreshortened and slightly angular; most of the background is patterned with dots and dashes, and the cloth upon which the model sits resembles in pattern Mme Matisse's Japanese kimono that figured so prominently in Fauvist painting in 1905.

As he worked at the twelve transfer lithographs of nudes and the three apocalyptic woodcuts, Matisse was painting *Bonheur de vivre* (fig. 19). At once archaic and classical, the painting owes as much to the Nabis as to Ingres, to Gauguin as to Puvis de Chavannes. In the prints of 1906 these seemingly diametrically opposed tendencies existed apart, but Marguerite Matisse Duthuit makes clear a relationship between Matisse's prints and his paintings: "Usually executed at the end of arduous sessions of painting, the prints provided an enjoyable conclusion for the artist. . . .The clarity of line and the special luminosity emanating from the plates that were produced in this manner constitute in a way the direct profit from the periods of sustained effort that had preceded them and offer delightful variations on the theme preoccupying him at the moment."[10] R. C.

Reclining Nude I. *Collioure, winter 1906–07. Bronze, 13½ in (34.3 cm) h., at base 19¾ x 11¼ in (50.2 x 28.6 cm). (C&N, p. 183)*

In the winter of 1906–07, working at Collioure, Matisse finally put aside the excited mixed-technique style of Fauvism. Even then, however, the decorative linear emphasis initiated by the *Bonheur de vivre* (fig. 19) was not allowed to dominate Matisse's art. Against it he set another "anti-graceful" mode, but one, unlike anything since the beginning of Fauvism, that was unequivocally concerned with volume and its effect on the flattened surfaces the decorative mode had established. Matisse returned to volumes as if to bring to the test of sculptural reality the idealized linear rhythms he had been developing over the past year. From this Collioure period come *Reclining Nude I* and its companion painting, *Blue Nude—Souvenir of Biskra* (fig. 24), both of which reexamine the arabesque in sculptural terms.[1] *Standing Nude, Arms on Head* was possibly also made that same winter, certainly no later than then.[2] It shares with *Reclining Nude I* that blend of sensuous pose and gestural, expressive distortion which characterizes many of Matisse's most important sculptural works.

Evidence that Matisse was testing the viability of simplifications first established in the *Bonheur de vivre* is the way in which the pose of the reclining nude derives from the nymph to the right center of the earlier painting and that of the standing nude from the girl with ivy at the left of that composition. The reclining nude has pictorial but not sculptural precedents that predate *Bonheur de vivre*.[3] The standing nude, in contrast, directly relates to two 1904

sculptures of a similar pose,[4] which was a familiar academic one.[5] In 1906, it was accompanied by a limbless figure known as *La Vie* (fig. 25) with which it shares exaggerated, pointed breasts and jutting buttocks suggestive of the influence of African Negro sculpture.[6] *Reclining Nude I* also has African connotations because of its relationship to the *Blue Nude*, a "souvenir" of Matisse's recent visit to Biskra in North Africa. It was preceded, however, by an almost classical figure, *Reclining Figure with Chemise*, 1906 (fig. 26). The generally relaxed pose of this work (relaxed despite the strong transverse thrust of the left leg) and its flowing antique drapery certainly extend the harmonious classical ambience of *Bonheur de vivre*. Its coarse modeling and separately expressed sections of limbs do not; they prepare for the far more emphatically expressed volumes and energetic rhythms of *Reclining Nude I*. A drawing of the undraped figure (fig. 27), probably made between the two sculptures, shows how Matisse has put aside the *Bonheur de vivre* method of rendering the essence of figures primarily through their silhouettes, without interior modeling. It is an oblique study in depth, examining how the arabesque can be transmitted by volume and not by contour. This achieves sculptural realization in *Reclining Nude I*. It was only finally realized, however, after yet another two-dimensional investigation of the model. The sculpture was damaged before being completed.[7] In frustration, Matisse made a painting of the subject, transposing the figure from its original Arcadian setting to an Algerian oasis, a reminiscence of Matisse's visit to Biskra in the spring of 1906. The *Blue Nude,* that "masculine nymph," as one critic called it,[8] reveals its sculptural source in its heavy volumes. The salvaged *Reclining Nude I* which followed the painting benefits from the expressive distortions established in the *Blue Nude,* and partakes of its newly instinctive mood. The heavy slab that forms the base of the sculpture recalls the grassy North African glade.

The "theme" of the sculpture has been well described as "an explosive energy and thrust, in tension with the horizontality and relaxation of the pose."[9] It is, in one sense, a discovery of the instinctive within the idyllic Golden Age source of the motif: not a turn from the classical and pastoral to the elemental and primitive, for the sensuous animal presence of the figure is contained by its recumbent pose, but a release of the primitive inherent in the pastoral. It is also, of course, a fragmentary presentation of the Golden Age motif, a fraction derived from the *Bonheur de vivre,* but Matisse presented the fraction, he said, to provide "the feeling of the whole."[10] He would subsequently include images of this sculpture in his paintings as representatives of the Golden Age. [11]

Standing Nude, Arms on Head. *1906. Bronze, 10⅜ in (26.2 cm) h., at base 4⅛ x 4⅞ in (10.2 x 12.3 cm). (C&N, p. 183)*

In a painting, however, the entire surface of the work, not just the individual motif, is the agent of expression. In sculpture, it belongs to and is held by the object itself. And yet even here there is an analogy to be made with the paintings. The expressive rhythms of *Reclining Nude I* are a function of the sculpture as a whole and not of the pose of the figure itself. Matisse has chosen a recumbent self-supporting posture to allow himself a maximum of inventive freedom in the disposition of masses that bear, both singly and in their combination, the mark not only of observation of the model but of the emotion that governs the observation.[12] Freed from the needs of resisting gravity (the figure could clearly never have been made to stand), the various anatomical parts are disposed across the base according to Matisse's expressive and architectural sense of relationships. The work is an accumulation of heavy masses: at one side, a foreshortened head with extremely

summary face, abnormally broad shoulders leading to thickened arms, lumpy breasts; at the other, enlarged buttocks and colossally heavy legs. The thinned-down waist, flattened horizontally to the slab of the base, allows these two sides to turn in contrapuntal relationship to provide an astonishing strenuous sense of rotation and sinuosity within the recumbent, passive pose.

The sculptural arabesque does not, however, extend itself into or pretend to animate the surrounding space. It is an enclosed and contained motif with the same kind of distance and purely internal disposition of parts as Matisse's paintings. Its distance from the viewer is emphasized not only by its smallness but by the way in which it is presented. Its wholeness is not that of the object *per se*, to be gradually revealed to us as the eye circulates around the sculpture amassing a series of views none of which is individually complete. Here, each view is complete, and the wholeness of the work is a function of the separate views and not of the object itself. Matisse did not work successively around a sculpture but modeled within a few observed viewpoints.[13] To see this sculpture first from the front and then looking directly at the feet—the two views Matisse instructed it be photographed from[14]—is to see two quite different images. The aesthetic totality of each view—and although they are linked there is no way of accurately predicting what the next will be—"bars us from identifying the object with any one of them…prevents the object from covering the totality of the images which it emits."[15] As in the paintings, the image is drawn from the figure and removes it from the physical world. The experience of volume is given in visual and abstract terms.

Music (Sketch). *Collioure, June–July 1907. Oil on canvas, 29 x 24 in (73.4 x 60.8 cm). (C&N, p. 184)*

Studies of the figure continued to preoccupy Matisse after completion of the *Blue Nude* and *Reclining Nude I*. Indeed ,the figure became his principal subject. Many of the subsequent paintings from 1907 directly addressed themselves, both iconographically and stylistically, to the implications of synthetic figure composition first raised in *Luxe, calme et volupté* and *Bonheur de vivre*. The revival of these interests began a development that culminated in the large decorative panels, *Dance* and *Music*, commissioned by Sergei Shchukin in 1909. *Music (Sketch)* of 1907 served as the iconographical starting point for *Music* of 1910, but since it depicts both music and dance it anticipates the subjects of both Shchukin panels—while looking back to *Bonheur de vivre*, which also combined these two

activities. It falls, in fact, chronologically, thematically, and stylistically midway between Matisse's first full representation of the Arcadian subject and its fullest early realization in the Shchukin panels.

Matisse went down to Collioure in 1907 in mid-June. After a month, however, he left for a journey to Italy, visiting Padua, Florence, Arezzo, Siena, and Venice, returning to Collioure in mid-August for the rest of the summer.[1] He probably stayed in the south until late October, not bothering to return to Paris for the opening on October 1 of the Salon d'Automne, where *Music (Sketch)* together with the first version of *Le Luxe* (hereafter *Le Luxe I*), also described in the catalog as a sketch (*esquisse*), was shown.[2] *Music (Sketch)* and *Le Luxe I* separate themselves from Matisse's other 1907 figure paintings such as *Standing Model, The Hairdresser,* and *Three Bathers,*[3] all of which are far blunter in drawing and heavier in facture. They also capitalize upon the turn away from the volumes of the *Blue Nude* successively revealed in these three works. The *Standing Model* was probably painted in Paris before June. The other two works were included with *Music* in a package of six paintings that Matisse sent to his Paris dealer on or around July 13, the day before he left for Italy.[4] It is evident, therefore, that in his first month at Collioure in 1907, Matisse transformed the "dark" Paris style of early 1907 into one that was lighter, softer, and more harmonious in effect. *Music* is certainly the most advanced, both stylistically and conceptually, of the works of this first Collioure stay, and was probably the last. *Le Luxe I*, which extended and enlarged its frescolike style and Arcadian theme, was presumably painted after the Italian trip, from which Matisse returned in mid-August full of admiration for Giotto, Duccio, and Piero della Francesca.[5] If so, he must have settled down to work very quickly, for the deadline for entries to the juried Salon d'Automne was early September.[6] In fact, both *Music* and *Le Luxe I* give the appearance of being very quickly painted; the designation *esquisse* they received implies a preliminary first version subject to further clarification.

Matisse's use of this term for paintings certainly no less finished than many of the Fauve works he had exhibited without it tells us much about the changing ambitions of his art. "Often when I start to work I record fresh and superficial sensations during the first session," he wrote in 1908. "A few years ago I was sometimes satisfied with the result. But if today I were satisfied with this, now that I think I can see further, my picture would have a vagueness in it: I should have recorded the fugitive sensations of a moment which could not completely define my feelings. . . . I want to reach that state of condensation of sensations

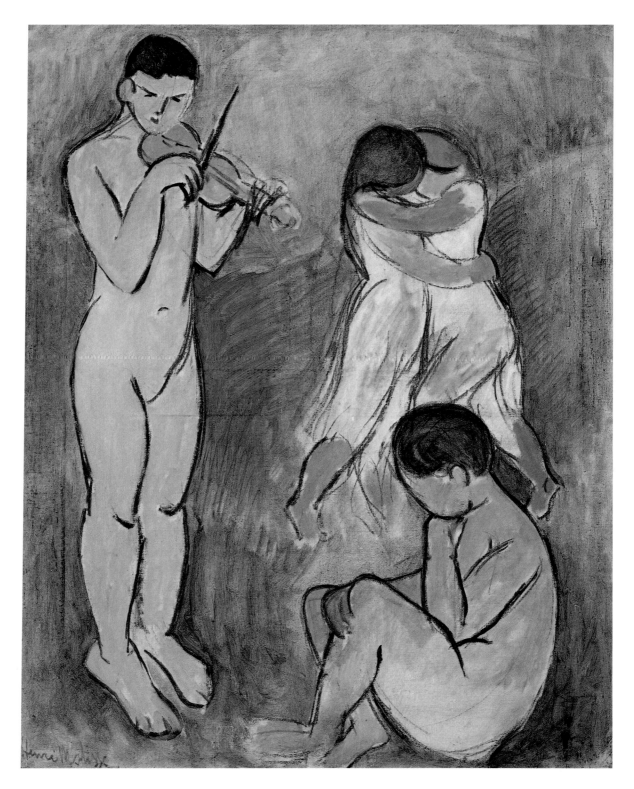

which makes a painting . . ."[7] The drive toward the synthetic that this passage expresses was corroborated by the invented Arcadian subjects to which Matisse was attracted, subjects already separated from the fugitive world. Although conceived of as a "sketch," this first version of *Music* was already a synthetic statement. It was further refined, but even in this state the transient is overcome because memory of form has replaced direct observation, and in memory only the permanent in the transient is retained.[8] The reliance on memory both to abstract experience—by submitting it to the imagination—and also to remember it—through the process of work of art which will eventually re-create it in imaginative terms—characterizes the future direction of Matisse's art, at least for the next ten years.

The forms of the first version of *Music* are remembered not only from nature but from art, from *Bonheur de vivre*. The violinist derives from the piping shepherd in the 1906 painting and the seated figure from the crouching lover to the lower right. The two passionately dancing girls in *Music* recall both the dance in *Bonheur de vivre* and the embracing couple to the left in that painting, though neither of these prototypes prepares for their tight, almost combative interlocking. Maillol's *Wrestling Women* of 1901 has been proposed as a possible source;[9] the wrestling children in Puvis's *Doux Pays* (fig. 15) may be another. Neither, however, is quite so inescapably sexual in connotation, nor shows the same enclosed concentration, which distances the dancers from the source of the dance. The isolation of the three ocher and white figure motifs, by virtue of their dark outlines and self-contained moods, both from one another and from the sparse green and blue setting, is perhaps the most striking feature of the composition. Even the three bathers in the Cézanne that Matisse owned seem more in communication. Here, musician, listener, and dancers, though all responsive to the same music, are each as if unconscious of the others' existence. The musician has been viewed as a surrogate self-portrait, for Matisse was a dedicated amateur violinist and later pictured himself in that role.[10] Interpretation of the artist as initiator of art but estranged both from its calming and enlivening results casts an anxious mood on the painting, and would seem to be belied by its fresh and candid charm. Still, themes of frustration and alienation, expressed in the compositional isolation of figures, are brought along with the theme of Arcadia and manifest themselves in subsequent paintings by Matisse.[11] Presentations of the Golden Age in modern times perhaps cannot escape disappointed reference to the knowledge that it is only a dream.

Whereas the first version of *Le Luxe* was soon followed by a second, more finished version, *Music (Sketch)* was not.

Although Matisse continued to investigate the triadic composition in a number of figure paintings of 1908 and early 1909,[12] the definitive version of *Music* (fig. 28) did not appear until 1910, and then it was in a very different form, the ocher of the figures replaced by an almost fluorescent red, and their green and blue background heightened to match its intensity. The two dancers do not appear in the new version painted for Shchukin. As noted earlier, the dance theme became the subject of a separate Shchukin panel. In the new *Music,* the violinist remains in modified form, as does the seated figure, though as the composition developed it was turned to face the viewer, like its three companions on the brow of the hill.[13] *Music (Sketch)* had passed into the collection of Leo and Gertrude Stein after the 1907 Salon d'Automne. Shchukin had certainly seen it there. It may well, as Alfred Barr says,[14] have formed a basis for discussion between Matisse and Shchukin when they were deciding upon subjects for the two commissioned panels of 1909–10.

Dance *(First Version). Paris, March 1909. Oil on canvas, 8 ft 6½ in x 12 ft 9½ in (259.7 x 389.9 cm). (C&N, p. 185)*

On March 31, 1909, Sergei Shchukin wrote to Matisse from Moscow commissioning the two large decorative panels *Dance* and *Music*.[1] Shchukin had first met Matisse around 1906 and had been collecting his paintings for a number of years. In 1908, however, he had begun to commission paintings from Matisse to decorate the rooms of his Moscow home.[2] The 1908 commissions being completed by the time Shchukin met with Matisse in Paris in late February or early March 1909,[3] a further commission was proposed by Shchukin to Matisse, this time for a painting or paintings to decorate his staircase. It is certain that Shchukin saw the first version of *Dance* (hereafter *Dance I*) during this visit to Paris, for when he wrote on March 31 upon his return to Moscow, he began the letter: "I find your panel 'The Dance' of such nobility, that I am resolved to brave our bourgeois opinion and hang on my staircase a subject with nudes." Since *Dance I* is of almost exactly the same dimensions as the second version purchased by Shchukin (hereafter *Dance II;* fig. 29) and therefore presumes Matisse's knowledge of the size of painting suitable for Shchukin's staircase, it is highly unlikely that Matisse painted it before the spring of 1909, that is to say, before having discussed the commission in at least general terms.[4] Hans Purrmann, who lived above Matisse in the former Couvent du Sacré-Coeur on the Boulevard des In-

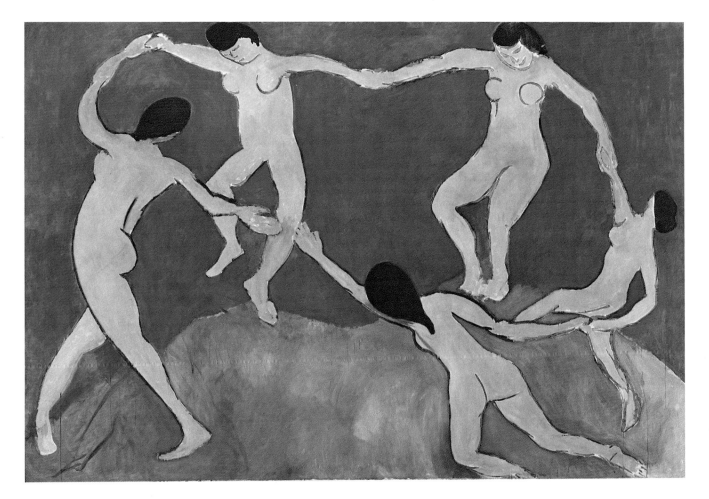

valides, has written that *Dance I* "was painted at the Blvd. des Invalides, surprisingly fast, I believe in one or two days."[5] It seems likely, therefore, that Matisse quickly painted *Dance I* in March 1909, after preliminary discussions with Shchukin, in order to clinch the commission before Shchukin left Paris. Shchukin was impressed and took Matisse to the Restaurant Larue, where they discussed prices, finalized their agreement on the *Dance,* and talked about possible subjects for a second and probably a third panel.[6] On April 12, 1909, Charles Estienne published an interview with Matisse in the Paris daily *Les Nouvelles* in which *Dance I* is specifically described (so that its creation by that date is confirmed)[7] and in which Matisse referred to having a three-level staircase to decorate. He broadly described the three works he had in mind: "the dance," "a scene of music," and "a scene of repose."[8] Presumably he gave the interview before the March 31 letter from Shchukin arrived commissioning only the first two works.

A number of art-historical sources have been proposed for Matisse's conception of a three-panel decorative ensemble,[9] and a much larger number for the specific imagery of the *Dance*. These include: Greek red-figure vases, images of the Three Graces, paintings by Mantegna and Poussin, a tapestry design by Goya, drawings by Rodin and by Art Nouveau artists, Carpeaux's famous sculpture on the facade of the Paris Opéra, and paintings by Maurice Denis, Henri-Edmond Cross, and more besides.[10] Matisse clearly could not have been ignorant of all of these earlier works on the dance theme. There was no shortage of iconographic precedents in the advanced and academic salons, as well as in illustrated journals and in the Louvre. Stylistic precedents for the arabesque rhythms of the work are to be found in a number of the same sources, as well as in Art Nouveau decoration.[11] The immediate source, however, was the ring of dancers in the background of the *Bonheur de vivre* (fig. 19), which may have derived from

any one or a number of the works listed above. Since completing that work, Matisse had made a wood relief and a ceramic vase, both showing a round of three dancing figures, and had presented a dancing nymph on both of the side panels of a commissioned large ceramic triptych.[12] By 1909 the dance was an established theme in Matisse's art, as it was in the art, and indeed in the conversation, of his contemporaries. That year saw the culmination of the first period of intense interest in the dance on the part of the Parisian avant-garde. Diaghilev arrived in Paris in 1909. The same year Isadora Duncan danced in the French capital.[13]

For a while, Isadora Duncan held a dancing studio in the same building where Matisse had his studio in 1909.[14] Matisse, however, was apparently unimpressed by her work[15]—but he did enjoy popular dances, and himself ascribed the source of the *Dance* to memories both of a Catalan *sardane* witnessed on the beach at Collioure and of a *farandole* he saw at the Moulin de la Galette in Montmartre.[16] He was interested in the popular dance, moreover, for reasons advanced by many members of the Symbolist generation. In the summer of 1910, when Matisse was working on *Dance II,* he gave an interview with Charles H. Caffin, an American critic. Caffin had earlier found Matisse's work analogous in its decorative qualities to Isadora Duncan's dancing,[17] and was particularly interested to see that Matisse was working on the Dance theme. The effect of the work, he wrote, "is barbaric ... and assists the primitive, elemental, one might almost say rudimentary, expression of the whole. For the rhythms of these dancing figures are those of instinct and nature. Matisse explains that he derived inspiration for them from watching the soldiers and *ouvriers* dancing with their sweethearts at the *Moulin des Galettes;* and added that the ballet at the opera interested him but was too artificial; in fact too *organisé.* He searches for the natural impression and then does the organizing for himself. And in the case of the *Dance,* organization and simplification were schemed to produce an expression of purely physical abandonment of lusty forms to sense intoxication."[18] Only popular dance was useful to Matisse because his art, like more sophisticated forms of dance, reworked "the natural impression" in an artificial and *organisé* manner. Matisse later told Marcel Sembat that "he regretted that *Dance* [II] wasn't more sublime, more reposed, more nobly calm."[19] His concern for the natural and the instinctive in the dance, and in rendering it in a self-contained form, is virtually a paradigm of the basic concerns of his whole art, and relates to the Symbolists' appreciation of dance both as art in its most basic and natural state and as an art in which form and meaning were organically combined.

Dance, Matisse said, provided "expressive movements, rhythmic movements, elements that were already alive" and that could readily be translated into static form by organizing the movement "at a level which does not carry along the bodies of the spectators, but simply their minds."[20] It could serve, that is to say, as a kind of mental ideogram conveying sensual pleasure in an abstracted form. Mallarmé admired the dancing of Loïe Fuller as "the visual incorporation of idea."[21] Dance was the kind of art in which end and means, form and matter, subject and expression, were coterminous and inseparable, a condition to which the other arts aspired. Fuller probably provided the inspiration for the dancing figures in Derain's *Composition (L'Age d'or)* of 1905, which was one of the sources for Matisse's *Bonheur de vivre,* and hence of the *Dance.*[22] In choosing dance as one of his basic themes, Matisse could hardly have been ignorant of the way in which, for his predecessors and for many of his contemporaries, dance represented the ideal of an autonomous and organic art, insofar as such an art was possible outside some instinctive Golden Age.

In the interview published by Charles Estienne in April 1909, Matisse said of *Dance I* that it was intended to provide a feeling of lightness, "this round of figures taking off above the hill."[23] Estienne described the figures as dancing Muses, but whether anything Matisse said provoked this reference is difficult to tell. He had turned to allegorical subjects for certain 1908 commissions; it would not be surprising if the *Dance* had been conceived as some kind of primordial bacchanal. His friend Marcel Sembat described it in just these terms.[24] The generalized hilltop setting, a traditional symbol of separation from the secular world,[25] and the elemental combination of earth and sky, with the figures seeming to levitate between the two zones, are certainly even more distanced from immediate reality than the ring of dancers in *Bonheur de vivre,* and are far indeed from a Montmartre *farandole.* Dance, Matisse said, meant "life and rhythm" in the abstract.[26] When asked by Bonnard why he had painted the figures all one color, he confirmed that he had deliberately avoided naturalistic references: "I know that the sky throws a blue reflection on the figures and that the fields throw a green one. I suppose I should indicate some light and shade, but what's the use of such dreadful complication. It is of no use in the picture and disturbs my possibility of expression."[27] The choice of colors was derived from natural observation: "I knew that my musical harmony was represented by a green and a blue (representing the relation of the green pines to the blue sky of the Côte d'Azur) completed by a tone for the flesh of the figures."[28] They were not meant, however, specifically to describe these sources: "When I put down a

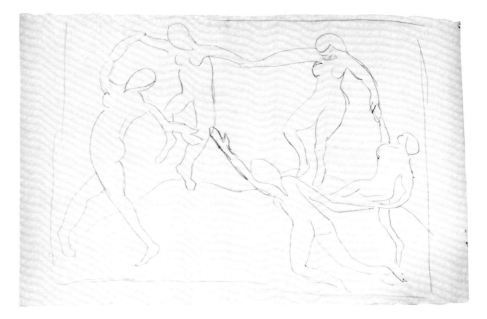

Study after **Dance** *(First Version). 1909. Pencil, 8⅝ x 13⅞ in (21.8 x 35.1 cm). (C&N, p.185)*

green, that doesn't signify grass; when I put a blue, that doesn't mean sky . . . All my colors sing together, like a chord in music."[29] As ever, it was the expressive combination that was important. He referred to his use of stronger versions of the same triad of colors in *Dance II* as an attempt to construct with the basic components of light itself.[30] In form as well as in meaning, the painting was conceived as an elemental work.

Taking as his starting point the round of six dancers swirling in a clockwise movement in *Bonheur de vivre,* Matisse refined the poses of the three foreground figures but eliminated the one to the back left and stilled the movement of the other two so that they seem to hang suspended at the back of the canvas. Since foreshortening is virtually eliminated, these two figures are proportionally much larger than they were in *Bonheur de vivre* and serve, therefore, to minimize the painting's depth. The forward leg of one of these figures even seems to explain why the chain of the dance is broken, coinciding as it does with the gap created as the dancer beneath it unsuccessfully strains upward to reach her neighbor. Matisse had replaced the general oval of linked arms in *Bonheur de vivre* with an irregular diagonal movement across the canvas. Breaking it at its point of maximum tension serves both to telescope pictorial space—by carrying the diagonal movement into the background as well as into the adjacent figure—and to justify Matisse's throwing of the figures against the perimeter of the canvas, as if the snap in the chain had pulled them apart. "Think of the hard lines of the stretcher or

the frame," Matisse had told one of his students; "they affect the lines of your subject."[31] Here, all except the striding figure leading the dance is tied to the shape of the picture support. So flattened to the pictorial surface is the chain of figures and so firmly bonded to its edges that the round of dancers actually becomes the decorative configuration of the work. The pictorial and the iconographic are given as one. If only for this, *Dance I* is a landmark in the development of Matisse's art.

It is also a landmark in the development of modern painting as a whole. Its extreme flatness, totally nonatmospheric space, and highly abstracted and schematic manner of representation mark a more complete break with Renaissance illusionism than produced by any previous painting. The surface is opened and expanded to give color its own visibility and own voice in a way virtually unknown in the West since Byzantine art. "I had decided to put colors on flat and without shading . . .," Matisse said. "What seemed essential was the surface quality of the colors . . . [which] would give the spirit of my composition."[32] Although the colors are not as flat as in *Dance II,* they show how Matisse has avoided impasto better to release the sheer coloredness of his work and blend image and ground in one equally affective surface. Indeed, the thinness of the paint in *Dance I* actually helps the coherence of the work: by yielding to the eye, it allows color to breathe in a space that seems impossibly flat.

Dance I is also, however, a deeply traditional painting. The point here is not merely that Matisse's ambition of

making monumental figure compositions was in essence a nineteenth-century one but, more basically, that he conceived of the painter as an image maker. Advanced painting from Impressionism to Cubism had repudiated depicted images lest they disrupt the unity of the flat pictorial surface. Matisse, like Gauguin and the Symbolists, recognized that some accommodation had to be made to the flat surface and was willing to give up the mass and volume of images—after all, they could be inferred from the inflections of drawn contours—but never their shapes. Shape was necessary to provide the "clear image of the whole" he guarded so much, and was, moreover, essential to a polychromatic art. The turn away from Fauvism was a turn away from the painterly abstraction to which advanced painting seemed to be tending and a turn toward imagery and polychromy. Imagined figure compositions became especially useful to Matisse at this point not only because they afforded new coloristic license; they also provided a new quasi-narrative context for his art. Matisse began to use the narrative relationships between figures as a way of affirming their interrelationships across the flat ground. In *Dance I,* the given subject is literally the means by which images are fixed together. Dancers and painting cohere simultaneously in the form of the dance.

Matisse's work since *Bonheur de vivre* and particularly since *Music (Sketch)* of 1907 (p. 53) had pointed toward this solution, but only by adapting to easel painting the scale and decorative simplicity of a muralist's art was Matisse able to achieve it. He benefited in this respect from the lesson of Puvis de Chavannes.[33] Matisse's particular form of expanded easel painting, however, was obviously very new, as was shown by the horrified reactions to *Dance II* and *Music* when they were exhibited at the Salon d'Automne of 1910.[34] The hybrid of painting and decoration seemed incomprehensible, and was clearly of a sort quite different from that created by Puvis, as critics, Russian as well as French, were quick to point out. Given the very great influence of this new form not only on Matisse's subsequent art but on much avant-garde painting since, especially on American painting since the mid-forties, it is amusing to note that in condemning Matisse one of the foremost Russian critics, J. Tugëndhold, insisted that he had "a dual personality." One half belonged to "half-dreams of a naïve primordial structure, of the lost harmony of the soul," i.e., to the world of Puvis de Chavannes; the other "to the frenzied American-style life of today." "Matisse 'americanizes' his colors," Tugëndhold complained. "He transforms his panels into garish posters, visible a mile away, quite forgetting that *a mural has its own traditions,* a thing that the unassuming Puvis de Chavannes kept well in mind, but which Matisse has

neither the time nor the wish to fathom."[35] Shchukin took fright and considered canceling the commission and taking a Puvis instead.[36] Back in Moscow, however, according to a February 1911 article by Aleksandr Benois, "he began to 'pine for' these pictures and hastened to send for them. Now he no longer regrets his bold step."[37] *Dance II* and *Music* arrived in Moscow on December 17, 1910.[38]

Because of the thinness of paint in *Dance I* we can see the pentimenti showing that Matisse finalized the poses of at least some if not all of the figures only while actually working on the canvas. Although he was working on the basis of a composition developed earlier (in *Bonheur de vivre*), it is nevertheless surprising that there are no extant drawings or other studies for this work. A large charcoal drawing at Grenoble (fig. 30) was previously considered to be a study for *Dance I,* but certainly followed it, and probably was an afterthought to both *Dance I* and *Dance II.*[39] Since The Museum of Modern Art's sheet (p. 57) so clearly follows the poses intuitively realized in *Dance I,* it obviously follows it, as does the watercolor Matisse sent to Shchukin (fig. 31), to which it closely relates and for which it may well have served as a preliminary study. (A drawing after *Dance II* similarly prepared for a watercolor version of that work Matisse made for Marcel Sembat.)[40] No compositional study for *Dance II* is known either, only a study for the poses of the back three figures (derived in part from Matisse's ceramic triptych of 1907), where the changes from *Dance I* are most evident.[41] Matisse may well have begun *Dance II* by transposing onto his new canvas the exact forms of *Dance I* and only modified them in the process of painting.[42]

Bather. *Cavalière, summer 1909. Oil on canvas, 36½ x 29⅛ in (92.7 x 74 cm). (C&N, p. 188)*

When Matisse sent the watercolor sketch of *Dance I* (fig. 31) to Moscow to confirm his design for the first panel to decorate Shchukin's staircase, he inscribed it *Composition I,* and sent with it a second watercolor inscribed *Composition II* (fig. 38). This leads one to assume that *Composition II* was intended to show Shchukin how far he had worked on the second commissioned panel. If this is so, Matisse's initial choice of subject for the second Shchukin panel was not music, for the watercolor shows five female nudes bathing and relaxing near a waterfall. In the interview published by Charles Estienne in April 1909, Matisse spoke of wanting to make three decorations for the three levels of a staircase: on the first level, dance; on the second, music; and on the third, "a scene of repose: some people

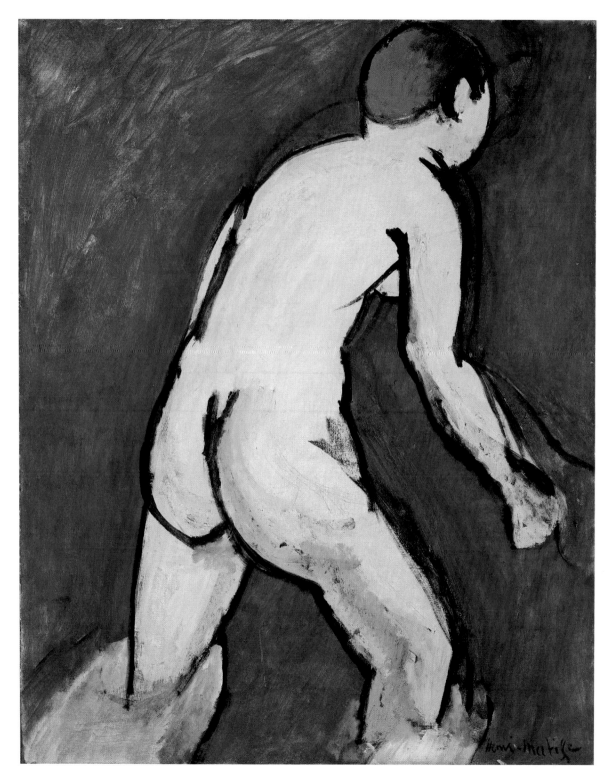

reclining on the grass, chatting or daydreaming."[1] Forced by Shchukin to drop one of the panels (there had clearly been some misunderstanding, for Shchukin's house was two-storied),[2] Matisse would seem to have wanted to abandon the center one. When the letter that Shchukin sent on March 31 arrived, commissioning *Dance* and *Music*, Matisse was obliged to change his plans. He did, however, as is now widely recognized, continue to plan the remaining panel and began to paint it in 1909. It eventually was transformed to become the *Bathers by a River* (fig. 39) and was not completed (and then not to Matisse's satisfaction) until 1916.[3]

The fact that Matisse was planning this painting in 1909 is confirmed by the studies he made that summer at Cavalière, of which The Museum of Modern Art's *Bather* is assumed to be one. It is well documented that Matisse spent the summer preparing for the Shchukin commission by making studies of the figure out of doors, having taken a model south with him for just that purpose.[4] One of his pupils remembered "the model with the glowing skin (we nicknamed her the Italian sunset)...who, posing among green pines against the Mediterranean blue, had suggested the color of *The Dance*."[5] The specific reference is undoubtedly to the so-called *Pink Nude* that Marcel Sembat bought at the end of October upon Matisse's return to Paris and in which he too saw the source for the colors of the Shchukin panels.[6] It is usually assumed that the *Bather* is a male figure. Certainly the hair is much shorter than that of the *Pink Nude* (and of the *Nude by the Sea* and *Nude in a Sunny Landscape,* also painted from "the Italian sunset"—her real name was Brouty)[7] and the body and legs are much broader. Although it seems unlikely that the *Bather* was painted directly from the same model, indication of what seems to be a breast beneath the right arm renders the gender ambiguous. The type of model is in fact close to that of the male figure in the *Nymph and Satyr* (fig. 40) painted at Cassis early in 1909,[8] as are the simplification of anatomy and the generalized setting of the work. Even the pose is analogous. It is not inconceivable that the *Bather* was also painted during that earlier visit to the south. However, given the relationship of the painting to the bathing theme of one of the Shchukin panels, it more likely represents a development of the Cassis manner at Cavalière after the three more naturalistic works. (Matisse himself said it was painted at Cavalière in 1910,[9] but had forgotten it was in 1909 that he worked there.) In any case, it is unlikely that the *Bather* was painted *in situ* as were the three Cavalière works mentioned above. Not only would the pose have been an un-

comfortable one, but the implication of movement provided by the ripples around the legs, plus the fact that Matisse changed his mind in positioning the extended arm, points to the work's being painted from memory.

The ultimate source of the pose is the left-hand figure in the Cézanne *Three Bathers* (fig. 4) which Matisse owned, suggesting that the work is a synthesis of observed and remembered forms from art and nature, a generalization of what he had learned from studying the figure out of doors in preparation for the third of the large compositions he was planning. It has been associated with the figure at the foot of the waterfall in the watercolor sketch *Composition II*,[10] and of course prepares for the bathing theme Matisse developed in the oil version of that composition. It also relates to the first of the Back reliefs (p. 73), which investigate the same theme.[11] Matisse said that the *Bather* was a study for *Dance*.[12] If so, it was only in the most general sense of examining how a figure may be joined to an intensely colored ground. Here, by identifying the vivid blue ground of the painting with the water through which the bather wades, Matisse asks us to imagine it wading through the plane of the picture too. Unlike the figures in *Dance*, the figure of the *Bather* is emphatically volumetric, making the tension between image and ground all the more acute. In seeking to accommodate so weighty, three-dimensional a form to the flattened surface, Matisse reprises a theme previously explored in works like the *Blue Nude* (fig. 24) and, before that, in such early figure paintings as the *Male Model* (p. 29). Once again, he has confronted the basic pictorial problem with which Cézanne also continually struggled. Comparison of the three paintings shows how economically Matisse is now able to express volume—with thick emphatic outlines, summary shading, and bold anatomical simplifications—and how the illusion of volume now seems so embedded in the surface of the work that it cannot be imagined apart from it. Though silhouetted against the blue ground, the figure cannot conceivably be pried away from it; though unmistakably sculptural in connotation, it eludes our sense of grasp. Matisse had seen the Giotto frescoes at Padua in 1907. The memory of volumes inseparably bonded to vivid grounds certainly remained with him; even late in life he said that the Arena Chapel had always been his ideal.[13] In 1909, preparing for his most important decorative commission to date, it may well have come to his mind, and had some bearing, if no direct influence, on the powerful and expressive *Bather* he painted at Cavalière.

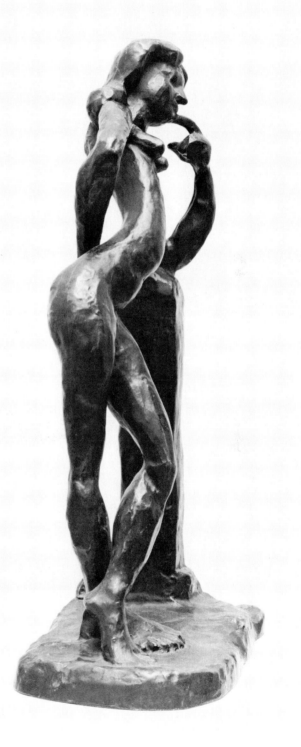

Exploration of the sculptural arabesque, which first found major expression in *Reclining Nude I* of 1906–07, continued to obsess Matisse until 1910. With the sole exception of the squarely simplified *Two Negresses* (1908),[1] the sensuous and voluptuous dominate Matisse's sculpture of this period, as they do his paintings, which reveal a preoccupation both with decorative figure compositions and, in still life, with the extreme arabesque.[2] In sculpture, this tendency found its most radical application in the *Serpentine* of 1909. It is also, however, the informing logic of the two great seated figures of these years, the *Decorative Figure* of 1908 (fig. 41) and the *Seated Nude (Olga)* of 1910 (fig. 42), and, among other sculptures, of the modest but animated *Seated Figure, Right Hand on Ground* of 1908, which mediates in part between the two larger works.

The *Seated Figure, Right Hand on Ground* is one of the last, if not indeed the very last, of a group of miniature figures and heads that Matisse made in the period 1903–08.[3] All of Matisse's sculptures with the exception of the Backs (pp. 73–79) are of modest dimensions, for he demanded an intimate and unrhetorical scale as well as feeling for his work in this medium. The reason for this was not only that the sculptures were made as private objects for clarifying ideas rather than as public manifestos, or that they were conceived for domestic or studio settings.[4] Smallness of scale also allowed Matisse the very direct engagement with the medium he needed in order to realize the essential rhythms observed in the model in the most immediate, forthright, and specific way; and the sensation of volume could most intensely be expressed in works of graspable proportions, works that could be enclosed within the hand. "A sculpture must invite us to handle it as an object," Matisse told his students, "just as the sculptor must feel, in making it, the particular demands for volume and mass. The smaller the piece of sculpture, the more the essentials of form must exist."[5]

Even within an oeuvre composed of small-scale works, the 1908 *Seated Figure* is tiny. As with its companion miniatures, not only the surface of the work but its very form seems to have been shaped by the pressure of the artist's hand. It is not so much the product of modeling—of form that is built up—as of tactile manipulation of lumps of form.

In the summer of 1908, after completing the voluptuous *Decorative Figure* with its play of vertical against serpentine forms, Matisse began experimenting on a smaller scale with a figure that was itself a coiled ara-

his new studio at Issy-les-Moulineaux in autumn 1909[8] (p. 2) shows that he began by staying quite close to the model's proportions. His subsequent reorganization of the masses of the figure was far more drastic than any he had ever done before. The thin vine of the figure tapers and then swells as it turns upward: from enlarged feet and heavy calves to narrow thighs and then to pear-shaped buttocks, and from there to tiny waist and thinned-down torso and arms and finally to flowerlike head. As often seems to be the case, however, forms we now find refined and harmonious were at first judged bizarre; the *Serpentine* provoked bewilderment and ridicule for its distortions.[9] Matisse's thinning of the forms was not, of course, merely willful, but was designed to make the linear continuity of the whole work "comprehensible from all points of view." Large areas of mass around the limbs and torso would have restricted the clarity and visibility of the linear rhythms—for these are given as much by the open spaces within the sculpture the thinned-down elements allow as by the elements themselves.[10] Matisse was unquestionably exploring the problems of rhythmic spatial movement in line and void that he also addressed himself to in the first version of *Dance* (p. 55), which preceded this sculpture, and in the second version, which accompanied and followed it. The *Serpentine* was an investigation of the movement of a body in space, of the kind of spatial openness definitively realized in the second *Dance:* for Matisse, it fulfilled a local and specific need for stylistic clarification. How else are we to explain the fact that he did not further explore the possibilities of this astonishingly radical work?[11]

The *Serpentine,* however, is in repose, while the figures in *Dance* are in energetic movement. Whereas the figures in a painting could pass on their movement from one to the next and contain it within the prescribed limit of the frame, a sculpture's self-containment had to be built into its very forms. "No lines can go wild...," Matisse insisted. "All the lines must close around a center; otherwise your drawing cannot exist as a unit, for these fleeting lines carry the attention away—they do not arrest it."[12] Matisse follows academic practice in avoiding extended gestures; he does so not from sheer conservatism, but because the internal consistency of his sculpture demands it. The linearity of this work has been compared to that of Rodin's figures of dancers made from clay coils and to Degas's dancers too;[13] but Matisse always avoids gestures that carry away from the figure. Here, the arms loop back into the curve that flows from the heavy right leg to the enlarged head. Seen from the front, they form an arabesque that carries the direction of the relaxed left leg through the motif, but on the way balances itself on the sturdy

besque, using as his source a photograph of a crouching model with left elbow resting on right knee and braced against the ground by extended right arm (fig. 43).[6] After making a first version, *Small Crouching Nude with Arms* (fig. 44), Matisse must have felt that the outstretched arm distracted from the arabesque, for he removed it, together with the modeled base which had hindered visibility of the volumes that rested there *(Small Crouching Nude without an Arm,* fig. 45). He then, however, reworked the whole figure in the highly manual fashion described above, reinstating the right arm as a roll of clay pressed swiftly into place. In the *Seated Figure,* the pose is lifted more to the vertical, and it is against the vertical submission to gravity that the seemingly still wet lumps of material are draped, bent, and bunched into soft loops. The *Seated Nude (Olga)* of 1910 (fig. 42) directly extends this pose in a more deliberated work. Before this was made, however, Matisse had tested the arabesque against the vertical in far more audacious form in the *Serpentine.*

This too was based on a photograph (fig. 46), of a model "a little fat but very harmonious in form and movement," Matisse said. "I thinned and composed the forms so that the movement would be completely comprehensible from all points of view."[7] The famous photograph by Edward Steichen of Matisse working on the sculpture in

above left and above: **Seated Figure, Right Hand on Ground.** *Paris, autumn, 1908. Bronze, 7½ x 5⅜ x 4⅜ in (19 x 13.7 x 11.2 cm). (C&N, p. 189)*

vertical post set parallel to the right, weight-supporting leg. This containment and contrast of the arabesque by verticals somehow "frames" the serpentine image and separates it from the constraints of gravity. The effect offsets the manual, graspable character of the volumes, lightens them visually to become aesthetic variables of the enclosed space that they articulate.

"Maillol, like the ancient masters, proceeded by volume; I am concerned with the arabesque like the Renaissance artists," Matisse said, referring perhaps to the *contrapposto* rhythms of Michelangelo.[14] In fact, he used volume as arabesque. Volume for Matisse was not a matter of holistic mass so contoured as to lead the eye smoothly around an implied core. It was used to carry rhythm and movement and to offer new and surprising views at each turn. Comparison of Matisse's *Seated Figure* of 1908 and Maillol's *Méditerranée* (which Matisse helped to cast in 1905) shows how in Matisse volume transmits a linear impulse.[15] In the *Serpentine,* volume is line. It is an abstraction of the instinctive voluptuousness of Matisse's sculpture of 1908, the sexuality discovered in the figure compressed into the charged coils of the sinuous pose. The sculpture shows what William Tucker has described as "the transformation of volume into line, so modulated as to re-invoke volume, of an entirely new order."[16] It is in

part the ambiguity that we are forced to confront between volume and line, and between what Tucker calls the grasped and the seen,[17] that accounts for the tense energy the work possesses. "Arms are like rolls of clay," Matisse told his students in 1908, "but the forearms are also like cords, for they can be twisted."[18] He also compared hands to the handles of a basket. Here, the arms themselves evoke that association and emphasize the graspable character of their volumes, something which the direction and movement of their lines otherwise diminish. And since the linear momentum of the work is never released but doubled back upon itself and thus contained, the work as a whole conserves in its very volumes the emotive energy of Matisse's response to the original source, from which, he insisted, everything derived.[19] Even the coquettish finger in the mouth is repeated from the photograph. Everything has its counterpart in the sculpture, except for the double coiled necklace around the model's neck—but then her whole figure is transformed into two intertwining strands of rope.

Girl with Tulips (Jeanne Vaderin). *1910. Charcoal, 28¾ x 23 in (73 x 58.8 cm). (C&N, p. 191)*

While Matisse often produced pairs of paintings of the same motif and often based series of paintings on the same general subject, it was in sculpture that the "serial" aspects of his art found their most direct realization: in the five heads of Jeannette of 1910–13 and in the series of four Backs of 1909–31. This may possibly be accounted for by Matisse's conception of sculpture as a medium for organizing his ideas "in the hope of finding an ultimate method."[1] It may also be relevant that both of these series, in their different ways, show Matisse responding to the innovations of Cubism. For Matisse, the affirmatively sculptural concerns and constructional, part-to-part organization of Cubist painting represented a development from the art of Cézanne parallel to his own.[2] Nevertheless, for an artist who had already developed his original style, Cubism presented a special challenge to the conventions on which his style was founded, and one that may well have suggested the progressive development of a single theme in order to test the viability of these conventions against the new freedom of organization that Cubism offered. In the Jeannette pieces we find a freedom of organization unprecedented in any earlier Matisse sculpture. The monolithic head becomes an accumulation of parts; a single unitary form is replaced by a construction of unitary forms, of which the head is but one. Observation gives way to invention, and the portrait is transformed into a sculptural motif. For all this, however, Matisse's basic expressive concerns carry through. Through the separation and construction of form he exaggerates and underscores the observed visual facts.[3] Invention does not depersonalize the motif; it makes more explicit the intensity of feeling.

It is known that the first two sculptures were made from life, from a young woman called Jeanne Vaderin who also posed for the painting *Young Girl with Tulips,* exhibited at the Salon des Indépendants of March 1910.[4] They both probably date therefore from early 1910, and they share with Matisse's painted portraits of this period broad, open faces with rather graphically rendered features embedded within them.[5] Jeannette's full oval face, prominent nose, and sharply defined eyes with heavy eyebrows, seen in the drawing for *Young Girl with Tulips* (p. 65), are repeated in *Jeannette I.* So is the curious asymmetry of the eyes in the drawing, but the eyes themselves are enlarged and the bones of the cheeks exaggerated to form large oval accents at each side of the nose. This section of the face would continue to engage Matisse's particular attention throughout the series. Here, however, the forceful graphic emphasis given to the eyes in the front

view loses something in definition from the side, while the nose achieves full sculptural identity only in the thrusting, beaklike profile.

Compared with Matisse's earlier and smaller heads, *Jeannette I* is a relatively passive work. Although broadly modeled, it offers little sense of the gestural manipulation of material, possibly because Matisse at first found it difficult to adapt his methods to the larger scale.[6] The greater animation of *Jeannette II,* built on a plaster cast of the earlier state, may therefore be explained by Matisse's having simplified his modeling technique to produce a more direct and forthright effect: the hair more broadly articulated, the eyes more concentrated and the distracting separate lines of the eyebrows removed, the nose and brow joined into a single dipping profile line. These works, however, are not only part of a progressively abstract development; they are separate sculptures—if no more final than Matisse conceived any of his works to be, then no more provisional.[7] These first two, moreover, comprise a pair. (We have no reason to assume that the works which followed were already planned when the 1910 sculptures were made.) They are two renderings of the same subject in alternate modes: the first, cool, calm, and more naturalistic; the second, more animated, rougher, and relatively more abstract, despite the brake on abstraction caused by the effort still to retain the holistic presence of the portrait head.

The paired nature of the first two Jeannettes prepares us for the similarly paired conception of *Jeannette III* and *Jeannette IV,* appreciation of which goes far to resolve the problems experienced by some commentators in explaining the progress of the abstracting development through these two works.[8] It is often observed that the expressiveness of *Jeannette II* seems to lead more directly to the almost expressionistic feeling of *Jeannette IV* than to the calmer, more architectonic structure of *Jeannette III,* which is closer to that of *Jeannette V.* Knowing that the fifth state was in fact built on a cast of the third, not the fourth, scholars have questioned the established order of the series. To see *Jeannette III* and *Jeannette IV* as a second pair of sculptures within the series, the former calm, the latter animated, as in the case of the first pair, is better to understand the somewhat dialectic continuity of the series. The second pair, however, can be less securely dated than the first. The two sculptures were certainly in existence by the end of October 1911, when Matisse left Issy for a visit to Moscow, which in turn was almost immediately followed by a journey to Tangier for the winter. *Jeannette IV* (possibly still in progress) appears in *The Red Studio* (painted before the Moscow trip), and *Jeannette III* was included, along with Jeannettes I and II, in Matisse's New

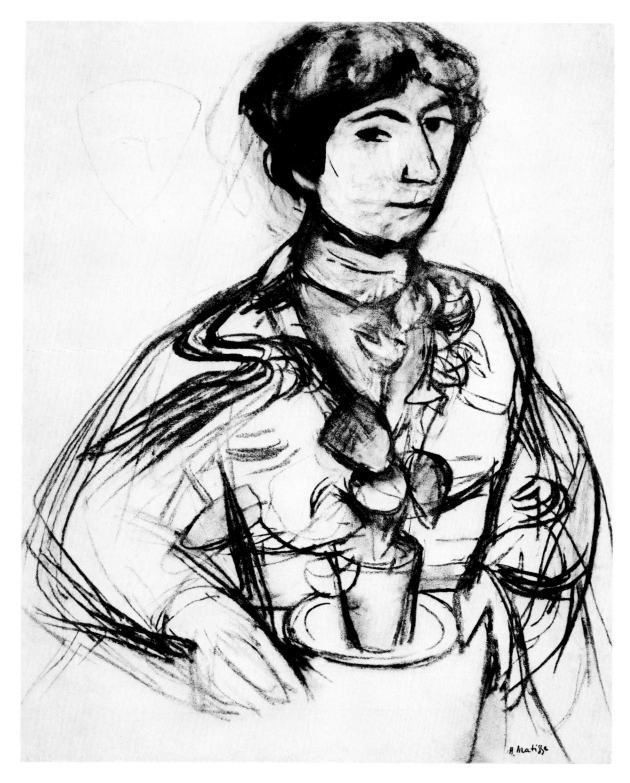

above and right: **Jeannette I.** *Issy-les-Moulineaux, early 1910. Bronze, 13 x 9 x 10 in (33 x 22.8 x 25.5 cm). (C&N, p. 191)*

York exhibition of March 1912, which opened before his return from Tangier. Since it is unlikely that they were made in the same period as the first pair, and since Matisse was away from Issy in the winter of 1910–11, they date therefore from one or both of the two stays at Issy in the spring and autumn of 1911.[9] They probably were completed in the latter period, the time of *The Red Studio* and of *Goldfish and Sculpture* (p. 85), which is constructed, like Jeannettes III and IV, on the basis of triadic relationships.

With *Jeannette III* and *Jeannette IV* the entire conception of the motif is radically altered. The portrait head is replaced by a three-part structure of head, bust, and base, reinforced by the rearrangement of the hair into three prominent volumes and by the emphasis given to the

triad of eyes and nose. Matisse had originally constructed a modeled conical base for *Jeannette I*.[10] Now he includes two supportive masses whose sculptural presence, however, far exceeds their function as supports. Not only is the mass of the head given new force by being the uppermost of the three piled-up masses, but the three masses themselves carry the sculpture upward from the general to the particular and in doing so enforce the abstractness even of the particular, by mirroring the three-part arrangement of volumes within the head itself. By differentiating the head as a unit, Matisse was able to give justification to the part-to-part juxtapositions of individual elements that comprise it.[11] Seen from the front both sculptures are like stubby columns, or like plants that alternately swell and contract as they grow to the petaled head.

left and above: **Jeannette II.** *Issy-les-Moulineaux, early 1910. Bronze, 10⅜ x 8¼ x 9⅝ in (26.2 x 21 x 24.5 cm). (C&N, p. 191)*

In *Jeannette III,* the nose holds its own in the front view far more securely than it did in the previous state. Seen from the side, its contour is steepened and better related to the line of the chin, which itself follows the line of the lower volume of hair at the back of the neck, thus forming the head into a triangular shape that seems all the more audacious for the contrast it affords with the oval these same elements create when seen from the front. The eye sockets, enclosing bulging eyes, are much enlarged beyond the previous state to intrude into the skull above. It has been noted that the reshaping of the eyes may be indebted to the Cézanne-like summaries of Matisse's *Self-Portrait* of 1906.[12] By the time that Matisse began the Jeannette series, the sense of volume had all but disappeared from his paintings, except from the inflections of

contour. But Cézanne had not only taught Matisse how to set volumes against a flat surface; he had also shown him how volume can be created from an accumulation of discrete touches of pigment. The aggregated lumps of matter that comprise the later Jeannette heads can be thought of as the extreme of Cézanne's lesson. Individual pictorial units, discrete in shape, are put together to create volumes that come across as visually felt. Volumes are created on the basis of Matisse's perceptions of tonal shifts across a face. As an established modeler, he readily accepts the implications of what exaggerated tonal differences will do to form: simplify and separate it. Perceived tonality is made sculptural not by effacing it, not by seeking the monolith behind the tonally broken surface, but by exaggerating it, making the perceived breaks in the surface

the divisions between separately defined forms. Whereas Brancusi's exactly contemporaneous first series of heads of Mlle Pogany smooth out the features and cluster the forms around an implied core, Matisse emphasizes the features and gives maximum visibility to the separate forms.

In *Jeannette IV*, as in *Jeannette II*, Matisse produces a more animated version of the companion piece. In a spontaneous reworking of the previous state, he gives up the quiet triangular profile of the head for a sequence of plumelike volumes that carry up the back of the neck, tip over the brow, and lead to the now protruding nose, whose undersurface, fixed parallel to the grimacing smile and line of the sliced lower jaw, carries the eye to the back of the head and begins the same circular movement within the interior of the face. The head and bust are narrower and more angular when seen from the front. Matisse's slicing of the upper as well as lower jaw has forced upward all the forms of the face. The cheeks push up into the zone previously occupied by parts of the eyes, obliterating the underlids; the eye sockets are pushed even further into the brow to create deep crevices that separate the eyes from the nose and provide a continuous passage from the nose to the swelling forehead above. This effect had been rehearsed in the *Head of a Young Girl* of 1906.[13] Here it prepares for the fusion of nose, forehead, and center roll of hair in the final version of this sculpture.

Jeannette IV is more broadly stated and more tightly integrated than its companion, but less nuanced and not without a certain caricatural aspect.[14] Matisse may have found it overdramatic or have been otherwise uncertain of it when he left Issy for his travels in the winter of 1911–12, for he did not choose to include it in his New York exhibition of March 1912 along with the preceding three states. It was exhibited with the others, however, in London in October of that year; but withdrawn from the group for Matisse's Bernheim-Jeune exhibition in April 1913.[15] Its marked expressiveness possibly seemed out of keeping with the decorative Moroccan paintings of 1911–13 shown at Bernheim-Jeune. That was likely the moment he decided to rework the image yet again. Although Matisse could not accurately remember the date of execution of these works, he said that *Jeannette V* was possibly finished after 1912.[16] If this is so, it coincides with *The Blue Window* (p. 91) and the beginning of a period of radical change in Matisse's art in 1913, accompanied by deep anxiety as to its future course—so that very few paintings were produced that spring and summer. For Matisse to turn to sculpture again to help him through his difficulties would be entirely in character. What caused or at least aggravated Matisse's difficulties was the sobering influence of Cubism. *Jeannette V*, along with the second of the series of

Backs, first clearly shows the effect that Cubism had on Matisse's art.

Both *Jeannette V* and *Back II* stabilize a previously animated pose and clarify in sharp linear fashion the division of their separate parts. *Back II* begins to make the figure one with its supporting plane; *Jeannette V* reasserts the wholeness of the head. It does so, however, by means of the most radical surgery, a kind of surgery that first cuts away the hair and then penetrates into the very core of the head to expose the volumes that comprise it. The form of the head is opened far more audaciously than in Picasso's *Woman's Head* of 1909, to which this work is sometimes compared and which seems merely inflected by detail in comparison.[17] Picasso's paintings and especially drawings (fig. 50) of 1909 offer a better precedent for the stylization of the features into a sequence of broad, knife-cut blocks and planes responsive partly to the inherent structure of the face, partly to the effect of illumination upon it, and partly to the autonomous relationship between the blocks and planes themselves. It has been suggested that one of the most blatant distortions, seen in the differing treatment of the two eyes, specifically reproduces the abstracting effect, seen in some early Cubist portraits, of a raking light from the left which deepens contrasts on that side while flattening the eye into the cheek on the other.[18] More credible is Albert Elsen's observation that Matisse had previously cut away volumes to emphasize a plane or contour and that here the suppression allows us to read the whole left side of the face against the similarly simplified neck and bust, thus enforcing the power of the head's asymmetry;[19] and enforcing too, it might be added, the continuity of the sculpture's three main volumes. *Jeannette V* is wholly personal, and Cubist more in its liberation than in the specifics of its style. Where its "Cubism" is manifested is in its dissection of the solid forms of the head and affirmatively part-to-part organization of the separate forms that make up the head and reconstruct its wholeness.

Apart from the radical treatment of the eyes, it is the fusion of nose, brow, and hair–and the way the gourd shape thus formed divides the center of the head and admits space into the left contour–that seems most audacious. Matisse was to let space eat into contours in some of the painted portraits he made the following year, but never to more dramatic effect and never quite in the same way.[20] The displacement of Mlle Yvonne Landsberg's left eye beyond the facial contour in her 1914 portrait does recall the similar feature in the sculpture, but it is hardly more direct a relationship than that of the severe oval mask of the 1913 *Mme Matisse* to the oval serenity of *Jeannette V*'s head. The simplifications and stylizations

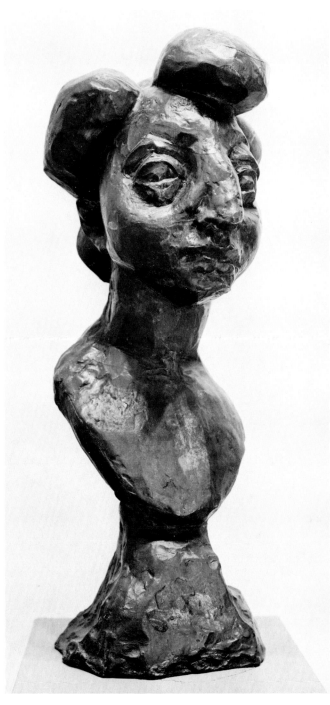

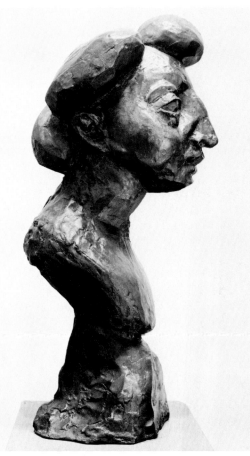

above and above right: **Jeannette III.** *Issy-les-Moulineaux, spring and autumn 1911. Bronze, 22¾ x 10¼ x 11 in (60.3 x 26 x 28 cm). (C&N, p. 191)*

that began to appear in Matisse's paintings were undoubtedly aided by the experience of making the sculpture, and they share the new Cubist-influenced sense of structure and sobriety the sculpture introduced. What Matisse found in sculpture helped him in his painting, he said;[21] but it was not simply transposed from one medium into the other, any more than was the solution of one work transposed to the next. In this sense, Matisse was stylistically the most unprejudiced of artists.[22] The development of the Jeannette heads demonstrates the point. No solution was actually carried over: one work became, in the form of the cast on which the next was made, the subject and point of departure of the next. A single sculptural idea was gradually realized, and that was carried over from Jeannettes III and IV to fulfillment in the last work—but not their solutions.[23] And the "idea" that was transmitted was not simply a formal problem. Matisse does not simplify and abstract to leave behind the original source. *Jeannette V* is psychologically as well as sculpturally the strongest and most forceful of the series.

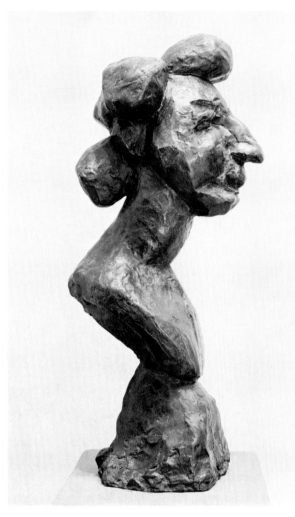

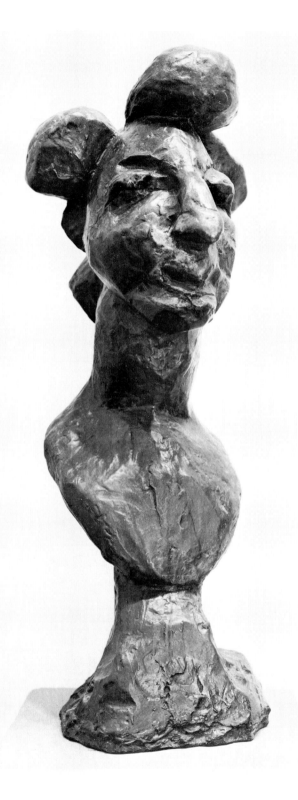

above and right: **Jeannette IV.** *Issy-les-Moulineaux, spring and autumn 1911. Bronze, 24⅛ x 10¾ x 11¼ in (61.3 x 27.4 x 28.7 cm). (C&N, p. 191)*

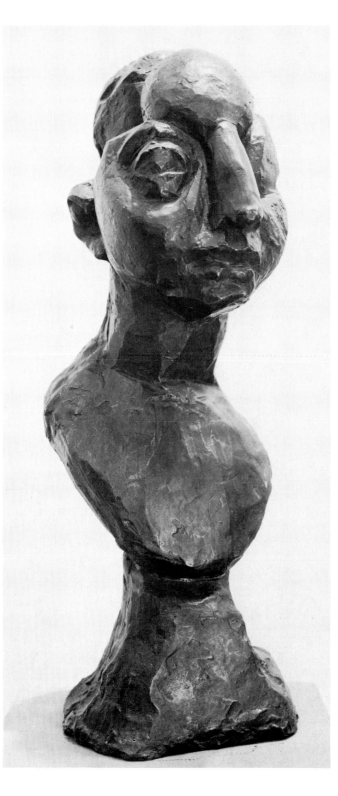

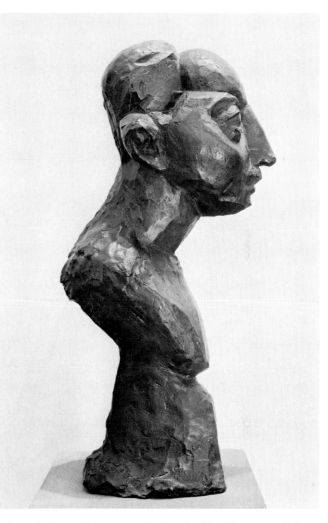

left and above: **Jeannette V.** *Issy-les-Moulineaux, spring–summer 1913. Bronze, 22⅞ x 8⅜ x 10⅝ in (58.1 x 21.3 x 27.1 cm). (C&N, p. 192)*

The Back. *1909. Pen and ink, 10½ x 8⅝ in (26.6 x 21.7 cm). (C&N, p. 192)*

Matisse's imposing set of life-size reliefs, the Backs, were made at widely spaced intervals over a period of some twenty years, from 1909 to 1931. Although they are usually now presented together as a series, where we can judge the remarkable transformation the image undergoes, they were never visible as such in the artist's lifetime. Indeed, late in life, Matisse did not even remember how many reliefs he had made. Although they give the appearance of being conscious public masterpieces, only *Back I* (1909) has long been publicly known, having first been exhibited at Roger Fry's Second Post-Impressionist Exhibition in London in 1912, and then at the New York Armory Show in 1913. The others were not exhibited until very much later. *Back III* (1916) and *Back IV* (1931) were virtually unknown until exhibited after World War II. Matisse had apparently forgotten about *Back II* (1913), for it was discovered only in 1955 after his death. Finally, as recently as 1971, Albert Elsen published a 1909 photograph of an-

other Back relief,[1] now known as *Back 0* since it predates the other four. *Back 0* is lost, and possibly was remodeled later in 1909 to become *Back I*.

Back 0 (fig. 51) was apparently photographed before being moved to Matisse's new studio at Issy from the sculpture studio of the art school he ran in the former Couvent du Sacré-Coeur on the Boulevard des Invalides.[2] Since Matisse spent the summer of 1909 at Cavalière and moved directly to Issy upon his return, this relief must presumably date from the spring of that year. It was by far Matisse's largest sculpture to date. With the exception of the Backs, Matisse's sculptures were extremely modest in scale. The anomalous position the Backs thus hold in the sculptural oeuvre has never been satisfactorily explained. It has been suggested that problems of time, expense, and studio space before 1909 account for the absence of large sculptures before that date,[3] problems solved by Matisse's increased financial security in 1909 and by the construction of a large studio at Issy. "Soon the enormous studio was filled with enormous statues and enormous paintings," Gertrude Stein wrote. "This was the period of the enormous for Matisse."[4] The improved circumstances indeed allowed him to make larger works, yet *Back 0* was made before the move to Issy, and after the move the remaining Backs were the only large sculptures he made. It was not the financial security or the new studio but what provided these things that explains the creation of Matisse's only life-size sculptural works. This was the commission he received from Sergei Shchukin in early 1909 to paint the two large figure compositions *Dance* and *Music,* the former composed of life-size figures.

Back 0 is contemporaneous with the first version of *Dance,* and *Back I* contemporaneous both with the second version and with the beginnings of *Bathers by a River* (fig. 39), a third figure composition proposed to Shchukin along with the other two (see pp. 58–60). *Back II* was made in 1913 when Matisse took up the *Bathers* again, and *Back III* in 1916 when the *Bathers* was completed. *Back IV* was made around 1931 when Matisse returned to large figure compositions, and to the Dance theme, yet again at the time of his commission for the Barnes murals. Useful relationships have been adduced between the Backs and the development of Matisse's painting.[5] The relationship, however, was of a very particular kind. Matisse sought to clarify his ideas in sculpture on a scale equivalent to that of the paintings he was preparing. In this sense, they served if not as studies then as sources of inspiration and mental organization for these paintings, and were, therefore, even more private than any other of his sculptures, and were treated as such.[6] But because they are, in their relief form, closer to Matisse's paintings than

The Back I. *Issy-les-Moulineaux, autumn 1909. Bronze, 6 ft 2⅜ in x 44½ in x 6½ in (188.9 x 113 x 16.5 cm). (C&N, p. 193)*

Study for **The Back II.** *1913. Pen and ink, 7⅞ x 6¼ in (20 x 15.7 cm). (C&N, p. 193)*

any other sculptures, they alone in the sculptural oeuvre share with the many grand paintings the look of ambitious, monumental, and public art. They are, of course, far more than the sculptural equivalents of specific paintings. They are, however, the sculptural realizations of specific pictorial preoccupations, the tension between the sculptural and the pictorial giving them their particular power.

As noted earlier (p. 54), Matisse painted *Dance I* with Shchukin in mind in March 1909. After swiftly completing the painting and on its basis securing the Shchukin commission, he began a protracted investigation of the figure. The softness of contour and modeling of *Back 0* and S-shaped curve that passes through the figure, pushing up from the extended right leg, traversing the curved spine, and curling around the head, can be related to the figures

seen from the back in *Dance I.* The point, however, is not that Matisse was studying again in sculpture the particular poses seen in *Dance* (only a modeled foot of 1909 was actually a sculptural study for the second painting),[7] or even that he was beginning to examine a complementary earth-bound pose before starting the *Bathers,* though this was certainly part of the intention. He was bringing the simplifications he had allowed himself in his figure paintings to the test of sculptural reality once again, and chose the expressively fairly neutral theme of the back as a way of doing so.[8]

There are ample precedents for Matisse's choice of this pose: in sculpture, works by Rodin, Dalou, and Bartholomé, among others;[9] in painting, a whole series of famous nineteenth-century images, from Ingres's *Valpinçon Bather* of 1808 and Courbet's *Bathers* of 1853 to certain of Gauguin's Tahitian paintings and Cézanne's Bathers compositions, the left-hand figure in Matisse's own Cézanne being the most widely cited source.[10] Matisse himself had included a figure seen from the back in his 1907 wood carving *The Dance,* whose arabesque curve and spine emphasized by long hair relate to the early conception of the Backs.[11] The planar, architectonic clarity of the *Two Negresses* (1908) also prepares for this series, as does the 1908 bas-relief, *Standing Nude,* which though seen from the front explicitly deals with the reconciliation of volume to surface, a concern that was to be so important in the Backs.[12] It may well have suggested further exploration of the theme on a larger scale.

Since *Back I* when exhibited in 1912 was described as a "sketch," that is to say, an *esquisse,* a term Matisse used to denote his first conception of a motif, it is likely that *Back 0* was reworked at Issy in the autumn of 1909 to become *Back I.* (Otherwise, *Back 0* would have been the *esquisse.*)[13] Before it was reworked, however, Matisse made a number of figure paintings at Cavalière in the summer, among them the *Bather* (p. 59), clearly derived from Matisse's Cézanne and clearly concerned with the penetration of the pictorial surface by the retreating figure. Then came a series of pen-and-ink drawings of a female model posed facing the wood-paneled wall of the new studio at Issy.[14] The drawing *The Back* (p. 72) and its companions were not only reinvestigations of the pose of the figure, but studies in the relationship of the figure to the plane of the wall behind. Matisse therefore returned to his drawing style of 1900–03, where pen hatchings around the figure advance a back plane or surrounding space to meet its contours (see p. 32). In the 1909 sheet, they cross the left side of the figure to join it to the plane behind. At the right of the figure, hatching of equal density (evidence that it does not merely denote shadows) exaggerates that more

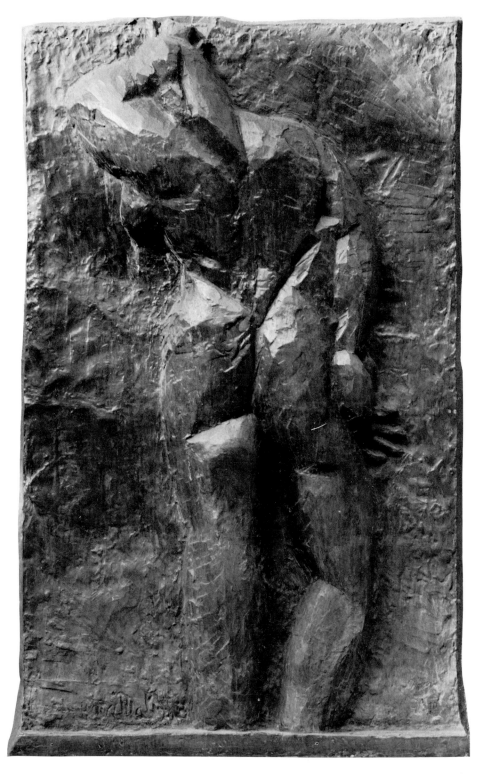

The Back II. *Issy-les-Mouli-neaux, autumn 1913. Bronze, 6 ft 2¼ in x 47⅝ in x 6 in (188.5 x 121 x 15.2 cm). (C&N, p. 193)*

animated contour. In the Backs, the figure's weight is set on the left leg, not the right as in the drawing, but the pose is obviously related. The hardened, rather angular organization of the drawing prepares for the revision of *Back 0* into *Back I*.

In creating *Back I,* Matisse seems to have pared away the soft flesh of *Back 0* to expose a more architectonic though certainly less graceful figure, opened and flattened to the plane of the relief. The left leg is straightened and thickened over the joint of the knee. "Above all, one must be careful not to cut the limb at the joints," he told his students, "but to have the joints an inherent part of the limb."[15] A space is opened between the two legs by removing the triangle of muscle behind the right knee. This, and the emphasis given to the paired ascending arcs of the buttocks, clarifies the movement from legs to torso and follows Matisse's dictum that in a standing figure "all the parts must go in a direction to aid that sensation. The legs work up into the torso, which clasps down over them." The figure, he continued, "must have a spinal column. One can divide one's work by opposing lines (axes) which give the direction of the parts and thus build up the body in a manner that at once suggests its general character and movement."[16] The already prominent spine of *Back 0* thus becomes an assertive linear stem off which spring branches that divide up the blocked-in parcels of muscle making up the back. "Fit your parts into one another and build up your figure as a carpenter does a house," he also admonished his students. "Everything must be constructed —built up of parts that make a unit: a tree like a human body, a human body like a cathedral."[17]

For all the sense of solidity, however, the figure is more active than before in its relation to the back plane. The upward movement carries further to the left as the now extended left arm and elongated, leaning neck find their source of direction in the bending top of the spine. Tucking in the right hand more evidently behind the hip pulls the hip toward us and thus emphasizes the spatial recession that accompanies the linear movement from bottom right to top left. The right leg is clearly nearer to us than the left, as if the figure were leaning against a wall.[18] And yet even at this stage, although the back plane is of course one continuous surface, the implied spatial recession through the figure is such that, if we are to accept that recession, we are prevented from seeing the background as one flat plane. Already, figure and ground modify each other. The figure is embedded into, and inconceivable apart from, the ground. It is also presented without feet, as if they were underground. This surprising device has been explained both mechanically—as Matisse's way of avoiding the problems foreshortened feet would have created[19]—

and metaphorically—as relating to Matisse's image of the figure as a tree rooted in the earth.[20] The feet, however, are not underground but underwater. The figure is a bather standing in a shallow pool. When viewed in this way, the Backs relate more directly not only to observed reality but to the themes of Matisse's painting, and thus escape the puzzling hermeticism within the oeuvre they otherwise seem to possess.

Back II is closer in form as well as theme to Matisse's contemporaneous paintings than *Back I*. While the bulbous volumes of *Back I* suggest as much a reprise of Fauve and pre-Fauve developments as do the drawings that accompany it,[21] *Back II* is closely related to the kind of painting Matisse began to make in 1913. We know from a letter to Camoin of September 15, 1913, that Matisse had just begun to work on the relief along with his portrait, *Mme Matisse,* and (more to the point) his large *Bathers by a River,* which he significantly revised from its original 1909 conception to far more geometric effect.[22] *Back II* is also broadened and simplified beyond the previous state. Even more than before Matisse tries "to feel a center line in the direction of the general movement of the body and build about that."[23] He straightens the spine, aligns it with the inner contour of the left leg, thus showing the vertical curve of the more erect figure. The activity of the surface is calmed: by reducing the number of now more emphatically divided sections of the body; by further paring the forms to far more planar effect; and by clarifying the contours. To the left, the breast is no longer behind but a part of the contour; to the right, the arm and hand are pulled into the side. Matisse thus all but obliterates the sense of spatial recession through the figure seen in *Back I* and with it any illusion of space between the figure and ground.

The single curve that joins neck to right wrist and the subsidiary one that veers off to cut into the back and eventually rejoin the spine have been compared to the radiating arcs around the shoulders of the portrait of Yvonne Landsberg of 1914,[24] and the play of straight and curved lines to the 1913 *Mme Matisse*.[25] The audacious fusion of head, hand, neck muscles, and arms certainly suggests comparison to the amalgamation of adjacent features in *Jeannette V,* also of 1913. All these devices, and even a highly condensed presentation of a back, can also be seen in a photograph of the 1913 state of *Bathers by a River* (fig. 54).[26] All speak of the effect of Cubism on Matisse's art. It is tempting to see a connection between *Back II* and the zigzag stylizations of certain Montparnasse Cubists like Gleizes or Le Fauconnier.[27] Matisse undoubtedly knew their work, and the modeling of the sculpture has Cubist facets that help the passage between the geo-

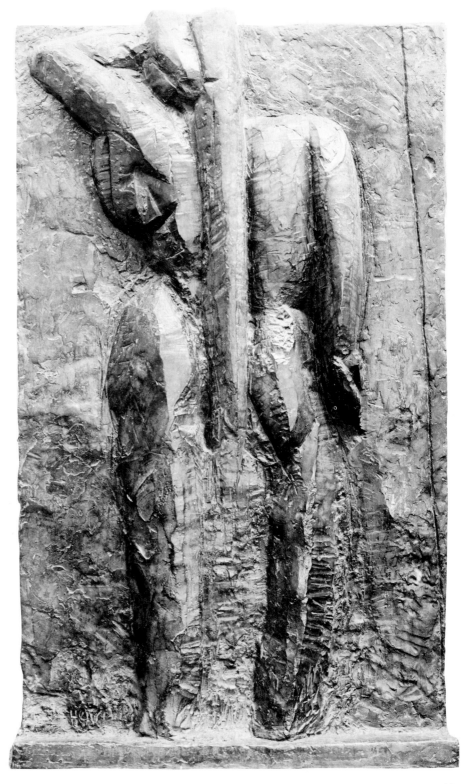

The Back III. *Issy-les-Moulineaux, summer 1916. Bronze, 6 ft 2½ in x 44 in x 6 in (189.2 x 111.8 x 15.2 cm). (C&N, p. 193)*

metrically aligned compartments of the figure and flatten it to the back plane, forestalling any tendency to read it in the round. As in Cubist painting this flattening of the figure opens it out to us, showing us more of it than is consistent with a single point of view. A study for *Back II* (p. 74) appears in this context as a more conservative version of Picasso's *Bather* of 1908.[28] What these comparisons show, however, is that Matisse remained far more closely tied to the integrity of the image than did the Cubists, always insisting on "a clear vision of the whole."[29] There is never that sense of competition between reality and its representation which is essential to the meaning of Cubist art.

Back III, as noted earlier, coincides with the final state of *Bathers by a River* in the summer of 1916.[30] We can certainly no longer imagine what the front of the figure might be like, so integrally a part of the ground has it become. As in the case of the *Bathers,* the figure presents a series of broad vertical zones of light and dark tonalities that carry the eye across the surface. The vestigial sense of an arabesque visible in *Back II* is replaced by the parallel uprights of trunklike legs, limp but weighty right arm, adjacent flattened area of back, and long fall of hair that replaces the spinal indentation but functions as a kind of external spine or fulcrum around which the other forms are balanced.[31] The verticality of the figure, emphasized by the extension of the head beyond the top of the relief, and the way it is complemented by the lateral reading its parallel elements enforce bear comparison not only with the *Bathers* but with a number of slightly earlier portraits,[32] and with other contemporaneous paintings such as the *Piano Lesson* and *The Moroccans.* The triangle around the head and the columnlike treatment of the back were reprised in the *Violinist by the Window* of early 1917. Of all the Backs, this is by far the closest to Matisse's painting, sharing with the contemporaneous paintings the sense of being an assembly and synthesis of separately studied and simplified figural parts. By 1916 Matisse had fully absorbed the schematizations of Cubism to create a newly architectonic decorative style in which the relationship of abstracted signlike planar units both with each other and with their surrounding space was more important than descriptive clarity. *Back III* is no less a product of this conception than the paintings of this period.

It still, however, relates to Matisse's Cézanne *Bathers* that was one of its original sources, combining the poses of the left and right figures in that painting and learning from its simplified weighty forms. *Back IV* also relates to that painting, its surface seeming, as Jack Flam points out, almost a direct equivalent of the brushwork in the Cézanne in unifying the masses and integrating figure and ground.[33] This last relief, however, sets itself apart from the preceding states not only chronologically (it was made over ten years after the preceding one) and thematically (it bears of course no relation to the development of *Bathers by a River*), but also conceptually. Although it completes the process of simplification begun twenty years before, no longer is it itself the product of explorative modeling, of a vigorous attack on the figure. It builds on those things, but its purity and utter tranquility are of an entirely different and far more distanced order.

Back IV comprises three simple vertical zones, much enlarged from before in relation to the ground, to whose rectangular shape they are locked by the newly prominent negative areas of the relief. The interaction of figure and ground is therefore much more a matter of design than it was in the previous states. Indeed, the nearly symmetrical harmony of the work, the homogenous nature of the surface, and the fluidity of the contours, which creates one uninterrupted flow from top to bottom, all speak of Matisse's willingness to surrender the expressiveness of individual parts to that of the designed surface as a whole. This, it has been pointed out, reflects his turn from the descriptive detail of the Nice period and is a harbinger of the new simplicity of the thirties and the preference for symmetrical composition almost entirely absent from the earlier work.[34] It is again worth noting that sculpture mediates an important stylistic shift in Matisse's art, not only with this Back but with other highly simplified sculptures of the late twenties.[35] "I nowadays want a certain formal perfection," he said in 1929, "and I work by concentrating my means…"[36] In 1936 he talked of "the courage to return to the purity of the means."[37]

It may seem curious that Matisse returned to the Back motif around 1930 after so long an absence. Certain 1920s sources in Matisse's painting have been suggested for the relief, but none convincingly expain why he should have turned again to monumental sculpture in this period.[38] The relief is usually dated to 1930, a particularly unsettled year for Matisse who, having hardly traveled at all for ten years except to Paris, spent the spring in Tahiti and the autumn and winter in America. It is possible, but unlikely, that *Back IV* was made between these two visits. It may be from the winter before the Tahitian trip, but Matisse was particularly restless at this time and unlikely to have taken up such an ambitious project. More likely it dates from 1931, after he received the commission for the Barnes murals.[39] The highly architectural conception of the relief —it has been described as a fitting support for the entablature of a temple[40]—as well as its composition from simplified anatomical parts relates to the early and highly sculptural studies for the Barnes commission.[41] The sub-

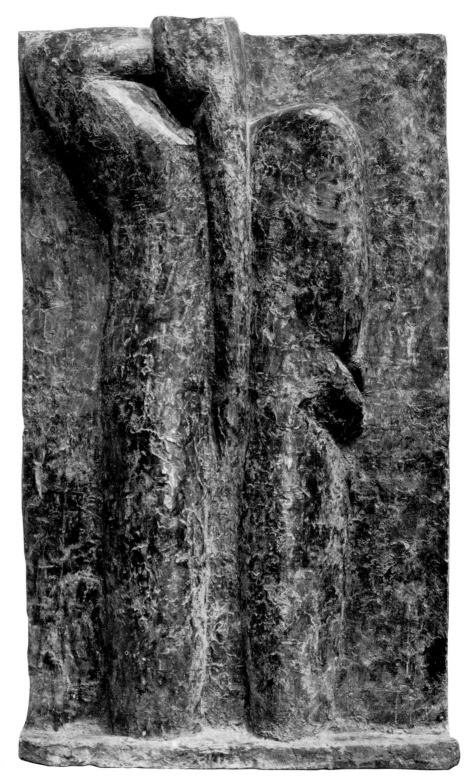

The Back IV. *Issy-les-Moulineaux,*
1931. Bronze, 6 ft 2 in x 44¼ in x 6 in
(188 x 112.4 x 15.2 cm). (C&N, p. 193)

ject Matisse chose for Barnes, *The Dance,* was of course the same as for one of the Shchukin panels. For Matisse to return to the Back as he returned to a Shchukin theme would seem entirely in character. "The expression of this painting," he said of the work at Merion, "should be associated with the severity of a volume of whitewashed stone."[42] He was speaking of the architectural setting, but the description well fits the effect of the plaster version of *Back IV* as we see it in photographs of his studio, set directly on the floor as he probably intended it be seen (fig. 56). It remained in his studio to the end of his life, where its reductive purity, the outcome of a development going back to his earliest decorative paintings, was totally in harmony with his last decorative works, the large-scale cutouts, for whose simplified, separated forms this work prepared.[43]

View of Collioure and the Sea. *Collioure, summer 1911. Oil on canvas, 24¾ x 20⅜ in (62.9 x 51.8 cm). (C&N, p. 195)*

The year 1911 was one of the very greatest in Matisse's art. In 1909 and 1910 he had finally brought to maturity the grand decorative style evolving since the *Bonheur de vivre;* 1911 saw both the consolidation and development of the style. The four great "symphonic"[1] interiors Matisse painted that year—*The Pink Studio, The Painter's Family, Interior with Aubergines,* and *The Red Studio*—both transported the decorative style to observed (not invented) subjects, renewing contact with one of the earliest themes of his art, the interior as sanctuary and treasure trove,[2] and transformed the "plain" decorative style of 1909–10 into a new "patterned" style which, when finally stripped of its ornament near the end of the year, led toward a newly architectonic form of decorative art. In 1911, it has been aptly said, Matisse was "at the crossroads of modern painting."[3]

When he painted *View of Collioure and the Sea* in the summer of 1911, he was in some ways taking a look back. There is certainly no sign of the arabesques and patterns that dominate the most important work of that summer, *Interior with Aubergines* (fig. 58). A landscape painted from near the same spot in 1908 is closer to the style of that painting.[4] In returning to a familiar motif, Matisse was indeed turning from the synthetic, abstracted treatment given to interiors to a far more empirical and analytical approach. In this sense the picture is a retrospective work. Matisse had first painted from the hillside above Collioure on his first visit there in 1905, looking down from the edge of a clearing in the woods to the village in the distance

(fig. 57). Comparison with the 1905 picture confirms that the strong diagonal line bisecting the 1911 work indicates a road traversing the valley, crossing a round-arched bridge at the center, with another road rising into the foothills at the right. The roofs of houses are visible in the valley; beyond the road we see the prominent tower of the Collioure church that Matisse painted in 1905 (p. 40). Since painting from the hillside in 1905, Matisse had returned to the same spot in 1906, 1907, and 1908.[5] He did not make the journey to Collioure in 1909 or 1910, but when he came in 1911 the pilgrimage was repeated. Of course, it was a kind of hallowed site for him. Looking through the arch of trees at the fringe of the wood and catching a sight of the strip of vivid blue sea had provided the setting for the *Bonheur de vivre.*[6] It was indeed a pilgrimage he made each summer, to revisit that source of inspiration for his mature art and paint once again a scene that was potent for him in almost the same way that Mont Sainte-Victoire was for Cézanne.

Matisse painted pure landscape only infrequently. Apart from the early and the Fauvist landscapes, and certain highly abstracted ones later, they are possibly the least-known part of his painted oeuvre, partly because they often seem to be the least assertively structured of his works. He was, of course, unable to reorganize the elements of the motif in a way possible with still lifes, interiors, and figure compositions, but additionally was usually unwilling to do so to any radical degree as he was painting. Nevertheless, the 1911 landscape is not as casual a work as it first appears. While it is dominated by soft brushwork and vivid color, these are controlled and counterpointed by the angular drawing that carries the eye up the surface, telescoping depth. Repetitions of similar forms in different spatial positions assist this effect: the pink-red rooftop in the valley points up to the complementary-colored roof of the church above; the tower of the church, arch of the bridge, and round blob of a tree in the foreground likewise help to draw together the three schematically divided zones of the painting in which these forms are located. Moreover, the counterpoint of drawing and color we see here is analogous to what Matisse was doing in more dramatic a manner in the large compositions of this year.

In an interview he gave that autumn,[7] Matisse spoke of his utter pleasure in the Collioure landscape and of his belief it was the most beautiful in the south. Every day, he said, he would take walks in the hills that skirt the coast, and on numerous occasions try to paint the landscape, only to find it impossible to reproduce its beauty. Since this was possibly the only Collioure landscape he kept (and exhibited) from that summer,[8] we may reasonably

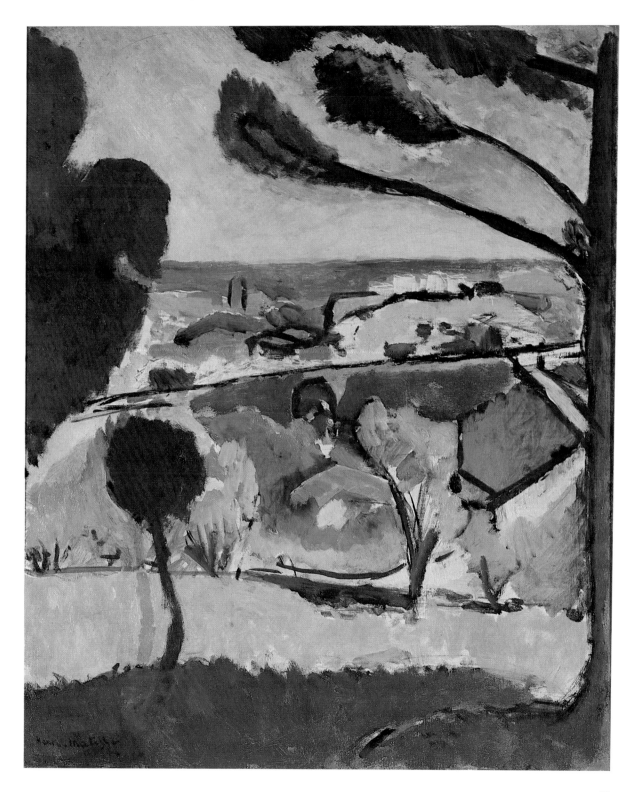

assume that for once he felt he was successful. One day, as he was striving to paint the landscape, he told his interviewer, the color yellow appeared to him, and he made a painting of yellow nudes in the woodland setting.[9] In the vibration created by the pink and green contrasts in this work too, the eye is asked to acknowledge the additive mixture of these colors, which creates yellow.[10] This, together with the warm ochers and pinks, overpainted in places by the soft ultramarine that also frames the painting, gives the work its remarkable sense of radiance—a sense of light that is not atmospheric and therefore transitory, but presents itself as a single, sustained and all-enveloping luminescence inherent in the very substance of the pigments that Matisse used.

Still Life with Aubergines. *Collioure, summer 1911. Oil on canvas, 45¾ x 35⅛ in (116.2 x 89.2 cm). (C&N, p. 196)*

Perhaps it was because Matisse found Collioure more beautiful a landscape than he could hope to re-create by painting it directly that his major effort in the summer of 1911 turned toward transposing the effect of landscape to an interior setting, in the magnificently decorative *Interior with Aubergines* (fig. 58), for which the *Still Life with Aubergines* served as a study. This still life was probably one of the works Matisse described as *esquisses décoratives* when he exhibited them at the Salon d'Automne of 1911.[1]

The *Interior with Aubergines* was the third of the four great "symphonic" interiors he painted in 1911. In a sense, they form two pairs. The first and the fourth, *The Pink Studio* (fig. 68) and *The Red Studio* (p. 87), both show the studio at Issy (the earlier in a more realistic way than the later), and both are painted in variations on the open, "plain" decorative style. They span the year, one dating from the spring and the other from the autumn. The second and the third interiors, *The Painter's Family* (fig. 59), from late spring, and the *Interior with Aubergines,* from the summer, both show domestic interiors (the former the house at Issy, the latter the villa at Collioure), and both are painted in an assertively "patterned" style, though the patterning of one is geometric and abrupt while the other is more restful and arabesque. However, the two works from the spring provide, albeit in different ways, relatively more of a feeling of deep space than the other two, although their spaces are still extremely ambiguous and their tangibility is finally contradicted by color or by pattern. The two works from the summer and

autumn, in contrast, are relatively more frontal in presentation and compound the series of integral images they contain to a picture plane whose unity is emphasized by the ubiquitous flow of pattern or monochromatic color. Matisse has provided us with no fuller a demonstration of how the modes of his art interrelate than in these four great masterpieces of 1911.[2]

A further dimension of Matisse's pictorial methods, however, is revealed in the still-life study for *Interior with Aubergines.* Here, it is to a large extent how color is applied that both gives and takes away depth in the painting.[3] Being so spontaneously and, more important, so lightly brushed, the ground is allowed to breathe and to show through, enlivening the brilliance of the color and giving a sense of spaciousness and airiness to the work. But lightness of touch and thinness of paint application also serve to join all parts of the picture together and to the surface with which color is identified. Color for Matisse was as much a property of surface as was pattern, and he was always highly responsive, therefore, as Clement Greenberg points out, to the very pressure of his brush on the surface. "Very much depends on the fact that he *soaks* his brush with paint rather than loads it. The primed surface is covered with a fluid, not a stuff, and makes itself felt as one with its covering."[4] This still life is an essentially geometric composition of three primary colors supported by their complementaries; its elements come together to form such an unconstrained whole largely because of Matisse's lively touch.

It is supported, of course, both by the depicted patterns of the work and by the patterns the brushstrokes themselves come to create. The latter were suppressed in the large interior painted in tempera; the former, however, proliferate in the more finished work. Comparison with that picture shows that the background of *Still Life with Aubergines* comprises a single large green-and-blue floral screen onto which a piece of yellow fabric, with a different floral pattern, has been fastened. The screen carries down beyond the right edge of the table. On the vivid red-orange tablecloth we see the objects that will become the focal point of the larger interior: the double-handled pot; the ten-inch-high plaster cast of a sixteenth-century Florentine *Écorché,* then believed to be a work by Michelangelo;[5] the pattern-edged plate containing two pears; and the three eponymous aubergines themselves. Matisse seems to have been fascinated by combinations of three and two images when setting up both still lifes and figure compositions.[6] Here he plays a game of formal analogy among them. The accentuated back of the plaster cast echoes the curve of the side of the juxtaposed pot, while the arms of the figure echo the pot's two handles. Both these objects

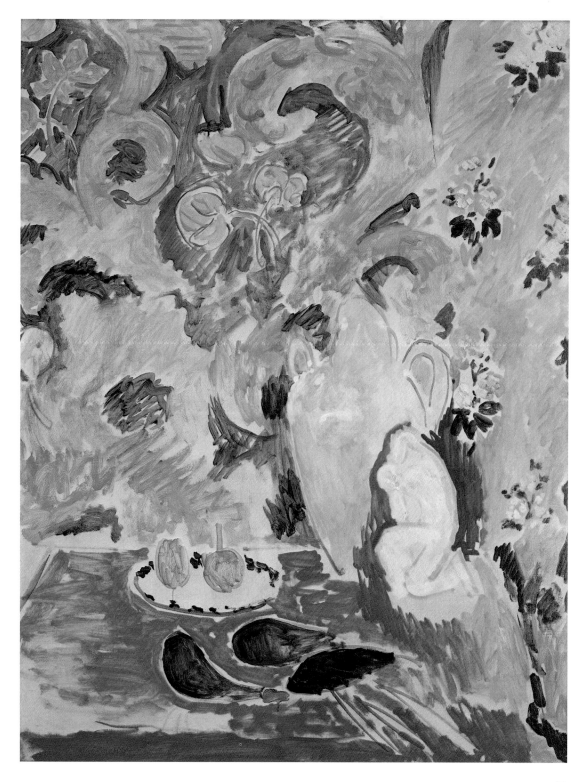

are hollow and bleached of color and, in the tabletop triad of groupings, are therefore clustered together as a two-part unit away from the two pears and from the three aubergines. "Resemblance," Matisse wrote, "is the kinship between things...resemblance is love, yes, love."[7] And again: "To copy the objects in a still life is nothing; one must render the emotion they awaken. The emotion of the ensemble, the interrelationship of the objects . . ."[8] When Jean Leymarie later told Matisse that according to an Oriental proverb to dream of three aubergines was a sign of happiness, Matisse was apparently delighted.[9]

A symbolic as well as visual comparison between the objects seems to be presented here. Cézanne's *Still Life with Plaster Cupid* of c. 1895—with which Matisse was probably familiar because it was then owned by his dealer, Bernheim-Jeune—contrasted a cupid, symbolic of love, with a painted copy of the same *Ecorché,* suggestive of suffering and death, that appears in the Matisse.[10] The flayed man in Matisse's painting, dwarfed by the rounded voluptuous pot and isolated in a halo of flame-red brushstrokes from the exotically colored fruit, seems to connote the frailty of human presence, if nothing more, in the paradisal garden presented by the still life. As noted earlier, Matisse has transposed his pleasure in the southern landscape to an interior setting, surrounding his tabletop pastoral with surfaces that both reproduce natural forms and recall the blue sky, the green foliage, and the sense of yellow light he said he experienced that summer at Collioure.[11] The still life is presented as a miniature pastoral garden with only the one note of unease the surrogate human presence creates, and that cannot compete with the profuse splendor of the garden itself. Matisse told an interviewer in autumn 1911 that he despaired of being able to represent flowers with their proper intensity of color, saying his were little better than the pictures in the gardening magazines he received.[12] He is right, of course, in that his flowers and fruits do not fully resemble their natural prototypes. Nevertheless, if this painting is a kind of illustrated horticultural catalog of his own invention, by the same token it is far more idealized a picture of the world than nature provides.

Goldfish and Sculpture. *Issy-les-Moulineaux, October 1911. Oil on canvas, 45¾ x 39½ in (116.2 x 100.5 cm). (C&N, p. 197)*

Beginning in 1906, Matisse started to include examples of his own paintings and sculptures, and sometimes both, in a number of his still lifes and interiors.[1] The presentation of works of art within works of art is a familiar theme in Western painting; the de Heem that Matisse copied in 1893 (fig. 84) has a tondo in the background. Among late nineteenth-century masters, Matisse was most likely influenced by a series of still lifes by Cézanne, and some by Gauguin and van Gogh, in which art objects have an important compositional and iconographic role.[2] It is significant, however, that he began making paintings of this kind in 1906, the year he completed the *Bonheur de vivre* (fig. 19), and that representations of sculptures, ultimately derived from figures in that composition, dominate the majority of these works. Most frequent of all is the sculpture that appears in this painting, the *Reclining Nude I* of 1907 (p. 50), companion to the famous *Blue Nude* of that year and daughter of one of the quiescent figures at the center of the 1906 composition. This representative of the *Bonheur de vivre* brings with it the sensual indolence of its original Arcadian setting to suffuse this simple interior with something of the same hedonistic spirit. Being also a work of art, it is representative too of contemplative meditation and of the calming influence that Matisse felt art should provide—particularly when combined with emblems of the animal and vegetable worlds that are also objects of contemplation. The three elements of the still life, or the things they contain, the woman, the flowers, and the goldfish, "are all taken from or based on nature, but transformed to serve a decorative purpose. No longer in their natural states, all are contained or miniaturized, reduced to an artificial state, which is that of ornament or art."[3]

This painting is one of a series of six interiors with goldfish,[4] of which two others (figs. 59, 60), both probably from 1912, also contain the same three elements, and in an identical arrangement, the latter being a more realistic version of the entire interior shown here. Another painting of 1912, the Pushkin Museum's *Goldfish,* is also related to the series, as is *Zorah on the Terrace* and the *Arab Café* of 1912–13 (fig. 91), in reference to which Matisse confirmed that what attracted him to the motif was the way in which the elements of the still life served to focus the act of contemplation.[5] The overt Orientalism of that painting serves to remind us that not only is the sculpture in *Goldfish and Sculpture* of exotic origin (by virtue of its derivation from the *Blue Nude,* a souvenir of North Africa), but so too are the elemental goldfish.[6] These scarlet and terracotta-orange neighbors meet around a vase of vermilion cut flowers, as if to bring together the primitive and the pastoral and assert their common harmony. But it is the harmony of the natural and the artificial—of making the natural the aesthetic—that is the controlling metaphor of the work, a metaphor that refers if not to the process of all

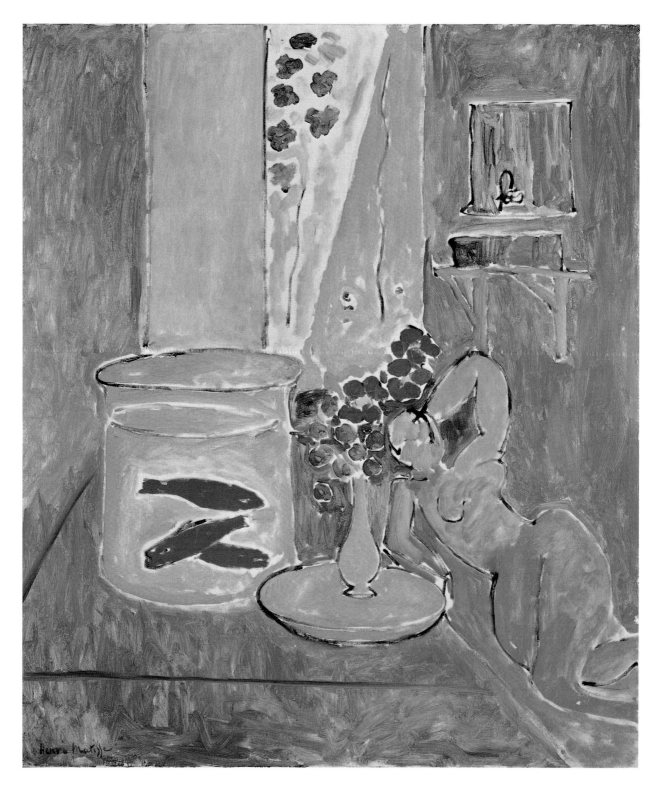

art, then certainly to Matisse's art, which was dedicated to achieving an equilibrium of this kind. Jean Puy once compared Matisse to a goldfish absorbing impressions of the world in the form of mirages as they passed through the dematerializing globe of his eye.[7] Perhaps he was thinking of Matisse's red hair and beard and passive demeanor. In any case, it is a marvelously evocative image of the artist as someone transparently open to the sensual world but seeing it through the medium of his own isolation from it, which gathers together what he sees in a common harmony.

This harmony is not simply a function of iconography, for the iconographic cannot properly be separated from the pictorial. It is a function of the spreading sea greens that spill out beyond the goldfish bowl to the dish below and doorway above—as if the contents of the aquarium had soaked into the very fabric of the painting, drawing these objects successively arranged in depth into one connecting plane. It is a function too of the flooded blue field and of all the flat and purely optical colors in the painting that evaporate the solidity of the objects they create. "Color dissolves all tactile associations, and tactile associations are dissolved *in* color—and yet in flat, not atmospheric color: color that remains flat even when it is not opaque."[8] Here it is only rarely opaque, and where it is it sings out in separate notes within a limpid, liquid field, made all the more immaterial by the absence of the Fauvist sketchlike brushwork that characterizes many of Matisse's earlier works, such as the *Still Life with Aubergines* (p. 83), of a similar transparency of effect.

With this newly reticent touch comes a new simplicity in composition, marking a turn away from the arabesques and the ornamentation that had hitherto dominated his major paintings of this year. The geometry of the work—the vertical and diagonal drawing pulled up parallel to the picture plane and the interior rectangles set in dialogue with the literal shape of the canvas—was all there in the earlier paintings of 1911, but is now stripped clean of decoration to achieve the new sense of clarity that will characterize the major part of Matisse's oeuvre until 1917. And with this new economy of means comes a new sense of space as larger and more expansive than before. The cutting off of the doorway at the top center of the composition and of the sculpture and the corner of the tabletop at the bottom two corners (a device ultimately traceable to the influences of Impressionism and of Oriental art)[9] helps to create the feeling of a space that expands outward from the center of the painting even beyond the limits of its frame. Surrounding the contours of objects with narrow margins of unpainted canvas, sometimes emphasized by a black line, or carrying the painted field uninterruptedly over contours prevents the foreshortened drawing from

breaking the continuity of the flat field, and further enforces the highly schematic nature of the space of the painting, which is denoted rather than actually described. "The table exists by inference . . . ," Alfred Barr has written; "we can read the space but we can scarcely feel it."[10] This is true also of the almost diagrammatic way in which the open door surrounded by ivy at the top of the painting is shown. Without the companion 1912 painting to guide us, we might have difficulty in recognizing just what is signified here. This notation for an exterior space, diagonally bisected by what is either strong sunlight or the edge of a lawn, was to be repeated in the *Piano Lesson* of 1916 (p. 115), which also contains a sculptural variant of *Reclining Nude I*. Hence, we find here an anticipation of the geometric structure typical of the paintings Matisse made under the influence of Cubism. When Matisse painted the last of his goldfish pictures four years after this one (p. 101), it was to build on the architectonic clarity already manifest in this work.

The Red Studio. *Issy-les-Moulineaux, October 1911. Oil on canvas, 71¼ in x 7 ft 2¼ in (181 x 219.1 cm). (C&N, p. 198)*

A visitor to Matisse's studio at Issy in June 1912 described what the interior shown in *The Red Studio* was really like. The studio was set to one side of the large walled garden that surrounded the Matisse house, "among trees, leading up to which were beds of flaming flowers. The studio, a good-sized square structure, was painted white, within and without, and had immense windows (both in the roof and at the side), thus giving a sense of out-of-doors and great heat. A large and simple workroom it was, its walls and easels covered with large, brilliant, and extraordinary canvases. . . . my main recollection is of a glare of light, stifling heat, principally caused by the immense glass windows, open doors, showing glimpses of flowers beyond, as brilliant and bright-hued as the walls within . . ."[1]

In *The Red Studio*, Matisse has avoided showing any sign of the out-of-doors. What seems to be part of a window appears at the extreme left. If that is what it is, it may not have looked out onto the garden, as a studio plan shows (fig. 62).[2] We are looking at an enclosed interior: at a corner of the studio and about twenty-three feet of one of the walls.[3] The wall of course is not white, as it was in fact, but like the floor and all the furniture is red. "You are looking for the red wall," Matisse observed to another visitor, who came to the studio shortly after the painting

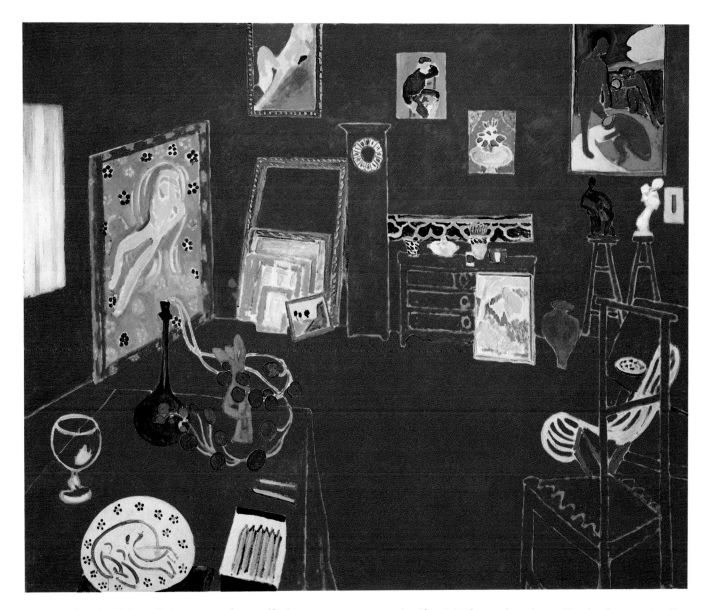

was completed; "this wall does not exist at all! As you can see here, I have painted the same pieces of furniture against a wall of the studio of a pure blue-gray color. These are the sketches, the studies if you wish; as pictures they did not satisfy me. When I had found the color red, I put these studies in a corner, and they remain there. Where I got the color red—to be sure, I do not know that . . . I find that all these things, flowers, furniture, the chest of drawers, only become what they are to me when I see them together with the color red. Why such is the case I do not know . . ."[4] Close inspection, confirmed by infra-red pho-

tography (fig. 65), shows that the walls of *The Red Studio* itself were originally painted "a pure blue-gray color," and the furniture against the back wall a pale yellow ocher.[5] Just as the *Harmony in Red* was a *Harmony in Blue* first, so this work seems to have been begun as a "Blue Studio." There are a number of Matisse's paintings of the Issy studio where he used a blue-gray to stand for the white walls,[6] and one where a shadow crossing the blue-gray wall is given in pink[7]—and, of course, another *(The Pink Studio)* where the entire wall is lavender-tinted pink. It is entirely possible that Matisse "found the color red" in the

interior shadows of the room. It could well have been produced optically when he entered the dazzling white interior after looking at the green of his garden, for he was particularly responsive to perceptual color substitutions of this kind, though inclined to justify them as emotive responses to his subjects[8]—which of course they became, regardless of what sparked them in the first place.

Wherever he found it, the mat red that invades the surface of *The Red Studio* is what largely contributes to its being "perhaps the flattest easel painting done anywhere up to that time."[9] It is Matisse's boldest attack to date on traditional three-dimensional illusionism. The virtually unreproducible Venetian red modified by the blue-gray underpainting establishes the frontality of the whole surface. It joins background to foreground, top to bottom, and side to side in one frontal plane. The division of floor and wall is mostly hidden and the angle of the corner not shown. The rectilinear architecture of the room itself is used to reinforce the painting's flatness and rectilinearity, as are the paintings and all the flattened-out objects shown. There are no depicted volumes at all. Anything inherently three-dimensional becomes either a silhouette (as if squeezed flat by the advance of the back wall in identifying itself with the picture surface) or a linear diagram (of usually bare canvas) through which the space of the room is allowed to pass. The depth of the whole room, however, is also diagramed in linear perspective. The three-dimensional is therefore always at least schematically present—if not in the painted surface itself, then in the space frames created by the interruption of the red field. The ambiguity of flatness as given in paint and depth as given in the absence of paint is part of the exhilarating tension of the work. Such is the ambiguity that although the paint is soaked into the surface, we cannot always read it as one with the surface, as we usually can with the American color-stain paintings developed from this aspect of Matisse's work.[10] The surface is spatially very unstable, at times yielding to the eye to provide a sensation of muffled interior space, at times flat and rigid, at times pushing forward optically to create the effect of a space much larger than the physical size of the painting. Matisse later spoke of how the Islamic art he saw at an important exhibition in Munich in 1910 suggested "a larger and truly plastic space."[11] The patterned interiors of 1911 almost certainly reveal the impact of this experience. It may also have had some effect on the flattened perspective and contrast of framed decorative motifs against areas of flat, uniform color in *The Red Studio*. The year 1911 was an important one for near-monochromatic painting with the first public manifestations of Cubism. No Cubist painting offers a richer study of the ambiguities between flat surface and spatial illusion than Matisse does in the monochrome field of *The Red Studio*.

An inventory of the contents of the studio is obligatory. The paintings represented are, left to right: *Large Nude with Necklace*, c. 1911 (whereabouts unknown; presumed destroyed);[12] *Nude with White Scarf*, 1909;[13] a small landscape, usually assumed to be a Corsican painting of 1898, but more likely a Collioure painting from the summer of 1911;[14] behind that, a group of canvases leaning on top of one another, none of which can be identified but which may be the studies for *The Red Studio* itself, which Matisse told his interviewer he had put "in a corner, and they remain there."[15] Above the chest of drawers we see *The Young Sailor II*, 1906–07,[16] and *Purple Cyclamen*, 1911;[17] leaning against it is either *A Bacchante and a Faun*, 1908, or *Reverie*, summer 1911 (whereabouts of both unknown),[18] and to the right *Le Luxe II*, 1908,[19] and a small unidentifiable drawing. On the sculpture stands below *Le Luxe II* we see the *Decorative Figure*, 1908 (fig. 41), and the (possibly unfinished) plaster of *Jeannette IV*, 1911 (p. 70). The sculpture on the table in the foreground is the *Upright Nude*, 1904, seen from the back.[20] Also on the table we see a tall bottle containing ivy, a large wineglass, a box of crayons, and one of Matisse's decorated ceramic plates of c. 1907.[21] Another plate appears on the low table just visible behind the two chairs to the extreme right; other ceramic pieces stand on the chest of drawers at the back, and a further pot stands on the floor beside it. A piece of decorative fabric, tacked on the wall (or possibly hanging from a shelf) behind the chest of drawers, and the tall grandfather clock with circular face but without hands complete the inventory.

The Red Studio was painted in October 1911.[22] As noted earlier (p. 82), it complements *The Pink Studio* (fig. 68), painted in the spring. In fact, the right-hand third of *The Red Studio* shows the same section of the room as the left-hand third of the earlier work. Matisse has turned his view away from the window and has modified the frontal viewpoint he used for interiors-with-windows that play off interior and exterior space.[23] The painting is assertively frontal, but the room itself is presented as if we were looking down into it from above. The view has been compared to that in Matisse's *Interior with a Top Hat* of 1896 (fig. 69).[24] Both use the downward viewpoint to beckon us into a corner of the studio while the painter is absent, and both let us discover his presence in the room in the paintings on walls and floor and the personal and professional objects we find on the table. In the earlier work, however, the experience is secretive and surreptitious. In *The Red Studio*, the room is prepared for visitors: we are invited to see a carefully arranged exhibition of the painter's art. It

belongs therefore less to the tradition of studio paintings as such than to the tradition of paintings that document collections or exhibitions of art.[25] Only things pertaining to art retain their local color and hence their identity amid the rust red that infiltrates everything else. Nearly all of Matisse's different media are represented in the interior,[26] but paintings dominate, usurping the function of windows in showing glimpses of another world.[27] All of Matisse's different subjects are shown—still life, portraiture, landscape, and figure compositions—but the idealized figure compositions dominate. The world presented in the paintings, and hence in this painting, is the idyllic, relaxed world of the *Bonheur de vivre*. Everything is shown in a passive state. Even the empty chairs that face the exhibited art serve to remind us of Matisse's ideal of art as a rest from physical fatigue.[28]

"There was a time when I never left my paintings hanging on the wall because they reminded me of moments of overexcitement and I did not like to see them again when I was calm," Matisse wrote in 1908. "Nowadays, I try to put serenity into my pictures..."[29] The serenity manifested in the paintings on the wall of *The Red Studio* is transposed to the whole interior, making it virtually a manifesto for what Matisse felt should be the effect of his art on its surroundings: "The characteristic of modern art is to participate in our life.... [it] spreads joy around it by its color, which calms us.... a painting on a wall should be like a bouquet of flowers in an interior."[30] The tabletop still life in the foreground reinforces the mood of the paintings. The sculpture surrounded by ivy, like the juxtaposition of sculpture and flowers in *Goldfish and Sculpture* (p. 85), evokes the Golden Age theme of nudes in a natural setting. *The Red Studio* amplifies the effect of Matisse's still lifes with art objects and forms a link between these works and the decorative idyllic interiors. Given the fact that in classical mythology ivy is the traditional attribute of Bacchus and a symbol of intoxication,[31] the presentation of the wineglass as part of the still life here might be seen as a further affirmation of sensual pleasure. Its transparency, however, recalls that of the goldfish bowl in *Goldfish and Sculpture*. Here, it mediates between the three-dimensional image of figure and foliage and the two-dimensional presentation of these same things in the ceramic plate,[32] while facing the box of crayons, emblematic of the artist's craft. The redness seen in the glass is of course that of the aqueous space of the whole room. One wonders whether this whole field of red is a surrogate image of the artist's presence in the interior.[33] Everything we see is held captive in this redness, which seems to belong to an order of reality quite different from what it encloses, as if it were beyond the normal range of a prism or a palette.[34] Not only does it unify the interior, but it separates us from it. It also separates us from the works of art and their fictive characters who seem, therefore, to be inhabitants of a private, imaginary, and timeless world.

The autobiographical nature of *The Red Studio* has often been noted.[35] It is, however, the similarity of the works in the anthology that requires emphasis. Much later, when showing a visitor a group of works resembling one another, Matisse commented: "That's what I call the cinema of my sensibility."[36] The works of art in *The Red Studio* represent a temporal succession of single views on a scarcely varying subject, showing therefore, in the Bergsonian sense, the "duration" of the pastoral ideal in the way the past is carried into and constitutes the present.[37] We see in the separate images the growth of that ideal, just as the separate but similar circular leaves on the stem of ivy growing from the pot in the foreground show us the different manifestations of that form of growth. The circularity of these leaves carries the eye to the round face of the clock. Although the paintings on the wall seem at first to be haphazard in their arrangement, they are in fact clustered around this clock without hands, thus enforcing the metaphor of past and present suspended in one timeless state. They are, moreover, fixed and preserved in the red ground, almost as if in illustration of Bergson's discussion of how separate temporal incidents stand out from the flux of time which bonds them together: "Discontinuous though they appear, however, in point of fact they stand out against the continuity of a background on which they are designed, and to which indeed they owe the intervals that separate them.... Our attention fixes on them because they interest it more, but each of them is borne by the fluid mass of our whole physical existence. Each is only the best-illuminated point of a moving zone... which in reality makes up our state."[38] Matisse continued to be absorbed by this collage effect of his own works on the walls around him. When, some forty years later, he began to create and not merely to depict grand decorative interiors, it was literally to collage images on his walls, in the large environmental cutouts he made toward the end of his life.

The Blue Window. *Issy-les-Moulineaux, summer 1913. Oil on canvas, 51½ x 35⅝ in (130.8 x 90.5 cm). (C&N, p. 200)*

The Blue Window was painted in the Matisses' bedroom of their house at Issy-les-Moulineaux, before a window looking out over the garden with its willow-pattern-like trees[1] and huge spherical bushes to the studio in the background,[2] over which hovers a large oval halo of a cloud not too dissimilar to those that floated over the beach of Saint-Tropez in *Luxe, calme et volupté* (fig. 10). On the table or shelf in front of the window[3] we see a still life of domestic objects: the cast of an antique head,[4] a vase of flowers set on a circular mat, a small decorated jar, a yellow-ocher dish containing a blue brooch, and what is probably a square mirror with a red frame. On the window ledge behind the mirror is a lamp, which had possibly been in Matisse's possession since his student days,[5] and seemingly fastened to the wall at the left is a green Chinese vase.[6] The painting is, as Alfred Barr has written, "all verticals and horizontals, as structural as scaffolding, against which are hung the free forms of the still life and landscape. Each object is as isolated and simply rendered as the objects on the table of a medieval Last Supper."[7]

And yet, as Barr points out, the isolation of the objects "is subject to whimsical magic,"[8] which brings them together in unexpected and illogical ways, thus joining the space of the room to that of the garden outside. When asked why he was attracted to the motif of the window, Matisse replied: ". . . for me space is one unity from the horizon right to the interior of my workroom . . . the wall with the window does not create two different worlds."[9] All of his paintings of windows establish the contiguity of the outside space of nature and the man-made space of the interior, thus asserting the harmony of the natural and the artificial. They do so, however, in a number of distinctly different ways. In the Fauve period, there tends to be a sense of balance between internal and external space, so that each possesses its unique characteristics and the picture-mimicking frame of the window mediates between them.[10] In the Nice period (see p. 119), the window itself has often the sense of solidity and presence of an object that seems to have trapped in its very forms the feeling of open air and deposited it in the interior. In *The Blue Window,* inside and outside interpenetrate and join in a single blue plane.

Much of this effect is due to oddities in juxtaposition and to formal analogies. The vase of flowers is elided into the foliage of the garden, while the circular mat on which it stands is echoed in the shapes of bushes and in the white cloud directly above. The mullion of the window seems to be growing out of the top of the plaster cast, and so resembles the trunk of the tree sprouting from the lamp (which itself appears to be standing on the mirror) that we may be excused for thinking that the mullion is a tree too. The triangular shape of the statue echoes the ocher triangle of Matisse's studio, joining art and the place where art is made, telescoping space between these two points. The whole set of ovals and circles inside and outside the window so clearly share a common order of being that inside and outside are given as one. Added to this, the ubiquitous blue, modulated with green and white and ranging from cobalt to ultramarine, fills and inflates most of the forms, causing them to swell out, as if full of the blue atmosphere that surrounds them and from which they are inseparable.[11] The pervading blueness of the picture unifies and flattens space, yet gives to space such a feeling of substance and density as to allow the objects that inhabit it a certain solidity too. In this respect, *The Blue Window* has been compared to Cézanne's *The Blue Vase* in the Louvre, with which it also shares the color blue and a frontal arrangement of isolated objects aligned to a predominantly vertical scaffolding.[12] Unlike Cézanne, however, Matisse makes no attempt to fully reconcile the two- and three-dimensional in every part of the painting. Although everything is tied together by color and by formal analogy, the ambiguity of "tangible passages in an essentially intangible space"[13] is accepted, indeed welcomed, for the way it varies the pulse of the color, amplifies the chain of analogies, and assists the blending of inside and outside space.

Although purchased by one of Matisse's German patrons, Karl Osthaus, the painting was apparently first intended for the designer Jacques Doucet, who rejected it, finding it "too advanced for him," Matisse recalled.[14] No specific documentation of this commission has come to light, nor anything to prove the suggestion sometimes made that it was to be the first element of a decorative ensemble.[15] There is indeed considerable confusion as to when *The Blue Window* was made. It is sometimes dated to 1912, but more often, per Barr's lead, to late 1911, although on one occasion Matisse himself dated it to 1913.[16] It certainly follows the use of a monochrome field established in *The Red Studio* of October 1911 (p. 87). However, the very density of the space and the way in which the ideogramic forms are dispersed across the front of a geometrically ordered and absolutely frontal picture plane mark a significant change from the more fluid space and more informal arrangement of parts that characterize Matisse's paintings of 1911. There, the eye is drawn into a space that seems to bend in front of it and shift obliquely despite the flatness of the picture surface. Here, events are presented in a substantive and Cézannist space, in an or-

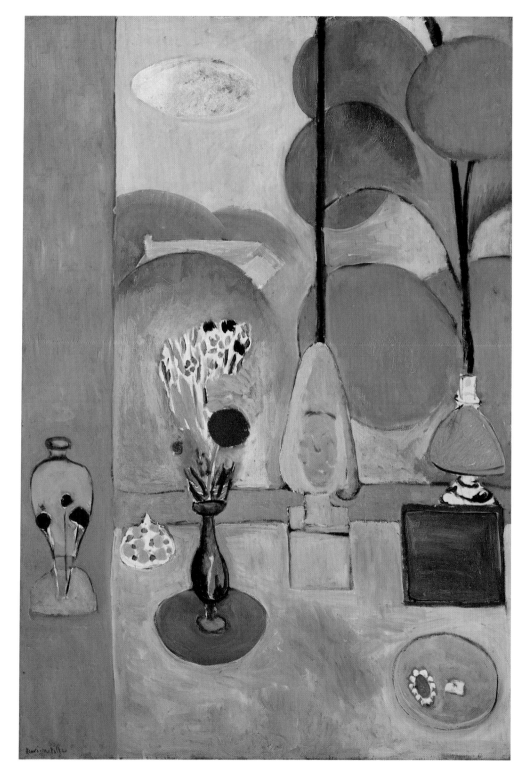

derly progression parallel to the picture plane, to far more monumental effect. In some respects it recalls the *Harmony in Red* of 1908 (fig. 2) with its somewhat similar tree forms—but now the geometric replaces the arabesque, making *The Blue Window* a harbinger of the newly architectonic feeling that entered Matisse's art in 1913.

The Blue Window was illustrated with the title *La Glace sans tain* (The Plate Glass) as one of seven reproductions after "recent works" by Matisse in the May 15, 1914, issue of *Les Soirées de Paris,* and there dated 1913. None of the dates given to the remaining works (all from 1914) are questionable.[17] Furthermore, on October 10, 1913, Shchukin wrote to Matisse from Moscow after having returned two weeks before from a visit to France, where he had seen the *Mme Matisse* (fig. 71) (exhibited at the 1913 Salon d'Automne) in the Issy studio.[18] Osthaus had been in Moscow. "I spoke of your blue still life [*The Blue Window*] which you had done for him," Shchukin wrote, "what a beautiful picture I found it, and what a great development I felt in your recent works (*Arab Café, Blue Still Life,* Mr. Morosov's *Fatma*)."[19] This suggests that Shchukin had seen *The Blue Window* when he visited Issy.[20] Certainly, he speaks of it together with paintings made in Matisse's second Moroccan visit. It was probably painted in the summer of 1913 after the return from Morocco. It is known that it was sent by Matisse to Osthaus in November of that year.[21] The arrangement of circular elements against a scaffolded dense blue field mediates between the more informal version of this pictorial idea in the *Arab Café* (fig. 91) and the even more rigorous architecture and even denser space of the *Mme Matisse,* while preparing for the ascetic formal analogies of *Woman on a High Stool* of 1914 (p. 93) and the whole period of analogizing form that culminated in 1916 in works like the *Gourds* (p. 113) and *The Moroccans* (p. 111).

Woman on a High Stool. *Paris, early 1914. Oil on canvas, 57⅞ x 37⅝ in (147 x 95.5 cm). (C&N, p. 202)*

After Matisse's return from his second trip to Morocco, his art began to change drastically. He was always a painter of contrasts, of opposites, but there is no greater contrast in his whole oeuvre than that between the voluptuous Moroccan compositions and the austere, ascetic paintings that soon followed. Signs of a change in direction had emerged in the period between the two journeys to North Africa.[1] Perhaps the second journey served to stave off something of the new mood; if so it began to reassert itself soon after the return to Issy in the spring of 1913. By the summer, *The Blue Window* (p. 91) showed a new concern for geometric structure. By the winter of 1913–14, austerity had fully taken hold of Matisse's painting, though not as yet defined itself as a new style. In some respects, it never was a new style. The period of Matisse's art between the winters of 1913–14 and 1916–17 is characterized by a severe, highly architectonic manner of picture-making. The products of this manner, though sharing an unmistakable family resemblance, are nevertheless often very different from one another. Each important painting embodies virtually a new pictorial idea. The constant exploration accounts for the imposing quality of Matisse's art in this period, which saw, if not more masterpieces, then more audacious masterpieces than any other comparable span of time—and accounts as well for the very great anxiety about his art that Matisse felt during these years.

He began to feel it in the late summer of 1913. The one painting he sent to the Salon d'Automne, the Pushkin Museum's *Mme Matisse,* took over a hundred sittings; when it was exhibited, to great critical acclaim, he found he was not happy with it after all.[2] Matisse recognized that he was at the beginning of a "very painful endeavor."[3] Part of his difficulty he put down to the depressing Parisian winter.[4] Part was certainly due to his uneasiness as France stood poised on the brink of the Great War. But a larger part must surely be attributed to his at times almost unwilling confrontation with Cubism, the single development in painting concurrent with his own prewar innovations that challenged many of his basic assumptions. Cubism gradually infiltrates Matisse's painting from late in 1913. Hardly anything is explicitly Cubist before late 1914. Before then, the geometry may be explained by reference to earlier austere compositions—but not completely or convincingly so. Matisse begins to respond to Cubist geometry and Cubist flatness but without borrowing stylistically from Cubism. True, he starts to create highly ambiguous figure-ground relationships within a painterly atmospheric space, and to true and fair his drawing in more deliberated a way than predicated by his earlier work. But by and large, he seems at first to be responding to the intellectual rigor of the Cubist syntax rather than to the specific nature of the syntax itself.

Woman on a High Stool was painted in the early months of 1914.[5] The subject has Cubist connotations, for the figure depicted is Germaine Raynal; she was the wife of the Cubist critic Maurice Raynal, and her portrait had been painted a year earlier by Juan Gris[6] (whose influence on Matisse after the summer of 1914 is discussed below, p. 106). Matisse's portrait is hardly guaranteed to please even so sophisticated a sitter—her face is reduced to an oval mask set on a straight neck whose parallel lines are

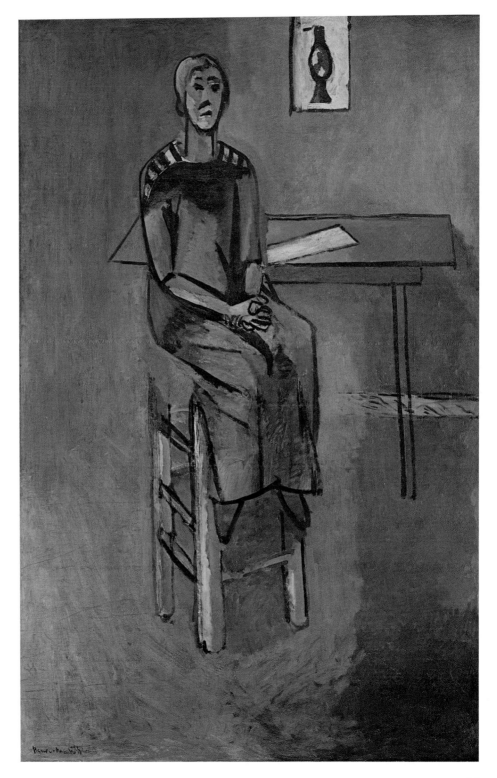

repeated to articulate the torso as well. The figure has been described as gaunt and emaciated, conveying "a sense of misery and mute endurance."[7] It can, in fact, hardly be described as a portrait; the severe linear architecture and enveloping gray ground seem actually to be destroying the material substance of the sitter. The way in which Matisse has carried the ground into the seat of the stool causes the figure to seem levitated in front of the canvas, apparently suspended by the line created by the change of gray tones to the right of her head. This kind of painting into the contours was familiar to Matisse from the late work of Cézanne, and he used it often in this so-called experimental period of his art—though never again to quite such disturbing effect.[8]

The severe iron-gray ground, only slightly warmed by the underpainting, dissolves the distinction between floor and back wall, just as do the grays in many of Manet's figure paintings, but additionally seems to penetrate into nearly every object on the canvas. Although the face and right arm of the figure, and parts of the stool, are brightened by a rose-pink light from the left, and the dress by glowing areas of blue and green, dark gray seems to be the local color of all of them. It even creeps into the underside of the brilliant tabletop which, set parallel to the horizontal edges of the painting, complements the vertically aligned area of green in the dress to reinforce in color the monochromatic geometry of the rest of the work. The left corner of the table and its only visible leg are schematically outlined on top of the gray ground—as also are parts of the seated figure—so that these sections of the painting appear transparent. The outlines themselves push forward of the ground much as those in High Analytical Cubist paintings assert themselves as closer to the viewer's eye than the gray or brown monochrome on which they lie. Only the sheet of white paper on the table, duplicating the angle at which the stool is set, retreats into depth, and then not completely so, being lifted up to the picture plane by the frontal presentation of the table itself and by virtue of its association with the sheet on the back wall. This seems to hang down over the top of the canvas, and also echoes its narrow vertical shape. The painting of the vase upon the paper—by Matisse's teen-age son Pierre[9]—echoes the abstractness of the figure beside it in a deliberated formal analogy that seems almost humorous in this severe context.[10] The *Woman on a High Stool* itself was to fulfill a rather similar function in the top right corner of the *Piano Lesson* (p. 115) two years later.

View of Notre Dame. *Paris, spring 1914. Oil on canvas, 58 x 37⅛ in (147.3 x 94.3 cm). (C&N, p. 203)*

In the autumn of 1913, Matisse took a studio at his old Paris address, 19 Quai Saint-Michel. He continued to paint at Issy in the summers, but since he did not make any protracted trips to the south until early 1917 he was glad to have a pied-à-terre in Paris for the dark months of the year.[1] When Matisse and his family had given up their apartment on Quai Saint-Michel early in 1908, his friend Marquet had taken it over. Matisse's new studio was on the floor beneath, so he was able to renew his friendship with Marquet, and to return to subjects that he and Marquet had painted in the early years of the century. The *View of Notre Dame,* of the late spring of 1914,[2] not only reprises a subject that Matisse had painted a number of times between 1900 and 1905, but uses the same compositional format as the earlier works: a view from the window masked off by the repoussoir window jamb on the right-hand side.

The asymmetrically framed view was provided by Matisse's looking to the right from his window (fig. 74). In his earlier presentations of the subject, for example, the *Notre Dame in the Late Afternoon* of 1902 (fig. 75), Matisse had used the near, right-hand vertical to balance and measure the illusion of depth offered through the window. A few weeks before painting the *View of Notre Dame* in 1914,[3] Matisse made a very loosely rendered version of the same scene (fig. 76), a version that, like the 1902 painting, gives a strong sensation of depth in the retreating perspective lines of the two sides of the river. The watercolorlike feeling of this work, plus its lively rendering of such topographical details as reflections in the water, traffic and pedestrians, and the Gothic forms of the cathedral, makes it seem even more specific and immediate a rendering of the scene than the early paintings of the same subject. In the *View of Notre Dame,* however, such a feeling is totally suppressed. The specific subject is hardly recognizable. The repoussoir window jamb, instead of offsetting an illusion of depth, becomes part of an insistent surface geometry of spontaneously drawn black lines that organizes the blue monochrome of the work, an "aerated" blue only modified by the patch of very light pink on the facade of the cathedral and the vivid green of the tree beside it.

Pentimenti visible beneath the blue surface suggest that *View of Notre Dame* was originally sketched out in fairly close conformity to the motif. Indications of the balcony of the window to the right and of buildings and the far quai to the left show what Matisse excised from the scene. The cathedral has clearly been enlarged and

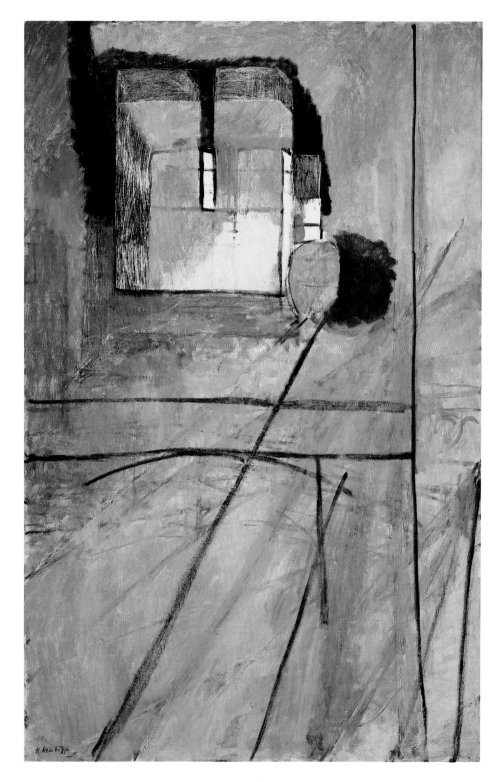

moved higher in the painting, the roof of the transept now carrying to the same height as the towers did originally. Even from the start, however, Matisse seems to have avoided showing anything of the Gothic character of Notre Dame. The pointed arches and rooftops and rounded windows visible in the earlier 1914 painting never seem to have had a place in the geometric conception of this work.

Matisse's refusal to include the lines showing the far quai, and failure therefore to complete the perspective schema indicated by the diagonal lines that are shown, means that depth is not represented in even a schematic manner. The diagonals do allude to the sense of depth, particularly the most extended one, yet the strong note of green that terminates this line keeps it forcibly on top of the surface, therefore transforming its momentum up the flat plane of the canvas. Matisse's decision to exaggerate the horizontals of the roadway crossing the bridge at the center and to link these to the vertical of the window jamb binds together the two spatially disjunctive zones, and further advances the principal diagonal toward the eye. Moreover, none of the drawn lines function as contours. Although derived from contours observed in the motif, in the painting they do not enclose anything, but carry flatly across the surface like ideograms for the objects to which they refer. The only drawn volumetric mass in the painting, the cathedral, does not seem volumetric because of being scored away around the edges. The image of Notre Dame given by drawing is countered by the zones of color and pattern into which it is broken and which camouflage it to the blue ground that seems actually to pass through it, as it seems to pass through everything in the painting. Both the cathedral and the set of drawn lines beneath it are spatial armatures that have been collapsed against the front of the picture surface.

The division of the canvas into two zones tied to an asymmetrically placed vertical is highly reminiscent of *The Blue Window* of the previous year (p. 91). In both paintings, a ubiquitous blue ground serves to telescope depth. Unlike *The Blue Window,* however, with its feeling of dense, almost substantive space, *View of Notre Dame* possesses a remarkably open, layered, breathing surface that would be atmospheric were it not so resolutely flat. The surface has something in common with that of the portrait *Mlle Yvonne Landsberg* (fig. 77), painted around the same time.[4] The scored paint that dissolves the edges of the portrait figure also relates it to the treatment of Notre Dame in this painting, as does the way the image is tied to the top edge by the black paint surrounding it. However, the sense of a field of color provided by the *View of Notre Dame* has no true precedent in Matisse's

art. Matisse had habitually been using large areas of open color, but never had he given a single field of color such command of a painting as he does here—and it is this that gives the work its particular sense of modernity. Not only does it anticipate Miró's blue fields with ideogramic drawing of the 1920s, but it looks forward to much abstract color painting done since World War II.[5] Its sense of exclusively optical space is where its radicality lies. It presents a surface that has depth but not tactility. The paint, stained and scumbled across the canvas, lets the priming show through; it is this that largely accounts for the airiness of the work and, together with the use of blue itself, evokes suggestions of sky, light, space, and water. The work is free from the associations of gravity and earth. The way that Notre Dame itself appears to levitate like a phantom presence at the top of the painting accentuates the feeling of disembodiment given by the entire spatial field.

Yvonne Landsberg. *1914. Pen and ink, 25⅝ x 19⅞ in (65 x 50.2 cm). (C&N, p. 204)*

In 1914–16, Matisse painted a number of canvases which reveal that he had not remained untouched by the Cubist experience. One of the most extraordinary of these is a portrait of a young girl bequeathed to the Philadelphia Museum of Art by Walter C. Arensberg. Alfred Barr discusses the circumstances of the portrait:

"Albert Clinton Landsberg, a young and discriminating amateur of Brazilian nationality, had been introduced to Matisse by Matthew Prichard. In the spring of 1914 Landsberg proposed to his mother that she commission Matisse to do a portrait drawing of his sister Yvonne. Mme Landsberg would have preferred a portrait by some fashionable artist such as Orpen, Boldini or Paul Helleu, but after meeting Matisse she agreed to her son's suggestion...

"'On the day of the first sitting, we found that before we arrived at the Quai Saint-Michel Matisse had spent the whole morning making lovely drawings of magnolia flowers—or rather, buds (which, he said, my sister reminded him of). He had been doing this all morning, and was bothered by the buds opening and turning into full-blown flowers so quickly...'

"Yvonne Landsberg, not yet twenty at the time, was sensitive, almost morbidly shy and rather overshadowed by an older sister; but Matisse found Yvonne interesting, won her confidence, and accepted the commission. The drawing, a full-face study of the head in pencil was accepted with satisfaction by the Landsberg family.

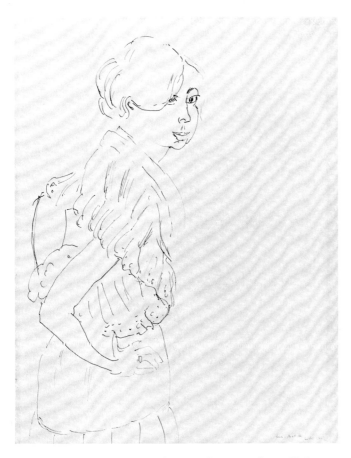

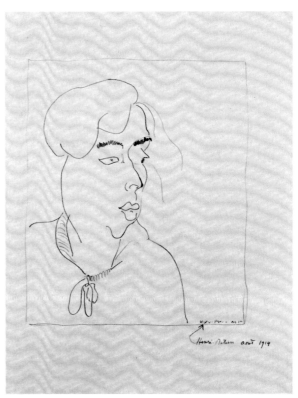

Yvonne Landsberg. *1914. Pencil, 11⅛ x 8½ in (28.2 x 21.7 cm). (C&N, p. 204)*

Prichard, enthusiastic, called it 'the most beautiful contemporary drawing in the world!' Matisse then asked if Yvonne would pose for a more ambitious portrait in oils. It was agreed that while he would be entirely free to paint it as he wished, Mme Landsberg would have the option but no obligation to buy the picture."[1] She did not.

The Museum owns three portraits of Miss Landsberg, two drawings and one etching. This last belongs to the series of portraits some of which are reproduced on the following pages. It shows the magnolia buds and leaves which are mentioned by Albert Landsberg and which also appear in other of the etchings.

Of the two drawings, the standing figure in pen and ink is the earlier and was drawn in July 1914. One is tempted to imagine, incorrectly, that this was Matisse's first impression of the young girl who peers timidly at the spectator. The Museum's second sheet, in pencil, is dated August. Yvonne's features have been dramatically altered; her awkward grace has been transformed into grotesque beauty. In pencil on tracing paper, Matisse copied a photograph of a larger drawing that he had kept. Matisse clarified his signature and date. Did he send this tracing to Mme Landsberg after she had refused the painted portrait? At any rate, it originally belonged, with other drawings of Yvonne, to the Landsberg family, who settled in Portugal.

W.S.L.

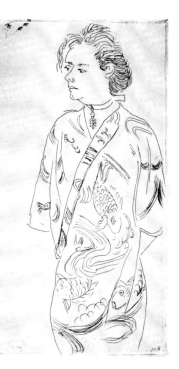

above left: **Woman in a Kimono (The Artist's Wife).** *1914. Etching, 6⁵⁄₁₆ x 2⅜ in (16 x 6 cm). (C&N, p. 204)*

above: **Marguerite in a Kimono.** *1915. Etching, 7¹¹⁄₁₆ x 4¼ in (19.6 x 10.7 cm). (C&N, p. 204)*

left: **Walter Pach.** *1914. Etching, 6⅜ x 2⅜ in (16.1 x 6.1 cm). (C&N, p. 204)*

Not only because of their format, Matisse's etchings of 1914 and the following year seem more intimate than his lithographs of the same time. Mostly portraits of friends and family, they build a brilliant sequence of quick and accurate characterizations: the wives of the painters Derain, Galanis, and Gris, Mme Vignier and her daughter Irène, the artist's wife and his children, and—surprising to a student of Matisse's art—several men, among them Galanis, three Spaniards, and the British muscologist Matthew Stewart Prichard. A single professional model seems to have posed, Loulou, who appears—head, front and back—wearing a hat. As portraits, these etchings offer more penetrating characterizations than do any of Matisse's paintings, where portraiture surrenders to decorative effect.

The etched portraits, all of them small, were finished with astonishing speed after careful consideration of the sitter. Matisse's needle is quick and decisive. Like all of Matisse's etchings, each is distinguished by simplicity. Individual features are reduced to detail, and often contours of a face fill the rectangular frame of the copper plate. The figure is treated at greater length only occasionally, notably in two etchings of Mme Matisse and Marguerite in kimonos, the former a figure curiously fatigued. Several friends, for instance Josette Gris, sat more than once, and in the series there are as many as seven different likenesses of the same individual. Matisse originally intended to gather the portraits as an album; but, instead, the etchings were published separately in editions of five to fifteen proofs each. To this gallery of miniatures he added a few studies of the nude and a sketch of foliage.[1]

The American painter Walter Pach vividly remembered Matisse as a print portraitist in 1914. One October morning in Paris the two had been "talking art" for several hours. Pach looked at the time and said: "I didn't know it was so late. I have an appointment and must be off in less than ten minutes."

"I'd like to do an etching of you."

"Fine. When shall I come?"

"I'll do it right now. I have a plate ready."

"But I've got to meet M. Hessel for lunch. I've got to leave in five minutes . . ."

"All right. I'll do it in five minutes."

Matisse placed his watch on the table, set to work, and within five minutes outlined the drawing on the plate.

"This isn't serious. I got interested in what you were saying about Rembrandt, and I wanted to set down an impression of you then and there. But come on Sunday morning and we'll have time for a real one."

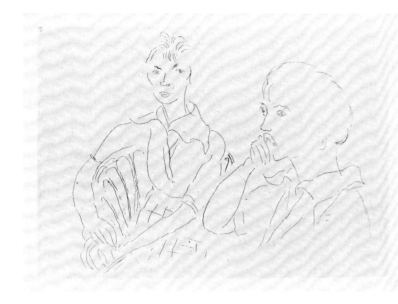

When Pach returned, he found the etching already printed. There were a few tiny, unimportant spots from "foul" biting of the etching acid. Matisse said: "I did not do those. God did. What God does is well done; it is only what men do . . ."

Pach sat again and for three hours Matisse sketched other plates. But, the American remembers, "we looked at the little five-minute etching . . . it had just the life that the more heavily worked things had lost."[2] W.S.L.

above: **Double Portrait: Mme Juan Gris.** *1915–16. Etching, 5 1/16 x 7 1/16 in (12.9 x 17.9 cm). (C&N, p. 204)*

above right: **Yvonne Landsberg.** *1914. Etching, 7⅞ x 4 5/16 in (20 x 11 cm). (C&N, p. 204)*

right: **Charles Bourgeat.** *1914. Etching, 7⅛ x 5 1/16 in (18 x 12.8 cm). (C&N, p. 204)*

Goldfish. *Paris, winter 1914–15. Oil on canvas, 57¾ x 44¼ in (146.5 x 112.4 cm). (C&N, p. 204)*

This remarkable painting from the winter of 1914–15 completes Matisse's series of six compositions with goldfish begun in 1911.[1] It also completes the second of two pairs of companion works within the series, being the successor to *Interior with Goldfish* (fig. 78) of early 1914. In the first pair of goldfish paintings—*Goldfish and Sculpture* of 1911 (p. 85) and *Goldfish* of 1912 (fig. 61)—the earlier work is flat, abstract, and light in color when compared with its more realistic companion. In the second pair, this the later work is again the darker, but its utter and arbitrary flatness and radical degree of departure from reality are in sharp contrast not only with its earlier companion, but with almost everything Matisse did before this time. In the 1911–12 period of the first pair, he was still investigating the alternatives of flatter and deeper space and was willing, therefore, to retreat from abstractness on occasion to produce a more realistic work. Early 1914 was a similar period of stylistic ambivalence: *Interior with Goldfish* is contemporary with *Woman on a High Stool* (p. 93).[2] By the late spring–early summer, however, with the completion of *Mlle Yvonne Landsberg* (fig. 77) and *View of Notre Dame* (p. 95), it was clear that abstraction had won once again. Returning to Paris toward the end of October, Matisse opened his art to the influence of Cubism in quite a new way.

In September, following the outbreak of World War I, Matisse had gone to Collioure after evacuating his children from Issy to Toulouse. In Collioure he found his friend Marquet and the Cubist painter Juan Gris. Writing to Kahnweiler from Collioure, Gris stated: "I see a lot of Matisse. We argue so heatedly about painting that Marquet can hardly sit still from boredom."[3] The conversations with Gris at Collioure have been represented as initiating a radical change in direction for Matisse, after which he began to assimilate Cubist principles into his work and to form contact with members of the Cubist circle of which Gris was a part.[4] They were almost certainly the stimulus for a renewed confrontation with Cubism, yet Matisse's art had been responding to Cubist geometry for the past year. They led to further contacts with Gris and his friends, yet the first contacts had almost certainly preceded the summer of 1914. Matisse probably began looking seriously at Cubist art and seeing something of artists like Gris, Gleizes, Metzinger, and Severini shortly after he established his Paris studio in the autumn of 1913. The intermediary may well have been Apollinaire, a longtime supporter of his work, for Apollinaire had singled out Matisse's portrait of Mme Matisse (fig. 71) as "the best

thing" in the 1913 Salon d'Automne when reviewing the show in the November 1913 issue of *Les Soirées de Paris* and illustrated it in the following issue.[5] In the May 1914 issue, he included "seven reproductions after recent works by Henri Matisse," thus giving Matisse's work equal prominence in this Cubist-dominated journal with Braque's, treated in the previous issue.[6] It is known that Matisse was visited by Metzinger and Severini in the spring of 1914, and he probably also met with Maurice Raynal and with Gris.[7] It seems likely in fact that he had some kind of contact with a number of those associated with *Les Soirées de Paris*. In the autumn, when the war had shrunk and therefore tightened the artistic community that remained in Paris, Matisse allowed himself to be further drawn, if not into the Cubist circle, then within reach of it: he saw more of Gris, probably something of Picasso, was in contact with the Steins, and in October was taken by Walter Pach to Puteaux, where he spoke at length with Raymond Duchamp-Villon.[8] The meeting with Gris in the summer of 1914 accelerated a preexisting trend in Matisse's art, one that made it seem compatible with what the Cubists were doing. When Matisse returned in the autumn to the subject of his spring goldfish painting, the compatibility was very evident indeed.

We know that Matisse intended this painting as a reprise of the *Interior with Goldfish*, for shortly after his return to Paris he wrote to Camoin of "making a picture, it is my picture of goldfish which I am remaking with a person who has a palette in his hand and who is observing (harmony brown-red)," and drew on the postcard a sketch (fig. 79) showing the seated artist at the right, looking down on the same still life as appears in both paintings.[9] It is interesting to note that the reverse of the postcard contains a reproduction of Dürer's *St. Jerome in His Study* (fig. 80), where the saint is writing beside tall vertical windows, with a band of shadow between them.[10]

In the completed painting (which was finished no later than June 1915, and probably earlier)[11] most of the seated figure is eliminated; only the ghost of a prehensile thumb shows through a rectangular palette—a motif that echoes the shape of the goldfish above their similarly floating rectangular plane. Where the figure was placed, a heavily reworked area is divided into a set of angular planes and diagonal lines. Those toward the top of the painting are highly reminiscent of the stylizations of the contemporaneous *Head, White and Rose* (fig. 81), suggesting they are not the arbitrary patterns they seem, but also vestiges of the seated observer Matisse abstracted and then erased. Only the curvilinear railing and the intense blue sky, tinged with white and lilac, remain of the view through the Quai Saint-Michel studio window explicitly rendered

in the spring painting of the same scene. That painting carried a solid dark plane down the left side of the window. Now such a plane arbitrarily divides the window, and the whole canvas; but, being so broad, it securely establishes itself as part of the flat surface and not a break in it. Matisse's unrivaled ability to compose with large, emphatic rhythms and abrupt juxtapositions that divide the surface only to carry the eye more surely across it is hardly ever shown to better advantage than in this work.

In their stark verticality, *Goldfish* and a number of Matisse's other paintings of this period have frequently been compared to such works by Gris as the 1913 *Glass of Beer and Playing Cards* (fig. 82).[12] The comparison is apt, yet Matisse never displaced the parts of an object down adjacent vertical strips as Gris did. Moreover, verticality was a fairly common feature in the Cubist art that Matisse would have seen, including the collages of Picasso and Braque;[13] and besides, the forcefulness with which every element stamps itself on the surface is without precedent in the work of any Cubist, except perhaps Léger.[14] (It looks forward to, and makes possible, the larger, even more monumental canvases painted by Matisse in 1916.) The transparent left-hand side of the tabletop may also suggest Cubist influence, but it is Cubist only to the extent that the table in *Woman on a High Stool* (p. 93) is—that is to say, in the most general way. Only the triangulation in the upper right corner suggests a very specific source, the kind of cagelike format Gris had developed in 1912. The treatment of the window in Gris's *The Man in the Café* of 1912 (fig. 83) offers a precedent for Matisse's work.

What is anti-Cubist in the *Goldfish* is the sense of light it provides. The dark vertical band that connotes interior shadow is warmed by underpainting and by the soft mauves and greens of the partly scraped-over, irrationally disposed legs of the table on which the still life stands. The sense of a screen across the window created by this band traps the space inside the room, and prevents the window from opening optimistically to the outside world. Indeed, outside this band nearly everything is cold and severe. Within it, however, the rich orange-and-yellow fruit and especially the red-and-magenta goldfish radiate a brilliant light that seems to infuse the scumbled white of the tabletop and the milky water of the aquarium. "The goldfish stand out as brilliant flashes of crimson against the blue and black," Theodore Reff has written, "as emblems perhaps of tropical splendor for the artist surrounded by somber austerity."[15] Once again, symbols of the human, vegetable, and aquatic worlds are combined, but now, in the first winter of the Great War, in nostalgic memory of earlier, more joyous versions of the same theme.

Seated Nude. *1913–14. Drypoint, 5 11/16 x 3 15/16 in (14.5 x 10 cm). (C&N, p. 205)*

Just before World War I Matisse returned to the print media. Probably the first works executed were a group of transfer lithographs of a nude model. Undoubtedly the sitter for the 1913 painting *Gray Nude with Bracelet,* this model with bangs is found in several drypoints as well.[1] The young woman of *Black Eyes* and *Seated Nude* is shown in unusual poses (in one lithograph she leans forward in a rocking chair, awkwardly off balance) that provide the possibility of imaginatively delineating a figure within a vague perspective, or what Matisse later called "a perspective of feeling."[2] The facility with which Matisse was able to draw from the model in crayon on transfer paper is in marked contrast with his rather hesitant attack upon the copper plate with a drypoint needle. As was suggested regarding his earlier prints, Matisse found the plate resistant to his flowing line. He was to devote some attention to this technical problem during

Black Eyes. *1914. Transfer lithograph, 17⅞ x 12¾ in (45.3 x 32.6 cm). (C&N, p. 205)*

Seated Nude, Seen from the Back. *1914. Transfer lithograph, 16⅝ x 10⅜ in (42.3 x 26.4 cm). (C&N, p. 206)*

the next few years as he created dozens of intaglio prints.

A small hand press for etchings was installed in the Matisse apartment on the Quai Saint-Michel around 1914. This allowed the artist the freedom to work upon small plates at will and instantly have the opportunity of seeing the printed result. Matisse executed drypoints, etchings, and monotypes while his daughter Marguerite evidently helped him etch and print. She has described part of the procedure as follows: "The monotypes (achieved between 1915 and 1917) were realized in three stages: the delicate application of ink onto copper; the spontaneous drawing which could not be altered; the risks of destroying the work during printing. And at the end of these three steps, a great moment of emotion at the instant when one discovered the imprint on the sheet of paper."[3]

Except for the difficulty of handling the freshly inked plate, Matisse was able to work on his monotypes with a

freedom similar to that expressed in his lithographic transfer drawings. For the most part, the subjects of the monotypes are nude models, portraits, and still lifes. The nudes are the same as those in the lithographs, and they and some portraits closely parallel the drypoints and etchings of the same subjects. The monotype torso illustrated here is considerably advanced over the lithographs in its economy of line (determined only slightly by the medium). The use of a single line to depict the inner and outer contours of the arm is perhaps the closest Matisse comes in print to the abstraction then current in his painting. Although one can cite similarities in subject between prints and paintings from 1914 to 1917, there is very little evidence that Matisse's Cubist tendencies could have arisen in his prints. These were drawn in short spurts, and the creation of a single etched composition in stages either did not appeal to the artist or required a commitment of time

Torso. *1915–17. Monotype, 6¹⁵⁄₁₆ x 5¹⁄₁₆ in (17.6 x 12.8 cm). (C&N, p. 206)*

Standing Nude, Face Half-Hidden. *1914. Transfer lithograph, 19¾ x 12 in (50.3 x 30.5 cm). (C&N, p. 206)*

that he was unwilling to undertake. In any case, the contrasting white line upon the black ground of these monotypes was a source of considerable pleasure for the artist,[4] and they reveal even more clearly than works in other media the perfection of balance in weights of line and ground that Matisse achieved.

Before we return to the lithographs, which are the central works in print of this period, mention must be made of the other monotypes. The still lifes correspond most closely to paintings of 1915–16 and, like the monotype portraits of family and friends that have etched counterparts, are studies in pattern and texture. Here the long, uninterrupted lines of the nudes are not in evidence; the still-life monotypes are all filled with small, nervous marks that give the otherwise static subjects both vibrancy and immediacy. The principle of repetition that Matisse used to create a rhythmic perception of his compositions is

taken up once again in the monotypes. It was not until 1929 that Matisse's handling of line and his use of repetitive motifs in line-etching dramatically coalesced, ultimately finding their most sublime manifestation in the plates for Mallarmé's poetry in 1930–31.

Although the 1920s were the years of Matisse's greatest activity in making lithographs, the nine transfer lithographs of 1914 represent an exalted moment in his graphic expression. The spare lines that describe the nude back are indelibly fixed in a space so exactly composed and defined that the edges of the Japan sheet (larger than the lithographs of 1906, but having the same proportions) are held away from each contour precisely as if plate margins existed. Unlike most drawings by other artists that have been transformed into lithographs, these works reveal no element of chance. What was imperfect in the 1906 prints is, in 1914, codified into an immutable perfection. R. C.

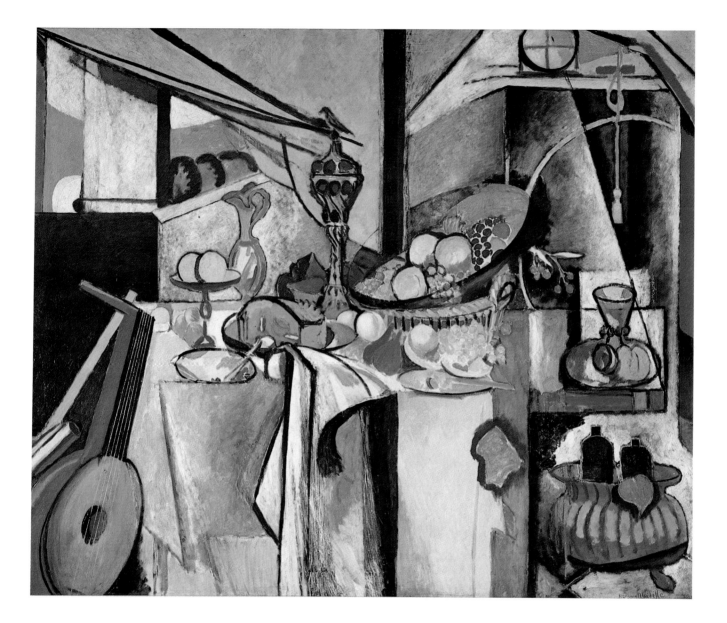

Variation on a Still Life by de Heem. *Issy-les-Moulineaux, late 1915. Oil on canvas, 71¼ in x 7 ft 3 in (180.9 x 220.8 cm). (C&N, p. 206)*

If the so-called experimental period of Matisse's art of 1914 through 1916 deserves its name, it is not only because his painting in those years calls into question some of the basic assumptions of his established decorative style. It is also because "in a way it is 'styleless' painting, or at least it does not fall easily into any of the established stylistic categories of the twentieth century."[1] That is to say, the continuity or coherence of that period is not that of a methodically developing style; each painting, or at least each major painting, was virtually a fresh approach to certain common pictorial preoccupations. As Clement Greenberg has noted, "If ever the continuity and coherence of a man's art were maintained by sheer quality, they were in Matisse's art in those years and in the years afterward."[2]

This serves to explain the difficulty that many commentators have found in adequately describing the over-

all character of Matisse's art in this period. While Matisse was unquestionably responding to the challenge of Cubism, it is clear that this body of work cannot as a whole be described as Cubist painting. Those exceptional works that are unequivocally Cubist, like the *Variation on a Still Life by de Heem*, give the appearance therefore of "sports," purely experimental works in which Matisse explored the vocabulary of Cubism but only to dismiss its usefulness in so dogmatic a state to the future unfolding of his art.[3] The de Heem variation, however, was far more than this. Although Matisse was never to paint anything so purely Cubist again, it marked for him not the exorcism but the assimilation of Cubism. Having allowed Cubism to infiltrate his art for some two years, and increasingly so in the second, he finally met the challenge head on in this large, ambitious, and programmatic work. It was for him "a testing ground for the discovery of those elements in Cubism that might be harmoniously combined in his own work."[4] Although the continuity of the experimental period is not that of a methodical stylistic development from one painting to the next, the span does divide itself into three parts. The first, from the late summer of 1913 to the summer of 1914, shows Matisse responding more to the spirit of Cubism than to its specific style. The second, from the autumn of 1914 to the end of 1915, is the period of specific Cubist influence. The third, from the end of 1915 to the end of 1916, saw Matisse's great architectonic masterpieces, executed when Cubism was fully assimilated into his personal style. The *Variation on a Still Life by de Heem* closes the second of these stages and opens the last.

The very fact that Matisse turned to a familiar image as the basis for this painting, rather than to nature or to invented subjects, confirms his programmatic intent. David de Heem's *Dessert* of 1640 (fig. 84) was one of Matisse's favorite works in the Louvre. He had copied it there as a student in 1893 (fig. 85), and it had served as the inspiration for two of his earlier synthesizing works, the *Dessert* of 1897 (fig. 1), which encapsulated his early Impressionist experiments and led to a more liberated painterly style, and the *Dessert (Harmony in Red)* of 1908 (fig. 2), which drew together the preoccupations of Matisse's early decorative period and prepared for the consummate masterpieces of that style. These may have been in Matisse's mind as he searched for a format within which to test and confront his Cubism, especially since the 1908 *Dessert* and the 1915 de Heem variation are almost identical in size. Matisse later acknowledged that the *Variation* was a conscious address to Cubist issues when noting how he had turned to his original 1893 copy of the de Heem and "began it again . . . with the methods of modern construction."[5]

The 1915 picture, based on his early copy,[6] was made at Issy toward the end of what had been a relatively fallow year for Matisse's painting. By November 22, the work was finished, Matisse was pleased with it, and it was sold, fittingly to Léonce Rosenberg, whose Galerie de l'Effort Moderne was starting to become the focus for an emerging form of newly classicized Cubism.[7]

This was not fully to emerge until 1917, but those who created it were all in or around Paris during the war years, and Matisse, as noted earlier (p. 100), had contact with this circle through Juan Gris. Moreover, he partook of some of the Cubists' enthusiasms. He read Henri Poincaré's *La Science et l'hypothèse* at the time he painted the de Heem variation, expressing great interest in its section on the destruction of matter,[8] and must have heard from his friends their views on Bergson's ideas, which were widely discussed among the Cubists and which had interested him for some time.[9] He also had long talked of the idealist basis of his art in terms not unlike those used by the Cubists and their apologists,[10] as well as recognizing Cubism as a development, parallel to his own, out of Cézanne's paintings, one no less opposed than his to "the deliquescence of Impressionism."[11] Marcel Sembat recalls Matisse's saying to Picasso, or vice versa: "We seek the same thing by opposite means."[12] Matisse himself, while contrasting the basis of Cubist art in reality against that of his own in imagination, insisted that "in those days we didn't feel imprisoned in uniforms, and a bit of boldness, found in a friend's picture, belonged to everybody."[13]

The military metaphor reminds us that "those days" were during World War I, the influence of which is often cited for the exceptional sobriety of Matisse's painting at this time. Less often noticed is the fact that a number of previously non-Cubist artists turned to Cubism as a result of their war experiences, explaining to the public at home that only such a geometric manner could record the sensations they felt in the face of this war of machines.[14] Matisse, constantly anxious for news from the front and worried for his friends in active service,[15] could hardly have been ignorant of the way Cubism thus seemed to answer a specific emotional need in what were very troubled times. For him, whose art had hitherto been utterly dependent on his enclosing himself within a protective paradisal garden of his imagination, the emotional need was also grave. We should not underestimate the disruption that the war brought to his artistic conscience and to its investment in a purified aesthetic reaction to the world. What cannot be overestimated is the heroic nature of his response to this challenge, as reflected in the canvases of the war years. His specific response was to muster the more calculated and severe aspects of his art. "I am such a romantic," he wrote

to his friend Camoin at the front, "but with a good half of the scientist, the rationalist."[16] In asserting his rationalism, he learned from the classicist and intellectual wing of Cubism, and particularly from Juan Gris.

When Matisse and Gris talked relentlessly about painting in the summer of 1914, Gris had begun making a series of sumptuous and elaborate *papiers collés* which represent the climax of the first stage of his exploration of Cubism. Matisse, however, seems to have been less interested in these (if we may judge from his own paintings) and more responsive to Gris's work of the previous two years. As noted earlier (p. 102), Matisse's only overt Cubist borrowing was from Gris's paintings of 1912. In these works, an emphatic cagelike grid, developed from the linear scaffolding of High Analytical Cubism, encloses a series of both abstracted and relatively realistic forms in a schematically flattened space. Matisse's de Heem variation demands comparison with such works as Gris's *Composition with Watch* of 1912 (fig. 86).[17] The blend of rectilinear grid with intersecting diagonals, the use of crisp, heavily drawn lines and curves for compositional as well as for contouring functions, and the flattening and compartmentalization of the picture space into a few large, basic rectangular units all speak of the lesson of Gris's approach. So too does the mixture of fairly abstract forms —even down to that typical Gris motif, the quartered circle—echoing each other throughout the composition, and realistic ones, including a tasseled cord such as appears in Gris's *Composition with Watch*.[18]

There is also evidence to suggest that Matisse actually followed Gris's highly methodical method of planning his compositions. Although at this stage in his career Gris certainly had a specific subject in mind before beginning a painting, even in 1912 and without doubt in 1913 he seems to have begun by laying out a set of carefully ruled lines, projected from various fixed points in horizontal, vertical, and diagonal directions, which join together to create a precise (though not necessarily mathematical) surface geometry.[19] Compositional analysis of Matisse's de Heem variation (fig. 87) reveals that Matisse must have done exactly the same thing. The exact alignments of projected lines are simply too numerous to have been intuitively realized. Splaying diagonals join a rectilinear grid with a precision that has no precedent in any other Matisse painting—and was never to appear again. The "methods of modern construction" fix all the salient points of the composition, even down to such minor details as the curvature of the arc above the center of the still-life group, the angle of the neck of the lute, and the way the drapery falls over the table. Comparing the 1915 painting with the 1893 copy from which Matisse worked,

we see how he has increased the proportions of the canvas toward verticality, emphasizing this by the strong black stripe down the center. The crisp diagonals have no precedent in de Heem; neither has the upturned rectangle of the tabletop, the schematically flattened view through the window, which replaces de Heem's deep chiaroscuro, or the frontal turning of the Cubist guitar. Two extant drawings from 1915 (figs. 88 and 89) show how Matisse simplified the central section of the still life.[20] Other details would be undecipherable had we not the de Heem for reference: for example, the quartered circle deriving from de Heem's globe and below that a segment of a circle taken from the tondo in the background of de Heem's painting.

"I have derived constant benefit from my use of the plumb line," Matisse wrote at a later date.[21] He had used it in the *Male Model* (p. 29) and in *Luxe, calme et volupté* (p. 37), and recommended it to his students, telling one of them, Pierre Dubreuil: "Always use your plumb line. Think of the hard lines of the stretcher or the frame, they affect the lines of your subject."[22] The color of the de Heem variation, with its black verticals and the reds and oranges forming bands around the edges, enforces its literal shape as strongly as do the compositional lines themselves. Within the center of the painting, the modulated grays, ochers, and beiges clearly speak of Cubism, though the vivid emerald greens and oranges finally tip the painting toward an almost Fauve intensity. Still, it remains a Cubist painting, and a highly deliberated one at that. "M. Matisse proceeds from the sensation to the idea, the Cubists from the idea to the sensation," wrote one of the Cubists, André Lhote.[23] For once, Matisse proved him wrong. "There are no laws until the work is finished,"[24] Matisse himself wrote. For once, he broke this only rule he had.

That the de Heem variation is a highly imposing work, irrespective of its debts, its unusual compositional methods, and its occasional eccentricities, hardly needs saying. What does require emphasis is that with this painting Matisse not only finally and directly faced the challenge of Cubism, but found that, even in its most conceptualized form, it was not incompatible with the previous direction of his art; it showed how he might invest open flat surfaces of color with a newly rigorous sense of structure, based on triangulation and on the grid, which was yet as harmonious and as elemental as the arabesques of his earlier painting. The right-hand section of the de Heem painting anticipates the composition of the *Piano Lesson* of 1916 (p. 115). The sober balance of geometrically disposed blacks and grays looks forward to *The Moroccans* (p. 111), finally started after two years of hesitation as soon as the de Heem variation was finished.

The Italian Woman. *Paris, early 1916. Oil on canvas, 46 x 35¼ in (116.6 x 89.6 cm). (C&N, p. 209)*

This portrait of Matisse's Italian model Laurette is the first of a number of paintings of the same subject from 1916 and 1917.[1] All of the subsequent works are more realistic in conception. Some anticipate the more intimate style of the Nice period; none reveal anything of the almost forbidding austerity that makes *The Italian Woman* one of Matisse's sternest as well as most arresting works.

It belongs to a series of portraits painted early in 1916 that take up again the highly ascetic form of portraiture initiated a year earlier in works like *Woman on a High Stool* (p. 93) and modify it to admit passages of volumetric modeling. Although previously dated to 1915, *The Italian Woman* must have been painted in the early months of the following year, for it is visible in an unfinished state in a photograph of Matisse's Paris studio (fig. 90), across the room from the portraits of Sarah Stein and Michael Stein (both dated 1916) and beside the also unfinished portrait of Mme Greta Prozer.[2] This photograph not only allows us to date the work securely but also confirms what the completed painting itself suggests: that Matisse began with a fairly realistic rendering of the somewhat stout model with broad oval face, then drastically pared away the forms as the painting developed.

The most drastic of Matisse's changes has been to carry one fall of hair down the front of the surface—painting it with such a dense black that it clings flatly to the picture plane—and to advance the color of the background up to the edge of the hair, so that the ground of the painting seems to drape over the model's shoulder like a shawl. It is as if the canvas had been slit open and the side of the figure slipped underneath. Matisse's persistent concern with joining volume to the flat picture surface here produces the curious and unsettling effect of a flat surface that appears to be partly volumetric and of a volumetric figure so integrally bonded to the surface as also to appear to be flat. This partial exchange of characteristics between figure and ground[3]—where the corporeality of the figure is transferred to the flatness of the ground, and vice versa—

is what largely accounts for the almost spectral feeling the figure imposes. The dense, substantive space of the painting recalls that of *The Blue Window* and many intervening works, but looks back further to earlier periods in Matisse's art when he experimented with Cézannist space. What Pierre Schneider calls the Moebius-strip effect of a continuous background that seems to bend from top to bottom of the painting ultimately derives from certain Cézannist still lifes of around 1908.[4] The abutting of background to one side of the figure recalls the treatment of the *Male Model* (p. 29) in 1900. Also Cézannist is the way in which the background space seems to eat away at the contours of the figure. This "destruction of substance" is ultimately Impressionist in derivation;[5] however, the interaction of a severely drawn image and a background that erodes the image is essentially "a translation of Cézannist space into Matissean terms."[6]

Much of this also applies to the contemporaneous portraits by Matisse mentioned above. Where *The Italian Woman* differs from these is in showing the extent to which Matisse was willing to allow different and conflicting methods of representation to coexist within a single painting. We are given, in almost diagrammatic form, three distinct levels of "realism," one above the other. The ocher and black zone of the skirt is flat and schematic. The gray and blue tones on the white blouse provide a limited illusion of volume in that area of the painting. The head is given in high sculptural relief. The figure therefore seems to loom up and develop substance as it rises in the painting, being assisted in this by the way the arms grow from virtually immaterial hands to flat, bladelike forearms and solidify only as they approach the shoulders. As a result of these shifts of method, the power and presence of the psychologically dominant head is greatly intensified. Floating amid the darkness of the surrounding hair, this austere and introverted mask is one of Matisse's most expressionist creations. Even within the head itself, however, we see a further shift in method as one side of the face is seemingly lifted and displaced above the other—and flattened to the dark fall of hair that travels down the front of the painting and returns the eye to the two-dimensional zone from which the figure seems to have grown.

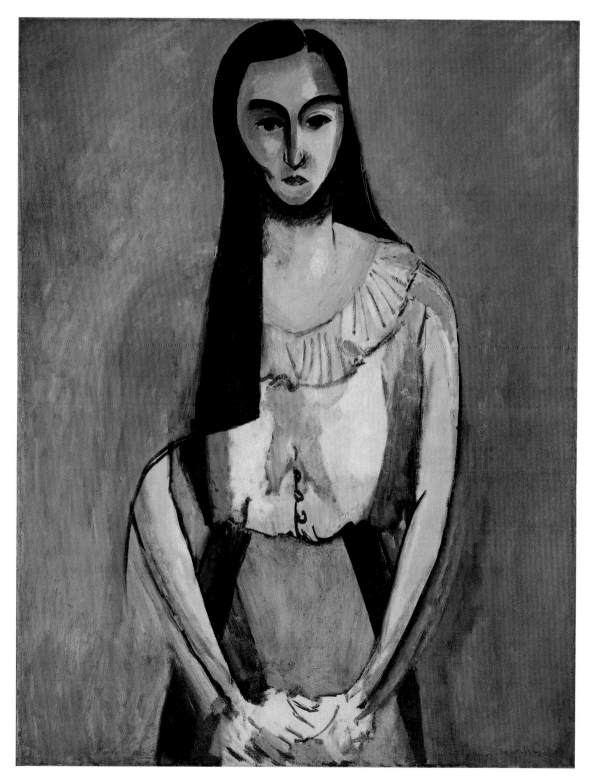

The Moroccans. *Issy-les-Moulineaux, November 1915 and summer 1916. Oil on canvas, 71⅜ in x 9 ft 2 in (181.3 x 279.4 cm). (C&N, p. 209)*

In April 1913, Matisse held his fourth one-man exhibition in Paris, at the Bernheim-Jeune Gallery. Dominating it were his Moroccan paintings of the winters of 1911–12 and 1912–13. The exhibition provoked great critical interest, and the most controversial painting proved to be the huge *Arab Café* (fig. 91), which, given its size (nearly six by seven feet) and the degree of abstractness, was taken to be the summation of Matisse's Moroccan art.[1] In fact, Matisse had made up his mind to sum up his Moroccan experiences in another picture, to be painted from memory, and was hoping to have started work by the summer of 1913.[2] *The Moroccans,* however, turned out to be a painting that gave Matisse a great deal of trouble. We have seen (pp. 92–94) that the summer of 1913 at Issy was a difficult one as Matisse's art began to take on a more austere and ascetic cast. By early September he had stretched a canvas for *The Moroccans,* but found it the wrong size for what he had in mind.[3] As his painting style continued to change, he clearly felt unready for the challenge of what was always intended to be a major synoptic work. It was not until he had finally faced the Cubist challenge head on and painted the *Variation on a Still Life by de Heem* (p. 105) that he returned to the painting that had been gestating for the previous two and a half years.

Writing to Camoin from Issy on November 22, 1915, to announce that the de Heem variation was finished and sold, Matisse sent a description and a sketch (fig. 92) of the painting he had just started, *"un souvenir du Maroc."* "It is the terrace of a small café with the languid idlers chatting toward the end of the day. You can see the small white priest at the base . . . [and] an Arab lying aslant on his burnoose."[4] The priest, seen from the back, was enlarged and moved to the lower right corner of the finished painting. However, a recent X-ray photograph of *The Moroccans* (fig. 93) shows that before this figure was finalized it was temporarily transformed into one highly reminiscent of the figure in Matisse's Cézanne *Bathers* (fig. 4) occupying the lower right corner of that painting.[5] In its final form, the sexually provocative pose was tempered to become as monumentally cool as those in the contemporaneous *Bathers by a River* (fig. 39) or as *Back III* (p. 77), with which it demands comparison. It is clear, nevertheless, that *The Moroccans* did not begin as a highly architectonic painting. Although the diagonally positioned Arab in the sketch disappeared from the final work, its presence in the sketch confirms that Matisse's original conception drew heavily on the composition of the *Arab*

Café, which contains a similar figure and was surely the prototype for the open and asymmetrical disposition of forms in the early state of *The Moroccans* recorded in the sketch.

Talking about *The Moroccans* some thirty-five years after he painted it, Matisse observed: "I find it difficult to describe this painting of mine with words. It is the beginning of my expression with color, with blacks and their contrasts. They are reclining figures of Moroccans, on a terrace, with their watermelons and gourds."[6] The painting in fact comprises three sections that are, as Alfred Barr pointed out, "separate both as regards composition and subject matter . . . These three groups might be described as compositions of architecture, still life and figures."[7] The architectural section at the upper left shows a balcony with a pot of blue flowers at the corner, the dome of a mosque behind, and a trelliswork roof above. The pot of flowers was anticipated in the sketch, but in a different part of the composition. That everything else in this area was invented during execution of the painting is proved by indications in the X-ray of the large parasol, visible in the sketch, which originally filled this part of the painting.[8] The still life of four yellow melons with large green leaves that we see below the architecture had certainly no precedent in the sketch. Only the shift in direction of the tile pattern between the melons recalls the original conception, for it follows the shape of the flight of steps that Matisse first included in this section of the work.

The third section, at the right, is by far the most ambiguous. However, reference to the sketch and the X-ray helps us decipher some of the motifs it contains. The dark oval form to the right of the priest's head has been interpreted as an Arab with burnoose drawn over his head.[9] More likely, it derives from a horseshoe-arched doorway, its upper half in shadow, such as we also see in *Entrance to the Casbah,* painted on Matisse's second Moroccan visit.[10] (The X-ray shows that there was originally what seems to be a flight of steps leading up to the doorway.) Recognition of this as an architectural feature supports interpretation of the two linear images above it as figures before or inside windows: the one to the right seems to derive from the crouching Arab with drawn-up knees to the right in the sketch; the other from the drinking figure of the sketch (only the diagonals of his legs remaining in the window-framed view in the painting). The two juxtaposed forms to the left of the priest's head cannot be deciphered with any certainty. The X-ray suggests that the white section of the larger area may have originally denoted the priest's raised arm. The circular form could be derived from a well or from a goldfish bowl

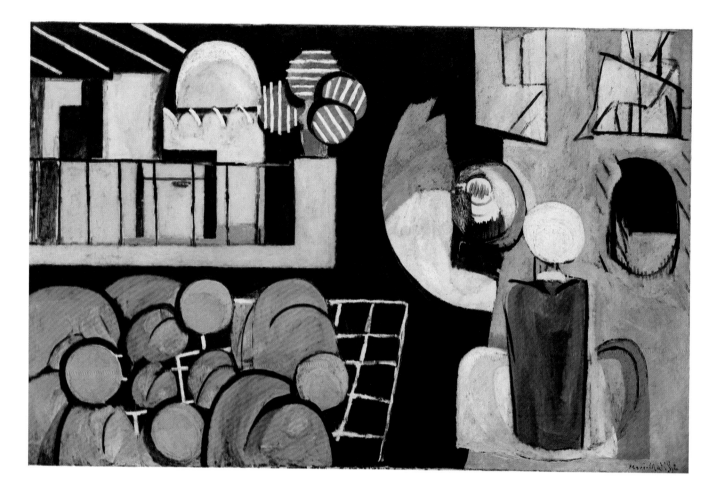

such as we see in the *Arab Café*. However, the two forms together have been interpreted as a circular turban form surrounded by the folds of a burnoose;[11] a circular image to the back of the sketch would tend to support this reading.

Although the three compositional groupings of *The Moroccans* are isolated one from the next, Matisse sets up "a polyphony of both formal and representational analogies"[12] that keeps the eye in perpetual movement across the work and thus joins its otherwise fragmented parts. Alfred Barr describes the analogies thus: "The four great round flowers in the architecture section echo the four melons in the still-life section. Yet these melons are so like the turban of the seated Moroccan in the figure section that the whole pile of melons with their leaves has sometimes been interpreted as Moroccans bowing their foreheads to the ground in prayer. At the same time, to complete the circle, some of the figures are so abstractly

constructed as to suggest analogies with the architecture section."[13] In addition, the seated priest in the foreground bears formal comparison with the mosque at the back, to which he is functionally related.

Given the presence in *The Moroccans* of elements specifically derived from the sketch, it would seem likely that the painting was finally begun in November 1915, the date of the letter to Camoin. However, Matisse told Camoin that the painting he had started was one of the "same dimensions" as the just-completed de Heem variation.[14] *The Moroccans* is larger than that, suggesting that Matisse had again miscalculated the format of the picture, as he had done in 1913. Whether he resolved this particular problem before moving to Paris for the winter cannot be known. What is certain is that Matisse did not complete *The Moroccans* until about nine months later.

When he returned to Issy in the spring of 1916, it was not to immediately begin work on *The Moroccans* again.

111

Writing to Hans Purrmann on June 1 after "working very hard recently," Matisse does not mention the work in the list of paintings he describes as "the important things of my life."[15] He had just completed the *Bowl of Oranges*[16] and the Detroit *Window*,[17] and had taken up yet again his *Bathers by a River* (fig. 39), to which he had also turned on an earlier occasion, in September 1913, when frustrated by *The Moroccans*.[18] Whereas the vertical emphasis of the *Window* and *Bathers by a River* relates these paintings to the format of many of Matisse's works of 1914–15, the bold circular forms of *Bowl of Oranges* were relatively new. The group of still lifes to which it belongs showed Matisse a way of using organic forms, such as he had been struggling with in *The Moroccans,* in a monumental fashion that was compatible with the rectilinear geometry of his preceding paintings. *The Moroccans* brought together the geometric and the monumentally organic in one synoptic work.

The last of the group of still lifes mentioned above, *Gourds* (p. 113) of summer 1916,[19] directly pointed to the way *The Moroccans* was finally to be resolved. Matisse said of the *Gourds* that it was "a composition of objects which do not touch—but which all the same participate in the same *intimité,*" and that "in this work I began to use pure black as a color of light and not as a color of darkness."[20] The relationship of the objects—which are isolated one from the next but associated by virtue of the pressure of their surrounding ground—is crucial, as Alfred Barr noted, to the success of the painting. "The background is a field divided diagonally into blue and black areas. Against this the objects neither stand nor hang—they simply exist. But they exist with the utmost clarity and vividness, their shapes vigorously drawn or modeled and silhouetted against the background like the isolated loaves and utensils strewn so carefully on the table of a Romanesque Last Supper."[21]

It is interesting to note that this work, which immediately preceded the completion of *The Moroccans,* also looks back to an earlier major synoptic painting, the *Dance* of 1910, like the *Gourds* composed of five self-contained images against a two-toned field. Comparison of the two works serves to remind us that while Matisse was indeed working toward a new architectonic method in the war years, and was turning to Cubism to help him create it, he was all the time drawing on the strengths of his earlier work. His ambition, it has been said, was "a synthesis of those broad saturations of color which he had himself pioneered and the superior intellectual rigor of Cubist syntax."[22] This is what *The Moroccans* achieved. Far more than in his previous large-scale Cubist-influenced work, the de Heem variation, he managed to find

in Cubism a way of composing that was fully compatible with his earlier ideals. Cubism, by late 1915, had in any case become far more an art of broad surfaces than at any earlier stage of its development. When Matisse, acknowledging that "there was perhaps a *concordance* between my work and theirs [the Cubists']," added provocatively, "But perhaps they themselves were trying to find me,"[23] he may not have been at all wide of the mark. Certainly, the redirection in Synthetic Cubism that began late in 1915 and led toward a new surface flatness and decorativeness, and, with the suppression of recessional space, a more monumental scale, brought Matisse's and Picasso's art closer together at this moment than perhaps in any other period. This is important to the present context because the particular painting by Picasso that marked the point of change in Synthetic Cubism turns out to be a hitherto unnoticed source for certain features of *The Moroccans.*

In late January or early February 1916, Matisse wrote to Derain that he had seen at Rosenberg's gallery "a Picasso in a new manner, a Harlequin, with nothing pasted on, only painting."[24] This must certainly have been The Museum of Modern Art's *Harlequin* (fig. 95), which was much admired in Picasso's circle. The enveloping black ground of the *Harlequin* is only its most obvious link to *The Moroccans.* The exceptional somber mood of the Picasso, its highly austere geometry, varied execution, schematic perspective, restricted color range, and play of patterned and solidly colored flat areas all serve to suggest that Matisse would have found it of particular interest. Other and disparate external sources may have had their part too, for Matisse was ever a great absorber of others' vocabulary, but always transforming what he saw, using it "without in any sense subscribing to the kind of system it suggested."[25] We know that he expressed enthusiastic interest in the grandeur of Hodler's compositions of bold abstracted figures disposed across open flat grounds;[26] he was also very likely looking again at the emphatic contours and figure-ground relationships of Gauguin's work,[27] and at Seurat's "simplification of form to its fundamental geometric shapes."[28] None of these sources directly reveal themselves in the composition of *The Moroccans,* any more than does the Picasso. For Matisse they were precedents rather than influences, precedents that suggested the kind of options open to him in making such a highly demanding and radical painting.

That Matisse did find *The Moroccans* a highly demanding work is shown by a letter to Camoin of July 19, 1916.[29] He had been working for a month on his *"tableau du Maroc,"* he said, and it had totally unsettled his mind. "I may not be in the trenches," he added, "but I am in a front line of my own making." By this date the final

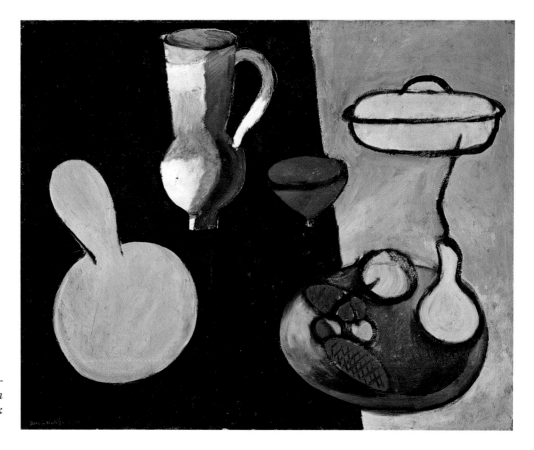

Gourds. *Issy-les-Mouli-neaux, summer 1916. Oil on canvas, 25⅝ x 31⅞ in (65.1 x 80.9 cm). (C&N, p. 209)*

dimensions of the painting had been settled, for he gave the size in the letter. He also described the subject as "the terrace of the little café of the casbah which you know well," thus confirming its derivation from memories of the Moroccan visit, for he had met up with Camoin in Tangier.[30] The subject itself was a staple of Salon painting and readily lent itself to romanticized, exotic treatment (fig. 96).[31] In its stark geometry and grand, measured drama the Matisse shows nothing of this, yet still marvelously evokes the intensity of tropical sun and shadow, conveying a remarkable sense of physical heat.

Crucial to this effect is the enveloping black ground; like that of the *Gourds,* it is, as Matisse said, "a grand black which is as luminous as the other colors in the painting."[32] It certainly dramatizes the other colors the painting contains. Its own sharp contrast with the warm whites reinforces (and is reinforced by) the other sets of contemporary colors in the work: green and violet pink; two different yellows and two different blues. Moreover, the strongest pair of complementaries, the green and the pink, are balanced across the black center. The black therefore serves as "a force . . . to simplify the construction."[33] It separates the three sections of the composition and pushes them out to the picture edges. This draws the perimeters of the work into the design itself and creates a sense of openness, so that the eye sweeps flatly across the picture surface, taking in its expansive conception and large scale. And because the black is so utterly dense, it serves to flatten potentially recessive areas while still creating an illusion of space—but of a space that seems as tangible as the objects suspended within it. It is known that Matisse particularly admired Manet's use of this color.[34] He may also have been indebted in this context to Japanese prints and to the Spanish paintings he had copied in the Louvre. By basing this great composition on exaggerated tonal contrasts, but ones divorced from conventional modeling, Matisse was able to give his work the gravity and solidity of traditional chiaroscuro painting without excavating the illusion of deep space that had once been necessary to achieve a grandeur of this kind.

Piano Lesson. *Issy-les-Moulineaux, late summer 1916. Oil on canvas, 8 ft ½ in x 6 ft 11¾ in (245.1 x 212.7 cm). (C&N, p. 211)*

The *Piano Lesson* is the most perfectly disciplined of Matisse's large-scale architectonic paintings of the mid-teens. It was probably painted in the late summer of 1916,[1] and is therefore one of the last of these works. It is also the most nearly abstract, dominated as it is by broad, open compartments of tranquil color that both flatten and enlarge the pictorial space and seem to have pushed out to the edges of the painting the few isolated images it contains. For all its formal clarity, however, the *Piano Lesson* is one of Matisse's most elusive and ambiguous paintings, rich in his personal symbolism and full of subtle analogies and allusions. The subject is Matisse's younger son Pierre practicing on the Pleyel piano beside the open window of the living room at Issy. It is, therefore, one of Matisse's "family" paintings and as such belongs to a series of interiors with portraits of family members engaged in cultural or domestic pursuits. But the emphasis is on art and the creation of art, so that this picture is related also to Matisse's studio paintings and to his still lifes containing representations of his own work. In such a context, Matisse's own son seated at the piano (he was originally destined by his father to be a musician) clearly functions as a symbol for the artist surrounded by emblems of his craft, and the painting itself assumes an autobiographical and allegorical role, telling of the history and character of Matisse's art.[2]

This is principally achieved through sets of polarities within the composition. In the bottom left corner we see a representation of Matisse's sculpture *Decorative Figure* of 1908 (fig. 41), and diagonally opposite, his painting *Woman on a High Stool* of 1914 (p. 93). The first shows Matisse's art at its most sensuous and instinctive; the second, at its most austere and abstract. This contrast is echoed in another form by the objects on the piano top. The gray pyramidal metronome, "like a metaphysical symbol [that] stands for measure, geometry, logic—intellectual process,"[3] points directly up to the head of *Woman on a High Stool* to which it is metaphorically associated. The golden candlestick at the corner of the piano is placed opposite the warm brown sculpture, with the head of the sculpture and the orange flame of the candle in exact horizontal alignment. Because of these juxtapositions, not only is the polarity of intellectual versus instinctive reinforced by the objects on the piano, but the female artistic symbols presented by the painting and sculpture are contrasted to ones that are "masculine" in shape and that allude to the principles rather than the products of

Matisse's art. The candlestick is colored, immaterial, and connotes light; the metronome is tonal, volumetric, and connotes time; and both of them evoke either ritualistic or artistic associations.

The disembodied, two-dimensional presentation of the candlestick separates it from the sculpture with which it is paired. (That, like the metronome, is schematically three-dimensional in form.) In this respect, the candlestick associates itself with the representation of the painting, which is given in such ambiguous terms that it has sometimes been mistaken for the image of a "teacher" who is overseeing the piano lesson.[4] It is reasonable to assume that Matisse intended an ambiguous reading in the case of both of the works of art shown. Just as he confuses the ground of *Woman on a High Stool* with the wall of the room—and therefore with the ground of the *Piano Lesson* itself—so he presents the *Decorative Figure* on its sculpted cubic seat but without its base, "so that each figure seems to hover in an ambiguous space, as much a human presence as a work of art."[5] Thus, although the "family" interior presented in the *Piano Lesson* is transcended by the inclusion of works of art, the works of art themselves function as inhabitants of the interior, no less "real" in this context than the radically abstracted face of the pianist that they surround.

Matisse's son Pierre was sixteen when this picture was painted; he clearly looks much younger.[6] It is because his face shows so little sign of worldly experience—seeming almost devoid of character—that he so successfully functions as a surrogate for another's character, the artist's. But the youth and innocence of the face serve another function too: they afford a particularly telling contrast between the surrogate artist and his two older female companions, the severe "teacher" and the sensual nude. Because the young pianist occupies the space between the metronome and the "teacher," he seems to be enclosed and absorbed by the discipline that they express—"so entirely so, in fact," Theodore Reff has written, "that only his left eye, the one aligned with the metronome and high stool, is open, very intently staring; whereas the other one, which might be distracted by a peripheral glimpse of the garden or the nude, is closed by a wedge of shadow, its shape an echo of the metronome's."[7] If the surrogate artist is thus held captive between the two vertically aligned symbols of discipline, the two instinctive symbols, in contrast, span horizontally a space that refers to the naturalistic sources of his art. They enclose the base of the abstracted window that looks out to the organic world. The triangle of green lawn in Matisse's garden is reminiscent of that in *Goldfish and Sculpture* of 1911 (p. 85), which juxtaposed a similar garden view with a sister of the sculpture shown here. In

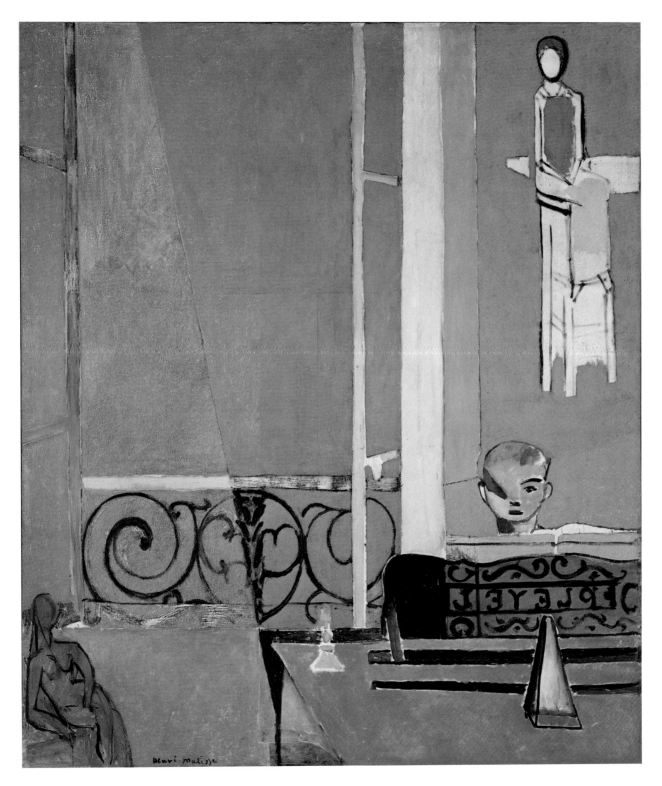

this painting, however, the raking diagonal draws the space of the exterior into the "artistic" interior itself, thus phrasing in a new way perhaps the most fundamental polarity of Matisse's art, that of the natural and the artificial, of the world of nature and the world of art. All the various polarities presented by the objects in the interior are finally reducible to that most basic one as well.

As in many of Matisse's works that juxtapose interior and exterior space, the window allowing the transition between them functions as a painting within a painting—here, certainly as abstract a one as the "real" painting, *Woman on a High Stool,* that hangs beside it. Its own division into organically and inorganically colored zones mirrors the theme of the entire work. The diagonal that creates the division seems to have been a late addition to the painting.[8] It was a brilliant improvisation. The green triangle thus created not only echoes the shape of the metronome (hence affording another contrast of the organic and the intellectual) and tempers the rectilinear geometry of the work; it also forms a coloristic complementary to the pink of the piano top. These two zones draw together in an almost magnetic way, creating "a valuable moment of excitement in an otherwise disciplined calm."[9] Each of these two zones, moreover, is flanked by a plane of arabesque grillwork. One, formed by the window balustrade, reinforces the organic connection of the abstracted landscape. Reminiscent of the tendrils of ivy that surround some other Matisse windows,[10] it "seems to articulate the process of growth itself."[11] The other arabesque grill, formed by the music rack, also has this organic connotation. However, it additionally seems to suggest, as Jack Flam points out, the sense of music being played, and is supported in this function by the reversed "Pleyel" that carries the eye across the front of the piano to the grillwork of the window, which picks up the same theme.[12] Together, the two sections of arabesque bring movement and sound into this still, silent composition, as well as joining the organic and the artistic in a common harmony. Between them the musician-cum-artist is seated. He is both the fulcrum of the geometric structure—for the Golden Section relationships that organize the work all serve to lock him into place—and the point of psychological access to the painting.

Although the boy at the piano quite clearly serves to present Matisse's vision of himself and his art, this does not mean that the "family" connotations of the painting are canceled by the "artistic" ones. Indeed, the contrast of "artistic" and "family" themes in the *Piano Lesson* adds resonance to the other sets of polarities it contains. It is reinforced by the contrast this painting affords with its more realistic companion, the *Music Lesson* (fig. 97),

painted the following summer.[13] One of Matisse's very earliest paintings had been an 1893 copy of Fragonard's *The Music Lesson* (fig. 99). Whereas the *Piano Lesson* shows Matisse at the summit of his modernism nearly a quarter of a century later, the *Music Lesson* of 1917 initiated the return to naturalism characteristic of Matisse's art in the Nice period after the war—a kind of soft, rococo naturalism not all that distant in feeling from the Fragonard copy with which the cycle began. The *Piano Lesson* and the *Music Lesson* therefore mark out different stylistic distances from Matisse's artistic roots. The one that clearly speaks of Matisse's chronological beginnings, the *Music Lesson,* is also the one in which the family ambience is stronger, for Matisse has added to Pierre at the piano the rest of his family and has emphasized the domesticity of the scene. In the *Piano Lesson,* Matisse's stylistic roots have been left far behind, and the family element as such is transformed into what is in effect "an artist's monologue"[14] of the most serious kind, in comparison with which the cultural pursuits depicted in the *Music Lesson* seem to be "mere leisure activity, a pleasant way of passing an afternoon."[15]

The *Piano Lesson,* however, should not too quickly be characterized as a manifesto on the separation of art from life or on the independence of the advanced artist from his artistic and familial sources. If the "family" element is indeed transcended, it is because it so completely fuses with the "artistic" one. The picture has well been described as uniting "the abstract precision of a Mondrian with the quiet emotion of the best intimist painting."[16] It joins the totally assimilated Cubism of Matisse's most avant-garde style with the restful self-contained feeling of his early domestic interiors. For Matisse, the domestic calm of his household was analogous to the sense of harmony that he sought in his paintings.[17] Here, artistic and domestic harmony are given as one.[18]

The Rose Marble Table. *Issy-les-Moulineaux, summer 1917. Oil on canvas, 57½ x 38¼ in (146 x 97 cm). (C&N, p. 213)*

The Rose Marble Table was painted in Matisse's garden at Issy-les-Moulineaux in the summer of 1917. The motif of a centrally placed table with fruit set against a relatively bare ground relates it to the group of still lifes on a circular table that Matisse had made the previous summer.[1] However, the sobriety of its color relationships marks the beginning of a change in direction in Ma-

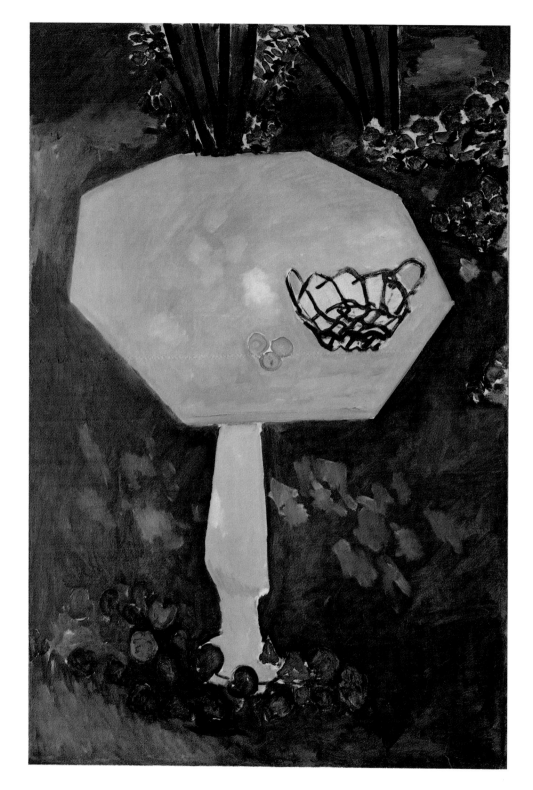

tisse's art. While many of his wartime canvases used muted tones, these tones were usually juxtaposed with brighter areas to give dramatic contrast to the paintings and to add resonance to the more purely prismatic hues that Matisse used. The closely related pink and green on dark brown of *The Rose Marble Table,* though linked to a design of exceptional grandeur and formal clarity, eschews the dramatic to create a soft, lambent, and almost melancholy feeling in its range of color that is all but unknown in Matisse's earlier work. Such a feeling may well have been evoked by the subject itself. Alfred Barr finds in the work a sense of "romantic gloom as if [it had been] painted at dusk."[2] It is also, however, a harbinger of the quieter, more meditative paintings that emerged at Nice in the years that followed. The impressive dignity of *The Rose Marble Table* is largely due to the way in which Matisse joins so subtle and restrained a palette—which looks to the future—with a bold and reductive composition, such as had characterized the architectonic period now coming to a close.

It is one of Matisse's sparest and most open paintings. Although centralized in composition, it is centrifugal rather than centripetal in effect, for the eye is carried outward from the flat tipped-up tabletop and across the relatively uninflected surround, which hardly reads as a "ground," being in fact denser and more substantive than the image placed upon it. This "reverse silhouette" effect[3] is yet another of Matisse's ways of identifying background and picture surface so that a sense of depth is provided by the same means that affirm the flatness of the work. It also gives the background a particularly important cohesive role in the design: the dark brown stands for negative space around the solid table, but because it is darker than the table, it also, paradoxically, presents itself as a kind of positive image that spreads and expands into the corners of the picture. Not only does this emphasize the velvety lightness the table seems to possess (by asking us to read the table as an intangible cut-out shape, almost as the absence of part of the more weighty dark field);[4] it serves to further open the whole surface to the perimeters of the work, which become an ineluctable part of the design without being specially emphasized in any way.

The shadowlike presences we see in the dark ground, particularly the foliage of linden trees at the top[5] and the garland of ivy at the bottom, do help to tie the image of the table to the perimeters of the work. They mainly serve, however, to echo the forms of the open-lattice basket and the apples on the table itself. The entwining ivy and the trinity of fruit, two of Matisse's familiar emblems of the Golden Age, ask us to see this painting as yet another representation of the paradisal garden. The presence of a similar table, still-life grouping, and surrounding vegetation in an early fifteenth-century *Paradise Garden* of the Cologne School (fig. 100) is of course but a happy coincidence,[6] for the rose marble table that Matisse painted was not an invented one but stood in his own garden at Issy and was pictured there on other occasions.[7] If Matisse's painting too "distills a world of delicate, sensuous perception,"[8] it was one that he had discovered in his immediate surroundings. From the time this painting was made, he turned increasingly to observed reality and found there the sense of calm and harmony that previously had to be drawn from his imagination.

Interior with a Violin Case. *Nice, winter 1918–19. Oil on canvas, 28¾ x 23⅝ in (73 x 60 cm). (C&N, p. 213)*

In the first five winter-spring seasons that Matisse spent in Nice, from 1916–17 to 1920–21, he lived there as a temporary visitor without establishing a regular place to stay. Even when he took larger and more luxurious rooms than hitherto at the Hôtel de la Méditerranée on the Promenade des Anglais in November 1918, and settled there for three seasons, he was apparently ready to leave at a moment's notice.[1] Nevertheless, from the time of the 1918–19 season he began to quell the restlessness of the preceding years. His manner of painting too began to settle into the characteristic Nice-period style. As Alfred Barr has noted, *Interior with a Violin Case,* painted at the Hôtel de la Méditerranée in the winter of 1918–19, "records the increased opulence of Matisse's style, its growing emphasis on rococo ornament and patterned surfaces, relieved in this picture by the violin case, the shining blacks of mirror and letter folder, and the sun-drenched blue of the sea."[2]

Matisse himself described this painting as a "study of light—the sentimental association [created] out of the light of the interior and exterior."[3] In May 1918, he had written to his friend Camoin of the beauty of the soft light of Nice,[4] and, comparing Gauguin and Corot, he noted that the use of firmly drawn contours produced a "grand style" but the use of halftones was "much closer to the truth."[5] At Nice, Matisse finally abandoned his own "grand style" in the search for greater truth to reality. Had he continued with it, he told an interviewer in June 1919, "I would have finally become a mannerist. One must always guard one's freshness, in looking and in emotion; one must follow one's instinct. Besides, I am finding a new synthesis . . ."[6] "For the moment," he said, "I work essentially with a black and gray, with subdued, neutral tones . . ." His earlier style had necessarily involved the sacrifice of some

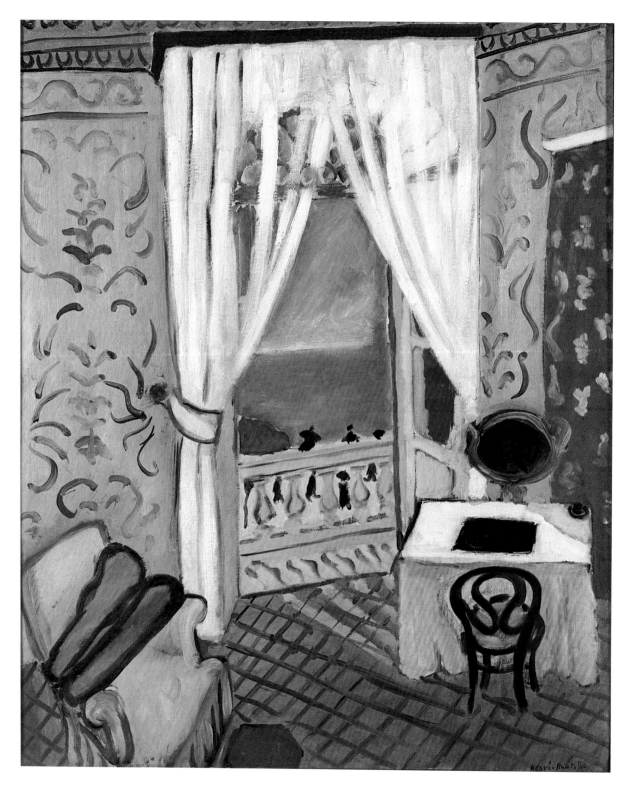

of the elements of painting: "substance, spatial depth, and richness of detail. Now I want to reunite all that, and think I am capable of it in the course of time."

The style that Matisse was creating was no longer "heroic" and avant-garde. In one basic way, however, nothing had changed. He had always sought to create a harmony of light. Previously it had been produced by contrasts of color; now color was submitted to light itself. "He underlaid and organized an entire canvas with light, which gradually took the place of color."[7] In the *Interior with a Violin Case,* all colors except black are dosed with white to produce the subdued, neutral tones to which Matisse referred. They join together as one luminous substance so that the room seems flooded with soft light. Matisse had always been as preoccupied with the spaces that flow around objects as with the objects themselves. In many of his paintings of the earlier teens, he had invested space with as dense and substantive a quality as the objects that inhabited it. At Nice, the equation was reversed: the objects often became as light and evanescent as the space in which they were suspended.

The function of the window is also reversed from what it was before. Instead of carrying the eye from interior to exterior space (or exactly balancing the two), it brings the light of the exterior into the room. The rose-colored stream of light that passes through the balustrade and the contrast of vivid white tabletop and pale viridian shadows around it obviously contribute to this effect, but so does the subtle perspectival displacement of the draped window itself, which advances that whole luminous zone toward the observer. Far from being simply carefree and relaxed, as Matisse's Nice-period work is sometimes claimed to be, the whole interior is atmospherically poignant in its soft, elusive colors and in the feeling of contemplative calm that it creates. Sight of the Marquet-like figures[8] on the busy Promenade des Anglais outside only accentuates the restful enclosure of the room, its silence, its emptiness, and also its artificiality. Over twenty years later Matisse still recalled with pleasure the "lovely Italian ceilings" of the hotel and the almost theatrical opulence of the "old rococo salon" he occupied. The light came into the room "from below like footlights. Everything was fake, absurd, terrific, delicious . . ."[9] The room as painted has indeed something of the sense of a stage set, but one from which all drama is deliberately excluded. As so often happens in Matisse's paintings of interiors, the artist himself is absent. Even his surrogate image, the violin, is missing from its sea-blue case, laid open upon the armchair in the foreground. But then the armchair too is a symbol of the soothing and restful effects that Matisse requires of his art[10]—effects that this painting beautifully provides.

The Plumed Hat. *1919. Pen and ink, 14¾ x 19½ in (37.2 x 49.4 cm). (C&N, p. 214)*

For many years, Alfred Barr was encouraged to believe that Matisse's painting *The Plumed Hat* would eventually enter the collection of The Museum of Modern Art. Indeed, the picture was one of the first color reproductions published by the Museum in 1939. *The Plumed Hat,* however, is now owned by the Minneapolis Institute of Arts, one in a constellation of twentieth-century works of extraordinary quality belonging to that museum.

In New York, the Museum is fortunate to have two drawings which relate to the painting: one was acquired by Abby Aldrich Rockefeller in 1928; the second was acquired almost fifty years later as the gift of The Lauder Foundation. Both are not in any sense preparatory studies, but belong to a score of sheets on the same motif that Dominique Bozo has described as "one of the most fabulous suites ever created by a draftsman."[1]

Except as an illustrator, Matisse was interested in form rather than in content. Frequently, obsessively but always with grace, he developed successive variations on a single theme. Matisse himself described such a series, which expresses and extends a range of mood and delineation, as "a motion-picture film of the feelings of an artist."[2] All sheets in *The Plumed Hat* sequence were drawn in Nice and from the same model, Antoinette.

Antoinette's hat is extraordinary. Mrs. Alfred Barr first saw it in the painting when it was shown in Paris in 1931. "I asked him where in creation he'd got that hat, so he laughed, welcoming the queston, and said he'd made it himself. He bought the straw foundation and the feathers and the black ribbon and put it together with pins on the

model's head. He said he had too much black ribbon, so that he had to stuff it into the crown with dozens of pins."[3] Matisse's accomplishment as a modiste need not astonish scholars of his work. Early in their marriage, and to support their family, Mme Matisse had opened a small millinery shop on the Rue de Châteaudun. She also served Matisse as frequent model, and he had certainly observed her at her own work.

Concerning his millinery creation, later and to Mr. Barr, Matisse added further and more precise details. "I worked very hard on that hat which I made myself with an ostrich plume, an Italian straw, and a multitude of black and blue ribbons called by milliners *la cométe*. The hat was done in such a way that one could wear it either by turning the back to the front or the front to the back. The latter as in my painting on a red background,"[4] the picture now in Minneapolis.

The sequence of drawings of Antoinette in the plumed hat (and once or twice without it) proceeds from its most realistic versions to those most free. Thus the Museum's vertical sheet is first in time, the horizontal second. Sometimes Antoinette wears a lace guipure elaborately detailed. This, however, is lacking in the Museum's two drawings.

Swedish connoisseur Ragnar Hoppe visited Matisse in 1920, just after the series had been completed. His account of that meeting has not previously been translated in English:

"'Take a look at this portrait of a young woman, with an ostrich-plumed hat. The plume is seen as an ornament, a decorative element, but it is also a material; one can feel, so to speak, its lightness, and the down seems so soft, impalpable, one could very well be tempted to blow it away. The fabric of the blouse is of a special kind; its pattern has a unique character. I want to express, at one and the same time, what is typical and what is individual, a quintessence of all I see and feel before a subject. You may think, as so many others do, that my paintings are improvised, put together accidentally and hastily. I am going to show you some drawings and sketches to enable you to better understand the way I work.'

"Matisse brought out a huge portfolio with about fifty drawings, all for the same portrait of a woman. On the wall were a couple of sketches in oil for the same painting; the finished one was in an art dealer's gallery.

"'You see here,' continued Matisse, 'a whole series of drawings I did after a single detail: the lace collar around the young woman's neck. The first ones are meticulously rendered, each network, almost each thread, then I simplified more and more; in this last one, where I so to speak know the lace by heart, I use only a few rapid strokes to make it look like an ornament, an arabesque, without

The Plumed Hat. *1919. Pencil, 21¼ x 14⅜ in (54 x 36.5 cm). (C&N, p. 214)*

losing its character of being lace and this particular lace. And at the same time it is still a Matisse, isn't it? I did just the same with the face, the hands, and all the other details, and I have naturally also made a number of sketches for the movements and the composition. There is a lot of work, but also much pleasure, behind such a painting. You can see for yourself how beautifully and firmly the hands rest in her lap. You may rest assured that I did not solve the problem so well at once. But the hands have to be held just so in order to be in harmony with the carriage of the body and the expression of the face. It was only little by little that it became clear to me, but once I was fully con-

Girl with Bouquet of Flowers. *1923.
Lithograph, 7¹⁄₁₆ x 10⁵⁄₁₆ in (17.8 x 26
cm). (C&N, p. 214)*

scious of it I could express my impression with the speed of lightning.'

"'Yes, indeed, this other drawing is bad, but I keep it anyhow, because, one day, I might learn something from it, just because I failed. One learns something every day, how else could it be? For instance, not until lately have I been conscious of the beauty of the color black, all it can give both as contrast and in itself. When you see my interior from Nice you will understand some of this. If the painting were here I would have liked to demonstrate it for you, but now it has to be some other time.'"⁵ W.S.L.

The Pink Blouse. *Nice, 1922. Oil on canvas, 22 x 18⅜ in (55.9 x 46.7 cm). (C&N, p. 214)*

In 1921, Matisse took an apartment on the Place Charles-Félix in Nice and finally established permanent quarters in the town. The paintings he made there in the early and mid-twenties consolidated the so-called Nice-period style. Working with a succession of favorite models, he created for himself a private world of *luxe, calme et volupté,* and domesticated the sensual and decorative pastoral theme that had informed much of his most important earlier

work. "In this mood of relaxation," Lawrence Gowing has written, "Matisse made his least obtrusive yet most intimately satisfactory discovery. The untroubled comfort of his own household was recognized as the very condition he had always sought in painting."¹ Observed reality itself now seemed to offer what previously had to be invented: a world of protective detachment, of sensuousness and calm. And as the subjects of Matisse's art became more intimate, so did its style. Fidelity to observed reality meant an analytical and realistic manner of painting. Its modernism often goes unnoticed, for it is unobtrusive.

The Pink Blouse was probably painted in 1922, since a charcoal-and-estompe study for the work, *Figure with a Scutari Tapestry* (fig. 103), bears that date.² Both show a model called Henriette whom Matisse retained longer than any other of his Nice-period models. She is also the subject of the lithograph *Girl with a Bouquet of Flowers.* Matisse seems to have been attracted to charcoal and estompe and to lithography in the early twenties because both media were particularly suited to investigating how his new preoccupation with tonal modeling could be reconciled with his longstanding concern for the decorative flatness of the picture surface. Both media ideally permitted him to create a wide range of soft, closely graded tones that appear to adhere to the flatness of the sheet,

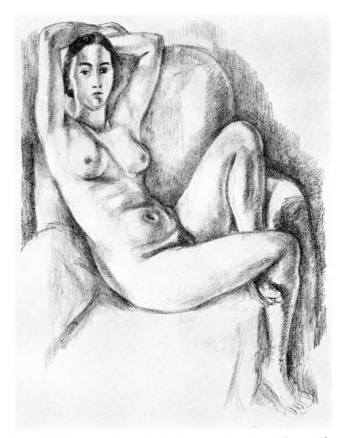

Arabesque I. *1924. Transfer lithograph, 19¹/₁₆ x 12⅝ in (48.5 x 32.2 cm). (C&N, p. 214)*

Seated Nude with Arms Raised. *1924. Transfer lithograph, 24¼ x 18¹³/₁₆ in (61.7 x 47.8 cm). (C&N, p. 214)*

and to release especially subtle effects of light from the luminous whiteness of the paper. The volumes thus created stayed "light" in feeling despite their solidity,[3] and it was this "light," disembodied sense of volume that he sought in his painting too. The figure in *The Pink Blouse* is modeled but is not heavily sculptural in effect. It is the eye that reads three-dimensionality in what is really a very discreet, almost bas-relief depiction of volume. The flattening of the figure between the patterned background that identifies itself with the upper part of the picture surface and the vertically lifted tabletop that identifies itself with the lower part assists this effect by compositional means. Without Matisse's reticent form of modeling, however, the figure could hardly be made to fit in the narrow pictorial space thus allotted to it.

The ambiguity of modeling that gives volume yet stays light and therefore relatively flat is matched by a similar ambiguity in the effect of color and in the overall mood of this painting. Although dominated by nominally sweet and satiating colors, *The Pink Blouse* also contains more subdued earth tones that temper the relaxed decorativeness of the work. Likewise the serene, prettily costumed figure reveals upon inspection such a frozen, introverted appearance that it too reinforces the bittersweet effect of the whole composition. The almost ironic visual tone in which this blandly pleasing subject is presented produces a curious psychological tension that is finally all the more telling for being given in such an unobtrusive way. Although at Nice Matisse "no longer attempted to work out new and 'heroic' solutions for the problems of flat painting, but relaxed into the arms of French tradition,"[4] as did a number of his contemporaries in the *rappel à l'ordre* of the 1920s, his measured, rigorous temperament continued to inform this newly intimate and lambent style.

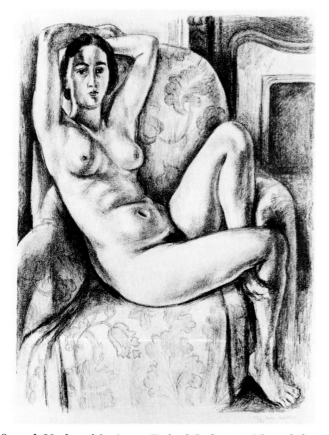

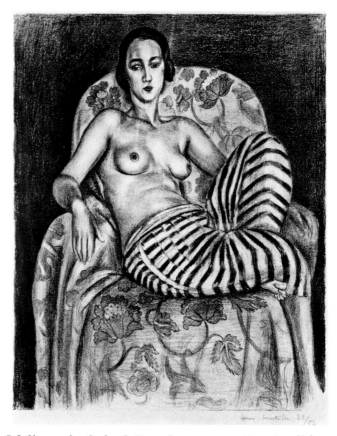

Seated Nude with Arms Raised before a Mantelpiece. *1925. Transfer lithograph, 25⅛ x 18⅞ in (63.8 x 48 cm). (C&N, p. 214)*

Odalisque in Striped Pantaloons. *1925. Transfer lithograph, 21½ x 17⅜ in (54.6 x 44.2 cm). (C&N, p. 214)*

Until the 1920s one characteristic of Matisse's drawings had not been incorporated in his prints. The artist often modeled his figures with shading, but, with the exception of his first lithograph on stone of around 1906, he used line exclusively in his prints. Beginning in 1922 Matisse endeavored to unite in his lithographs both the complete style of his drawing and most of the subjects that occupied him in painting. As he devoted much effort to drawing at this time, he was easily able to execute the shaded and elaborate transfer drawings without the erasures that would have obscured the clarity of the compositions. These drawings were transferred and printed on the press of Mme Duchâtel in editions of fifty.[1] Matisse also worked directly upon the stone during this period, and the litho-

graphs so produced naturally display stronger contrasts between the black ink and white paper. The subjects of these prints—and the regular production of between ten and twenty lithographs each year—suggest that Matisse's art had found a popular audience. Like the 1960s, the 1920s were a time when many artists were encouraged by astute dealers and publishers to make prints. Both Frapier and Vollard proposed to issue print albums, mainly of nudes, and Matisse produced works for them both.

It was, then, under such supportive circumstances that Matisse was able to create in printed form the commanding representations of his model Henriette that are considered by many to typify most significantly his style of this period. The three prints of a seated model with one leg raised are among several works with poses similar or identical to those in paintings of 1923–24 and the sculpture *Seated Nude* of 1925.[2] These transfer lithographs

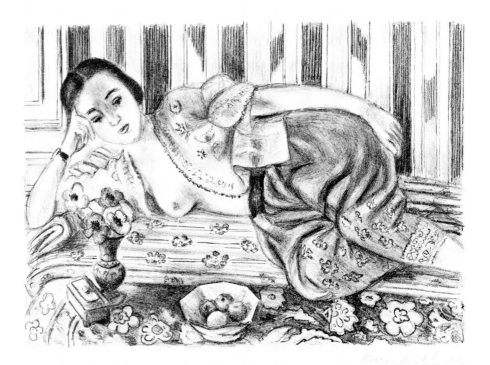

right: **Reclining Odalisque with Basket of Fruit.** *1925. Lithograph, 7½ x 10⅝ in (19 x 27 cm). (C&N, p. 215)*

below: **Sleeping Dancer on a Couch.** *1927. Transfer lithograph, 10¹⁵/₁₆ x 18 in (27.8 x 45.7 cm). (C&N, p. 215)*

126

Odalisque in a Tulle Skirt *1929*
Lithograph, 11¼ x 15 in (28.6 x 38.1 cm). (C&N, p. 215)

progress from the bright and lightly modeled *Nude in an Armchair* to a more complete composition with fireplace, added decoration, and heavier chiaroscuro (this the second state of the first-mentioned print) and finally to the *Odalisque in Striped Pantaloons,* which utilizes the same draped chair, with the model now in a relaxed pose. This last print, of 1925, is Matisse's masterpiece in his soft-crayon style, and part of its attraction is the particularly bold contrast of the contours of the model and chair against a densely filled-in background. At a time when the bright light of the French Riviera articulated most of his compositions, Matisse chose this manner of enclosing and strengthening what had successively become a more sensuous handling of form.

After the years of rigorous introspection that resulted in the torturously abstracted works of the war years, Matisse moved progressively toward more graceful and voluptuous subjects in the 1920s. In painting, color and light, pattern and flesh mingled to represent delightful aspects of the languorous Mediterranean environment. The proximity of Arab Africa, his memories of Morocco and Tangier (which he visited in the winters of 1911–12 and 1912–13), and the cosmopolitan quality of Nice itself served as increasing inspiration for the introduction of the odalisque as a subject for Matisse's art. The romantic fantasy of the harem slave was politely stated by the artist: "I do odalisques in order to do nudes. But how does one do the nude without it being artificial? And then, because I know that they exist. I was in Morocco. I have seen them."[3]

Swathing models in exotic clothing, veiling their faces and breasts in embroidered transparent material and emphasizing their torsos wth low-slung, ballooning harem culottes, Matisse gave a voluptuous aura to his carefully constructed compositions. Central to the prints of the 1920s was the element of completeness, for most of the works picture a model within a setting. Compositions now contained figures rather than merely representing them. Not only were there the usual chairs and couches, but Oriental objects such as a brass ewer and stove. Walls and floors were covered with floral and linear patterns that Matisse used to "suggest the form or value accents necessary to the composition of the drawing."[4] For the most part, the characteristic "still and heavy atmosphere of the seraglio" noted by William Lieberman pervades the lithographs of 1922–26.[5] Only occasionally did Matisse release a spare, linear drawing that recalled his earlier work and offered a similar vivacity.

More typical of his figure drawing, outside the elabo-

Reclining Nude. *1927. Pen and ink, 10⅞ x 15 in (27·7 x 32 cm). (C&N, p. 215)*

rately composed odalisque scenes, were the ten transfer lithographs of dancers issued in 1927 by Alvares for his Editions de la Galerie d'Art Contemporain. The introduction by Waldemar George was his second regarding Matisse's work (Matisse: Dessins was published in 1925; George's Picasso: Dessins, published in 1926, included Picasso's 1925 drawings of Diaghilev's Ballets Russes de Monte Carlo). For the most part the single figures of the lithographs are casually posed with few props to augment the diverse linear patterns of the dancer's bodice and tutu. Repose and contemplation rather than lethargy are the passive situations that Matisse revealed in his representation of normally active dancers. Barr supposed that the subject of a ballerina evolved from Matisse's renewed contact with the Diaghilev company during the new production in 1927 of Le Chant du rossignol (for which Matisse had created costumes and scenery in 1918).[6]

During the following two years Matisse returned to the odalisque and to the nude reclining upon carpets and cushions covered wth arabesques. The artist's two styles of lithography, developed during the twenties, are brought to their ultimate point in these last works (only a few lithographs were issued in the 1930s, although Matisse attempted to execute lithographs in 1934 for his illustrations of Joyce's Ulysses). The linear style, enlivened with patches of crayon worked sideways, often presents the type of contrived, awkward pose of the 1914 prints. Conversely, the heavy chiaroscuro that Matisse introduced for the first time in his prints in 1922 is used for a sort of illusory sculptural effect in his Odalisque in a Tulle Skirt and other 1929 lithographs that were directly drawn upon stone. It is evident that Matisse sought some means of conveying a sense of light and structure in his black-and-white works: structure through the articulation of linear motifs, light through strong contrasts of ink and paper. It is not incidental that each highly modeled print emphasizes the sitter's face, seeking out with surface light the "spiritual light that it reflects."[7]

The softened effect that results from extensive shading and/or surface patterning tends also to imply certain coloristic values. Matisse's work in his lithographs was a sort of obbligato to his concurrent production of painting and sculpture. One sees here and there references to specific compositions, formal questions resolved one way in print and another in painting. There is continuity in the several manners in which Matisse approached his various media in these last years of the twenties, but the keen focus that was inherent in earlier work seems to have become diffused to some degree. Voyages to Tahiti and New York released Matisse from a period of comfortable

Odalisque with a Moorish Chair. *1928. Pen and ink, 25¾ x 19⅞ in (65.4 x 50.5 cm). (C&N, p. 215)*

routine and little challenge. The Barnes murals and the etchings for Mallarmé's *Poésies* were the kind of disciplinary ballast that brought Matisse onto a course he followed for the next quarter-century. R.C.

Girl Looking at Goldfish Bowl. *1929. Etching, 3⅝ x 4⅞ in (9.2 x 12.4 cm). (C&N, p. 215)*

Because he approached drypoint and etching with the idea of achieving linear purity neither marred by cross-hatching nor devitalized by steelfacing, Matisse's work on copper or zinc plates in 1929 retained the clarity and direction that seemed dispersed in his lithographs of that year. At least 115 plates were printed in small editions on China paper exactly the size of the plate, applied during printing to a larger sheet (a technique more common in nineteenth-century lithography than in twentieth-century etching). China paper is not absorbent and retains the ink upon its surface—characteristics well suited to Matisse's thin, dry lines. The slightly grayish tone of China is uniform and serves as the equivalent of the thin residue of ink that is often left on the surface of plates during printing. This gray ground supports the slender lines, subtly enhancing their threadlike meanderings and providing a visual boundary for the compositions.

The subjects of Matisse's drypoints and etchings of the 1920s were, as in his work in other media, languishing sloe-eyed nude models, surrounded by accouterments of the harem environment that he used as a setting in his studio. He returned to the fascinating goldfish bowl as a motif, used again for contemplation and decoration. In the several etchings of the girl before an aquarium, the model's profile is correlated with the fish forms, the outlines of the face echoed by those of the fish within the bowl.[1] This contrapuntal suggestion in graphic terms is a natural one for an artist whose musical sensitivities were so well developed. Quiet watching might be the visual equivalent of listening, and the girls who dream in front of the magic goldfish bowls seem to communicate this sort of receptivity. On the other hand, the etched compositions of nudes with goldfish bowls utilize this favored object for totally decorative purposes. The play of lines within the bowl extends the floral details of carpets and wall hangings, while the bowl itself often fills an open area requiring a lively geometric form.

The models are viewed from unexpected angles and thus are transformed into decorations themselves. Those prints in which spare linearity is the prevailing mode are the most distorting of form, stretching the possibilities of interpreting mass and depth as well as recognizing physical specifics. In the drypoint plates, particularly in the group depicting a model in a caftan, the varying width and blackness of the undulating lines, as they travel around the sitter and across the background, create a sort of sensuousness that is more typical of Matisse's lithographs. However, there is a restraint in even these works that characterizes his efforts to create in the small format that he preferred for intaglio. The drypoints are generally the same size as his very first attempts in the medium around 1903. Only in a few etchings did Matisse begin to elaborate and enlarge the scale of his plates, creating a few works ten inches in height or width. This expansion prepared him for his full-page etchings for Mallarmé, but in single prints such largesse was not duplicated again until Matisse worked in aquatint in 1951. The larger etchings of 1929, however, represent a slow and clear development of Matisse's authority in printmaking. The compositions are exquisitely balanced, and while they lack the adventurous exploration of distortion that brightened some of the smaller plates, etchings such as *Woman in a Peignoir before a Mirror* are marvelous examples of Matisse's art of the twenties.[2] The fluent movement of lines in all directions, opening and enclosing form, detailing without obscuring, is so perfectly measured and weighed that a light-printed passage or a dark speck of ink in any area would impair the total equilibrium.

This fine symbiosis between subject, composition, and technique came at a moment when the world was quickly losing its hold upon its own weak equilibrium. Quite outside this day-to-day deterioration, Matisse nevertheless also ended his longest and most productive printmaking period in 1929. There is no question that he accomplished, in that final year, a great deal that would be fundamental in the creation of masterworks to come. Matisse evolved, during the mellow years of his first decade in Nice, a mature sense of the proportion of his subjects. Leaving behind most of the need to experiment or seek new forms, he seems to have brought together in the most harmonious manner what was significant for him. Certainly his etchings of 1929 unequivocally represent the most succinct statement of Matisse's midde age. R.C.

131

above: **Reclining Nude, Upside-Down Head, with Gold-fish Bowl.** *1929. Etching, 6⅝ x 9⅜ in (16.8 x 23.8 cm). (C&N, p. 215)*

opposite: **Reclining Nude, Upside-Down Head.** *1929. Etching, 4⅜ x 5⅞ in (11 x 14.9 cm). (C&N, p. 215)*

H. M

133

above left: **Seated Nude with Bracelets.** *1929. Drypoint,* $5^{13}/_{16}$ x $3^{15}/_{16}$ *in (14.7 x 10 cm). (C&N, p. 215)*

above: **Head, Fingers Touching Lips.** *1929. Etching,* $3^{15}/_{16}$ x $5^{7}/_{8}$ *in (10 x 15 cm). (C&N, p. 215)*

left: **Seated Hindu I.** *1929. Drypoint,* $6^{1}/_{16}$ x $4^{5}/_{16}$ *in (15.4 x 11 cm). (C&N, p. 215)*

Woman in a Peignoir Reflected in the Mirror. *1929. Etching, 10 x 6 in (25.4 x 15.2 cm). (C&N, p. 216)*

Alfred Cortot. *1926. Transfer lithograph, 15 x 15⅛ in (38.1 x 38.5 cm). (C&N, p. 216)*

John Dewey. *1930. Charcoal, 24⅜ x 19 in (61.9 x 48.4 cm). (C&N, p. 216)*

With the exception of his own self-portraits, single faces of other men seem unexpected in Matisse's art. Two are reproduced here, one of a musician, the other of a philosopher. The actual achievements of both sitters remain perhaps more memorable than Matisse's renditions of their likenesses.

Alfred Cortot, the pianist and conductor, was born in Switzerland in 1877. By the turn of the century he had already established his reputation as a musician in France and Germany. In 1920 he was cofounder of the Ecole Normale de Musique in Paris, and he remained its president and director until his death. He was best known for his chamber ensembles, and he also frequently wrote about music.

In megalopolitan Paris, Cortot knew many artists and was widely liked. As early as the winter of 1911–12, Picasso paid him tribute in a large, long Cubist still life showing an absinthe glass and bottle, a pipe, and various musical instruments resting on top of a piano.[1] In 1926 Cortot sat for Matisse. The portrait, a somewhat oversized and uncharacteristic image, was drawn on paper and then transferred to stone. The lithograph is among fifty prints by

various artists bequeathed to the Museum by Lillie P. Bliss in 1931.

In 1962 James Thrall Soby wrote to Pierre Matisse to thank him for another gift to the Museum, a charcoal by his father: "It really is a beautiful drawing and, though I never saw Dewey, I suspect it is a very good portrait. Of course, almost any drawing by Matisse would be welcome, but when a great artist does a portrait of a famous man the result is apt to have special attraction which this work certainly does."[2] The circumstances of the drawing may be of interest.

In 1930 Matisse had accepted an invitation to serve on the jury of the Carnegie International Exhibition of Painting in Pittsburgh. Matisse also visited the Barnes Foundation in Merion, Pennsylvania. Dr. Albert C. Barnes, his host and a great collector of his paintings, was particularly anxious to have Matisse decorate the walls of the central gallery of the Foundation, a commission which a year later the artist accepted.

Dr. Barnes also suggested to Matisse that he sketch John Dewey. Barnes had been inspired by Dewey's *Democracy and Education* and in 1917 enrolled as a "spe-

cial" student in Dewey's seminar at Columbia University. In 1925 Dewey was appointed educational director of the Barnes Foundation. Dewey, a decade Matisse's senior, was seventy-one years old when they met in New York. The drawing was intended to be a preliminary study for a lithograph. Another study is owned by the Fleming Museum at the University of Vermont. W.S.L.

right and p. 138: **Tiari.** *Nice, summer 1930. Bronze, 8 in (20.3 cm) h., at base 5½ x 5⅛ in (14 x 13 cm). (C&N, p. 216)*

After his journey to the South Seas in 1930, Matisse described his memory of a "Tahitian girl, with her satin skin, with her flowing, curling hair, the copper glow of her coloring combining sumptuously with the somber greenery . . . the almost suffocating scent of tuberoses and of that Tahitian flower the tiari tell[s] the traveler he is nearing that isle of thoughtless indolence and pleasure, which brings oblivion and drives out all care for the future."[1] The *Tiari* combines the two parts of this remembrance. Matisse sought to fuse the image of a tiari, or Tahitian gardenia (fig. 104), worn by the Tahitian women in their hair, with the shape of a woman's head.[2] The simplified oval of the head—which is also the center of the flower—with pistillike nose is therefore surrounded and surmounted by a group of petals or leaves—which are also bunches of hair—that grow from a smooth wedge of a stem fitted into the back of the smooth neck. The two stalks, human and botanical, combine to produce the same flower. It is an image unique in Matisse's sculpture for its punning ambiguity.

Inevitably, a connection with the double images of Surrealism has sometimes been made, especially since the purified organic volumes of the sculpture recall those that Arp began to make that same year.[3] There is a relationship between the organicist vocabularies of Matisse and Arp; not, however, in Surrealism, but in their common source in Art Nouveau and Symbolist art, which provided a number of twentieth-century artists with a vocabulary of basic elements evocative of growth, a vocabulary that could express an underlying natural order behind appearances. As interpreted in biomorphic Surrealism, this morphology was used to give internal mental images a universality that alluded to the natural world. Matisse's art, in contrast, was rooted in perception of the natural world. He worked away from his perceptual starting points, only, however, to "rejoin the first emotion" that shaped his perceptions,[4] an emotion which sometimes meant that he saw in terms of formal analogies. He did so most obviously in

the case of the *Tiari,* when he was particularly involved with Symbolist literature, reading Mallarmé and comparing his work to Gautier's and Baudelaire's,[5] but he had done so before, particularly in the early decorative period in the years around 1910, and did so again in many of the works made after 1930.[6] The *Tiari* is exceptional only for the overtness of its analogizing form.

Matisse also separates himself from Surrealist biomorphism—and also from Brancusi's work, to whose smooth forms the *Tiari* is sometimes related—in that the reference to the organic is made through the solid volumes of the sculpture and not through the inner events that volume can imply. If Brancusi's work is centripetal in conception—the artist paring away to reveal the simplest, most economical form—and Arp's is centrifugal—the work appearing to have grown from an internal nucleus[7]—then Matisse's is really constructional in basis; not in the sense of linear-planar constructivism, but in the sense of being constructed from an aggregation of solid mounds of clay that neither singly nor in combination provide the sense of a central core. The *Tiari* is a conglomeration of solid volumes.

The organization of the volumes owes much to the

137

painting was beginning to regain its decorative characteristics after the Nice period. It seems to be no coincidence that only in this time of transition around 1930 does the abstract purity of form and surface in Matisse's painting affect his sculpture to any considerable degree. Once again through sculpture he sought "to put order in my feelings and find a style to suit me."[12] It is to this search, rather than to external influence, that Matisse's approximation to traditional finish and use of smooth, poetic forms should be attributed. They may also have been provoked by the very subject of the work: by memories of the "satin skin" of the Tahitian girl he described to Aragon, and by "the copper glow of her coloring"; and also by a desire to recapture in sculptural form an image that would evoke the "indolence and pleasure" of his experience of the South Seas.

opposite and p. 140: **Venus in a Shell I.** *Nice, summer 1930. Bronze, 12¼ in (31 cm) h., at base 7¼ x 8⅛ in (18.3 x 20.6 cm). (C&N, p. 217)*

Matisse made two versions of the *Venus in a Shell,* the first in 1930, the second in 1932. The first is smoother, more holistic, and more sensual an image; the second (fig. 107) more rugged and aggressive, its parts more separately defined. Matisse's frequent alternation between opposite modes—cool and warm, feminine and masculine, restful and restless—in pairs of works using the same subject thus reappears in his last important sculptural study of the seated, crouching nude that had been a persistent motif in his work in this medium since 1908 (see p. 63).

The two Venuses bring to a conclusion a particular interpretation of this motif first established in the years 1923–25. In the Nice period of the languid odalisques, Matisse drew and modeled at the Ecole des Arts Décoratifs from a cast of Michelangelo's *Night* from the Medici tomb.[1] This was the starting point for a number of paintings and lithographs of figures in a half-seated, half-reclining pose, and for the sculpture *Large Seated Nude* of 1923–25.[2] A photograph taken no earlier than 1929 (fig. 109) shows Matisse working on a figure sprawled on a shell, a piece that is clearly a paraphrase of the *Large Seated Nude,* though more fluidly orchestrated than the earlier work.[3] That form of the pose, however, was abandoned. *Venus in a Shell I* lifts the figure to a firm, upright position and settles it more securely within the shell, which therefore functions as the base of the sculpture. Matisse had previously sought out the vertical dimension in a seated posture in the series of small crouching nudes

level of the abstractness realized in the Jeannette heads: the bold hair-leaf forms recall *Jeannette III* (p. 69) and the pistil-nose *Jeannette V* (p. 71). The general format, however, looks further back, to a small *Head with Necklace* of 1907; one version of the *Tiari* was given an actual necklace.[8] How it mainly differs from these sources is in giving up the vigor of affirmatively modeled surfaces. "The surfaces are almost neutral . . .," Jacques Lipchitz said of the *Tiari;* "the volumes are poetized to a sublime degree."[9] A number of sculptures from the late twenties prepare for the purified harmonies of this work, but none make harmony itself their virtual subject in the way the *Tiari* does.[10] It was the only sculpture he allowed to be translated into stone—evidence of his recognition of its special purity—and his son Jean carved a white marble version around 1934 which, as Albert Elsen points out, extends the reference to the white Tahitian gardenia in a highly evocative way.[11]

Worthy of note is the fact that Matisse opted for the poetic, the decorative, and the calm at the very time his

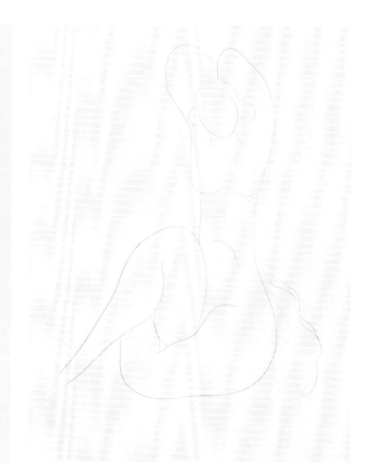

Page 147 from **Poésies** *by Stéphane Mallarmé. Lausanne, Albert Skira & Cie, 1932. Etching, 13 1/16 x 9 15/16 in (33.2 x 25.4 cm). (C&N, p. 217)*

of 1908 (p. 62). One of his persistent sculptural interests was not only to transmit weight directly down to the ground, thus freeing his figures from seeming to resist the effects of gravity; it was also to transmit movement out of the ground, to carry upward the growing stem of an arabesque or a spine to animate the different parts of the body. We see this in the *Serpentine* (p. 61) and in the series of Backs (pp. 73–79), the last of which is contemporaneous with *Venus in a Shell I* and shares its emphatic verticality.

The redefinition of the pose from the original state undoubtedly owes something to Matisse's *Upright Nude, Arms over Her Head* of 1927 and to the two small phallic torsos he made in 1929.[4] The smooth forms and surfaces of the 1927 sculpture, as well as its pose, are reprised in less abstracted a manner in the torso, elongated neck, and simplified round head of the 1930 Venus. The virtual absorption of the breasts in the two 1929 torsos and the erect eroticism of these sculptures are developed more ambitiously in the 1930 work. There is little, however, to pre-

pare us for the radical absorption of arms into head in the Venus. Only the *Reclining Nude II* of 1927 gives us a foretaste of it, and then only a partial one. Here, when the sculpture is viewed from the back, we see the shape of an opening bud apparently sprouting on top of a broad stem, itself rising from the enclosure of the shell. The sculpture seems to analogize vegetable growth.

A number of classical and contemporary renderings of the Venus in a Shell motif, from Hellenistic terra-cottas to Bourdelle's *The Birth of Venus* of 1928, have been suggested as possible sources for Matisse.[5] That late nineteenth-century integrated-base sculpture, Degas's *The Tub* of c. 1886, may also be profitably compared to Matisse's work—if only to point up the self-contained calm of the Matisse.[6] But there is another possible source for the

Pages 8 and 9 from **Poésies** *by Stéphane Mallarmé. Lausanne, Albert Skira & Cie, 1932. Etchings, 13¹/₁₆ x 9¹⁵/₁₆ in (33.2 x 25.4 cm). (C&N, p. 217)*

It was not until Matisse was over sixty that he began to illustrate books. His drawings had "ornamented" a book by Pierre Reverdy in 1918, but as they were of various periods and subjects it seems doubtful that the artist played a direct role in the publication. However, when Albert Skira approached him in 1930, Matisse was prepared to accept the problem of creating a book embellished with drawings that illustrated the subject.

From the beginning Matisse denied the subservience of the artist to the author, the illustration to the text. In France, publishers continually sought to illustrate their books with the works of well-known artists. Occasionally they were able to coax the artist to read the text and represent its themes and subjects. More often the publisher chose available works that would enhance the book but might have little if any relation to the text. Matisse's point of view allowed him both to accept inspiration from the text and to create without restriction. Only rarely is the word "illustration" appropriate to his work of this kind; the terms "decoration" and "embellishment" commonly imply a lower degree of creation, but Matisse perceived them otherwise. The delicate threads of etched line with which Matisse presents his contribution to Skira's *Poésies de Stéphane Mallarmé* offer the reader a series of visions parallel to those of the poet. It is as if the artist untangled all the italic letters of the poems and realigned them into forms equally rhythmic, evocative, and beautiful.

The Mallarmé volume with its twenty-nine etchings is the equivalent in intensity and artistic dedication of any major painting. Matisse made drawing after drawing to prepare his hand and eye for the severe simplicity of the etchings. With the determination of one who is compelled to succeed from the first onslaught, he measured the poetry and attempted to equal it without overwhelming it. When the artist's vision follows the poet's the etching carries the poetic image further than merely representing it. Every pictorial page is compelling in itself but also turns the eye toward the page of verse. Matisse compared the Mallarmé pages to the objects used by a juggler, principally to explain his attempt to balance black and white: "Let us suppose . . . a white ball and a black ball as well as my two pages, the light and shade so different but nevertheless face to face. In spite of the differences between the two objects, the art of the juggler makes them a harmonious ensemble to the eyes of the spectator."[1]

Matisse's second book was of a quite different character, executed under circumstances totally unrelated to

motif, and one that helps to explain its organic connotations. Matisse made the sculpture upon his return from a voyage to Tahiti. Describing his experiences there to his friend the poet Aragon, Matisse recalled how he had become interested in analogies between natural and human forms.[7] The sculpture *Tiari* (p. 137), also of 1930, is an acknowledged product of this interest; so too may be the *Venus in a Shell.* Discussing with Aragon the etchings of 1930–32 he was making for the *Poésies de Stéphane Mallarmé,* Matisse referred to a quatrain by Gautier from *Emaux et camées,* which he believed Mallarmé must have known.[8] It described a sculptural cloud rising into the blue sky like a naked maiden rising from the waters of a lake; and Matisse showed Aragon a photograph he had taken of a cloud at Tahiti from which he had made an etching of a nude that holds a pose identical to that of *Venus in a Shell* (p. 139).[9] Matisse made a number of drawings and prints using a similar pose.[10] The one that Matisse pointed out to Aragon (chosen to illustrate Mallarmé's phrase *la torse et native nue*), with a seated nude rising from a pedestal of clouds, combines the same sense of organic growth and erotic erection that we find in the sculpture. This same motif would be repeated, in further abstracted form, in another Memory of Oceania over ten years later (p. 168).

LE GUIGNON

u-dessus du bétail ahuri des humains
Bondissaient en clartés les sauvages crinières
Des mendieurs d'azur le pied dans nos chemins.

Un noir vent sur leur marche éployé pour bannières
La flagellait de froid tel jusque dans la chair,
Qu'il y creusait aussi d'irritables ornières.

those of the Mallarmé *Poésies.* James Joyce's *Ulysses* with etchings and drawings by Matisse was published as a deluxe offering for the members of the Limited Editions Club in New York. All the publications of the Club were the result of collaboration between specialized printers and well-known book illustrators. For the members, Arthur Rackham or W. A. Dwiggins would have been a more acceptable illustrator of finely printed volumes than any French painter. However, George Macy, the Club's director, hoped to represent as many types of illustration as possible and chose Pablo Picasso to illustrate *Lysistrata* and Matisse to illustrate *Ulysses.* The commentaries and interpretations regarding Matisse's knowledge of Joyce's text and his own appraisal of the publication are myriad.[2] *Ulysses* was not a book designed by Matisse, and the project has been misunderstood because of Matisse's published statements concerning the creation of some of his illustrated books. Like many other artists commissioned to illustrate Limited Editions Club publications, Matisse submitted several full-page plates as well as related drawings that might be used to augment the book's typographical design. The eventual decision to use Matisse's drawings as supplemental plates was George Macy's attempt to placate his conservative members who might not

understand the more abstract etched plates, and has led to the erroneous notion that Matisse had little if anything to do with the publication. On the contrary, Matisse did list *Ulysses* among his illustrated books, although it did not conform to his usual standards.[3] Matisse played Homer's *Odyssey* against Joyce's *Ulysses* in a deliberate intensification of the rather amorphous classical foundation of the twentieth-century epic. Joyce agreed to this interpretation and to the specific episodes Matisse had chosen.[4]

At the beginning of the project Matisse created the plates as lithographs. After attempting to complete three stones to his satisfaction he found that the printer was unable to provide him with the techniques he sought.[5] Matisse then turned to soft-ground etching, the most direct method (other than transfer lithography) that he could use. The images were drawn with pencil on paper over a prepared plate, the pressure of the pencil parting the soft substance covering the plate and exposing it for the etching process. The etchings have a soft, grainy appearance and relate quite clearly to other drawings of the period.[6] The two versions of Ulysses blinding Polyphemus well illustrate the sensitive evolution of Matisse's compositions. In this particular plate, one that has been commented upon for its unique brutality in the work of this

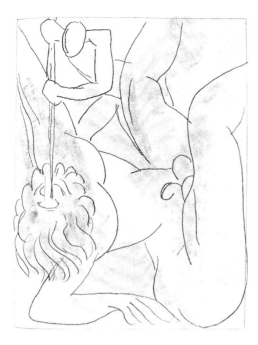

peaceable artist,[7] the published version has a finer balance of structure and color than the discarded plate, ameliorating somewhat the violent nature of the subject.

The confusion about Matisse's attitude regarding *Ulysses* hinges upon his often-published statement "How I Made My Books."[8] In this text, which appeared in 1946, the artist referred to his second book as *Pasiphaé* by Henri de Montherlant, published in 1944. In the sense that Matisse created his *Poésies* of Mallarmé by designing the total book, his *Pasiphaé* is the second of a type. For the first time he used linoleum cuts, which carried the images in relief, allowing the simultaneous printing of text and plates. Matisse not only cut the full-page plates but also cut initials and decorative elements. The white lines incised into the black ground of each plate provided a considerably different weight to the illustrations as they opposed pages of text, and the embellishment of the text pages with initials and head and tail pieces deftly offset this imbalance. As in the Mallarmé, Matisse created a set of visual accompaniments rather than episodic illustrations. Subjects that directly relate to the text mingle with the artist's habitual renderings of women. For the first time purely decorative elements, such as groups of undulating lines, serpentines, and stars, are plucked from their customary positions in Matisse's compositions and, in bands above and below, act like traps for the loose blocks of typography. These bands, as well as the red initials inserted at the beginning of many paragraphs, have been added for artistic reasons and only incidentally function as signals within the text. Martin Fabiani, one of the executors of Ambroise Vollard's estate and publisher of several illustrated books left unfinished at his death, not only issued *Pasiphaé* but acted as Matisse's official dealer during the war period.[9]

Two other publishers, however, dominated Matisse's book creations. Skira had tried to persuade Matisse to compile his memoirs. Failing to come to terms, the artist and publisher decided, instead, to work together on a selection of Ronsard sonnets, which was titled *Florilège des Amours de Ronsard*.[10] This second and last collaboration began during 1941, after the artist underwent major surgery in Lyons. Immediately upon completing his drawings for the Ronsard in 1942, Matisse set to work on the *Poèmes de Charles d'Orléans,* issued by the Greek publisher of *Verve* magazine, Ephstratios Tériade. Matisse had already designed two covers for *Verve*, and his second and third books for Tériade, *Lettres portugaises* and *Jazz,* were both published before the delayed appearance in 1950 of the Charles d'Orléans folio.

The odyssey of Matisse's Ronsard is carefully detailed by Skira,[11] but a short account of the vicissitudes involved in bringing out this illustrated book will explain something of Matisse's indefatigable creativity. Before he began his drawings Matisse had chosen a selection of poems

opposite left: **Blinding of Po-lyphemus,** *plate 3 from* **Ulysses** *by James Joyce. New York, The Limited Editions Club, 1935. Soft-ground etching, 11¾ x 9 in (29.8 x 22.9 cm). (C&N, p. 218)*

opposite right: **Blinding of Po-lyphemus,** *rejected plate for* **Ulysses** *by James Joyce. 1935. Soft-ground etching, 10⅝ x 8½ in (27 x 21.6 cm). (C&N, p. 218)*

right: Pages 26 and 27 from **Pasi-phaé, Chant de Minos** *by Henri de Montherlant. Paris, Martin Fabiani, 1944. Linoleum cuts, 12⅞ x 9¾ in (32.7 x 24.8 cm). (C&N, p. 218)*

aintenant, toi, approche, fraîchie sur des lits de violettes.

Moi, le roi aux cils épais, qui rêve dans le désert ondule.

moi, je vais rompre pour toi mon pacte fait avec les bêtes,

et avec les génies noires qui dorment la nuque dans la saignée

de mon bras, et qui dorment sans crainte que je les dévore.

Des sources qui naissent dans tes paumes je ne suis pas rassasié encore.

26

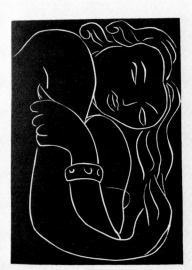

... fraîchie sur des lits de violettes...

from the 1578 edition of the *Amours.* Intending to make about thirty lithographs, he began by cutting up an ordinary edition and sketching in a scrap book of the pasted poems. Type was set and Matisse continued to draw on the proof pages. The Garamond type chosen proved unsuitable, and Skira eventually found a worn Caslon Roman type that was old and scarce. The type, once again set, seemed to inspire Matisse to create even more drawings. Matisse was supposed to supervise the printing in Zurich, but his poor health and the Nazi occupation of France delayed the project. When Skira was finally able to see the maquette it was 1946. The type again had to be reset and printed, and the lithographs were ready to print on the typeset sheets when it was discovered that the paper had discolored. The old type was no longer serviceable, and great efforts were made to find a substitute. Finally William Caslon's eighteenth-century molds were found and the type was recast. This delay provided time for Matisse to change thirty of the lithographs, so that the large pages of gray-tinted Arches paper eventually carried 126 lithographs. Alfred H. Barr, Jr., in relating this tale of "quixotic perfectionism," remarked: "The drawings, wonderfully free in style, sometimes extend almost the full height of the page or boldly spread across the sheet beneath the text without regard for margins. Matisse had absorbed himself in Ronsard's poetry; his illustrations . . . harmonize perfectly with the vernal grace of style and whimsically erotic sentiment of the sixteenth-century master (to whom even Queen Elizabeth paid homage)."[12]

The *Poèmes de Charles d'Orléans* (see p. 146), a folio volume, contains Matisse's only multicolor lithographs. The crayon drawings, for the most part devoted to variations of fleurs-de-lis, are very pale in tone and quite lyrical in comparison with the bold compositions Matisse created during the same period for *Jazz* (pp. 150, 151).

Tériade's third publication, but in fact the first to be issued, was the poignant *Lettres,* an edition of the work traditionally known as *Lettres de la religieuse portugaise.* This work comprises the love letters of the nun Marianna Alcaforado, published in the seventeenth century and often attributed to their translator, Gabriel-Joseph de Lavergne, Vicomte de Guilleragues. Matisse's volume was the result of several years' thought, coincident with the second round of work on the Ronsard maquette. The *Lettres,* embellished with fifteen portraits of the nun, appeared in 1946. There is a strong temptation to attribute Matisse's inspiration to his former nurse and model, Monique, who became Sister Jacques-Marie in the mid-forties. Certainly his friendship with her must have helped him understand more intimately the circumstances of his character. His model, however, was a fourteen-year-old Russian girl named Doucia whose features underlie the progressively more harrowed and benumbed face of the nun whose love was unrequited.[13] Each of the letters is

PETIT nombril, que mon penser adore,
Et non mon œil, qui n'eut oncques le bien
Que de te voir, et qui mérites bien
Que quelque ville on te bastisse encore.

Signe amoureux, duquel Amour s'honore,
Representant l'Androgyne lien,
Et le courroux du grand Saturnien,
Dont le nombril tousjours se rememore.

N'y ce beau chef, ny ces yeux, ny ce front,
Ny ce beau sein où les fleches se font,
Que les beautez diversement se forgent,

26

Ne me pourroient la douleur alenter,
Sans esperer quelque jour de taster
Ton compagnon, où les amours se logent.

right: Pages 26 and 27 from **Florilège des Amours** *by Pierre de Ronsard. Paris, Albert Skira, 1948. Lithographs, 15 x 11 1/16 in (38.1 x 28.1 cm). (C&N, p. 218)*

below: Pages 24 and 25 from **Lettres portugaises** *by Marianna Alcaforado. Paris, Tériade, 1946. Lithographs, 10 5/8 x 8 1/4 in (27 x 21 cm). (C&N, p. 218)*

de vostre cœur, et de vostre fortune ; sur tout, venez me voir.

A DIEU, je ne puis quitter ce papier, il tombera entre vos mains, je voudrois bien avoir le mesme bonheur : Hélas ! insensée que je suis, je m'apperçois bien que cela n'est pas possible. Adieu, je n'en puis plus. Adieu, aymez-moy toujours ; et faites-moy souffrir encore plus de maux.

prefaced by a page of drawings of leaves and pomegranates printed in purple. The text is also embellished with fruit and flowers as well as initials that parallel the decorative vegetation in form and feeling. The decorated pages are among Matisse's most beautiful.

The abundance of book illustration that flowed from the hand of Matisse during the 1940s derives from several special circumstances, not the least of which was the impact of World War II. The changes in Matisse's household that were due to his resolve to remain in southern France had long-term repercussions on his life and work. We have seen how the inevitable isolation of occupied France thwarted the production of Ronsard, yet prolonged the artist's attention to the theme. Inevitably this situation provoked further work that was possible in the confinement of his home. Moreover, this home was not the environment of habitual occupancy, but hotel rooms in the Régina in Cimiez from 1938 to 1943. During this time, from January to May 1941, he was confined in a hospital in Lyons after two operations, and spent much of the following year fighting various infections. He was, after all, in his seventies, but his creative energies overcame all adversities. He was able to draw at all times during his completely bedridden periods and during the many sleepless nights. These prolonged periods of drawing continued at Vence in his villa, Le Rêve, which he occupied in 1943. Still, the war impinged on his work. Although he had the satisfaction of seeing his *Pasiphaé* in print during the occupation in 1944 because his publisher had an exceptional relationship with the Vichy government, he was burdened with the unknown fate of his estranged wife, who was imprisoned, and feared for his daughter, who was about to be deported for her work in the Resistance.

The year 1944 was a significant one in the history of Matisse's book production for another reason. He had decided to decorate Baudelaire's *Les Fleurs du mal*. As was his habit, he drew his compositions, a series of thirty-five heads, on lithographic transfer paper. Unfortunately, it was summer and the grease crayon dried in the heat. The normal antidote used by the printer, dampening the sheets overnight, led to their stretching and thereby warping the images when they were transferred to the stones. Matisse at first attempted to redraw the images, but the initial vision had deserted him, although he was anxious to rescue the project. Eventually his second attempt resulted in an album of *Twenty-three Lithographs* published in an edition of five in 1946. The book *Les Fleurs du mal* was published in 1947, with thirty-three plates made from photographs of the transfer drawings taken before they were damaged, one etching, and sixty-seven ornamental drawings made into wood engravings. His

Frontispiece (page 6) from **Lettres portugaises** *by Marianna Alcaforado. Paris, Tériade, 1946. Lithograph, 10⅝ x 8¼ in (27 x 21 cm). (C&N, p. 218)*

concentration upon heads, reflecting occasionally but not specifically the subjects of Baudelaire's verse, was Matisse's fundamental expression in drawing for the years 1941–47. Matisse had determined that portraits of models and friends functioned better to illuminate the writer's ideas and expression than any other image. He wrote: "It is not what one generally expects for illustrations of this poet. One could easily imagine a series of more or less tormented legs in the air."[14] After his work on Baudelaire, Matisse continued his portrait-illustration with Reverdy's *Visages* (published in 1946 and containing fourteen lithographs) and Rouveyre's *Repli* (published in 1947 and containing twelve lithographs, half of young women and half of the author). His last effort in this vein was made in 1954 when he drew twenty-eight heads for John-Antoine Nau's *Poésies antillaises,* issued posthumously in 1974.[15]

Pages 26 and 27 from **Poèmes de Charles d'Orléans.** *Paris, Tériade, 1950. Lithographs, 16⅛ x 10⅜ in (41 x 26.3 cm). (C&N, p. 218)*

Matisse peopled his books with the thousands of faces that filled the vacant spaces of his older years; and yet, for the most part, the heads of the forties are as much abstract line drawings as representations. The arabesques enlivening the pages of text that intervene between these portraits are as personal as any one portrait. It is perhaps this continuity of form pervading all of Matisse's books that lifts even the least of them to a plane above so-called book art. His love of the poetry or prose that filled the texts he chose to embellish had to be foremost in order to have motivated such a profound dedication to each project.

R. C.

Lemons against a Fleur-de-lis Background. *Nice, March 1943. Oil on canvas, 28⅞ x 24⅛ in (73.4 x 61.3 cm). (C&N, p. 218)*

The fleur-de-lis emblems of royal France which dominate this painting are also the persistent motifs of Matisse's illustrations for the *Poèmes de Charles d'Orléans.* The frontispiece for that book, a portrait of the fifteenth-century lyric poet who spent twenty-five years in captivity after Agincourt, was drawn in the same month as this painting, March 1943. The book, perhaps Matisse's most lighthearted and informal, is also his most elaborate. Most

of it is filled with a profusion of ornamental motifs complemented by a facsimile of the artist's transcript of Charles d'Orléans's poems. A few pages with illustrations, mostly portraits, interrupt this sequence. A similar kind of counterpoint between allover decorative imagery and specific realistic representations characterizes the painting too. Another version of the work (fig. 110) shows the opening of the illustrated book above the pot of forget-me-nots. A just-visible rectangle in that area in The Museum of Modern Art's painting shows that Matisse considered using a similar motif for this work too. Matisse took up the Charles d'Orléans project just before leaving Nice. Although the war in general was beginning to turn in the Allies' favor, Nice was threatened by bombing, and soon after completing the *Lemons against a Fleur-de-lis Background* Matisse moved to Vence. "It isn't possible to look at this picture," Louis Aragon wrote (and Matisse approved this interpretation), "without remembering the date when it was painted, without understanding how, in his own way, through the medium of painting Matisse uttered his own protest, or rather his assertion of French hopes."[1]

It may also be seen as an assertion of personal hopes. In early 1943, Matisse was completing his long period of recuperation after a serious operation in January 1941. This was a critical moment in Matisse's career. Since the early thirties, he had by and large abandoned the description of objects in space characteristic of his paintings from c. 1918–29 and turned to the denotion of objects as ideational signs. His paintings of the thirties and early forties became flatter and more abstracted than hitherto as the creation of imagery from a blending of drawing and color in light was replaced by a counterpoint of spontaneous surface drawing and areas of saturated color. Eventually this separation of drawing and color came to bother Matisse, and from the period of this painting he began to turn his energies to paper cutouts so as actually to draw in color with his scissors. (The first important cutout project, *Jazz,* was begun within weeks of the completion of this painting.) The sense of a whole surface of color this painting provides, and of the objects and signs as placed flatly against the surface, relates both to the preoccupations of the thirties and to those developed in the cutouts. The dominance in area allowed to the pink field is fairly unusual in Matisse's art at this time. This in particular anticipates the single-colored fields of many of the cutouts on which forms appear to float free of the constraints of gravity, as they also do in this work.

Here, however, the elements of the still life appear to float on the mantelpiece because Matisse compresses the space between the fireplace and wall by painting these

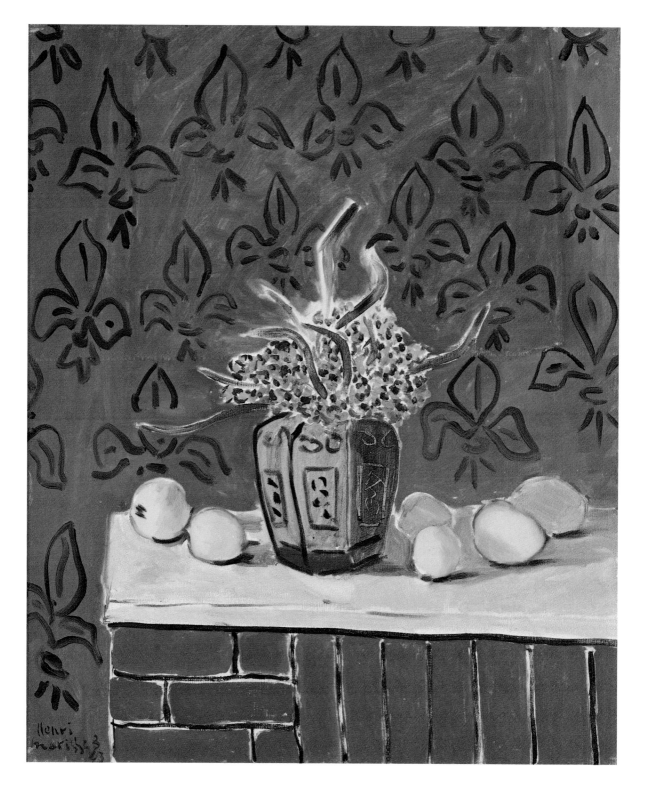

147

areas with the same thinly washed pink. (Matisse described the pigments he used in a diagram, fig. 111, he made of the painting for *Verve* in 1945.) The pink of the fireplace was the local color (Matisse himself had designed it using rose-colored bricks), but the walls of the room were covered with beige burlap.[2] The Chinese vase appears in a number of Matisse's works around this time. Lemons, of course, were among his favorite motifs, and look back to paintings as early as the *Lemons and Bottle of Dutch Gin* of 1896 (p. 24). Vividly contrasted against the flat pink ground, the elements of the still life cast shadows on the beige marble mantelpiece to create a zone of volume and solidity within the enveloping flatness, but a kind of solidity apparently without weight.

Self-Portrait. *1945. Crayon, 16 x 20¾ in (40.5 x 52.5 cm). (C&N, p. 219)*

Did Matisse smile? Rarely, if one is to believe the many photographs that record his likeness. In his own painting self-portraiture is not a continuing theme. Representations of himself occur more frequently in his drawing, and in series, particularly after the mid-1930s. He also drew on stone a few lithographs of himself, sometimes intended as gifts to certain members of his family and to his few close friends.

When Alexander Liberman visited Matisse in 1949, he was immediately impressed by the master's presence, and by his beard: "His was no ordinary beard. It had been trimmed and shaped with a profound knowledge of form; it was a form in relation to other forms. . . . The bristles moved and intelligent eyes showed behind the rims of the glasses. Those eyes were haunting. Small, in relation to the enlarged features of the face, they were magnetic in their

grip. They penetrated, even intimidated. They were the eyes of a bird. As very old people sometimes do, he viewed with discernment all outside manifestations—a knowing, questioning, quizzical appraisal."[1]

The Museum is fortunate in owning two late self-portraits—similar to each other, though different in technique. They eloquently illustrate the rhythmic possibilities of drawing in outline. Without modeling, line alone describes contour. Both sheets are the same size, and they were drawn within a few days of each other. World War II had just ended, and Matisse was able to pay a brief visit to Paris early in the summer.

The horizontal likeness in graphite shows the artist with a pencil clutched tightly in the fist of his left hand. Individual details of the head, when isolated, bear little semblance to anatomical reality, but, as Matisse at that very time insisted, "exactitude is not truth."[2] The other drawing, in pen and ink, is one of a pair drawn on June 11. The pose, the ear, the spectacles, and the pipe vividly recall a portrait of Matisse painted by Derain forty years before in Collioure, where they spent the summer of 1905.[3]

Matisse's observations on art are always relevant. In 1908 he spoke about drawing: "One must always search for the desire of the line, where it wishes to enter or where to die away. Also always be sure of its source; this must be done from the model. . . . Depressions and contours may hurt the volume. If an egg be conceived as a form, a nick will not hurt it; but if as a contour, it certainly will suffer. . . . Remember, a line cannot exist alone; it always brings a companion along. Do remember that one line does nothing; it is only in relation to another that it creates a volume. And do make the two together. Give the round form of the parts, as in sculpture. Look for their volume and fullness. Their contours must do this. In speaking of a melon one uses both hands to express it by a gesture, and so both lines defining a form must determine it. Drawing is like an expressive gesture, but it has the advantage of permanency. . . . No lines can go wild; every line must have its function. . . . Do remember that a curved line is more easily and securely established in its character by contrast with the straight one which so often accompanies it. The same may be said of the straight line. If you see all forms round they soon lose all character. The lines must play in harmony and return, as in music. You may flourish about and embroider, but you must return to your theme in order to establish the unity essential to a work of art. . . . Ingres said, 'Never in drawing the head omit the ear.' If I do not insist upon this I do remind you that the ear adds enormously to the character of the head, and that it is very important to express it carefully and fully, not to suggest it with a dab."[4] W.S.L.

Self-Portrait. *1945. Pen and ink, 20½ x 15¾ in (52 x 40 cm). (C&N, p. 219)*

Horse, Rider, and Clown, *plate 5 from* **Jazz.** *1947. Pochoir, 16⅝ x 25⅝ in (42.2 x 65.1 cm). (C&N, p. 219)*

The cut-and-pasted colored papers for *Jazz* represent a renaissance in Matisse's creative activity. The brilliant book that resulted from the artist's first sustained attention to this manner of working is itself a landmark in the history of printing. Matisse's attitude toward the illustration of books as decoration became clarified as he appropriated the tools of the decorator, sketching with scissors in the actual colors, arranging and pinning shapes until the pieces of each "decor" became a perfect whole. He considered the process of creating these *découpages* to be the unification of color and drawing in the same movement.[1] For the book the cutouts were "reproduced" by using the same Linel paints that colored them; the uneven coverage was retained by painting through stencils.[2] The resulting compositions lost the slight dimensionality of the maquettes, but the flat abutment of shapes and, more particularly, the precise meeting of colors were, for future developments in art and particularly in print-making, a considerable accomplishment. At its publication Matisse was extremely disappointed, considering the book "absolutely a failure."[3] He found the *découpages*, once transposed into printed form, to be like jigsaw puzzles—achieving exactly that characteristic which later in-

fluenced the "hard edge" painters of the 1960s. Two months after its publication Matisse began to accept some of the virtues of the work, explaining that ". . . for anyone who has not seen the originals, what the book itself imparts is the thing that counts. . . . According to the newspapers, and from what I've heard from various sources, this book has had considerable impact on painters, who see color and drawing brought together without, for all that, a canceling of the often delicate feeling."[4]

Matisse's decision to add his own text in bold handwriting was another important stage in his development. Rounded, serpentine black script rolling across the white pages heightened the radiant effect of the colored plates. The two strong elements in Matisse's work, brilliant color and flowing black line, met in a fresh juxtaposition that soon afterward formed the basis of his decoration for the Rosary Chapel at Vence.

It has been thought that Matisse's presentation of his text in handwriting rather than type is due to the influence of Picasso. Before World War II Picasso had collaborated with Paul Eluard in the creation of a single etching, *Les Yeux fertiles,* which incorporated the poet's handwritten text and the artist's surrounding illustration on one plate (certainly not the first occurrence in print of this type of collaboration). During the war, Picasso spoke of issuing his own writings with illustrations

un moment
di libres.
Ne devrait-on
pas faire ac-
complir un
grand voyage
en avion aux
jeunes gens
ayant terminé
leurs études.

54

Icarus, *plate 8 and page 54 from* **Jazz** *by Henri Matisse. Paris, Tériade, 1947. Pochoir, 16⅝ x 25⅝ in (42.2 x 65.1 cm). (C&N, p. 219)*

in a similar form, but his *Poèmes et lithographies* was not completed until 1954. It may be that by 1946, when Matisse wrote his "accompaniment to my colors,"[5] he had seen the handmade book produced by Eluard and Picasso in 1941 titled *Divers Poèmes du livre ouvert.* The artist and writer had worked together to produce fifteen copies, each handwritten by Eluard and embellished with bright abstract watercolors by Picasso. Evidently the pages were colored first by Picasso and then written upon, a work of love and patience carried on during the bleak war period. Tériade, the publisher of *Jazz,* was planning to publish a text by Pierre Reverdy with marginal decorations by Picasso in 1946 (*Chants des morts,* published in 1948). This book also paired handwriting with color, but there is no way of knowing if the publisher himself promoted this form to both artists (it was clearly a means of avoiding costly typesetting charges as well as coping with the paucity of complete type fonts after the war). Tériade, noting the success of *Jazz,* certainly encouraged Fernand Léger to write his own text by hand for *Cirque* (1950).

Jazz consists of twenty plates, each preceded by several pages of text that, Matisse explains in the preface, have a purely visual function. The subjects of the text, rendered as quite personal reflections, run from the artist's belief in God to comments upon the airplane (which appear next to the image of Icarus). He directly refers to lagoons, the subject, according to Matisse's drawn table of illustrations, of three abstract compositions. In his conclusion he writes: "The images presented by these lively and violent prints came from crystallizations of memories of the circus, of popular tales, or of travel," and there are ten plates that have definite circus or theatrical references. There is a portrait of the wolf from *Little Red Riding Hood* that Matisse referred to in his notes to the publisher as "the better to eat you with, my child."[6] The purest image is that titled "Forms," which Matisse called *poses plastiques,* a double-page decoration of two torsos, one pale on a dark ground, the other in opposite tones. This work evidently was a substitute for another circus subject, Nini Casse-Cou and Joseph Casse-Tout.[7]

The imagery of *Jazz* evolved from many earlier works, isolating formerly subsidiary forms and thereby rebalancing and refining their contours. The falling dancer from *The Dance,* his project for the Barnes Foundation (the maquette for which was one of the earliest uses by Matisse of cut paper), eventually became the sole figure in the *Jazz* plate *The Toboggan.*[8] The leaf forms that surround *Pierrot's Funeral* and *The Knife Thrower* figure impor-

151

H. Matisse
47

tantly in the background of several paintings of the late 1930s[9] and become the dominating motif for the chapel at Vence. Cutting these forms over and over again and putting them together into rectangular compositions, Matisse created a vocabulary of signs abstracted from nature that could, like a hieroglyphic language, tell many stories. *Jazz,* a title that has led to much speculation about its choice, means music to most of us, and this meaning must have inspired its use. However, a Frenchman might recognize its similarity to a word in his language (*jaser,* to gab). Questioning his motives in the first line of *Jazz*— "Why, after having written: 'he who dedicates himself to painting, let him begin by cutting out his tongue' need I employ other media than my own?"—Matisse indulges us (and himself) in a little *jaserie.* In choosing to speak to the reader directly Matisse created his most autobiographical work. The vibrating cyclamens, blues, and yellows cut into so many scintillating syllables curiously engage one in a sort of syncopated rapprochement with the artist. R.C.

Dahlias and Pomegranates. *1947. Brush and ink, 30⅛ x 22¼ in (76.4 x 56.5 cm). (C&N, p. 220)*

In February 1949, Pierre Matisse held at his gallery in New York an exhibition that for the first time gathered together paintings, scissors-cut drawings of colored papers, and drawings in black ink, created by his father since 1945. In its entirety, the exhibition revealed an exuberant vitality, audacious in experiment and dazzling in effect.

Included was *Dahlias and Pomegranates,* a drawing of 1947, which was reproduced as the cover of the exhibition catalog and also served as a poster. Unlike the other black-on-white drawings in the exhibition, which represented studio interiors, *Dahlias and Pomegranates* is simply a close-up of a still life. The sheet is not completely covered, and its contraposition of black and white is the boldest and least cluttered in the sequence.

After acquiring *Dahlias and Pomegranates* for the Museum, Alfred Barr wrote: "The drawings of 1947–48 are not only closely related to the paintings of the period in motifs—interiors with flowers and fruit—but rival them in scale and power. In fact they are quite unprecedented in Matisse's graphic art . . . Early in his career Matisse had used brush and ink for sketching but since that time his drawing had been largely confined to pencil, crayon, charcoal and stump or pen and ink. The *Dahlias and Pomegranates* is a simpler subject than most of these big drawings but it will demonstrate the certainty with which Matisse wielded his big brush.

"Without the benefit of the millennium-old, exquisitely disciplined tradition of Far Eastern brush-and-ink painting behind it, the *Dahlias and Pomegranates* would doubtless seem brash and unsophisticated beside a Sung or Ashikaga still life. Yet the modulation of the ink and the spotting of blacks suggest the rhythmic vitality which Hsieh Ho, about the year 500, pronounced the first principle of good painting."[1]

Besides *Dahlias and Pomegranates,* the Museum unfortunately owns only one late drawing by Matisse, *The Necklace.* It was brushed in the spring of 1950 when the artist was eighty. Like the earlier still life, it displays the complete mastery of black on white, of negative and positive, which throughout Matisse's career served as self-imposed and disciplined relief, a necessary alternate to the heritage of those paintings which had established him securely as this century's greatest colorist.

The Necklace displays an authority of instinct that says no earlier drawing could be more Fauve. In less than thirty broad, assured strokes of a thick brush, Matisse quickly defines the head, arms, and torso of a standing nude. With some dozen more jabs of his brush he creates

The Necklace. *1950. Brush and ink, 20⅞ x 16⅛ in (52.8 x 40.7 cm). (C&N, p. 220)*

her necklace; and how vividly animated is the passage where the fingers dance with the beads! However, Matisse made one stroke too many. Not without amusement, Lester Avnet, the donor of the drawing, liked to point out that Matisse had whited out the navel of the nude.

The Necklace can be studied with Matisse's aquatints of the same time. In these the artist used the sugar-aquatint technique, also taught to Picasso, to reduce into heraldic designs, more fluid but with fewer strokes, masks and faces of friends.

 W.S.L.

Maquette for red chasuble (front). Nice, 1950–52. Gouache on cut-and-pasted paper, 52½ in x 6 ft 6⅛ in (133.3 x 198.4 cm). (C&N, p. 221)

"In 1952, when I last saw Matisse in his studio at Nice," wrote Alfred Barr shortly after Matisse's death, "there were a score of the chasuble designs spread out on the walls like gigantic butterflies [fig. 113]. I could easily understand Picasso's enthusiasm for them. They seemed to me among the purest and most radiant of all Matisse's works."[1] These chasubles were the last items that Matisse designed for the Chapel of the Rosary of the Dominican Nuns at Vence, an addition to the convalescent home known as the Foyer Lacordaire, close to his villa, Le Rêve, where he lived from 1943 to 1949. After having first become interested in designing windows for the chapel, late in 1947, Matisse then, early in 1948, offered his services as designer for the entire project and personally underwrote a considerable part of the costs of construction.[2] His work on the Vence chapel engaged most of his creative energies in the period 1948 to 1952. He considered it "in spite of its imperfections . . . my masterpiece."[3]

That Matisse chose to design a chapel at all, let alone talk of it as "the ultimate goal of a whole life of work,"[4] created considerable controversy at the time, and it was suggested that this artist who had devoted his life to representations of sensual pleasure had undergone a conversion to Catholicism.[5] In Matisse's published statements about the chapel, however, he scrupulously avoided making reference to his own personal beliefs, and on at least one occasion expressed annoyance that the work had become "nothing more than a pretext for gossip."[6] Although he had long before talked of "the so-to-speak religious feeling that I have toward life"[7] and occasionally spoke of the creative process as a kind of divine possession,[8] he never in his adult life held any specific religious beliefs. Before his work at Vence he had completely avoided religious subject matter. When originally asked by Brother L.-B. Rayssiguier, the architect of the chapel, to consider treating a specifically religious theme, "a Virgin, for example," he replied: "No, I do not feel such subjects . . . when I paint something profane, God directs me, and it goes beyond me. If I tried to make a Virgin, I would be forcing."[9]

Matisse's decision to undertake the design of the chapel may be attributed to two factors, one personal, the other artistic. The personal reason was that he originally discussed the chapel with a Dominican nun staying at the Foyer Lacordaire, Sister Jacques-Marie, who had nursed him during his convalescence after a serious operation in 1941; and he saw in the chapel project a way of expressing gratitude to the Dominicans. The artistic reason Matisse himself explained: "For a very long time, I wanted to synthesize my contribution. Then this opportunity came along. I was able, at the same time, to do architecture, stained glass, large mural drawings on tile, and to unite all these elements, to fuse them into one perfect unity."[10]

Matisse had long been interested in the theme of a

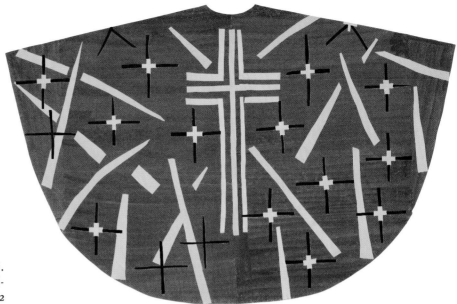

Maquette for red chasuble (back). Nice, 1950–52. Gouache on cut-and-pasted paper, 50½ in x 6 ft 6½ in (128.2 x 199.4 cm). (C&N, p. 221)

harmonious total environment. A number of his important paintings had been dedicated to that subject, notably the large decorative interiors of 1911 but also many of the Nice-period pictures. Since the early 1930s, he had become particularly interested in the possibility of creating such environments in literal and not merely depicted form. The Barnes murals of 1931–33 provoked this renewed interest in what Matisse called "architectural painting," whose aim, he declared, should be to animate interior space and give it "the atmosphere of a wide and beautiful glade filled with sunlight, which encloses the spectator in a feeling of release in its rich profusion . . ."[11] When he spoke of wanting the Vence chapel to be a spiritual space that would arouse "feelings of release, of obstacles cleared . . . where thought is clarified, where feeling itself is lightened,"[12] he was talking not from a new religious impulse, but from a long-standing belief in the therapeutic properties of his art. As Lawrence Gowing has noted, "Matisse thought of his paintings as actually emitting a beneficent radiation"[13] and on several occasions left them in friends' sickrooms in the belief that they would aid recovery. It was appropriate that when he finally built his beneficent environment it was attached to a convalescent home.

When Matisse wrote that the Vence chapel was created "toward the end of the course that I am still pursuing by my researches" and that "the chapel has afforded me the possibility to realize them by uniting them,"[14] he had specific researches in mind. As his assistant, Lydia Delectorskaya, has explained, "Matisse's artistic activity was divided at that time between two modes: large drawings made with a thick brush and India ink, which covered all the walls of his studio, and compositions of cut-out gouache-painted paper, which were hung on the walls of his bedroom. He envisaged the Chapel scheme as a chance to combine these two modes with which he was then concerned."[15] From the drawings developed the ceramic-tile murals, and from the cutouts the windows and chasubles. In a manner rather like that of the *Jazz* project (discussed p. 150), his "principal aim was to balance a surface of light and colors against a solid wall with a pattern of black on white."[16] In this scheme, the contrast of the priests' colored chasubles against the black and white habits of the nuns echoed the similar contrast afforded by the windows and murals of the architecture. As mobile objects the chasubles additionally "bridge the gap between the chapel as a structure and the chapel as a setting for the performance of cultic rites."[17]

The Vence chapel is important not only as Matisse's most realized form of a total luminous environment, but for consolidating paper cutouts as his major medium of expression in his last years. He first used paper cutouts in the early 1930s as a mechanical aid in fixing the imagery of the Barnes murals and of subsequent paintings and as a form of maquette for magazine-cover designs. It was only

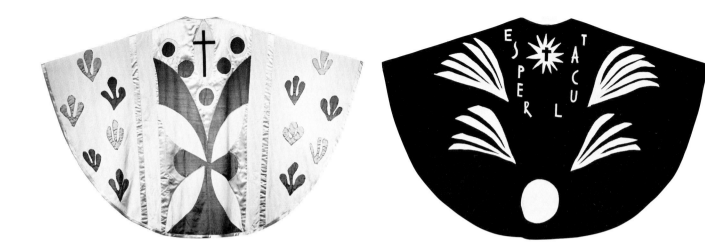

White chasuble. (Front.) Designed Nice, 1950–51; executed 1951. White silk with yellow and green appliqué, 49 in x 6 ft 6½ in (124.4 x 199.4 cm). (C&N, p. 220)

Black chasuble. (Front.) Designed Nice, 1950–52; executed 1955. Black crepe with white crepe appliqué, 51 in x 6 ft 4 in (129.5 x 193 cm). (C&N, p. 220)

during recuperation after his 1941 operation that, bedridden, he began to find distinct potential in the cutout technique in its own right, and in 1943–44 produced his first major cutout project, the designs for *Jazz*. Matisse began to develop extensively a repertory of images in small-scale cutouts. Although in 1946 he made two pairs of large, far more ambitious works using this medium, it was only during work on the Vence chapel that cutouts came so totally to satisfy his artistic ambitions as actually to supplant all other forms except drawing. In 1950 he made his last sculpture, in 1951 his last painting. It was during the 1950–52 period of his work on the chasubles, therefore, that the paper cutout became Matisse's sole medium for major expression; and so it remained until his death in 1954.

Before working on the chasubles, Matisse had never designed anything whose iconography, as well as size and shape, was a matter of established convention. He followed his adviser on liturgical matters, Father Marc-Alain Couturier, in establishing certain basic design principles: utilizing only the six prescribed liturgical colors—white, green, violet, red, rose, and black—as the grounds for the set of six chasubles, each of which was required for a specific occasion or period of the Church calendar;[18] working within the large semicircular shapes that Couturier himself had reintroduced into vestment design; and using symbolic rather than representational imagery.[19] These were all principles which Matisse's own concern for sim-

plicity readily accommodated. Although Couturier certainly advised Matisse on the meaning and appropriateness of particular symbols (as well as of colors), neither motifs nor compositions were prescribed. While working on the chasubles, Matisse insisted that he could not make use of "signs that never change"[20] and created his own individual interpretations of conventional liturgical symbols, a number of which in fact he had already explored in secular works. The plant and leaf forms in several chasubles certainly derive from cutouts of the 1940s. The palm-cum-flame images in the green chasuble relate to images in some of the very earliest cutouts.[21] Equally, certain symbols first used in the chasubles were subsequently developed in contemporaneous and later nonreligious compositions. For example, the butterfly forms and geometrically divided field of the violet chasuble reappear in the 1951 cutout *The Wine Press*.[22] There are, nevertheless, specific liturgical meanings attributable to all of the symbols Matisse used, and the iconography of each chasuble was developed in accordance with recognized emblems appropriate to the festivals and periods of its intended use.[23]

The paper cutout was a particularly appropriate medium for creating the symbolic imagery that the chasubles required, since it had developed as a way of best producing what Matisse called pictorial "signs." Since the time of his first theoretical statements about his art in 1907 and 1908, he had talked of wanting to express in the simplest

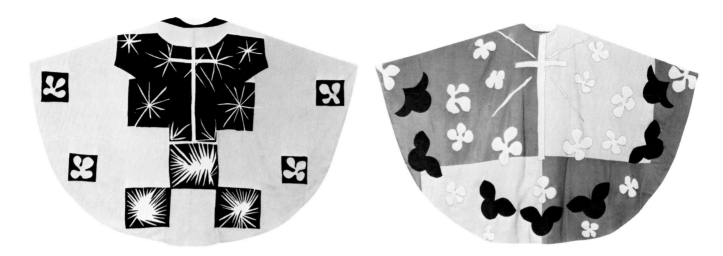

Green chasuble. (Front.) Designed Nice, 1950–51; executed 1955. Green silk with black velvet, white and yellow silk appliqué, 50¼ in x 6 ft ¼ in (127.7 x 187.4 cm). (C&N. p. 221)

Violet chasuble. (Front.) Designed Nice, 1950–52; executed 1955. Violet silk in two shades with green and blue silk appliqué, 52⅛ in x 6 ft 1¾ in (132.4 x 187.4 cm). (C&N, p. 221)

and most economical way possible the "essential character" of an object.[24] This he came to describe as its "sign." In creating such a sign with color, he had long felt that color must not "simply 'clothe' the form: it must constitute it"[25] if the sign was to seem whole. This was finally achieved by "drawing with scissors on sheets of paper colored in advance, one movement linking line with color, contour with surface."[26] "The cut-out paper," Matisse said, "allows me to draw in color. It is a simplification. Instead of drawing an outline and filling in the color—in which case one modified the other—I am drawing directly in color, which will be the more measured as it will not be transposed. This simplification ensures an accuracy in the union of the two means."[27] The cutouts allowed him to create "form filtered to the essentials"[28] such as we see in the scissored signs for palm leaves, halos, fish, stars, and crosses in the chasubles.

In all, Matisse made twenty-two individual cutout maquettes, from which he chose twelve to serve as front and back designs of the six chasubles. He did not begin work

on them until late in 1950, when all other aspects of the chapel design had been resolved,[29] since only the white set needed to be completed in time for the dedication of the chapel on June 25, 1951. The designs for the remaining chasubles were not all finished until 1952. Matisse selected the fabrics for the chasubles himself and supervised both their dyeing and final manufacture by the Dominican Sisters of Les Ateliers des Arts Appliqués at Cannes. The white set proved to be too heavy when used. The Museum of Modern Art therefore arranged to obtain it in exchange for commissioning a lighter replacement for use in the chapel, while at the same time acquiring the maquettes for the red chasuble and accouterments. Subsequently, the Museum arranged through Matisse the commission of a set of the remaining five chasubles. Of these, the unfinished rose chasuble was produced from a design that Matisse eventually replaced when he finalized the set for the chapel.[30] The designs of the Museum's set and of the set in use at Vence, the only ones in existence, therefore differ in this single respect.

157

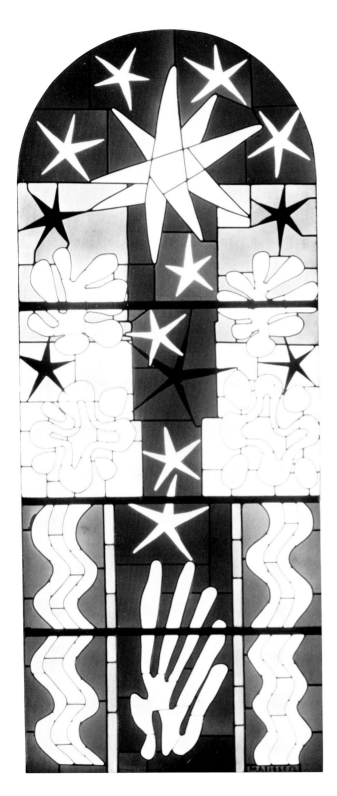

Nuit de Noël. *Paris, summer–autumn 1952. Stained-glass window fabricated by Paul and Adeline Bony under the artist's supervision. Metal framework: 10 ft 11 in x 54¾ in x ⅜ in (332.5 x 139 x 1 cm). (C&N, p. 224)*

In the period 1950 to 1952, while working on the Vence chasubles, Matisse started making larger and more ambitious independently conceived cutouts than he had done previously; the medium came to absorb most of his creative energies. He also eagerly accepted a number of commissions, from designs for a carpet to book and magazine covers, that could be prepared by using cutouts. Thus in 1951 he completed the *Mimosa* rug design for Alexander Smith Carpets in New York (fig. 124) and prepared cover designs for Alfred Barr's book, *Matisse: His Art and His Public* (p. 160), and for an exhibition catalog of his work at The Museum of Modern Art (p. 161).[1] Having enjoyed making the windows for the Vence chapel, he became particularly attracted to designing for stained glass and in the last four years of his life undertook a number of commissions for stained-glass windows. These fall into two general groups: designs that belong with a series of vertical cutouts of 1950 to early 1952, where images are disposed on top of a gridlike arrangement of colored-paper rectangles; and those of 1953, where the imagery is laid out across an open ground, as also in Matisse's large mural decorations of that year.[2] *Nuit de Noël,* the final work in the series of vertical gridded cutouts, is probably the best-documented of all Matisse's works in this medium, largely because he had color photographs taken to evaluate his progress; they allow us a fascinating insight into the way the cutouts were made.

On January 15, 1952, after preliminary negotiations, *Life* magazine formally commissioned Matisse to design a stained-glass window.[3] By January 17 he had laid out the basic elements of the paper cutout design, working directly on the wall of his bedroom at the Hôtel Régina, Nice (fig. 125).[4] In making each of his cutouts, Matisse used two distinct processes: first, the spontaneous "drawing with scissors" to create individual images or "signs"; and second, a more deliberated process of composing the preformed signs on the pictorial surface. Since making the maquettes for *Jazz* in 1943–44, his principal compositional method had been to relate one or a few signs to a single background rectangle of approximately the same size as that from which a sign was cut; then, when he wanted to produce larger works, he combined sets of the sign-containing rectangles in pairs, friezes, and (increasingly often) upright grids. In many works, each sheet seems to have been independently completed before being brought together with its family members. In *Nuit de Noël,* however,

as presumably in other commissioned works with pre-scribed dimensions, the organization of the background rectangles preexisted the applied imagery.[5] In the January 17 state, the containing shape of the work is rectangular, organized by matching blocks of color down each side and capped by a T shape in ultramarine. These ground colors were little changed in the development of the work,[6] which principally involved a continual adjustment of the applied imagery. At this early stage, the large star with three leaf forms below already establish the basic theme of the work as a Christmas Eve sky over a landscape of organic shapes.

By January 30 the rounded window top was established and each rectangle of the composition had been allocated its individual sign (fig. 126). The three original leaf forms are no longer there. Two of them were made into small independent cutouts, evidence of the flexible interaction between different works the cutout method allowed.[7] They are replaced by fuller-shaped, more curvilinear leaves, which better complement the small spiky stars that have appeared around the larger one—in part a reprise of the front design of the green chasuble, used in the Christmas season. In addition, two diagonal-cross stars have been introduced in the lower section of the work, but Matisse was obviously dissatisfied with this area, for by mid-February all of the signs below the foot of the ultra-marine T shape were replaced (fig. 127). In making this change Matisse significantly altered the allover symbolism of the work, and we see here, even more than in the chas-ubles, how Matisse reinterpreted Christian iconography in the light of his own particular iconographic concerns.

Although the pair of open white leaf forms (replacing black ones) on the cadmium-yellow grounds at the center of the work simply redefine the organic meaning of that section, everything below them is no longer organic but now aquatic: a large algae form at the center with smaller algae surmounted by wave images at each side. The cutout has now three zones—sea, earth, and sky—and these are reinforced in the definitive version of the work, which had been reached by February 27 (fig. 128). The smaller algae have been removed to become independent works,[8] the wave forms enlarged, and the horizontal strips Matisse has added accentuate the effect of three zones. Moreover, by carrying the blue of the sky right down the center of the work, he not only affirms a continuity between the two nonearthly zones, but clarifies the pictorial organization

Maquette for **Nuit de Noël.** *Nice, January–February 1952. Gouache on cut-and-pasted paper, 10 ft 3 in x 53½ in (312.8 x 135.9 cm). (C&N, p. 224)*

Design for jacket of **Matisse: His Art and His Public** *by Alfred H. Barr, Jr. Paris, September 1951. Gouache on cut-and-pasted paper, 10⅝ x 16⅞ in (27 x 42.9 cm). (C&N, p. 224)*

by suggesting a top-to-bottom movement down the sides too.[9] This strengthens the force of the symbolism as we read down the strata from blue sky to green and yellow earth to wine-dark sea.

Most of Matisse's cutouts explore the kind of elemental imagery we see in *Nuit de Noël*. The vast majority of his small-scale works in this medium use leaf and vegetable forms. His first two large-scale cutout projects, of 1946, were pairs of panels dedicated to sky and sea.[10] The series of vertical gridded cutouts of 1950–52 to which *Nuit de Noël* belongs includes the similarly stratified *Beasts of the Sea* (1950) as well as a number of compositions of leaves, algae, vegetables, and fish.[11] Increasingly, the cutouts became for Matisse a way of presenting on a large scale an idealized picture of the natural world, a picture that also functioned as a rich, luminous environment. Color in the cutouts, Matisse said, is the expression of light.[12] Hence his interest in the stained-glass window, which, he said, "is an orchestra of light."[13]

Matisse kept *Nuit de Noël* in his studio until at least March 19, 1952,[14] presumably in case he wanted to make yet further changes, and it was photographed there beside the yet unfinished *The Parakeet and the Mermaid* (fig. 129). It was later turned over to Paul Bony, the stained-glass craftsman who had made the Vence chapel windows, and the window was executed during the following four months. On December 8, 1952, the window arrived in New York and was displayed in the reception center of the Time-Life Building at Rockefeller Center in time for Christmas Eve.

"I had it at home for two days [before it left for New York; see fig. 130]," Matisse wrote to Alfred Barr on December 4, 1952, "which allows me to assure you that it is a success. It will be exhibited during the Christmas holiday at Rockefeller Center. If you have a chance to see it, you will agree with me that a maquette for a stained-glass window and the window itself are like a musical score and its performance by an orchestra." In June 1953, both the window and the maquette were given to The Museum of Modern Art by *Life* magazine. Writing to Barr on August 24, 1954, to acknowledge receipt of installation photographs of the works at the Museum, Matisse repeated his observation that the maquette was like a musical score and the window its orchestral performance. He had previously spoken of his use of a restricted color range (such as comes about with the pure unmixed gouaches of the cutouts) as "like music which is built on only seven notes,"[15] and of each color as having its own particular expression or voice.[16] The metaphors are particularly apt: since color is conceived as light and the stained-glass window as an orchestra of light, the maquette is its notation and individual colored images the musical notes.

This is not, however, to say that Matisse viewed the cutouts as mere patterns. Even those he made expressly

Design for cover of **Exhibition: H. Matisse.** *Paris, September 1951. Gouache on cut-and-pasted paper, 10⅝ x 15¾ in (27 x 40 cm). (C&N, p. 224)*

as maquettes he valued as independent works in their own right. They have an analogous relation to the finished commissions, as do his early painted *esquisses* to their more finished counterparts; and Matisse indeed used this method of describing them with special reference to *Nuit de Noël*.[17] Moreover, in his letter to Barr of August 24, 1954, Matisse affirmed the quite different status of each work by asking that they not be exhibited side by side lest viewers assume that the differences between the two works were due to faults in execution. Matisse never sought to imitate the appearance of the material into which a cutout

was to be translated. He had supervised the creation of the *Nuit de Noël* window from the maquette and was well aware that adjustments in design were necessary when transposing from one medium into another. The window itself is importantly different from the maquette in that the units of composition are no longer single spontaneously cut images, but interlocking leaded panes that join imagery and ground far more firmly than in the cutout design. Also, of course, the sense of luminosity that the cutout provides is made literal in the window itself.

narrative manner.[15] There was, therefore, for Matisse far less of a methodological division than usual between making and placing of images. The very composition of the work is an extension of the image-making process. Additionally, the distinction between image and ground that characterizes most of Matisse's other cutouts is subverted here, because the ground on which images are placed is part, and sometimes the whole, of the imagery itself. The very restrictions this form imposed thus served to open the work to the kind of internal surface development characteristic of Matisse's painting but missing, with few exceptions, from his other mural-size cutouts. These, in contrast, seem far more outward-looking, more situational and architectural, appearing to project their frontal imagery into the viewer's space.[16] Although *The Swimming Pool* is physically by far the largest of the cutouts, and also the most explicitly environmental, it escapes this situational quality because it does not confront the viewer to invite his complicity as the large decorations do. Its self-generating internal narrative guarantees its pictorial independence and carries it beyond the parameters of decoration. In presentation, it is neither a painting nor a mural decoration, but has a marvelously ambiguous status between the two forms—yet a fully independent status for all that, with not a hint of compromise involved.

Despite the continuity of the white band, we are asked to interpret sections of its length in different ways, according to the different postures the bathers assume. At times we are looking down into the pool, at others we are close to the surface, and at yet others we seem to be seeing the pool in cross section. Figures are presented from above, from the water itself, and from the side. Because of the organic nature of the composition, there is no sense of division between the different views. Nevertheless, the implicit visual warp of the white surface caused by the changes in viewpoint is part of the keen spatial tension of the work. This modification and pictorialization of the empty white surface by the drawing of the blue shapes is further accentuated by the way in which the composition develops. It is not certain in which order the various figures in *The Swimming Pool* were made. The very first image to be cut may well have been the one, immediately adjacent to the left of the doorway, for this was published in 1952 as an independent cutout.[17] However, the devel-

Completed in this way, it became therefore not only a garden of fruits and plants and parakeet, but also an underwater garden that looks back to his earlier use of aquatic imagery, and forward to *The Swimming Pool*. The first dramatic swimmer in *The Swimming Pool* (it follows the starfish and dolphin on the right-hand section of the work) was a modified form of the mermaid from the preceding mural.

The Swimming Pool complemented *The Parakeet and the Mermaid* on the walls of Matisse's apartment. *The Parakeet and the Mermaid* was made in the daytime in Matisse's bedroom; *The Swimming Pool* in the dining room, Matisse working on it only at night.[12] One is multi-colored, the other confined to blue and white against a beige ground, originally that of the dining-room walls. Whereas the format of the earlier work evolved only gradually and its specific components were finalized only after much trial and error, the basic conception of *The Swimming Pool* was established from the start. The individual figures were developed sequentially, but Matisse clearly began with the whole general scheme in his mind since his first act was to stretch the large band of heavy white Can-

son paper around the entire room.[13] On this depends first of all the great drama and exhilaration of the work.

"Shouldn't a painting based on the arabesque be placed on the wall, without a frame?" André Verdet had asked Matisse when discussing the cutouts. "The arabesque is only effective," Matisse replied, "when contained by the four sides of the picture." But he added a rider: "When the four sides are part of the music, the work can be placed on the wall without a frame."[14] In *The Swimming Pool,* the containing edges are indeed part and parcel of the whole design; the bathers leap in and out of the long rectangular strip, its taut whiteness stretched out like an elastic band. Its narrowness, whiteness, and geometry serve to accentuate the energy, and even at times abandon, of the freely contoured blue forms.

By first establishing the friezelike white band, Matisse also created the conditions for a new, far more organic method of composition than exists in any of the other cutouts. The position and shape of each image were dictated by the images preceding it on the unrolling panorama, with the result that the work appears to grow internally, one image generating the next in an almost

The Swimming Pool [La Piscine]. *Nice, summer 1952. Two-part mural. Gouache on cut-and-pasted paper mounted on burlap, 7 ft 6⅝ in x 27 ft 9½ in (230.1 x 847.8 cm) and 7 ft 6⅝ in x 26 ft 1½ in (230.1 x 796.1 cm). (C&N, p. 224)*

The Swimming Pool is by far the largest of Matisse's cutouts, with a total length just short of fifty-four feet. It is also his most ambitious, being a summation of some of the most important themes, both formal and iconographic, of his artistic career. Its importance is emphasized by the fact that it was not produced in response to a specific commission, as were nearly all of his mural-size cutouts, but was made for himself as an independent pictorial work to decorate the walls of his dining room at the Hôtel Régina in Nice (fig. 131).[1] Confined either to his bed or to a wheelchair, Matisse covered the walls of his apartment with groups of cutouts that together created the atmosphere of an idealized and lyrical natural world brought indoors. In the two largest cutouts of 1952, this environmental impulse was the motivating force behind the works themselves. Matisse referred to *The Parakeet and the Mermaid* (fig. 135) as "a little garden all around me where I can walk."[2] Of *The Swimming Pool,* he said, "I have always adored the sea, and now that I can no longer go for a swim, I have surrounded myself with it."[3] Each of these works served to re-create for Matisse the sense of equilibrium and of sheer exuberant pleasure that he had found in his reactions to the natural world, and brought to an audacious conclusion his long-standing concern with the harmonious and decorative interior environment.

A proper appreciation of the special place occupied by *The Swimming Pool* among Matisse's cutouts requires some knowledge of the works which preceded it in 1952. That year saw the finest of his cutouts; in the sheer number of important works produced, it was one of the richest of Matisse's career. It is, however, a year in which his stylistic development is far from self-evident, because of the often quite different character of the works produced. It has often been assumed that Matisse's art in 1952 followed two separate, parallel paths: one initiated by the series of seated Blue Nudes, culminating in *The Swimming Pool;* the other, launched with his work on *The Parakeet and the Mermaid,* which finally led to the large decorative murals of 1953. Although there were indeed two general developments that year, the two paths did interrelate; the way in which they did was important for the genesis and for the meaning of Matisse's grandest cutout work.[4]

The year opened with *Nuit de Noël* (see pp. 158–59), which was completed on February 27. It was followed by *Sorrow of the King,* which, unlike the vast majority of the cutouts, gives the appearance of a "painting" in paper.[5] The cutouts had now supplanted painting in Matisse's art but had hitherto largely been conceived within the modalities of decoration. Matisse now seemed to be looking for ways in which to invest them with certain qualities that had traditionally belonged to his paintings, notably the possibility of empirically developing imagery as part and parcel of the creation of the whole surface composition. This was something that the distinctive two-part cutout process—of image formation followed by image arrangement—did not easily allow. Matisse also seemed to miss in the decorative cutouts one of his favorite subjects, the human figure. While working on *Sorrow of the King* (completed toward the end of March), Matisse began to lay out the openly dispersed pattern of leaf forms that eventually became *The Parakeet and the Mermaid,* and cut the sign for the parakeet, almost certainly the first of his blue cutout images of 1952.[6] He also, however, began work on *The Negress* (fig. 136), attempting to create a figure composition using the same open displacement of discrete images on a white ground he was employing for *The Parakeet and the Mermaid.* This use of a white ground, initiated in 1952, may be understood as an attempt to address the surface as a whole from the start, rather than composing by means of an accretion of colored rectangles as in the preceding large-scale cutouts. The turn to the human figure may be interpreted as deriving from Matisse's wish to bring to his most advanced cutout method the figurative imagery used in *retardataire* fashion in *Sorrow of the King.* Matisse, however, was clearly dissatisfied with the progress of *The Negress* and temporarily abandoned it sometime in early April,[7] while he investigated in smaller works how the human figure could best be treated in cutout form. These were the series of four seated Blue Nudes.[8] Their sculptural connotations have often been noted: Matisse's scissors provide their contours with a remarkable sense of implied volume.[9] The sculptural connection has an additional implication. Matisse used to turn to sculpture, he said, "for the purpose of organization, to put order into my feelings and to find a style that suits me."[10] The sculptural Blue Nudes were made in exactly this spirit.

They spawned a whole series of similar works in April and May, a number of which were tried out in *The Parakeet and the Mermaid* in the corner finally occupied by the mermaid.[11] However, Matisse was not satisfied with them in this context, and probably at the beginning of June returned to the image of the dancer (the subject of *The Negress* and of one of the figures in *Sorrow of the King*). The cutouts *Acrobats* (fig. 137) and *La Chevelure* established the dramatic gestural form. A variation on these works produced the mermaid to complete the large mural.

opment of the work seems to begin at the far end of the section to the right of the door.[18] As it develops around the room, whiteness itself starts to give the bathers their shape. Increasingly, their contours are opened and their forms separated to admit white, which comes to stand not only for the water in which they swim, but for parts of their bodies too. Matisse here resolves what *The Negress* had begun: the absorption of even so psychologically holistic an image as the human figure into its surrounding space.

We see this process gradually taking hold of the composition as it develops across the first, right-hand section. It begins with self-contained and firmly silhouetted images of increasingly vigorous form. Reading from right to left, we see a starfish, a dolphin, then the profile swimmer with arched back developed from the mermaid of *The Parakeet and the Mermaid*. Following and below this is a more ambiguous shape, possibly another dolphin, or perhaps an enlarged seahorse image.[19] Then, above the small fish, we see a highly abstracted sign for another arched-back swimmer, reminiscent in some respects of the women being lassoed in *The Cowboy* plate from *Jazz*.[20] Next comes

a swimmer (or possibly a mermaid; witness the pointed tail-cum-feet) with knees bent up, and then a back-diving figure, the only image for which Matisse modified the edge of the white band to enclose its silhouette. It is at this point that the swimmers begin to be absorbed into the white ground. Within this section, however, there is as yet functional justification for the encroachment of the white. In the side-stroking figure (one of the most obvious moments at which the vantage point is changed), the blue shapes denote the parts of the swimmer above the water. In the final figure of this section (preceded by a wave notation like those in *Nuit de Noël* and a jellyfish like those in *Oceania: The Sea* of 1946),[21] the breaking of the forms is explained by the splash created as the figure drops into the water. This bather apparently caused Matisse some difficulties and took him a very long time to make.[22] It is interesting that here, for the first time (excepting the previous stylized wave), parts of the water as well as of the figure are rendered in blue shapes, thus beginning the newly dramatic interaction of image and ground that is further developed in the second half of the work.

Photographs of *The Swimming Pool* in Matisse's din-

ing room (figs. 131–34) show it divided by another cutout, *Women and Monkeys* (fig. 138), in a recess above the doorway. The women had originally been made in the context of *The Parakeet and the Mermaid*,[23] but were opened up from the relative compactness of their earlier state (fig. 139) —which suggests that they were redesigned to complement the effect of *The Swimming Pool*. *Women and Monkeys* may have been completed and positioned as soon as the first section of *The Swimming Pool* was made. More likely, however, it awaited the completion of *The Swimming Pool* before its design was finalized.[24] In any case, Matisse's use of a continuous silhouette for the two monkeys was probably an attempt to provide firmer architectural accents at the perimeters of the work; the second side of *The Swimming Pool* also marks a return to more complete figures.

That is to say, the second side does not directly extend the "decomposition" at the end of the first. Instead, it forms a complement and counterpoint to it, taking as its starting point the back-diving figure at the center of the first side. The break in continuity of the white band above that figure therefore serves as a notational point of refer-

ence, drawing one's attention to the motif to which the new series of variations are related. Indeed, remembering Matisse's musical analogies, we may consider the entire second section of *The Swimming Pool* as virtually a set of four variations on the theme thus stressed in the first movement. The swimmer is significantly flattened for its first appearance in the new section, and therefore recalls its original source, *The Swimmer in the Aquarium* plate from *Jazz* (fig. 140). That image was derived from the spectacle of a female swimmer in an aquarium that Matisse had seen on the stage of one of the large Paris music halls.[25] The relation of *The Swimming Pool* to this source confirms the reading of part of the work as a view through the panoramic windows of an indoor pool into the water beyond. Where images cross the boundaries of the white strip, however, the reading is reversed, and the feeling is of being inside the pool looking out to the windows that surround it—another instance of the multiplicity of viewpoints that the work suggests.

As the same sprawling figure is developed on the second side of *The Swimming Pool*, it successively dissolves into the white ground. The central panel is highly ambiguous

and cannot be deciphered with any certainty. It probably derives from a modification of the same pose to a left-side profile, with the curving form at the bottom enclosing the white of the swimmer's back and upper legs, the narrow piece directly above that enclosing the upper part of the same sections of anatomy, and the more rounded tapering piece that pushes between these other two standing for the figure's left arm. In this reading, the larger of the shapes above the top of the arm is not the figure's head. Rather, its lower surface encloses the contour of the upper breast, with the head not being shown but apparently thrown backward as the whole figure assumes a serpentine shape, executing a butterfly stroke and splashing through the water thrown up around it.

After what is probably another exaggeratedly large sea-horse shape and before the final starfish appears the culminating and most dramatic figure in the entire ensemble. The pose of the preceding swimmers is reversed; Matisse's very methods are turned inside out, and it is white itself, surrounded by color, that gives the bather its form. In the traditional sense this figure is really without form. In its absence of body, it is unlike any object that exists in the world. Nor is it a shape, as are the earlier figures in *The Swimming Pool.* Space not only flows through it, melting it into the surrounding whiteness of which it is a part, but it is itself without shape or form—sheer emptiness. The cut edges that contain it give it their shape and the sense of form and volume that they imply, but our perception of these attributes is so purely optical and our experience of them so wholly mental that this blind spot swimming across our vision has the shape and form only of a mirage.

Matisse had written to his friend André Rouveyre in 1942 "that in the work of the Orientals, the drawing of the empty spaces left around leaves counted as much as the drawing of the leaves themselves."[26] He told André Verdet in 1952 that such empty spaces give a "white atmosphere, a rare and impalpable quality," to a composition.[27] Early in his career, Matisse had learned from Cézanne how the white surface of a picture can be made pictorial even when not covered with paint. In many of his finest paintings, white "breathes" through the color, charging the surface with a great sense of spaciousness and airiness. In the paintings of the Nice period, both form and color were submitted to the underlying whiteness of light. In *The Swimming Pool,* this submission, now to a brighter and harsher white, takes a more audacious form, and Matisse brings to a remarkable climax that Symbolist concern with the still silence at the center of the work of art, as transmitted through Mallarmé's belief that "the intellectual core of the poem conceals itself, is present—is active—in the blank space that separates the stanzas and in the white of

the paper: a pregnant silence, no less wonderful to compose than the lines themselves."[28] The use of blue also evokes Symbolist connotations, as well as again referring back to Cézanne, from whose work Matisse had learned that blue can be used in large areas without becoming visually oppressive.[29] The blues are multiple in *The Swimming Pool.* Although all ultramarine, the precise hues varied according to the slightly differing composition of the batches of gouache used and to the ways in which they were mixed and applied to the paper. Additionally, the overlapping of separate pieces in some images reinforces the active and decidedly manual feeling of the blue surfaces throughout the work. And although the sharp contrast of varied blues and uniform white carries the principal coloristic force of *The Swimming Pool,* the optical shimmer produced by the contrast of blue against brown-beige jute (a close approximation of the wall covering of Matisse's dining room) significantly contributes to the drama of the whole.

Specific sources for some of the poses and images have already been cited. It should finally be noted that the imagery as a whole draws on the vast number of sprawling and reclining figures, odalisques, and dancers that Matisse had made during his career. It separates itself from nearly all of these, however, in the way that the human figure itself here creates the decorative configuration of the entire composition. Of Matisse's preceding works, only the 1909 and 1910 versions of the *Dance* (see pp. 54–58) and the Barnes murals (fig. 141), also devoted to the dance theme, truly achieve this effect. The aquatic ballet of *The Swimming Pool* is usefully viewed in the context of these two earlier large works, each synthesizing periods of work, and each looking back to the pastoral theme of the *Bonheur de vivre* (fig. 19). For all his avowed dedication to serenity and relaxation, Matisse's great synthesizing figure compositions are energetic as often as calm. *The Swimming Pool,* restricted to three colors like the *Dance* and environmental like the Barnes murals, treating nonnaturalistically colored figures linked in continuous rhythms like both of them, looks back through these works to the Arcadian, Golden Age imagery of his early work. We are reminded of the bathers by the sea of *Luxe, calme et volupté* (see pp. 38–39), of the brilliant strip of of ocean behind the *Bonheur de vivre,* and of the whole mythology of sensuous water nymphs on which Matisse had drawn. It has been suggested that in *The Swimming Pool* Matisse was recalling Catullus and the image of "Nereids, daughters of the deep, the naked nymphs, breast-high uprising from the white swirl."[30] He had earlier made a cutout on the subject of Amphitrite, one of the Nereids brought by dolphins to marriage with

Poseidon;[31] *The Swimming Pool* may also allude to this theme. If it does, the ambiguously abstract section before the final white bather opens itself to the interpretation of showing the metamorphosis of Amphitrite to Queen of the Sea. But whether or not Matisse had mythology particularly in mind, *The Swimming Pool* certainly draws together his explorations of the ideal aquatic world of his imagination, explorations that had stretched over nearly fifty years, and presents them in newly distilled form. Talking in 1951 about his cutouts, he said: ". . . from *Bonheur de vivre*—I was thirty-five then—to this cutout—I am eighty-two—I have not changed . . . because all this time I have looked for the same things, which I have perhaps realized by different means . . . There is no separation between my old pictures and my cutouts, except that with greater completeness and abstraction I have attained a form filtered to its essentials, and of the object which I used to present in the complexity of space I have preserved the sign which is sufficient, and which is necessary to make the object exist in its own form and in the totality for which I conceived it."[32]

Memory of Oceania [Souvenir d'Océanie]. *Nice, summer 1952–early 1953. Gouache and crayon on cut-and-pasted paper over canvas, 9 ft 4 in x 9 ft 4⅞ in (284.4 x 286.4 cm). (C&N, p. 227)*

Memory of Oceania was begun in 1952, probably while *The Swimming Pool* was still in progress; in September Alfred Barr saw both of these works in Matisse's studio at Nice. Signed and dated in 1953, *Memory of Oceania* was that year temporarily placed on the studio wall as the right wing of a triptych with the cutouts *The Snail* (also dated 1953)[1] on the left and *Large Decoration with Masks* (begun at the end of January 1953)[2] at the center.[3] *The Snail* (fig. 142) and *Memory of Oceania* are both square-shaped works (an unusual format not only for Matisse but for all painting at this time),[4] of almost identical size, and are unique among Matisse's very large cutouts in giving to multiple colors a directly structural role. As *The Swimming Pool*, whose unity importantly depends upon its restricted color, neared completion, Matisse seems to have wanted to find in the cutout method a way for color itself to construct space, as it had in his paintings. Although he had, of course, previously used multiple colors in large-scale cutouts, most recently in *The Parakeet and the Mermaid*, and would continue to do so in the large decorations of 1953, their organizing structure is more a compositional than a chromatic one.[5] There can be no doubt that Matisse was consciously trying a different approach in *The Snail* and *Memory of Oceania*, for he is known to have referred to the former, and first completed, work as "La Composition chromatique."[6]

In order to give construction in color—that is to say, the second, color-arranging, part of the two-part cutout process—greater prominence when making *The Snail*, Matisse minimized the first—image-creating—part, using what are for him extremely neutral shapes, modified rectangles and squares. It was as if at that stage either the first (as with *The Swimming Pool*) or the second part of the cutout process must dominate the other for the work absolutely to succeed. *Memory of Oceania* is remarkable for the way in which the two parts of the process come together again; and it is perceived as a picture precisely because that is what happens here. Image-making and construction in color are bonded together. Images exist both as discrete shapes and as whites surrounded by color. Color truly energizes the open white space. The composition is at once geometric and free, and everything is informed by the sense of light, established by the relationship of colored papers and white ground, that suffuses the whole work. "The light of the Pacific in the Islands, a deep golden goblet into which you gaze," was one of Matisse's principal memories of Oceania, visited twenty-two years before.[7]

It was Matisse's deepening understanding of his painting as a construction of colors expressing light that provoked his visit to Tahiti in 1930 in the first place. "Having worked forty years in European light and space," he told Tériade, "I always dreamed of other proportions that might be found in the other hemisphere. I was always conscious of another space in which the objects of my reveries evolved. I was seeking something other than real space."[8] Although he found the atmosphere of Tahiti too indolent to allow much work, the light seemed to him to be "pure matter."[9] "It was as if the light would be immobilized forever. It is as if life were frozen in a magnificent stance."[10] Something of the effect of forms frozen in dazzling light, "like a block of crystal in which something is happening,"[11] informs his memory of the Oceanic experience, along with the gemlike colors he found there: "pure light, pure air, pure color: diamond, sapphire, emerald, turquoise."[12] He explained to Aragon how, the better to appreciate the light and color of the Tahitian islands, he would dive beneath the waters of the lagoon, then suddenly raise his head into the brilliant sunshine.[13] The disposition of the blues in the cutout, which give the sense of a single sheet of color pulled apart to the edges of the work, re-creates the experience of surfacing in front of what Matisse called "that isle of thoughtless indolence

and pleasure, which brings oblivion and drives out all care for the future."[14]

The cutout is suggestive rather than specific in its evocation of Matisse's Oceanic reverie. Nevertheless, its relationship to his earlier Tahitian pictures allows us to discover likely sources for the various abstracted signs. Aquatic imagery is common in Matisse's art from the time of the Tahitian journey, and came to dominate many of the cutouts, beginning with the Lagoon plates in *Jazz*.[15] It also significantly affected his painting and graphic art, most immediately the etchings for his first illustrated book, the *Poésies de Stéphane Mallarmé*, made in 1930–32. The etching *The Windows*, prepared for that book, was based on a photograph Matisse took of the schooner *Papeete* seen through the trees from his window in Tahiti (fig. 143). It subsequently formed the basis of the 1935 tapestry design *Window at Tahiti* (fig. 144), made into a Beauvais tapestry the following year.[16] Parts of *Memory of Oceania* seem to derive from the same source.[17] The upright fuchsia-colored strip suggests a mast and the large green rectangle the top of the ship itself, with the black curve of a mooring rope crossing its flat blue prow. The irregular blue shape to the right generally corresponds in shape and position to a repoussoir curtain in the etching and tapestry, and the orange and black border, like the floriate border of the tapestry, suggests the frame of a window. The placement of the large horizontal orange and deep-yellow rectangles reflects the position of sea and distant land respectively in the earlier works. There is no precedent in the etching or tapestry for the tapering yellow shape at the lower right. This, however, may refer to a native pirogue of which Matisse had made a drawing.[18] Far more problematic are the sources for the charcoal drawing at the center and for the set of contoured images at the upper left of the work.

It has been suggested that the charcoal drawing suggests a reclining nude.[19] A number of Matisse's drawings may be adduced to support this interpretation.[20] However, it also resembles furled sails in one of the Mallarmé plates.[21] Most likely, given its position, and again given the stylization in some of the Mallarmé etchings, it connotes the memory Matisse described to Aragon of "the murmur of the free sea over the reef against the quiet, unruffled water of the lagoon."[22] The yellow shape to the upper left has been described as the sign for a banana tree.[23] However, the contours of the adjacent blue shapes have strong anthropomorphic connotations, especially when seen in the context of such contemporaneous cutouts as *Venus*[24] and the last white bather in *The Swimming Pool*. If we recall the method of formal analogy Matisse

used in another Tahiti-inspired work, *Tiari*, where the same sculpted image stands for a plant and a head (see pp. 137–38), it seems likely that this upper area of the cutout refers at one and the same time to a tree and to a female figure. Comparison with the sculpture *Back IV* (p. 79), the plaster of which was in Matisse's studio when *Memory of Oceania* was made, suggests that the area be interpreted as a figure seen from the back, with prominently defined spine surmounted by yellow hair, raised left arm and curved right contour, the left side of the body being enclosed by white and the right by blue.[25]

Writing to Aragon about the Tahitian experience, Matisse referred to the analogy of woman and plant.[26] He also talked about how he had developed the image of a nude woman from the forms of a cloud seen over the Tahitian islands.[27] *Venus in a Shell* of 1930 (p. 139) probably derived in part from the same source. The area under discussion in *Memory of Oceania* may also allude to this theme, particularly since Matisse, writing about Tahiti, described the cloud as a symbol the natives took to indicate the forthcoming arrival of a boat in the lagoon.[28] Be this as it may, the fragmentary suggestions of sea, ship, and figure rising from the waves draw together important and persistent themes in Matisse's whole art, looking back even to the composition of *Luxe, calme et volupté* nearly fifty years before.

As in the case of *The Swimming Pool*, Matisse's retrospective mood toward the end of his career produced in *Memory of Oceania* a work that refers to the forms of a number of his earlier major paintings, and not only to those of a directly Arcadian theme. The enclosing frame finds a precedent in several important works beginning with the Grenoble *Interior with Aubergines* of 1911 (fig. 58),[29] and also refers to the window iconography of many earlier pictures.[30] However, the structural grandeur of the composition, with its bold disposition of horizontals, verticals, and diagonals, large areas of color, and open, unconfined design, returns us to Matisse's great experimental works of the teens, most notably perhaps to the *Piano Lesson* (discussed pp. 114–16), but also to the *Bathers by a River* (fig. 39). And just as the Bathers completed in monumental form a sequence begun by the arabesques of the *Dance* (discussed pp. 54–57), so the disciplined calm of *Memory of Oceania* complements the fluid rhythms of *The Swimming Pool*, and brings to a fitting conclusion the series of decorative evocations of an ideal land which Matisse had made throughout his career. This, arguably Matisse's last masterpiece, presents in distilled and contemplative form the geography of such a place.

CATALOG AND NOTES

Works are listed in the catalog in the order in which they appear in the body of the book. A date is enclosed in parentheses when it does not appear on the work. Dimensions are given in feet and inches and in centimeters, height preceding width; a third dimension, depth, is given for some sculptures. Sheet size is given for drawings; plate or composition size is given for prints; page size is given for books. In the catalog entries for prints, the parenthetical notation Pl., followed by a capital letter and a number, refers to the forthcoming catalog of Matisse's graphic work being prepared by Marguerite Duthuit. Wherever possible, references for quotations from Matisse and for works cited but not illustrated are made to the following sources, which are given in abbreviated form:

Barr: Alfred H. Barr, Jr., *Matisse: His Art and His Public* (New York: The Museum of Modern Art, 1951).

Elsen: Albert E. Elsen, *The Sculpture of Henri Matisse* (New York: Abrams, 1972).

Flam: Jack D. Flam, ed., *Matisse on Art* (London: Phaidon, 1973).

Fourcade: Dominique Fourcade, ed., *Henri Matisse: Ecrits et propos sur l'art* (Paris: Hermann, 1972).

Paris 1970: Paris, Grand Palais, *Henri Matisse: Exposition du centenaire,* Intro. Pierre Schneider, 2nd ed. (Paris: Réunion des Musées Nationaux, 1970).

Lemons and Bottle of Dutch Gin
Paris, (early) 1896
Oil on canvas, 12¼ x 11½ in (31.2 x 29.3 cm)
Signed and dated L.R.: "H. Matisse. 96"
Provenance: Lenhart Heijne, Stockholm
Gift of Mr. and Mrs. Warren Brandt
Acq. no. 722.76
Ill. p. 24

Still Life
Paris, (early 1899)
Oil on canvas, 18⅛ x 15 in (46 x 38.1 cm)
Signed L.L.: "Henri Matisse"
Provenance: F. Valentine Dudensing, New York
Gift of A. Conger Goodyear
Acq. no. 7.49
Ill. p. 25

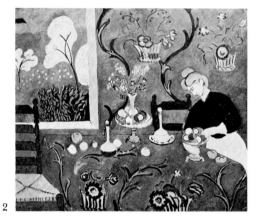

1. Matisse's very first painting was apparently a copy of a landscape, but his first original painting, dated June 1890, was a still life of books (Barr, p. 13). By far the majority of his student-period works were still lifes. See the description by Henri Evenepoel of a visit to Matisse's studio in spring 1896 with Gustave Moreau, quoted in Edouard Michel, "Gustave Moreau et ses élèves: Lettres de Henri Evenepoel à son père," *Mercure de France*, no. 161, 1923, pp. 407–8.

2. Clement Greenberg, *Henri Matisse* (New York: Abrams, 1953), n.p.

3. Matisse, "Témoignage," 1951, Fourcade, p. 247; trans. Flam, p. 136.

4. Quoted by Pierre Schneider in "The *Bonheur de vivre*: A Theme and Its Variations," lecture at The Museum of Modern Art, Mar. 30, 1976, where this issue was discussed in detail. See also Paris 1970, pp. 30–31.

5. The classic discussion of this theme is Meyer Schapiro, "The Apples of Cézanne: An Essay on the Meaning of Still Life," *Art News Annual*, no. 34, 1968, pp. 34–53.

6. Letter to Pierre Matisse, Sept. 1, 1940. Barr, p. 256.

7. Raymond Escholier suggests that Gustave Moreau's taste for glittering objects and things Oriental had an effect on Matisse's early still lifes (*Matisse ce vivant* [Paris: Fayard, 1956], p. 26). Pierre Schneider has stressed the way that Matisse's mature still lifes blend features derived from Dutch realism and Oriental exoticism (*Henri Matisse*, forthcoming).

8. Matisse's copies are discussed in Gaston Diehl, *Henri Matisse* (Paris: Tisné, 1954), p. 11, and seventeen are listed in Christian Zervos, ed., *Henri Matisse* (New York: Weyhe, 1931), p. 12. The remaining three were: Ribera's *The Clubfoot*, Vermeer's *The Lacemaker*, and Delacroix's *The Abduction of Rebecca*.

9. Clara T. MacChesney, "A Talk with Matisse," 1912, Flam, p. 52.

10. See John McCoubrey, "The Revival of Chardin in French Still-Life Painting," *The Art Bulletin*, XLVI, 1964, pp. 39–53.

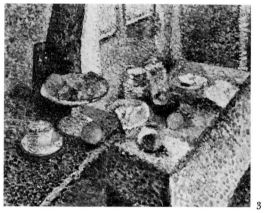

1. *La Desserte*, 1897. Oil, 39⅜ x 51⅝ in. Private collection, Paris
2. *Harmony in Red*, 1908. Oil, 69¾ x 85⅞ in. The Hermitage Museum, Leningrad
3. *Buffet and Table*, 1899. Oil, 25⅞ x 32⅛ in. Dumbarton Oaks Collection, Washington

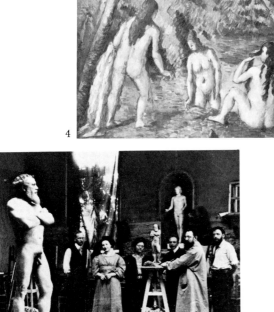

4

5

11. Matisse to Pierre Courthion, in Escholier, *Matisse ce vivant,* p. 26.

12. Paul Baignères, quoted in Escholier, *Matisse ce vivant,* p. 24.

13. Paris 1970, cat. 2A.

14. The whole question of when Matisse first saw Impressionist paintings is reviewed by Marcelin Pleynet, "Le Système de Matisse," in *L'Enseignement de la peinture* (Paris: Editions du Seuil, 1971), p. 32. See also William Rubin, "Cézannisme and the Beginnings of Cubism," in *Cézanne: The Late Work* (New York: The Museum of Modern Art, 1977), p. 195, n. 1.

15. The *toile de Jouy* fabric in the background of the painting, as well as its broad style, helps to identify it as a Paris work. The juxtaposition of fabric and high-backed chair reappeared in the *Harmony in Red* of 1908 (fig. 2).

16. Matisse, letter to Pierre Matisse, July 16, 1942, Barr, p. 50.

17. The usages of this term are discussed in John Elderfield, *The "Wild Beasts": Fauvism and Its Affinities* (New York: The Museum of Modern Art, 1976), p. 18.

18. "Matisse and Impressionism," *Androcles,* I, no. 1, Feb. 1932, p. 31.

19. E.g., Paris 1970, cat. 4, 6.

20. Jean Puy, "Souvenirs," *Le Point,* XXI, July 1939, p. 22, from which the quotation below also derives.

21. Matisse to Gaston Diehl, quoted in Diehl's "Les Nourritures terrestres de Matisse," *XXe Siècle,* 2, Oct. 18, 1945, p. 1.

22. "Notes by Sarah Stein," 1908, Barr, p. 552.

23. Quoted by Lawrence Gowing, *Matisse, 1869–1954* (London: The Arts Council of Great Britain, 1968), p. 8.

Male Model [L'Homme nu; "Le Serf"; Académie bleue; Bevilaqua]
Paris, (1900)
Oil on canvas, 39⅛ x 28⅝ in (99.3 x 72.7 cm)
Provenance: Pierre Matisse, New York
Purchase
Acq. no. 377.75
Ill. p. 29

The Serf
Paris, (1900–03)
Bronze, 36⅜ in (92.3 cm) h., at base 13 x 12 in (33 x 30.5 cm)
Signed on top of base at back: "Henri Matisse"
Provenance: Mrs. Ruth Dubonnet
Mr. and Mrs. Sam Salz Fund
Acq. no. 553.56
Ill. pp. 30, 31

Study for Madeleine I
Paris, (c. 1901)
Pencil, 11¾ x 9¼ in (29.6 x 23.4 cm)
Estate stamp L.R.: "H. Matisse"

4. Cézanne, *Three Bathers,* 1879–82. Oil, 23⅞ x 21½ in. Musée du Petit Palais, Paris

5. Matisse's sculpture class in the old Couvent du Sacré-Coeur, Boulevard des Invalides, Paris, c. 1909

Provenance: Estate of Henri and Amélie Matisse; Pierre
 Matisse, New York
Gift of Mr. and Mrs. Pierre Matisse in honor and memory of
 Victor Leventritt
Acq. no. 1573.68
Ill. p. 32

Standing Nude
Paris, (1901–03)
Brush, pen and ink, 10⅜ x 8 in (26.4 x 20.3 cm)
Signed L.R.: "Henri-Matisse"
Provenance: Edward Steichen, New York
Gift of Edward Steichen
Acq. no. 11.52
Ill. p. 32

1. Barr, p. 38. A variant account appears in Georges Duthuit, *The Fauvist Painters* (New York: Wittenborn, Schultz, 1950), p. 59, n. 1. The Sisley reference suggests that the conversation with Pissarro took place in 1899, the year of Sisley's death as well as of Matisse's purchase of the Cézanne.

2. For related works see: Paris 1970, cat. 35, 44; Elsen, p. 33; Diehl, *Henri Matisse*, pl. 13; Jacques Lassaigne, *Matisse* (Geneva: Skira, 1959), p. 36; Alan Bowness, *Matisse and the Nude* (New York and Toronto: New American Library, 1968), pl. 1.

3. Matisse, "Notes d'un peintre," 1908, Fourcade, p. 49; trans Flam, p 38.

4. Jean Puy wrote later that Bevilaqua was "une espèce d'anthropoïde aussi hideux qu'un aborigène d'Australie" ("Souvenirs," p. 19). Bevilaqua is probably the model seen in fig. 5. He had been one of Rodin's models; it is known that he and Matisse discussed Rodin's methods (Elsen, pp. 28–29).

5. A further suggestion of Matisse's indebtedness to Cézanne is provided by a hitherto unpublished painting (fig. 6) formerly in the collection of Pierre Matisse, which is remarkably close to certain of Cézanne's late paintings of his gardener Vallier. However, this resemblance may be fortuitous because the Valliers in question apparently date to 1906 (*Cézanne: The Late Work,* pp. 236–38). The Matisse would seem to date from the same period as the *Male Model,* with which it shares a blue tonality. It may also depict Bevilaqua.

6. John Jacobus, *Henri Matisse* (New York: Abrams, 1972), p. 94.

7. E.g., *The Italian Woman,* 1916. See p. 108, where this effect is further discussed.

8. Jacobus, *Henri Matisse,* p. 94.

9. Victor I. Carlson, *Matisse as a Draughtsman* (Baltimore: The Baltimore Museum of Art, 1971), cat. 2, 3.

10. Related works are listed in *Henri Matisse: Dessins et sculpture* (Paris: Musée National d'Art Moderne, 1975), cat. 10. Previously thought to date c. 1907, this group of works was convincingly dated earlier by Gabrielle Kueny and Germain Viatte (*Dessins modernes: Grenoble, Musée de Peinture et de Sculp-*

6

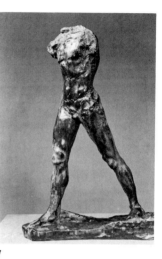

7

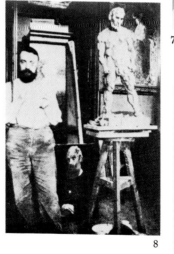

8

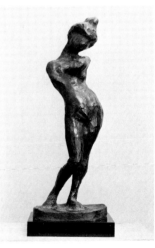

9

6. *Seated Man,* c. 1900. Oil, 25⅝ x 21¼ in. Private collection

7. Rodin, *Man Walking,* 1875–78. Bronze, 33½ in h. The Metropolitan Museum of Art, New York, gift of Miss Louise G. Robinson

8. Matisse in his studio with *The Serf*

9. *Madeleine I,* 1901. Bronze, 23⅜ in h. Collection Mrs. M. Victor Leventritt, New York

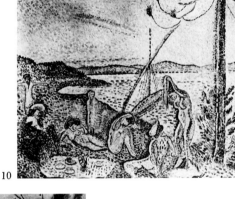

10

11

10. *Luxe, calme et volupté,* 1904–05. Oil, 38¾ x 46⅝ in. Private collection, Paris

11. *The Terrace, Saint-Tropez,* 1904. Oil, 28¼ x 22¾ in. Isabella Stewart Gardner Museum, Boston, gift of Thomas Whittemore

ture [Paris: Musées Nationaux, 1963], cat. 131) .

11. Jacobus, *Henri Matisse,* p. 94.

12. It is known that Matisse visited a van Gogh exhibition at Bernheim-Jeune's in 1901; he had also obtained one or two van Gogh drawings in 1897. See Elderfield, *Fauvism,* pp. 30 and 153, n. 21.

13. Frank Anderson Trapp, "The Paintings of Henri Matisse: Origins and Early Development (1890–1917) ." Ph.D. dissertation, Harvard University, 1951, p. 70.

14. Duthuit, *The Fauvist Painters,* p. 26.

15. See Elderfield, *Fauvism,* pp. 18, 20.

16. Matisse, "Notes d'un peintre," 1908, Fourcade, p. 42; trans. Flam, p. 36.

17. Hilton Kramer, "Matisse as a Sculptor," *Bulletin: Museum of Fine Arts, Boston,* LXIV, no. 336, 1966, p. 53.

18. Puy, "Souvenirs," pp. 16, 22.

19. See "Notes by Sarah Stein," 1908, Barr, pp. 550–52, especially the section on study of the model.

20. Letter to Riva Castleman, Mar. 7, 1978.

21. Jean Guichard-Meili, *Henri Matisse, son oeuvre, son univers* (Paris: Hazan, 1967) , p. 170.

22. See Barr, p. 52; Elsen, pp. 41, 43.

23. See especially Henry Geldzahler, "Two Early Matisse Drawings," *Gazette des beaux-arts,* LX, Nov. 1962, pp. 497–505. This comparison is reviewed, and the differences between Rodin and Matisse convincingly stressed, in Elsen, pp. 28–29, and William Tucker, "Four Sculptors, Part 3: Matisse," *Studio International,* CLXXX, no. 925, Sept. 1970, pp. 82–83. Rodin's *The Walking Man* is shown here as fig. 7.

24. Guillaume Apollinaire, "Henri Matisse," 1907, Fourcade, p. 56; trans. Flam, p. 32.

25. Schapiro, "Matisse and Impressionism," p. 35.

26. Tucker, "Four Sculptors," p. 83.

27. William Tucker, *Early Modern Sculpture* (New York: Oxford University Press, 1974) , p. 12.

28. "Notes by Sarah Stein," 1908, Barr, p. 551; letter to Raymond Escholier, Nov. 10, 1936, Barr, p. 40.

29. Matisse, "Notes d'un peintre," 1908, Fourcade, p. 47; trans. Flam, p. 37.

30. Escholier, *Matisse ce vivant,* p. 162.

31. *Henri Matisse: Dessins et sculpture,* cat. 166. Estimates vary: see Barr, p. 48; Elsen, p. 27.

32. Matisse, "Notes d'un peintre," 1908, Fourcade, p. 42; trans. Flam, p. 36.

33. "Notes by Sarah Stein," 1908, Barr, p. 550.

34. Tucker, *Early Modern Sculpture,* p. 88.

35. Elsen, p. 29.

36. Barr, p. 52; Elsen, p. 30.

37. Elsen, p. 30.

38. Schapiro, "Matisse and Impressionism," p. 35.

39. Kramer, "Matisse as a Sculptor," p. 53.

Standing Nude, Hands on Her Face
(1902–03)
Etching and drypoint, 5⅞ x 3¹³⁄₁₆ in (14.9 x 9.7 cm) (Pl. E.56 bis)
Purchase Fund
Acq. no. 142.49
Ill. p. 33

Two Studies of a Nude Model; Studies of the Artist's Children, Jean and Marguerite
(1902–03)
Drypoint, 5⅞ x 4 in (14.9 x 10 cm) (Pl. E.55)
Purchase
Acq. no. 55.51
Ill. p. 34

12

Self-Portrait as an Etcher
(1903)
Etching and drypoint, 5⁵⁄₁₆ x 7⅞ in (15.1 x 20.1 cm) (Pl. E.52)
Gift of Mrs. Bertram Smith
Acq. no. 75.69
Ill. p. 35

1. Victor Carlson, *Matisse as a Draughtsman*, p. 22, refers directly to the etching in confirming the date of the pen, brush and ink drawing *Self-Portrait, Smoking a Pipe*. A *Self-Portrait* in the Musée Matisse at Cimiez (inv. 374) is related, as is the one in the J.M. Collection (*Henri Matisse, Dessins et sculpture*, cat. 2).

2. The earliest painted example in which Matisse incorporates this device seems to have been the bold *Carmelina* of 1903 (Boston Museum of Fine Arts).

3. John Elderfield, *Fauvism*, pp. 34–35, illustrates three works by Marquet and Matisse of them painting a nude in Manguin's studio. It seems unlikely, however, that Matisse made his drypoints of the nude in this setting, partly because of the sketches of his children on one plate.

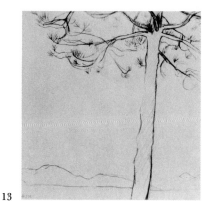

13

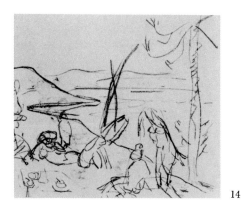

14

Study for Luxe, calme et volupté
Saint-Tropez, (late summer) 1904
Oil on canvas, 12¾ x 16 in (32.2 x 40.5 cm)
Signed L.R.: "Henri Matisse"
Provenance: Private collection, Paris
Promised gift of the Honorable and Mrs. John Hay Whitney
Ill. p. 37

1. Barr, p. 45.

12. *By the Sea [Golfe de Saint-Tropez]*, 1904. Oil, 25½ x 19⅞ in. Collection Contigny Trust, Wheaton, Ill.

13. *Study of a Pine Tree*, 1904. Conté crayon on paper, 12⅝ x 13⅜ in. Musée Matisse, Nice-Cimiez

14. Study for *Luxe, calme et volupté*, 1904–05. Charcoal on paper, 8¾ x 10⅝ in. Private collection

177

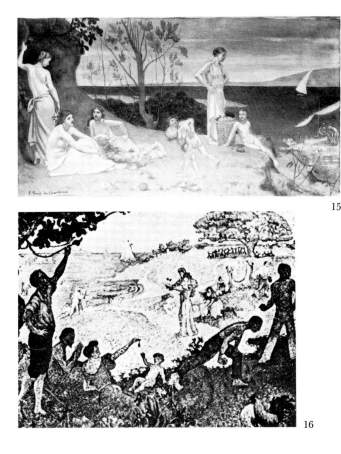

15

16

15. Puvis de Chavannes, *Doux Pays* [*Pleasant Land*], 1882. Oil, 10⅛ x 18⅝ in. Yale University Art Gallery, New Haven, Mary Gertrude Abbey Fund

16. Signac, *Au temps d'harmonie*, 1893–95. Oil. Mairie de Montreuil

2. See above, p. 27.

3. Signac and Luce had Druet Gallery exhibitions in 1904, Cross and van Rysselberghe in 1905.

4. Françoise Cachin, *Paul Signac* (Paris: Bibliothèque des Arts, 1971) , p. 79.

5. See Barr, pp. 314, 315; *Henri Matisse* (Los Angeles: University of California Art Galleries, 1966) , cat. 17.

6. Paris 1970, cat. 55.

7. Mme Marguerite Duthuit, conversation with the author, Mar. 1978. Pierre Schneider discussed the creation of *Luxe, calme et volupté* in his lecture "The *Bonheur de vivre:* A Theme and Its Variations."

8. Matisse, Questionnaire II from Alfred Barr, Mar. 1950, Archives of The Museum of Modern Art. (See Barr, p. 529, for details of questionnaires.)

9. Matisse, "On Modernism and Tradition," 1935, Flam, p. 72.

10. It is, in fact, fairly restrained compared with some Neo-Impressionist studies from nature, for example, Signac's study for *Au temps d'harmonie* in Cachin, *Signac,* p. 89.

11. M. T. Lemoyne de Forges, ed., *Signac* (Paris: Musée du Louvre, 1964) , p. 102.

12. See *Henri Matisse: Dessins et sculpture,* cat. 30.

13. See below, nn. 22, 23.

14. Elderfield, *Fauvism,* p. 102.

15. Henri Dorra, "The Wild Beasts—Fauvism and Its Affinities at the Museum of Modern Art," *Art Journal,* XXXVI, no. 1, Fall 1976, p. 53.

16. Diehl, *Henri Matisse,* p. 28.

17. Diehl, *Henri Matisse,* p. 30, stresses the importance for Matisse of "reserve" areas of canvas between color blocks in Neo-Impressionist paintings. Matisse could also have seen a similar effect in the late works of Cézanne.

18. E. Tériade, "Visite à Henri Matisse," 1929, Fourcade, p. 93; trans. Flam, p. 58.

19. E. Tériade, "Matisse Speaks," 1952, Flam, p. 132.

20. See above, n. 18.

21. See below, n. 25. In 1904 Cross wrote to van Rysselberghe, saying: "I want to submit everything to a harmony of colors and linear directions." Robert L. Herbert, *Neo-Impressionism* (New York: The Solomon R. Guggenheim Museum, 1968) , p. 217.

22. Paris 1970, cat. 55.

23. Schneider, "The *Bonheur de vivre:* A Theme and Its Variations," quoting from the same letter.

24. The comparison was first made by Barr, p. 60. For detailed discussion of Matisse's indebtedness to Puvis, see Richard J. Wattenmaker, *Puvis de Chavannes and the Modern Tradition*

(Toronto: Art Gallery of Ontario, revised ed. 1976), pp. 12–14, 122–23, 154.

25. The figure combing her hair is close to one in Cross's *Composition—Air du soir*, 1893–94, owned by Signac; the woman on her elbow and the nude seen from the back relate to figures in Cross's *La Plage ombragée*, 1892, shown at the Salon des Indépendants of 1903, where Matisse was a member of the hanging committee. See Isabelle Compin, *H. E. Cross* (Paris: Quatre Chemins–Editart, 1964), cat. 42, 97. The comparison with *Air du soir* was made by Cachin, *Signac*, p. 83.

26. See Elderfield, *Fauvism*, pp. 97–99.

27. The description is also evocative of Matisse's later Nice-period interiors.

28. E. Tériade, "Visite à Henri Matisse," 1929, Fourcade, p. 94; trans. Flam, p. 58.

29. This suggestion was made by William Rubin, who points out that the absence of any adult male figure in the painting is what particularly evokes this association. He further notes that Matisse would certainly have been aware of the many late nineteenth-century representations, both visual and literary, of dressed madams and naked girls, and that it would have been typical of Matisse's wry humor to have wanted to evoke this kind of secondary association.

30. See Robert L. Herbert, "City vs. Country: The Rural Image in French Painting," *Artforum*, VIII, no. 6, Feb. 1970, pp. 44–55.

31. See Elderfield, *Fauvism*, pp. 97 and 155, n. 3.

32. See Compin, *Cross*, pp. 56, 146; Elderfield, *Fauvism*, p. 99.

33. *Matisse, 1896–1954*, p. 11.

34. Dorra, *"The Wild Beasts,"* p. 54.

35. Barr, p. 53; Matisse, "On Modernism and Tradition," 1935, Flam, p. 72.

36. When the "Intimistes" held a second group show at the same galleries in 1906, Matisse was not included.

37. See Elderfield, *Fauvism*, p. 32.

38. Ibid, pp. 65, 102; Trapp, "The Paintings of Henri Matisse," pp. 105–6.

39. See above, n. 18. Before painting *Bonheur de vivre*, however, Matisse made a second large Neo-Impressionist composition, *Le Port d'Abaill*. (See below, p. 180, n. 6.)

40. Danièle Giraudy, ed., "Correspondance Henri Matisse–Charles Camoin," *Revue de l'art*, no. 12, 1971, p. 18. Letter of [autumn 1914]. (This correspondence is hereafter cited as: Matisse-Camoin.)

View of Collioure with the Church
Collioure, (summer 1905)
Oil on canvas, 13 x 16¼ in (32.9 x 41.3 cm)
Signed L.R.: "H.M."
Provenance: Edward Steichen

17

18

17. *Mediterranean Port: Collioure, the Church and the Lighthouse*, 1905. Ink on paper, 10⅝ x 17¾ in. Private collection

18. Photograph from the window of Matisse's apartment in Collioure

179

19

20

21

19. *Bonheur de vivre*, 1905–06. Oil, 68½ x 93¾ in. © The Barnes Foundation, Merion, Pa.

20. *Landscape at Collioure (Study for Bonheur de vivre)*, 1905. Oil, 18⅛ x 21⅝ in. Statens Museum for Kunst, Copenhagen, J. Rump Collection

21. *Landscape (Study for Bonheur de vivre)*, 1905. Oil, 16½ x 21¾ in. Private collection

Extended loan and promised gift of Kate Steichen in memory of Edward Steichen
E.L. 76.320
Ill. p. 40

Landscape at Collioure
Collioure, (summer 1905)
Oil on canvas, 15⅜ x 18¼ in (39 x 46.2 cm)
Signed L.L.: "Henri Matisse"
Provenance: Sidney Janis, New York

Promised gift of Mrs. Bertram Smith
Ill. p. 41

The Harbor of Collioure
(1906–07)
Lithograph, 4⁵⁄₁₆ x 7⅝ in (10.9 x 19.4 cm)
Gift in memory of Leo and Nina Stein
Acq. no. 252.50
Ill. p. 43

1. See Elderfield, *Fauvism*, pp. 31–32.

2. E.g., Paris 1970, cat. 58.

3. See Elderfield, *Fauvism*, p. 49.

4. André Derain, *Lettres à Vlaminck* (Paris: Flammarion, 1955), pp. 154–55. Discussed in Elderfield, *Fauvism*, p. 49.

5. *Lettres à Vlaminck*, p. 161; Elderfield, *Fauvism*, p. 51.

6. Despite Matisse's break with Neo-Impressionism this summer, he clearly did not feel ready, even at the end of the summer, to produce an ambitious Salon painting in his new style. On September 19, 1905, he wrote to Simon Bussy from his Paris studio: "Je suis en ce moment attelé à un tableau de 1 m 50 sur 40 cm. représentant le port de Collioure (Pyr. Orient[ies]), où je viens de séjourner 4 mois. J'ai obtenu un sursis du Salon d'A. et je dois me dépêcher pour arriver à temps, comme je fais des petits points, c'est assez long, surtout qu'il [sic] ne sont pas toujours réussis du premier coup. A part ça tout va bien—surtout ces jours-ci car je viens de vendre un tableau assez important qui était exposé au Salon des Indép[ts] et que j'avais baptisé '. . . luxe, calme & volupté.' Baudelaire, l'Invitation au voyage, je crois, à moins que ça ne soit la pièce qui précède ou celle qui suit. C'est aussi du petit point; ce qui a fait que c'est Signac qui me la [sic] acheté; ça se comprend." The painting he refers to must be *Le Port d'Abaill* (Paris 1970, cat. 59). It is certain, then, that although prepared for in studies of the summer of 1905, *Bonheur de vivre* was not begun at least until after the opening of the 1905 Salon d'Automne on October 18, if not in fact later, for Matisse did not manage to finish *Le Port d'Abaill* in time for the Salon (or felt dissatisfied with it if he did). Only Fauve works were shown in October. *Le Port d'Abaill* was exhibited at Matisse's Galerie Druet exhibition in March–April 1906.

7. E. Tériade, "Matisse Speaks," 1952, Flam, p. 132.

8. The church tower can be seen at the left of the photograph.

9. E. Tériade, "Visite à Henri Matisse," 1929, Fourcade, p. 94; trans. Flam, p. 58.

10. E.g., Paris 1970, cat. 65–67.

11. E.g., Paris 1970, cat. 60, 61, 69; Elderfield, *Fauvism*, p. 56.

12. See *View of Collioure and the Sea* (p. 81) and the works listed in nn. 4, 5 of that commentary, which were probably painted from the same place or close by.

13. See Elderfield, *Fauvism*, p. 51.

14. Ibid. The curvilinear forms, as well as Matisse's palette that summer, may well also owe something to the influence of Gauguin. See Elderfield, *Fauvism*, pp. 49–50.

15. The sequence of these paintings, as given below, is based on their increasingly more direct relationship to *Bonheur de vivre*.

16. Schapiro, "Matisse and Impressionism," p. 24.

17. Hilton Kramer, "Those Glorious 'Wild Beasts'," *New York Times*, Apr. 4, 1976.

18. This aspect of Impressionism is discussed in more detail in the author's "The World Whole: Color in Cézanne," *Arts Magazine*, LII, no. 8, Apr. 1978, p. 148.

19. "Notes by Sarah Stein," 1908, Barr, p. 552.

20. See Elderfield, *Fauvism*, pp. 49–50, 102.

21. Matisse, "Rôle et modalités de la couleur," 1945, Fourcade, p. 199; trans. Flam, p. 99.

22. E. Tériade, "Visite à Henri Matisse," 1929, Fourcade, pp. 94, 96; trans. Flam, p. 58.

23. Carlson, *Matisse as a Draughtsman*, cat. 5.

24. Elderfield, "Color in Cézanne," p. 151.

25. John Rewald, *Post-Impressionism: From van Gogh to Gauguin* (New York: The Museum of Modern Art, 1956), p. 244.

26. Duthuit, *The Fauvist Painters*, p. 43.

27. An additional study for *Bonheur de vivre*, a tiny (4¾ x 7½ in) oil sketch on wood, is in the Barnes Foundation. See Albert C. Barnes and Violette de Mazia, *The Art of Henri Matisse* (New York: Scribner's, 1933), p. 240.

Girl Reading [La Lecture]
Paris, (winter 1905–06)
Oil on canvas, 28⅝ x 23⅜ in (72.7 x 59.4 cm)
Signed L.L. corner: "Henri Matisse"
Provenance: Galerie Druet, Paris; Frank Perls, California; Mr. and Mrs. William Goetz
Promised gift of Mr. and Mrs. David Rockefeller
Ill. p. 45

Marguerite Reading
Collioure, (1906)
Pen and ink, 15⅝ x 20½ in (39.6 x 52.1 cm)
Signed L.R.: "Henri-Matisse"
Provenance: Collection the artist

22

22. *La Liseuse*, 1895. Oil, 24¼ x 18⅞ in. Musée National d'Art Moderne, Paris

Acquired through the Lillie P. Bliss Bequest
Acq. no. 417.53
Ill. p. 46

Jeanne Manguin
Paris, (1906)
Brush and ink, 24½ x 18½ in (62.2 x 46.9 cm)
Signed L.R.: "Henri Matisse"
Provenance: Pierre Matisse Gallery, New York; T. Edward Hanley, Bradford, Pa.; E. V. Thaw and Co., Inc., New York
Given anonymously
Acq. no. 17.68
Ill. p. 47

1. See Barr, pp. 81–82.

2. Escholier, *Matisse ce vivant*, p. 36.

3. Most of this paragraph is adapted from Elderfield, *Fauvism*, p. 56.

4. Schneider, *Henri Matisse*, forthcoming, from which the reference below to flame imagery in *Girl Reading* is also derived.

5. E.g., Barr, p. 293; Paris 1970, cat. 32.

6. Hans Purrmann, "Aus der Werkstatt Henri Matisse," *Kunst und Künstler*, XX, no. 5, Feb. 1922, pp. 167–76.

7. See Jack D. Flam, "Jazz," in *Henri Matisse: Paper Cut-Outs* (The St. Louis Art Museum and The Detroit Institute of Arts, 1977), p. 39.

8. Henri Bergson, *Creative Evolution*, trans. Arthur Mitchell (London: Macmillan, 1911), p. 4.

9. Schneider, *Henri Matisse*, forthcoming.

10. Matisse, "Notes d'un peintre," 1908, Fourcade, p. 50; trans. Flam, p. 38.

11. Letter to Alexander Romm, Mar. 17, 1934, Fourcade, p. 148; trans. Flam, p. 70.

12. Matisse, "Notes d'un peintre," 1908, Fourcade, p. 45; trans. Flam, p. 37.

13. Schneider, *Henri Matisse,* forthcoming.

14. This drawing is dated 1906–07 in *Henri Matisse: Dessins et sculpture,* cat. 25. Carlson, *Matisse as a Draughtsman,* cat. 14, suggests 1906. Given its relation to the mixed-technique painting style that Matisse abandoned in the winter of 1906–07 (see below, p. 50), the drawing probably dates from 1906, if not indeed from the 1905–06 period of *Girl Reading.*

15. Carlson, *Matisse as a Draughtsman,* cat. 14.

16. Barr, p. 332. Another 1906 drawing of Marguerite (*Henri Matisse: Dessins et sculpture,* cat. 21) may well have been made at the same time. Apparently the sculpture *Standing Nude,* 1906 (Elsen, p. 64), was worked on concurrently with the painting. (See Pierre Schneider, "Matisse's Sculpture: The Invisible Revolution," *Art News,* LXXI, no. 1, Mar. 1972, p. 22).

17. Carlson, *Matisse as a Draughtsman,* cat. 13.

Nude
(1906)
Lithograph, 11³⁄₁₆ x 9¹⁵⁄₁₆ in (28.4 x 25.3 cm) (Pl. L.29)
Gift of Abby Aldrich Rockefeller
Acq. no. 91.55
Ill. p. 48

Seated Nude Asleep (Grand Bois)
(1906)
Woodcut, 18¾ x 15 in (47.5 x 38.1 cm) (Pl. W.2)
Gift of Mr. and Mrs. R. Kirk Askew, Jr.
Acq. no. 559.41
Ill. p. 48

Pensive Nude in Folding Chair
(1906)
Lithograph, 14¾ x 10⅝ in (37.4 x 26.9 cm) (Pl. L.4 bis)
Given in memory of Leo and Nina Stein
Acq. no. 253.50
Ill. p. 49

Seated Nude (Petit Bois Clair)
(1906)
Woodcut, 13½ x 10⅝ in (34.2 x 26.9 cm) (Pl. W.3)
Abby Aldrich Rockefeller Fund
Acq. no. 612.54
Ill. p. 49

1. Elderfield, *Fauvism,* p. 42, relates the history of Mme Matisse's tapestry work. Pierre Schneider, Paris 1970, p. 102, notes: "Around 1906, the antiquarian Bidault asked Mme Matisse to restore for him a Gothic tapestry, saying that only Matisse could recover the drawing in it. Matisse refused, saying that such a thing would mean too much work. Mme Matisse had already worked on the restoration of Beauvais tapestries." Barr, p. 99,

23

23. Drawing by Matisse used as Plate IV to illustrate *Les Jockeys camouflés* by Pierre Reverdy (Paris: A la Belle Edition, 1918), 9¾ x 8¾ in (sheet). The Museum of Modern Art, New York, Louis E. Stern Collection

writes, "The two smaller 'woodcuts' are milder and were accepted by some critics as decorative designs 'for tapestries.' "

2. William S. Lieberman, *Henri Matisse, Fifty Years of His Graphic Art* (New York: Braziller, 1956), p. 19, n. 3.

3. Barr, reprod. p. 322.

4. Christian Zervos, *Cahiers d'art,* VI, no. 5–6, 1931, p. 92.

5. Frank Perls, "Henri Matisse—Twenty Years Later," *Henri Matisse: Graphic Work* (London: Lumley Cazalet Ltd., 1974), n.p.: "The present exhibition at Lumley Cazalet contains most of the best of the graphic work by Henri Matisse. The early period is well represented by the three woodcuts Matisse made in 1906, inspired by the Gauguin woodcuts. Ambroise Vollard had asked Matisse to pull some prints from the woodblocks Gauguin had sent to Vollard from Tahiti. Becoming familiar with the technique of woodcarving by having these woodblocks right under his hands, Matisse became enthusiastic about this medium and set out to carve for himself three woodblocks. The largest one is in this exhibition; the other two have 'disappeared.' At the same time Vlaminck had been asked by Vollard to pull prints from the Gauguin woodblocks and he, too, became obsessed by this age-old medium and produced a number of woodcuts. Neither artist, however, ever copied any of Gauguin's wood prints. They were simply the inspiration—a creative suggestion, a hint from faraway Tahiti—to use wood. One cannot find in the wood prints by either artist the slightest influence of what appears in Gauguin's prints."

6. Elderfield, *Fauvism,* pp. 108–9.

7. Marguerite G. Duthuit, letter to author, Mar. 24, 1978. The

block is now in the collection of the Victoria and Albert Museum, London.

8. Barr, p. 99.

9. *Standing Nude Drying Herself,* reprod. Carlson, *Matisse as a Draughtsman,* cat. 11.

10. Marguerite G. Duthuit, letter to author, Mar. 7, 1978.

Reclining Nude I
Collioure, (winter 1906–07)
Bronze, cast no. 7 of an edition of 10; 13½ in (34.3 cm) h.,
 at base 19¾ x 11¼ in (50.2 x 28.6 cm)
Signed rear left corner of base: "Henri Matisse 7/10"
Provenance: Buchholz Gallery, New York
Acquired through the Lillie P. Bliss Bequest
Acq. no. 143.51
Ill. p. 50

Standing Nude, Arms on Head
(1906)
Bronze, cast no. 10 of an edition of 10; 10⅜ in (26.2 cm) h.,
 at base 4⅛ x 4⅞ in (10.2 x 12.3 cm)
Signed near base, on support for back leg: "Henri Matisse/10"
Promised gift of Mrs. Bertram Smith
Ill. p. 51

1. Matisse spent the spring and summer of 1906 at Collioure, travelling there immediately upon his return from Biskra. He was back in Paris in time for the opening of the Salon d'Automne in October, but then returned to Collioure for the winter. The sculpture and painting referred to here were made during this second Collioure visit. The *Blue Nude* was exhibited at the Salon des Indépendants, which opened in March 1907.

2. The possibility that it was made at the same time as the two related 1904 sculptures (see below, n. 4) cannot be ruled out. However, the greater clarity of its modeling tends to support the later date.

3. Its ultimate source is the reclining figure to the left center of the study for *Luxe, calme et volupté,* 1904 (p. 37). In *Bonheur de vivre,* the pipe-playing nymph in the foreground and the left-center figure are also variants on the pose. The drawing published in *Henri Matisse: Dessins et sculpture,* cat. 27, was almost certainly made after the sculpture, probably later in 1907 around the time that Matisse made some ceramic-tile versions of the motif (see John Hallmark Neff, "Matisse and Decoration, 1906–1914; Studies of the Ceramics and the Commissions for Paintings and Stained Glass," Ph.D. dissertation, Harvard University, 1974, Appendix A). Two subsequent sculptures, *Reclining Nude II,* 1927, and *Reclining Nude III,* 1929 (Elsen, pp. 155–59), were based on the pose developed in this sculpture. A brief account of Matisse's use of this pose is Gertrude Rosenthal's "Matisse's Reclining Figures: A Theme and Its Variations," *The Baltimore Museum of Art News,* XIX, no. 3, Feb. 1956, pp. 10–15.

4. Elsen, pp. 59, 60. It also anticipates in some respects the 1911 sculpture *The Dance* (Elsen, p. 104).

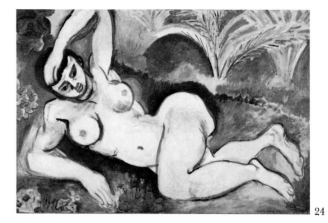

24

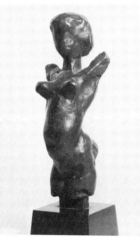

25

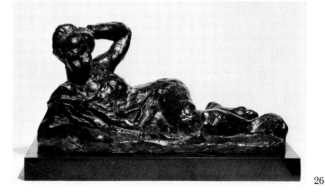

26

24. *Blue Nude,* 1907. Oil, 36¼ x 44⅛ in. The Baltimore Museum of Art, Cone Collection

25. *Torso with Head [La Vie],* 1906. Bronze, 9⅛ in h. The Metropolitan Museum of Art, New York, Alfred Stieglitz Collection

26. *Reclining Figure with Chemise,* 1906. Bronze, 5½ x 11¾ x 6 in. The Baltimore Museum of Art, gift of Albert Lion

5. Elsen, p. 69.

6. Alicia Legg, *The Sculpture of Matisse* (New York: The Museum of Modern Art, 1972) , p. 12.

7. See Barr, p. 94.

8. Louis Vauxcelles, *Gil Blas,* Mar. 20, 1907; Elderfield, p. 112.

9. Tucker, "Four Sculptors," p. 84.

10. Georges Charbonnier, "Entretien avec Henri Matisse," 1960, Fourcade, p. 154; trans. Flam, p. 139.

11. See below, p. 85, 87, 115.

12. Kramer, "Matisse as a Sculptor," p. 53.

13. Elsen, p. 64; John Elderfield, "Matisse Drawings and Sculpture," *Artforum,* XI, no. 1, Sept. 1972, p. 82.

14. Elsen, p. 75.

15. Schneider, "Matisse's Sculpture," p. 70.

Music (Sketch)
Collioure, (June–July 1907)
Oil on canvas, 29 x 24 in (73.4 x 60.8 cm)
Signed L.L.: "Henri Matisse"
Provenance: Leo and Gertrude Stein; John Quinn;
 A. Conger Goodyear
Gift of A. Conger Goodyear in honor of Alfred H. Barr, Jr.
Acq. no. 78.62
Ill. p. 53

1. Matisse was in Collioure by at least June 13, 1907. On July 14 he left for Italy, traveling via Cassis (to see Derain and Girieud) , La Ciotat (to see Friesz and Braque), Saint-Clair (to see Cross) , and Saint-Tropez (to see Manguin) . He arrived back in Collioure around August 14. See Neff, "Matisse and Decoration," pp. 72–73; Neff, "An Early Ceramic Triptych by Henri Matisse," *Burlington Magazine,* CXIV, no. 837, Dec. 1972, p. 852; Barr, p. 83.

2. Matisse wrote to Vlaminck on August 29, 1907, saying he intended to remain in Collioure until the end of October (Maurice de Vlaminck, *Portraits avant décès* [Paris: Flammarion, 1943], pp. 103–4; cited by Neff, "Matisse and Decoration," pp. 29, 73). Also exhibited at the Salon d'Automne were: *Tête d'expression* (see below, n. 4), *Paysage (esquisse)* (probably *Brook with Aloes,* see below, n. 4) , and two drawings.

3. Barr, pp. 338–39.

4. Neff, "Matisse and Decoration," p. 72. Matisse described the three remaining paintings as "Aloes" (Elderfield, *Fauvism,* p. 134) , "Tête d'expression," and "Une Fleur."

5. Barr, p. 83.

6. Neff, "An Early Ceramic Triptych," p. 852.

7. Matisse, "Notes d'un peintre," 1908, Fourcade, p. 43; trans. Flam, p. 36.

8. Meyer Schapiro notes that the reliance on memory rather than observation separates Post-Impressionism from Impressionism ("Matisse and Impressionism," p. 22). However, Matisse's

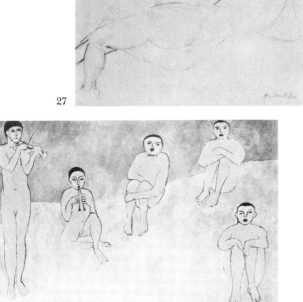

27

28

27. *Reclining Nude,* 1907 (?) . Pencil on paper, 16¼ x 23 in. Musée Matisse, Nice-Cimiez

28. *Music,* 1910. Oil, 8 ft 5⅝ in x 12 ft 9½ in. The Hermitage Museum, Leningrad

use of memory images is more extensive than the Post-Impressionists'. See below, pp. 86–89.

9. Albert Kostenevich, "La Danse and La Musique by Henri Matisse: A New Interpretation," *Apollo*, C, no. 154, n.s., Dec. 1974, p. 510.

10. Jack D. Flam, "Some Observations on Matisse's Self-Portraits," *Arts Magazine*, IL, no. 9, May 1975, p. 51.

11. Ibid., pp. 50–52.

12. Barr, pp. 341, 356, 357.

13. See Barr, p. 138; John Hallmark Neff, "Matisse and Decoration: The Shchukin Panels," *Art in America*, LXIV, no. 4, July–Aug. 1975, pp. 42–44; Kostenevich, "La Danse and La Musique," pp. 510–11.

14. Barr, p. 78.

Dance (First Version)
Paris, (March 1909)
Oil on canvas, 8 ft 6½ in x 12 ft 9½ in (259.7 x 389.9 cm)
Provenance: Pierre Matisse Gallery, New York;
 Walter P. Chrysler, Jr.
Gift of Nelson A. Rockefeller, in honor of Alfred H. Barr, Jr.
Acq. no. 201.63
Ill. p. 55

Study after Dance (First Version)
Issy-les-Moulineaux, (1909)
Pencil, 8⅝ x 13⅞ in (21.8 x 35.1 cm)
Provenance: Pierre Matisse, New York
Gift of Pierre Matisse
Acq. no. 103.71
Ill. p. 57

1. Barr, p. 133. Barr's extensive discussion of the Shchukin commissions, pp. 132–34, is the basic account of this somewhat complicated affair, but requires revision in the light of more recent research (see below). In particular, Barr's assumption that the negotiations dragged on through August 1912 is clearly unfounded.

2. See John Hallmark Neff, "Matisse and Decoration: An Introduction," *Arts Magazine*, IL, no. 10, June 1975, p. 85.

3. Matisse was still in Cassis on February 7, 1909, where he had just completed the last of his 1908 Shchukin commissions, *Nymph and Satyr* (Neff, "Matisse and Decoration: An Introduction," p. 85). Since Shchukin wrote to Matisse on March 31 after having seen Matisse in Paris, this gives us the likely time of their meeting.

4. It is of course possible that the commission had been discussed in preliminary terms in 1908. However, it was far more ambitious an undertaking than the 1908 ones and almost certainly awaited their satisfactory completion before being started. In 1951, Matisse stated that the commission for *Dance* and *Music* was only given after the others (E. Tériade, "Matisse Speaks," 1951, Flam, p. 133). Furthermore, *Dance I* is stylistically more advanced than *Nymph and Satyr* and the preceding

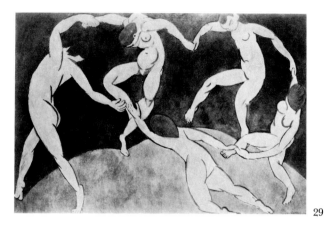

29

30

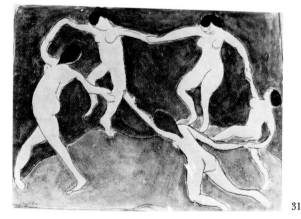

31

29. *Dance II*, 1910. Oil, 8 ft 5⅝ in x 12 ft 9½ in. The Hermitage Museum, Leningrad

30. *The Dance*, 1911. Charcoal on paper, 18⅞ x 25⅝ in. Musée de Peinture et de Sculpture, Grenoble

31. *Composition No. I* (Study for *Dance II*), 1909. Watercolor and pencil on paper, 8⅝ x 12⅝ in. The Pushkin Museum, Moscow

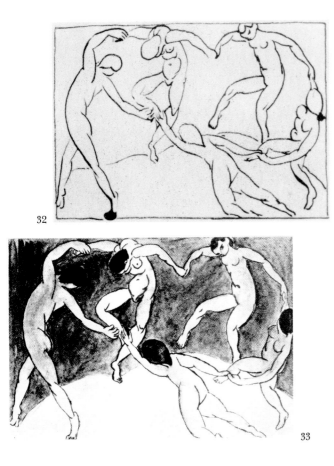

32. *The Dance*, 1911. Ink on paper, 6½ x 9 in. Private collection
33. *The Dance*. 1911. Watercolor on paper, 11¾ x 17½ in. Musée de Peinture et de Sculpture, Grenoble

figure paintings.

5. Letter to Alfred Barr, Mar. 3, 1951, Archives of The Museum of Modern Art.

6. Matisse, Questionnaire VI from Alfred Barr, Mar.–Apr. 1951, Archives of The Museum of Modern Art. See Barr, p. 133.

7. Further confirmation that *Dance I* was in existence by spring 1909 is provided by a letter from Matthew Stewart Prichard to Isabella Stewart Gardner, Boston, dated Easter Day (April 11), 1909: "I have seen a photograph of his [Matisse's] last composition, a ring of dancing women, or a ring expressing the rhythms of women dancing, for their existence is only suggested by light female symbols against a blue or darker background." Quoted by Neff, "Matisse and Decoration," p. 165. Additionally, *Dance I* was reproduced in *Zolotoye Runo* (Moscow), no. 6, June 1909.

8. Charles Estienne, "Entretien avec M. Henri Matisse," 1909, Fourcade, pp. 62–63; trans. Flam, p. 49. John Neff suggests that the interview was conducted at the Salon des Indépendants, possibly in the last week in March. (Neff, "Matisse and Decoration," p. 181.)

9. Most interestingly, Pierre Schneider has cited Gustave Moreau's *The Life of Humanity* panels, whose subjects include morning and dream, noon and song, and evening and death. Schneider directly relates this scheme to that of the three Shchukin panels ("The *Bonheur de vivre*: A Theme and Its Variations"). There are no visual resemblances between the two schemes. See *Musée Gustave Moreau: Catalogue sommaire des peintures, dessins, cartons et aquarelles* (Paris: Portail, 1926), cat. 73.

10. Barr, p. 135; Elsen, p. 80; Jacobus, *Henri Matisse,* p. 122; Neff, "The Shchukin Panels," p. 42.

11. On Art Nouveau influences on Matisse, see Frank Anderson Trapp, "Art Nouveau Aspects of Early Matisse," *Art Journal*, XXVI, no. 1, Fall 1966, pp. 2–8. According to Escholier, Matisse briefly studied with Hector Guimard (*Matisse ce vivant*, p. 30).

12. See Neff, "An Early Ceramic Triptych," pp. 848–53.

13. Barr, p. 135. See also Frank Kermode's *Romantic Image* (London: Routledge and Kegan Paul, 1961), pp. 49–91 and passim, and "Poet and Dancer before Diaghilev," in his *Modern Essays* (London: Fontana, 1971), pp. 11–38, for highly stimulating essays on the dance and the Parisian avant-garde.

14. Christopher Rawlence, "Matisse and Oriental Art: A Study of the Influence of Oriental Art on Matisse's Artistic Development between 1895 and 1912." M.A. report, The Courtauld Institute of Art, London University, May 1969, p. 24.

15. Barr, p. 15. Mme Duthuit told John Neff in 1971 that Matisse did indeed see Isadora Duncan dance but found her movements "limités au lieu de se prolonger dans l'espace." (Neff, "Matisse and Decoration," p. 174.)

16. Barr, p. 135.

17. Charles H. Caffin, "Matisse and Isadora Duncan," *Camera Work,* no. 25, Jan. 1909, pp. 17–20.

18. Charles H. Caffin, *The Story of French Painting* (New York: The Century Co., 1911) , pp. 214–16. This important firsthand description was discovered by Wattenmaker, *Puvis de Chavannes*, pp. 12–13.

19. Marcel Sembat, "Henri Matisse," *Les Cahiers d'aujourd'hui*, no. 4, Apr. 1913, p. 193.

20. Georges Charbonnier, "Entretien avec Henri Matisse," 1960; trans. Flam, p. 138.

21. Kermode, "Poet and Dancer before Diaghilev," p. 35.

22. The work is illustrated in Elderfield, *Fauvism*, p. 103. A photograph of Fuller dancing appears in Leroy C. Breunig, ed., *Apollinaire on Art: Essays and Reviews, 1902–1918* (New York: Viking, 1972) , p. 258.

23. See above, n. 8.

24. Marcel Sembat, *Matisse et son oeuvre* (Paris: Editions de la Nouvelle Revue Française, 1920) , p. 9.

25. Kostenevich, "La Danse and La Musique," pp. 510–11 (but with some questionable conclusions developed from this point) .

26. See above, n. 20.

27. Hans Purrmann, "Aus der Werkstatt Henri Matisses," pp. 167–76; trans. Barr, pp. 136, 138.

28. Letter to Alexander Romm, Oct. 1934, Fourcade, p. 140; trans. Flam, p. 70.

29. Pierre Courthion, *Le Visage de Matisse* (Lausanne: Marguerat, 1942) , pp. 84, 81.

30. Alexander Romm, *Henri Matisse*, trans. Jack Chen (New York: Lear, 1947) , p. 62; cited by Neff, "The Shchukin Panels," p. 44.

31. Quoted by Escholier, *Matisse ce vivant*, pp. 80–81.

32. See above, n. 28.

33. Charles Estienne noted in his 1909 interview with Matisse that "Matisse sounds like Puvis de Chavannes" (see above, n. 8) . See also Wattenmaker, *Puvis de Chavannes*, pp. 12–14; Neff, "Matisse and Decoration," p. 151.

34. Kostenevich, "La Danse and La Musique," pp. 511–13.

35. J. Tugëndhold, "The Salon d'Automne," *Apollon*, no. 12, 1910, p. 31, quoted by Kostenevich, "La Danse and La Musique," p. 512.

36. The Puvis replacement question is reviewed in detail by Neff, "Matisse and Decoration," p. 151. Unfavorable comparisons of Matisse's panels with Puvis's work, such as Tugëndhold's, may well have affected Shchukin's choice of a possible replacement.

37. See Yu. A. Rusakov, "Matisse in Russia in the Autumn of 1911," *Burlington Magazine*, CXVII, no. 866, May 1975, p. 288.

38. Ibid, pp. 287–88. In conclusively proving the arrival of the paintings by this date, Rusakov suggests that the letter from Shchukin to Matisse of August 22, 1912 (Barr, pp. 134–35, 555), which led Barr to assume that negotiations extended until then,

34

35

36

37

34. *The Dance*. 1910. Pencil on paper, 11 x 9 in. Private collection

35. *Nymph*, 1907. Painted ceramic tile, left panel of triptych, 23 x 15½ in. Haus Hohenhof, Hagen

36. Matisse in his studio, 1909

37. Matisse in his studio, 1909

38

39

40

38. *Composition No. II*, 1909. Watercolor on paper, 8⅝ x 11⅝ in. The Pushkin Museum, Moscow

39. *Bathers by a River*, 1916. Oil, 8 ft 7 in x 12 ft 10 in. The Art Institute of Chicago, Worcester Collection

40. *Nymph and Satyr*, 1909. Oil, 35 x 46⅛ in. The Hermitage Museum, Leningrad

is misdated. However, the date must be correct, for the first paragraph refers to Matisse's request to show *Nasturtiums and the 'Dance'* at the Salon d'Automne; it was indeed exhibited at that Salon. The reference in the letter to a "definite order for the two panels" (assumed by Barr to be *Dance* and *Music*) must have been for two other works, most likely *Amido, the Moor* and *Goldfish* (also referred to in the letter), despite the fact that they are, as Barr points out (p. 537, n. 2 to p. 134), *tableaux*, not *"panneaux."*

39. See Neff, "The Shchukin Panels," p. 44, Cf. *Henri Matisse: Dessins et sculpture,* cat. 35, and Dominique Fourcade, *Matisse au Musée de Grenoble* (Grenoble: Musée de Peinture et de Sculpture, 1975), p. 16.

40. Matisse confirmed that he made the watercolor at Sembat's request c. 1911 after painting *Dance II* (Matisse, Questionnaire VI from Alfred Barr, Mar.–Apr. 1951, Archives of The Museum of Modern Art). The drawing is reproduced here as fig. 32 and the watercolor as fig. 33.

41. The torso of the left rear figure in *Dance II* is related to that of the figure in the left wing of the triptych. See figs. 34 and 35.

42. Since the two works are of the same size this would have been a method acceptable to Matisse, who had earlier used full-size cartoons to plan important paintings. Whether *Dance II* was created in this way cannot be known for certain since Matisse often (though not always) cleaned his canvas with solvent to remove compositional elements he wished to change (Questionnaire II from Alfred Barr, Mar. 1950, Archives of The Museum of Modern Art). If it was, the photographs of Matisse in his studio shown as figs. 36, 37 may well have been taken at Issy as is traditionally supposed (Barr, p. 23) and the painting in the background is an early state of *Dance II*. However, given the fact that some areas of the painting seen in the photographs have already been filled in with color, it seems more likely that the painting is *Dance I*—which means that the photographs were taken in Paris in the spring of 1909 and that the painting *Still Life with the 'Dance'* (Barr, p. 346) seen on the easel should be redated to that period. See also below, n. 4 to *Bather,* on the question of when Matisse moved to Issy.

Bather
Cavalière, (summer 1909)
Oil on canvas, 36½ x 29⅛ in (92.7 x 74 cm)
Signed L.R.: "Henri Matisse"
Provenance: Etienne Bignou Gallery, New York
Gift of Abby Aldrich Rockefeller
Acq. no. 17.36
Ill. p. 59

1. Charles Estienne, "Entretien avec M. Henri Matisse," 1909, Fourcade, pp. 62–63; trans. Flam, p. 49.

2. Kostenevich, "La Danse and La Musique," p. 509. Of course, a two-story house could accommodate three staircase panels if one were placed at street level. Shchukin could have simply changed his mind about the scope of the commission. Matisse's

statement to Alexander Romm (letter of Jan. 19, 1934) that he had seen Shchukin's house before receiving the commission is certainly a mistake (Fourcade, p. 145; trans. Flam, p. 68).

3. The development of this work is plotted by Neff, "The Shchukin Panels," pp. 45–47, and Lisa Lyons, "Matisse: Work, 1914–1917," *Arts Magazine*, IL, no. 9, May 1975, pp. 74–75. See also below, commentary on the Backs (especially n. 30). Mme Duthuit told the author in March 1978 that Matisse did not consider the *Bathers* a completely finished painting.

4. Barr, p. 104; Sembat, "Henri Matisse," pp. 190–91. Matisse was still in Paris on June 14, 1909 (Neff, "Matisse and Decoration," pp. 115, 170a). He was established at Issy by at least September 18, for that address was given on the contract he signed with Bernheim-Jeune on that day (Barr, pp. 553–54).

5. John Lyman, "Matisse as a Teacher," *Studio International*, CLXXVI, no. 902, July–Aug. 1968, p. 3.

6. Sembat, "Henri Matisse," pp. 190–91. See also Sembat's letter of Nov. 1, 1909, quoted in Fourcade, *Matisse au Musée de Grenoble*, p. 15.

7. Paris 1970, cat. 95. For illustrations of the three works see Paris 1970, cat. 95, 96; Barr, p. 359. The drawings illustrated in Barr, p. 137, and Sembat, *Matisse et son oeuvre*, p. 13, are also presumably from the same model.

8. See Neff, "Matisse and Decoration: An Introduction," p. 85.

9. Matisse, Questionnaire I from Alfred Barr, 1945, Archives of The Museum of Modern Art.

10. Neff, "The Shchukin Panels," p. 45.

11. See below, p. 74.

12. See above, n. 9.

13. Jean Clair, ed., "Correspondance Matisse-Bonnard, 1925–1946," *La Nouvelle Revue Française*, XVIII, Aug. 1, 1970, p. 70.

La Serpentine
Issy-les-Moulineaux, (autumn 1909)
Bronze, cast no. 1 of an edition of 10; 22¼ in (56.5 cm) h., at
 base 11 x 7½ in (28 x 19 cm)
Signed, base: "Henri Matisse 1/10"
Provenance: Montross Gallery, New York; Arthur B. Davies
Gift of Abby Aldrich Rockefeller
Acq. no. 624.39
Ill. pp. 61, 62

Seated Figure, Right Hand on Ground
Paris, (autumn 1908)
Bronze, cast no. 7 of an edition of 10; 7½ x 5⅜ x 4⅜ in
 (19 x 13.7 x 11.2 cm)
Signed at rear: "7/10 HM"
Provenance: Gerald Cramer, Geneva
Abby Aldrich Rockefeller Fund
Acq. no. 198.52
Ill. p. 63

1. See Elsen, pp. 83–87.

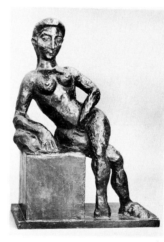

41

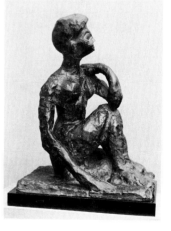

42

41. *Decorative Figure*, 1908. Bronze, 28¾ in h. The Hirshhorn Museum and Sculpture Garden, Washington

42. *Seated Nude (Olga)*, 1910. Bronze, 17 in h. Collection Mr. and Mrs. Lee V. Eastman

43

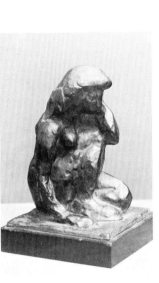

44

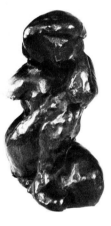

45

46

43. Photograph of a model used by Matisse in 1908 for his *Small Crouching Nude with Arms* (fig. 44)

44. *Small Crouching Nude with Arms,* 1908. Bronze, 6 in h. Private collection

45. *Small Crouching Nude without an Arm,* 1908. Bronze, 4¾ in h. The Cone Collection, Weatherspoon Art Gallery, University of North Carolina at Greensboro

46. Photograph of a model used by Matisse for *La Serpentine* (pp. 61, 62)

2. Barr, p. 126.

3. The related works of 1908 are discussed below. The reinstated right arm places it later than the other works of the series. Apparently, the original version lost its arm by accident in Paris (Margaret Potter, ed., *Four Americans in Paris* [New York: The Museum of Modern Art, 1970], p. 162). Since the series as a whole followed the *Decorative Figure,* made at Collioure in summer 1908, this must have happened in the autumn of 1908, and *Seated Figure, Right Hand on Ground* must therefore date from the end of that year.

4. Elsen, p. 46.

5. "Notes by Sarah Stein," 1908, Barr, p. 550.

6. This photograph was published by Elsen, p. 100.

7. Matisse, Questionnaire I from Alfred Barr, 1945, Archives of The Museum of Modern Art. See Barr, p. 139.

8. Barr, p. 104. *La Serpentine* is often said to have been made in the summer of 1909 at Collioure with Matisse working from a photograph because no model was available (Elsen, p. 91; William Tucker, "The Sculpture of Matisse," *Studio International,* CLXXVIII, no. 913, July–Aug. 1969, p. 26). This is clearly incorrect, for Matisse was at Cavalière, not Collioure, that summer, and he did have a model with him (see *Bather,* p. 60). Matisse himself said the sculpture was made at Issy (Questionnaire I from Alfred Barr, 1945, Archives of The Museum of Modern Art).

9. Barr, p. 139.

10. See William Tucker, "Matisse's Sculpture: The Grasped and the Seen," *Art in America,* LXIV, no. 4, July–Aug. 1975, pp. 62, 65.

11. This was suggested by Carl Goldstein in a review of Elsen's *The Sculpture of Henri Matisse* (*Art Quarterly,* XXXVI, no. 4, Winter 1973, p. 421). Jean Guichard-Meili points out that the upper center figure in *Dance II* is close in pose to *La Serpentine* (*Henri Matisse,* p. 171). The relationship of this sculpture to the Dance theme is bolstered by the fact that one of Loïe Fuller's most famous dances was *La Serpentine.* Interestingly, Matisse's friend Roger Marx wrote about Fuller (Kermode, "Poet and Dancer before Diaghilev," p. 32).

12. See above, n. 5.

13. Rosalind E. Krauss, *Passages in Modern Sculpture* (New York: Viking, 1977), p. 36; Albert E. Elsen, *Origins of Modern Sculpture: Pioneers and Premises* (New York: Braziller, 1974), pp. 16–17.

14. Escholier, *Matisse ce vivant,* pp. 163–64. It has been pointed out that the pose of *La Serpentine* can be traced back to a Pollaiuolo drawing of Adam in the Uffizi and to Piero della Francesca's *Old Age of Adam* in the church of St. Francis at Arezzo, known to Matisse (Denys Sutton, "The Sculpture of Henri Matisse," *Country Life,* Jan. 23, 1953, p. 224).

15. Elsen, pp. 97, 99.

16. Tucker, "Four Sculptors," p. 84.

17. See above, n. 10.

18. See above, n. 5. William Tucker emphasizes the way in which the looped arms of *La Serpentine* recall the handles of jugs or cups ("The Grasped and the Seen," p. 64) .

19. See Paris 1970, pp. 30–31.

Girl with Tulips (Jeanne Vaderin)
Issy-les-Moulineaux, (early 1910)
Charcoal, 28¾ x 23 in (73 x 58.8 cm)
Estate stamp L.R.: "H. Matisse"
Provenance: Mme Marguerite Duthuit, Paris; Frank Perls, Beverly Hills, Cal.
Acquired through the Lillie P. Bliss Bequest
Acq. no. 154.70
Ill. p. 65

Jeannette I
Issy-les-Moulineaux, (early 1910)
Bronze, cast no. 0 (artist's proof) of an edition of 10;
 13 x 9 x 10 in (33 x 22.8 x 25.5 cm)
Signed R. at nape of neck: "0/10 HM"
Provenance: Pierre Matisse Gallery, New York
Acquired through the Lillie P. Bliss Bequest
Acq. no. 7.52
Ill. p. 66

Jeannette II
Issy-les-Moulineaux, (early 1910)
Bronze, cast no. 2 of an edition of 10; 10⅜ x 8¼ x 9⅝ in (26.2 x
 21 x 24.5 cm)
Signed at back of head: "2/10 HM"
Provenance: Pierre Loeb, Paris
Gift of Sidney Janis
Acq. no. 383.55
Ill. p. 67

Jeannette III
Issy-les-Moulineaux, (spring and autumn 1911)
Bronze, cast no. 5 of an edition of 10; 22¾ x 10¼ x 11 in (60.3 x
 26 x 28 cm)
Signed at R. side of base: "5/10 HM"
Provenance: Pierre Matisse Gallery, New York
Acquired through the Lillie P. Bliss Bequest
Acq. no. 8.52
Ill. p. 69

Jeannette IV
Issy-les-Moulineaux, (spring and autumn 1911)
Bronze, cast no. 5 of an edition of 10; 24⅛ x 10¾ x 11¼ in
 (61.3 x 27.4 x 28.7 cm)
Signed on base, rear R. side at bottom: "5/10 HM"
Provenance: Pierre Matisse Gallery, New York
Acquired through the Lillie P. Bliss Bequest
Acq. no. 9.52
Ill. p. 70

47

48

49

47. *Girl with Tulips*, 1910. Oil, 36¼ x 28¾ in. The Hermitage Museum, Leningrad
48. *Jeannette I*, 1910. Plaster, 26 in. h. (including plaster base) . Whereabouts unknown
49. *Still Life with Plaster Bust*, c. 1915. Oil 39½ x 31¾ in. © The Barnes Foundation, Merion, Pa.

191

50

50. Picasso, *Head No. 2 (Woman)*, 1909. Brush and ink on paper, 25 x 19⅜ in. The Metropolitan Museum of Art, New York. Alfred Stieglitz Collection

Jeannette V

Issy-les-Moulineaux, (spring–summer 1913)
Bronze, cast no. 5 of an edition of 10; 22⅞ x 8⅜ x 10⅝ in (58.1 x 21.3 x 27.1 cm)
Signed rear of base on R.: "5/10 HM"
Provenance: Pierre Matisse Gallery, New York
Acquired through the Lillie P. Bliss Bequest
Acq. no. 10.52
Ill. p. 71

1. Guichard-Meili, *Henri Matisse*, p. 170.

2. E. Tériade, "Matisse Speaks," 1952, Flam, p. 134.

3. Kramer, "Matisse as a Sculptor," p. 58.

4. Barr, p. 140. See fig. 47.

5. E.g., *Girl with Green Eyes*, 1909; *Olga Merson*, 1910; *Girl with a Black Cat*, 1910. (Barr, pp. 352–54.)

6. Elsen, p. 124, observes that *Jeannette I* was only the second life-size head that Matisse had made, the first being the 1900 *Bust of an Old Woman* (Elsen, p. 115).

7. For the "serial" aspects of the Jeannettes see: Tucker, "Four Sculptors," p. 86; Schneider, "Matisse's Sculpture," pp. 25, 68–70; John Elderfield, "The Language of Pre-Abstract Art," *Artforum*, IX, no. 6, Feb. 1971, p. 49.

8. See Elsen, p. 129; Robert Goldwater, "The Sculpture of Matisse," *Art in America*, LX, no. 2, Mar.–Apr. 1972, p. 43.

9. Matisse was in Germany in the late summer of 1910 (Barr, p. 109). Pausing briefly in Paris, he went to Spain immediately after the opening of the Salon d'Automne and did not return until late January 1911 (Matisse-Camoin, p. 11; Barr, p. 143). He worked at Issy until the summer, which he spent at Collioure. For Matisse's movements during the rest of this year see n. 4 to *Goldfish and Sculpture*, p. 197. Since Jeannettes I, II, and III were exhibited in March 1912 and since Matisse did not return to Issy from Tangier until early April (Matisse-Camoin, p. 12), these sculptures must have been completed before November 1, 1911, when he left for Russia, because the return from Russia was immediately followed by the trip to Tangier.

10. Elsen, pp. 125, 129. The work was exhibited on this base on a number of occasions during Matisse's lifetime, for example at the Second Post-Impressionist Exhibition, London, Oct.–Dec. 1912, the Bernheim-Jeune Gallery, Paris, Apr. 1913, and the Montross Gallery, New York, Jan.–Feb. 1915. See fig. 48.

11. Tucker, "Four Sculptors," p. 16; John Elderfield, "Matisse Drawings and Sculpture," p. 83.

12. Elsen, p. 132.

13. Elsen, pp. 118, 132.

14. Robert Goldwater, "The Sculpture of Matisse," p. 43.

15. Since *Jeannette IV* was probably still in progress in October 1911 (as is suggested by its presence in the *Red Studio*), Matisse may well have been unwilling to commit it to the March 1912 exhibition before he left Issy on November 1, 1911. There are no circumstantial details, however, that explain why it was left out of the April 1913 exhibition, which contained a large representation of sculptural works.

16. Matisse, Questionnaire VII from Alfred Barr, July 1951, Archives of The Museum of Modern Art. The presence of what seems to be *Jeannette V* in Matisse's painting *Still Life with Plaster Bust* (fig. 49) has suggested to some that the sculpture should be dated no later than 1912, the date often given to the painting. However, the painting is clearly a later work and should probably be placed c. 1915 (cf. fig. 94, which seems to be related to it).

17. Barr, p. 142; Elsen, p. 134.

18. Goldwater, "The Sculpture of Matisse," p. 43.

19. Elsen, p. 133.

20. E.g., *Woman on a High Stool* (p. 93), and later, *The Italian Woman* (p. 109).

21. Guichard-Meili, *Henri Matisse*, p. 170.

22. Tucker, "The Grasped and the Seen," p. 62.

23. See Elsen, p. 129; Schneider, "Matisse's Sculpture," p. 25.

The Back

Issy-les-Moulineaux, (1909)
Pen and ink, 10½ x 8⅝ in (26.6 x 21.7 cm)
Signed L.R.: "Henri-Matisse"
Provenance: Heinz Berggruen, Paris
Carol Buttenweiser Loeb Memorial Fund
Acq. no. 22.69
Ill. p. 72

The Back I
Issy-les-Moulineaux, (autumn) 1909
Bronze, cast no. 2 of an edition of 10; 6 ft 2⅜ in x 44½ in x
6½ in (188.9 x 113 x 16.5 cm)
Signed L.L. front: "Henri Matisse." Scribbled in plaster to the
right and a little above signature: "H.M. 2/10 1909"
Provenance: Pierre Matisse Gallery, New York
Mrs. Simon Guggenheim Fund
Acq. no. 4.52
Ill. p. 73

Study for The Back II
Issy-les-Moulineaux, (1913)
Pen and ink, 7⅞ x 6¼ in (20 x 15.7 cm)
Signed left of center: "H. Matisse"
Provenance: Pierre Matisse, New York
Gift of Pierre Matisse
Acq. no. 104.71
Ill. p. 74

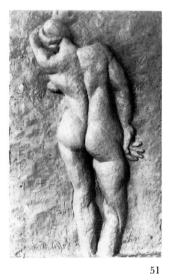

The Back II
Issy-les-Moulineaux, (autumn 1913)
Bronze, cast no. 2 of an edition of 10; 6 ft 2¼ in x 47⅝ in x 6 in
(188.5 x 121 x 15.2 cm)
Signed L.L.: "Henri Matisse"; L.R.: "HM 2/10"
Provenance: Pierre Matisse Gallery, New York
Mrs. Simon Guggenheim Fund
Acq. no. 240.56
Ill. p. 75

51

52

The Back III
Issy-les-Moulineaux, (summer 1916)
Bronze, cast no. 1 of an edition of 10; 6 ft 2½ in x 44 in x 6 in
(189.2 x 111.8 x 15.2 cm)
Signed L.L.: "Henri M."
Provenance: Pierre Matisse Gallery, New York
Mrs. Simon Guggenheim Fund
Acq. no. 5.52
Ill. p. 77

The Back IV
Issy-les-Moulineaux, (1931)
Bronze, no cast mark; 6 ft 2 in x 44¼ in x 6 in (188 x 112.4 x
15.2 cm)
Provenance: Pierre Matisse Gallery, New York
Mrs. Simon Guggenheim Fund
Acq. no. 6.52
Ill. p. 79

53

1. Elsen, pp. 182–85.

2. Ibid., p. 182, citing information provided by Mme Marguerite Duthuit.

3. Ibid., p. 174.

4. Escholier, *Matisse ce vivant,* p. 87. What may be *Back I,* or a large drawing related to it, is visible to the right in *The Pink Studio* (fig. 68).

51. *Back 0,* spring 1909. Clay, 6 ft 2 in h. As photographed by Druet

52. Courbet, *Bathers,* 1853. Oil, 7 ft 5⅜ in x 6 ft 4 in. Musée Fabre, Montpellier

53. Gauguin, *Tahitian Women on Beach,* c. 1891–92. Oil, 43¼ x 35¼ in. The Metropolitan Museum of Art, New York, Robert Lehman Collection

54

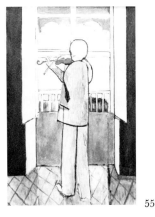

55

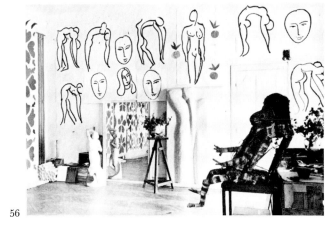

56

54. Photograph, 1913, showing transitional state of *Bathers by a River* (fig. 39)

55. *Violinist at the Window*, 1916–17. Oil, 58⅝ x 38⅜ in. Musée National d'Art Moderne, Paris

56. *Back IV* in Matisse's studio, Nice, c. 1953

5. See particularly Jack D. Flam, "Matisse's *Backs* and the Development of His Painting," *Art Journal,* XXX, no. 4, 1971, pp. 352–61.

6. Their exhibition history suggests as much, as does the way in which they were worked on directly adjacent to *Bathers by a River* (see below, n. 26). Mme Duthuit points out that for Matisse they were, in a sense, really one sculpture that passed through several stages (letter to the author, Apr. 26, 1978). When viewed in this way, the casts made of the separate states may be seen as analogous to the in-progress photographs Matisse had made of the *Bathers* at equivalent stages of its development.

7. Elsen, pp. 108–10.

8. See Schneider, "Matisse's Sculpture," p. 24. Cf. Elsen, pp. 176–80.

9. See Elsen, pp. 176–80.

10. See figs. 52, 53 and Jacobus, *Henri Matisse,* p. 55; Flam, "Matisse's Backs," pp. 353, 356. Elsen, p. 180, also draws attention to paintings by Rouault in this context.

11. Reprod. Elsen, p. 79.

12. Reprod. Elsen, p. 177.

13. Elsen, p. 183, suggests that "the signature, the fact of being photographed, and the state of the clay surface strongly argue for [*Back 0*] being a completed work in the eyes of the artist in 1909." The photograph, however, is explained both by Matisse's wish to have a record of the state in case of damage in transit to Issy (Elsen, p. 182) and by Matisse's frequent use of photographs to keep a record of works in progress (photographs were also made of the states of *Bathers by a River* after each extended session of work). (See Neff, "The Shchukin Panels," pp. 43, 46.) The signature cannot stand as evidence since no other state was signed after being completed; in fact, this original signature was all but obliterated in the later states. The state of the modeling, though highly accomplished, is more conservative than in Matisse's contemporaneous sculptures, suggesting again that *Back 0* was the realistic beginning for *Back I,* the completed "esquisse." Mme Marguerite Duthuit insists that Matisse had casts made of each of the states that satisfied him (letter to the author, Apr. 26, 1978).

14. The vertical pen strokes that stand for the paneled wall allow us to date all drawings containing them to no earlier than autumn 1909, when Matisse built the Issy studio. Elsen's comparison of The Museum of Modern Art sheet with a 1906 Marquet drawing (Elsen, p. 180) is therefore unfounded. For related drawings see: Barr, p. 141; *Henri Matisse: Dessins et sculpture,* cat. 31; *Cinquante Dessins par Henri-Matisse* (Paris: the artist, 1920), pl. II.

15. "Notes by Sarah Stein," 1908, Barr, p. 551.

16. Ibid. See also Rodin's comments on the importance of the spine, quoted by Elsen, p. 176.

17. Ibid., p. 550.

194

18. Flam, "Matisse's *Backs*," p. 253.

19. Elsen, *Origins of Modern Sculpture*, p. 141.

20. Schneider, "Matisse's Sculpture," pp. 23–24.

21. Flam, "Matisse's *Backs*," p. 354, relates *Back I* to *Carmelina*, 1903, and *Blue Nude*, 1907, and additionally sees its form of modeling as the sculptural equivalent of the harsh coloristic modeling in Fauve paintings (p. 361).

22. Matisse-Camoin, p. 16. See also the letter from Camoin [summer 1913] where Camoin asks for news of progress on the *Back*.

23. "Notes by Sarah Stein," 1908, Barr, p. 551.

24. Elsen, p. 188; Flam, "Matisse's *Backs*," p. 355.

25. Flam, "Matisse's *Backs*," p. 355.

26. The photograph was presumably taken after the period of work on this painting mentioned in the letter to Camoin (above, n. 22). The relationship of *Back II* and *Back III* to the 1913 state of *Bathers by a River* is confirmed by information from Pierre Matisse (conversation with the author, June 1978) that they were placed next to each other in Matisse's studio (see fig. 62) and worked on concurrently. Similarly, *Back III* was made in 1916 next to *Bathers by a River* in the final period of work on the painting.

27. E.g., John Golding, *Cubism: A History and an Analysis, 1907–14*, 2nd ed. (New York: Harper & Row, 1968), pls. 75, 79.

28. Golding, *Cubism*, pl. 4B.

29. Matisse, "Notes d'un peintre," 1908, Fourcade, p. 47; trans. Flam, p. 37.

30. On June 1, 1916, Matisse wrote to Hans Purrmann to say he was working on *Bathers by a River* (Barr, p. 181). Given the intimate relation of the Backs to this painting, it is reasonable to assume that he began *Back III* around the same time. It has traditionally been linked to the final state of the *Bathers;* both Mme Duthuit and Pierre Matisse have recently confirmed that they were worked on together. *Back III* and the completed *Bathers* are usually dated 1916–17. Given Matisse's travels in these years (see n. 1 to *View of Notre Dame*, p. 203), this dating implies two periods of work: June to late summer 1916 and June through August 1917. No other Back straddles two separate periods of work; the traditional dating of this one is based on the assumption that Matisse's "experimental" style extended into 1917. However, this is unproven. It now seems highly probable that the *Piano Lesson* was completed by the late summer of 1916 (see below, p. 211, n. 1). It is certain that *Bathers by a River* was completed before Matisse left Issy that autumn, for a photograph of the finished work was registered at Bernheim-Jeune's in November 1916 (Neff, "Matisse and Decoration," p. 183). Additionally, *Violinist by the Window* (fig. 55), though traditionally dated to the winter of 1917–18 (Paris 1970, cat. 156), has recently been convincingly placed to Nice, early 1917 (Jack D. Flam, "Matisse in Two Keys," *Art in America*, LXIII, no. 4, July–Aug. 1975, p. 86), a date that would make it the last of the "experimental" works painted before the return to a more naturalistic style at Issy in 1917. If, then, the "experimental" style did not carry over into 1917, it seems fair to assume that *Back III*, like the *Bathers*, was completed in 1916. Its simplifications affected the treatment of the backview figure in *Violinist by the Window*.

31. Memorandum by Alfred Barr, Archives of The Museum of Modern Art.

32. See Flam, "Matisse's *Backs*," p. 356. Comparison might also be made with the geometricism of two 1915 portrait drawings (*Henri Matisse: Dessins et sculpture*, cat. 51, 52).

33. Flam, "Matisse's *Backs*," p. 357.

34. Ibid., p. 360.

35. E.g., Elsen, pp. 154, 156, 158. See also *Tiari* (p. 137) and *Venus in a Shell I* (p. 139).

36. E. Tériade, "Visite à Henri Matisse," 1929, Fourcade, p. 98; trans. Flam, p. 59.

37. E. Tériade, "Constance du fauvisme," 1936, Fourcade, p. 128; trans. Flam, p. 74.

38. See Paris 1970, p. 24.

39. *Henri Matisse: Dessins et sculpture*, cat. 75, shows a Back study, supposedly of 1927, which might support an earlier date for *Back IV*. This drawing, however, is probably a much earlier work, as the authors of the catalog acknowledge. *Back IV* may be even later than 1931; it bears particular comparison with Matisse's Ulysses lithographs of 1935, especially with the one reproduced in Fourcade, p. 2.

40. Guichard-Meili, *Henri Matisse*, p. 180.

41. Flam, "Matisse's *Backs*," pp. 357–58.

42. Letter to Alexander Romm, Feb. 14, 1934, Fourcade, p. 146; trans. Flam, p. 68.

43. *Back IV* may have influenced the treatment of the upper left corner of *Memory of Oceania*. See below, p. 168.

View of Collioure and the Sea
Collioure, (summer 1911)
Oil on canvas, 24¾ x 20⅜ in (62.9 x 51.8 cm)
Signed L.L.: "Henri Matisse"
Provenance: Michael and Sarah Stein
Promised gift of Nelson A. Rockefeller
Ill. p. 81

1. Barr, p. 151.

2. John Russell, *The Meanings of Modern Art* (New York: The Museum of Modern Art, 1975), vol. 9, pl. 32.

3. Jack D. Flam, "Matisse in 1911: At the Cross-Roads of Modern Painting," *Actes du 22e Congrès International d'Histoire de l'Art, Budapest 1969* (Budapest: Akademiai Kiadó, 1972), II, pp. 421–30.

4. Paris 1970, cat. 88.

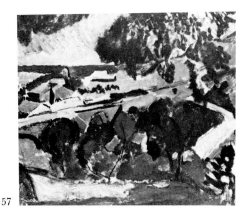

57

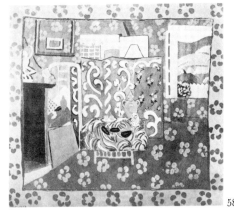

58

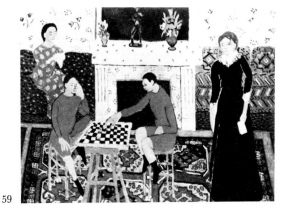

59

57. *Landscape, Collioure*, 1905. Oil, 18 x 21¾ in. Private collection, New York

58. *Interior with Aubergines*, 1911. Tempera, 6 ft 10¾ in x 8 ft ⅛ in. Musée de Peinture et de Sculpture, Grenoble

59. *The Painter's Family*, 1911. Oil, 56¼ x 6 ft 4⅜ in. The Hermitage Museum, Leningrad

5. Barnes and de Mazia, *The Art of Henri Matisse*, p. 242; Roger Fry, *Henri Matisse* (Paris: Chroniques du Jour, 1930), p. 23; Paris 1970, cat. 88.

6. Pierre Schneider was told this by a member of the Matisse family ("The *Bonheur de vivre:* A Theme and Its Variations").

7. Ernst Goldschmidt, "Strejtog i Kunsten," *Politiken*, Dec. 24, 1911. In Dominique Fourcade, "Autres Propos de Henri Matisse," *Macula*, no. 1, 1976, pp. 92–93.

8. Paris 1970, cat. 105, is also said to be from 1911, but is probably an earlier work, possibly from 1906 as Diehl has it (*Henri Matisse*, pl. 23). In a letter to Alfred Barr, July 1, 1951, Hans Purrmann, who visited Matisse at Collioure that summer, recalls that "then he painted very little from nature. I remember one view over the tree line to the ocean, all in blue, a picture that I later saw again in Germany." (Archives of The Museum of Modern Art.) He is likely referring to *View of Collioure and the Sea*, which was shown in October 1912 at the Goltz Gallery in Munich and in 1930 at the Thannhauser Gallery in Berlin.

9. Fourcade, "Autres Propos," p. 92.

10. Lawrence Gowing makes this point with reference to Matisse's 1905 Collioure paintings (*Matisse, 1869–1954,* p. 11).

Still Life with Aubergines
Collioure, (summer 1911)
Oil on canvas, 45¾ x 35⅛ in (116.2 x 89.2 cm)
Signed L.L.: "Henri Matisse"
Provenance: Mr. and Mrs. Pierre Matisse; Mrs. Marcel Duchamp
Promised gift of Mrs. Bertram Smith
Ill. p. 83

1. *Interior with Aubergines* is the subject of an important study by Dominique Fourcade: "Rêver à trois aubergines...," *Critique*, XXX, no. 324, May 1974, pp. 467–89. Hans Purrmann recalled later that at Collioure in the summer of 1911 Matisse "painted at the time in his studio a large decorative picture with a little table on which aubergines were lying. He showed me all the motifs for his pictures." (Letter to Alfred Barr, July 1, 1951, Archives of The Museum of Modern Art.) A photograph of Matisse and members of his family with an early state of *Interior with Aubergines* in the background appears in B. and E. Göpel, eds., *Leben und Meinungen des Malers Hans Purrmann* ... (Wiesbaden: Limes, 1961), pl. 22.

2. These works are extensively discussed in Matisse literature. See especially: Barr, pp. 151–54, 163; Jacobus, *Henri Matisse,* pp. 126–32; Flam, "Matisse in 1911," pp. 423–24. See also the discussion of the *Red Studio*, pp. 86–89.

3. The importance of Matisse's touch is emphasized by Clement Greenberg in "Matisse in 1966," *Bulletin: Museum of Fine Arts, Boston,* LXIV, no. 336, 1966, pp. 66–76; "Influences of Matisse," *Henri Matisse* (New York: Acquavella Galleries, 1973), n.p. Matisse warned his students against using thick paint because it "does not give light." ("Notes by Sarah Stein," 1908, Barr, p. 552.)

4. Greenberg, "Matisse in 1966," p. 73.

5. See Elsen, pp. 23–24, for Matisse's 1903 copy of this sculpture.

6. See *Music (Sketch)* (p. 53), *Dance* (p. 55), *Goldfish and Sculpture* (p. 85), *The Rose Marble Table* (p. 117).

7. André Verdet, *Prestiges de Matisse* (Paris: Editions Emile-Paul, 1952), p. 76.

8. "Notes by Sarah Stein," 1908, Barr, p. 552.

9. See Fourcade, "Rêver à trois aubergines," p. 474.

10. Theodore Reff draws attention to the Cézanne in discussing Matisse's *Still Life with a Statuette* of 1906 ("Matisse: Meditations on a Statuette and Goldfish," *Arts Magazine,* LI, no. 3, Nov. 1976, p. 109).

11. Fourcade, "Autres Propos," p. 93.

12. Ibid. It may even be suggested that Matisse's decorative rendering of flowers in this period owes something to color reproductions of this kind.

Goldfish and Sculpture
Issy-les-Moulineaux, (October 1911)
Oil on canvas, 45¾ x 39½ in (116.2 x 100.5 cm)
Signed L.L.: "Henri Matisse"
Provenance: Hans Purrmann, Berlin
Gift of Mr. and Mrs. John Hay Whitney
Acq. no. 199.55
Ill. p. 85

1. See: Eric Gustav Carlson, " 'Still Life with Statuette' by Henri Matisse," *Yale University Art Gallery Bulletin,* XXXI, no. 2, Spring 1967, pp. 5–13; and especially Reff, "Meditations," pp. 109–15.

2. Reff, "Meditations," p. 109.

3. Ibid., p. 112. A similar interpretation was also advanced by Pierre Schneider in his lecture "The *Bonheur de vivre:* A Theme and Its Variations," given at The Museum of Modern Art, March 30, 1976.

4. The dates of some of these paintings are problematic. The Museum of Modern Art painting has traditionally been dated to late 1911; given its more developed form of the transparency and geometry of *Still Life with Aubergines* (p. 83), this date seems reasonable. Matisse was still in Collioure on September 19, 1911 (see *Matiss, Zivopis, skul'ptura, grafika, pisma* [Leningrad, 1969], p. 129). He left for St. Petersburg and Moscow on November 1, 1911, returning around November 20 (Rusakov, "Matisse in Russia," pp. 285, 291), and then went to Morocco shortly afterward. A date of October 1911 therefore seems probable for this painting. The Copenhagen *Goldfish* (fig. 60) was dated by Barr to 1909 or 1910 (Barr, p. 127), but Mme Duthuit suggests 1912 (Paris 1970, p. 38), a date accepted by Copenhagen (*Matisse: En retrospektiv udstilling* [Copenhagen: Statens Museum for Kunst, 1970], cat. 33) on the grounds that it is stylistically similar to the Barnes *Goldfish* (fig. 61), dated by Barr to 1912 (Barr, p. 385). Although no documentary evidence has come to light to confirm the 1912 date of the Barnes painting, the two works

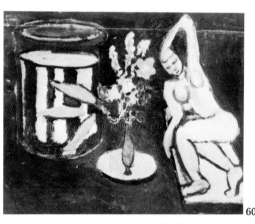

60

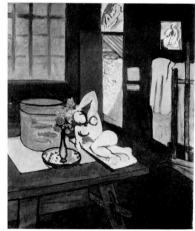

61

60. *Goldfish,* 1912. Oil, 32¼ x 36¾ in. Statens Museum for Kunst, Copenhagen, J. Rump Collection

61. *Goldfish,* 1912. Oil, 46 x 39¾ in. © The Barnes Foundation, Merion, Pa.

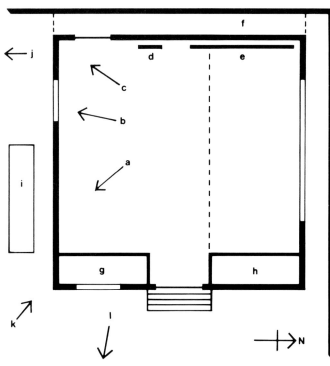

62

62. Schematic plan of Matisse's studio at Issy-les-Moulineaux. (The studio, a prefabricated structure approximately ten meters square, was built in Matisse's garden, adjacent to the boundary wall, in 1909. The northern section of the pitched roof was glazed.)

a. View shown in *The Red Studio* (p. 87)

b. View shown in *The Pink Studio* (fig. 68)

c. View shown in *Goldfish and Sculpture* (p. 85) and *Goldfish* (fig. 61)

d. Each of the Back reliefs (pp. 73, 75, 77, 79) worked on here

e. *Bathers by a River* (fig. 39) kept and worked on here

f. Covered passageway between studio and garden walls where Backs were stored

g., h. Storage areas

i. Small ornamental pool. (A second pool, seen in *The Music Lesson* [fig. 97], lay just west of the house, which itself was in the corner of the garden diagonally opposite to the studio.)

j. Gardener's hut

k. *The Blue Window* (p. 91) painted looking in this direction from the house

l. To site of the rose marble table. (See p. 117 and fig. 102.)

visible in the background of that painting seem to confirm this date. They are probably: above the door, *Nude with White Scarf*, 1909 (*Matisse: En retrospektiv udstilling*, cat. 26); and to the right, *Zorah in Yellow*, early 1912 (Barr, p. 379). This suggests a date of summer–autumn 1912 (between Matisse's two Moroccan visits) for the Barnes and Copenhagen paintings. The Pushkin *Goldfish* (Barr, p. 376) is traditionally dated 1911. Mme Duthuit accepts this date, placing the painting either in the spring or autumn of that year (Paris 1970, cat. 107). However, Shchukin wrote to Matisse on August 22, 1912, asking that the painting be delivered to him (Barr, p. 555), which suggests that it too is a 1912 work. The dates of the remaining two Goldfish paintings (both 1914) are discussed in the commentary on *Goldfish*, p. 100.

5. See Barr, p. 160.

6. Reff, "Meditations," pp. 113, 114. The Orientalism of the goldfish is confirmed by the fact that Apollinaire was led to complain in 1911 about "an awful lot of goldfish at this year's exhibitions," adding, "People say that cyprinoids are in fashion this year because of the Chinese exhibitions..." (Breunig, *Apollinaire on Art*, pp. 160–61). There were Chinese exhibitions at Bernheim-Jeune's (Matisse's dealers) in January 1911 and at the Cernuschi Museum in May.

7. Jean Puy, "Souvenirs," p. 24.

8. Greenberg, "Matisse in 1966," p. 73.

9. Schapiro, "Matisse and Impressionism," p. 28; Barnes and de Mazia, *The Art of Henri Matisse*, pp. 89, 106.

10. Barr, p. 168.

The Red Studio

Issy-les-Moulineaux, (October 1911)
Oil on canvas, 71¼ in x 7 ft 2¼ in (181 x 219.1 cm)
Signed L.L.: "Henri Matisse"
Provenance: David Tennant, England; Georges Keller, New York
Mrs. Simon Guggenheim Fund
Acq. no. 8.49
Ill. p. 87

1. Clara T. MacChesney, "A Talk with Matisse," 1912, Flam, p. 50. This interview was published in the *New York Times Magazine* on March 9, 1913. MacChesney says in it that she talked with Matisse "on a hot June day."

2. I am indebted to Pierre Matisse, on whose memories the plan of the studio (now destroyed) is based. Photographs of the interior and exterior of the studio taken in 1945 are shown here as figs. 63, 64. Although the exterior photograph shows a window to the left of the studio door, Pierre Matisse is sure that there was no window in the sections of the walls shown in the *Red Studio*. Presumably the window seen in the photograph served to admit light to the storage area, unless the storage area remembered by Pierre Matisse was added after 1911, in which case what we see to the left of the *Red Studio* is in fact a curtained window.

3. This dimension is extrapolated from the actual dimensions of the paintings shown in the *Red Studio*.

4. Fourcade, "Autres Propos," p. 92.

5. The infra-red photograph also shows that the pot with ivy was originally of the same tone as the areas surrounding it, and that the Venetian red of the figures in *Le Luxe II* was a late addition. (The grid visible on this photograph is the painting's stretcher bars.) The red watercolor of the *Red Studio* (fig. 66) was clearly made after the painting was completed.

6. E.g., Barr, pp. 349, 355, 377.

7. Paris 1970, cat. 100.

8. Louis Aragon, *Henri Matisse: A Novel* (London: Collins, 1972), II, p. 251.

9. Greenberg, *Henri Matisse*, n.p. (pl. 19).

10. "The Relevance of Matisse: A Discussion between Andrew Forge, Howard Hodgkin and Phillip King," *Studio International*, CLXXVI, no. 902, July–Aug. 1968, p. 17.

11. Matisse, "Le Chemin de la couleur," 1947, Fourcade, p. 203; trans. Flam, p. 116.

12. See fig. 67 and Fourcade, "Rêver à trois aubergines...," p. 471.

13. *Matisse: En retrospektiv udstilling*, cat. 26.

14. Barr, p. 163, states that the landscape is a Corsican painting; I have been unable to find one that it could be. If it is a later painting, it of course disallows interpretations of the *Red Studio* as an autobiographical summary of the full sweep of Matisse's earlier art.

15. Fourcade, "Autres Propos," p. 92.

16. Barr, p. 335.

17. Paris 1970, cat. 108.

18. See Neff, "Matisse and Decoration," p. 159; Fourcade, "Autres Propos," p. 92.

19. Barr, p. 341.

20. Elsen, p. 67.

21. See Neff, "Matisse and Decoration," Appendix A, no. 8.

22. See n. 4 to *Goldfish and Sculpture*, p. 197, for details of Matisse's travels summer–winter 1911, which also suggest an October 1911 date for the *Red Studio*. The fact that an interview dealing with this painting was published on December 24, 1911 ("Autres Propos," p. 92), further reinforces the October 1911 date.

23. See Carla Gottlieb, "The Role of the Window in the Art of Matisse," *Journal of Aesthetics and Art Criticism*, XXII, no. 4, Summer 1964, pp. 393–423.

24. Jack D. Flam, "Recurrent Themes in the Art of Matisse," Lecture at the Baltimore Museum of Art, Mar. 25, 1976. The importance of the downward view is also emphasized by Robert F. Reiff, "Matisse and the 'Red Studio,'" *Art Journal*, XXX, no. 2, Winter 1970–71, p. 145.

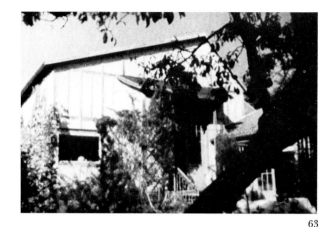

63

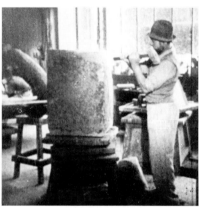

64

65

63. Exterior of the studio at Issy-les-Moulineaux, 1945
64. Photograph of the interior of the studio at Issy-les-Moulineaux, 1945, showing the artist's son Jean
65. Photograph of *The Red Studio* taken with infra-red light

66. *The Red Studio,* 1911. Watercolor and pencil on paper, 8⅝ x 10⅝ in. The Pushkin Museum, Moscow

67. *Large Nude with Necklace,* 1911 (?). Destroyed

68. *The Pink Studio,* 1911. Oil, 69¾ x 6 ft 10¼ in. The Pushkin Museum, Moscow

25. John Jacobus, "Matisse's Red Studio," *Art News,* LXXI, no. 5, Sept. 1972, p. 33.

26. Of the media that Matisse had used by 1911, only the different forms of printmaking are not represented.

27. Reiff, "Matisse and 'The Red Studio,'" pp. 144–45, compares the paintings to areas of colored glass. It is interesting to note that Matisse was involved in stained-glass design in this period. See John Hallmark Neff, "Matisse's Forgotten Stained Glass Commission," *Burlington Magazine,* CXIV, no. 837, Dec. 1972, pp. 867–70. The effect of windows against a darker ground relates the *Red Studio* to Matisse's *Studio under the Eaves,* 1903 (Paris 1970, cat. 49).

28. Matisse, "Notes d'un peintre," 1908, Fourcade, p. 50; trans. Flam, p. 38.

29. Ibid., Fourcade, pp. 43–44; trans. Flam, p. 36.

30. Léon Degand, "Matisse à Paris," 1945, Fourcade, p. 308; trans. Flam, p. 106.

31. Reff, "Meditations," p. 114.

32. The foliage patterns on the plate are also echoed in the border of the *Large Nude with Necklace,* which itself relates to the lost border of *Interior with Aubergines.* See Fourcade, "Rêver à trois aubergines . . . ," p. 479.

33. Flam, "Recurrent Themes."

34. Jacobus, "Matisse's Red Studio," p. 34.

35. E.g., Helen Franc, *An Invitation to See* (New York: The Museum of Modern Art, 1973), p. 74; Jean Laude, "Les Ateliers de Matisse," *Coloquió,* no. 18, June 1974, pp. 16–25.

36. Francis Carco, "Conversation avec Matisse," 1941, trans. Flam, p. 84.

37. Bergson, *Creative Evolution,* p. 2.

38. Ibid., p. 3.

The Blue Window
Issy-les-Moulineaux, (summer 1913)
Oil on canvas, 51½ x 35⅝ in (130.8 x 90.5 cm)
Signed L.L.: "Henri Matisse"
Provenance: Karl Osthaus; Folkwang Museum, Essen;
 Buchholz Gallery, New York
Abby Aldrich Rockefeller Fund
Acq. no. 273.39
Ill. p. 91

1. Lawrence Gowing has suggested the possible influence of willow-pattern plate decoration on Matisse's stylization of trees in this period (conversation with the author, Mar. 1978).

2. The view is from the northwest corner of the house looking north, with the large north-light windows of the studio therefore on the far side of the roof (see fig. 62). A 1911 painting from the same spot is reproduced as fig. 70. Matisse has confirmed that the building visible was his studio (Questionnaire I from Alfred Barr, 1945, Archives of The Museum of Modern Art).

3. Matisse said that the window was set over a chimney piece (Questionnaire I).

4. It is impossible to identify this sculpture from its depiction in the painting. However, it resembles an Iberian head of a veiled woman acquired by the Louvre in 1907. See *Société des Artistes Indépendants: 89ᵉ Exposition* (Paris, 1978), pp. 31–32, recording a Cubist section in this exhibition, where the work was shown.

5. It resembles the lamp to be seen in *Interior with a Top Hat*, 1896 (fig. 69).

6. Barr, p. 166, sees a yellow pincushion with black hatpins in front of the vase. However, these shapes probably denote the base and decorations of the vase itself.

7. Barr, p. 166.

8. Ibid.

9. "Matisse's Radio Interviews, 1942," Barr, p. 562.

10. Elderfield, *Fauvism,* pp. 54–56.

11. See Lawrence Gowing, *Henri Matisse: 64 Paintings* (New York: The Museum of Modern Art, 1966), p. 18.

12. Flam, p. 24, who points out that the Cézanne was part of the Camondo gift to the Louvre in 1911. However, the fact that the gift was not put on exhibition until 1914 (at the Jeu de Paume) raises questions as to the direct influence of this particular Cézanne.

13. Flam, "Matisse in 1911," p. 426.

14. Barr, p. 166, says it was first made for the couturier Paul Poiret. This, however, must have been a transcription error, for Matisse told Barr it was made for Doucet (Questionnaire I, 1945). Mme Duthuit told John Neff that Doucet was the original client (Neff, "Matisse and Decoration," p. 198).

15. Jacques Lassaigne says that it was definitely intended as such (*Matisse* [Geneva: Skira, 1959], p. 77); Jacobus suggests it as a possibility (*Henri Matisse,* pp. 31–32).

16. Matisse, Questionnaire I from Alfred Barr, 1945, Archives of The Museum of Modern Art. When Barr questioned Mme Matisse, she was unsure of the date of this work, first suggesting 1912, after Matisse's first Moroccan visit (Questionnaire VII, July 1951), then 1911, before that visit (Barr, p. 540, n. 8 to p. 514). Dr. Karl Wirth said that he remembered seeing the painting in the summer of 1911 when he was first affiliated with Osthaus's Folkwang Museum, then at Hagen (letters to Alfred Barr, March–May 1949, Archives of The Museum of Modern Art). If this were true, it would place the painting no later than the spring of 1911 (Matisse was at Collioure that summer)—a dating inconceivable on stylistic grounds. However, what Wirth probably saw, in the summer of *1912,* was another "window," a stained-glass window design that Matisse made for Osthaus (*Cresson des Indes,* in *Important Impressionist and Modern Drawings and Watercolours* [London: Sotheby, Dec. 1, 1976], lot 191), for Wirth mentions being shown the work by Osthaus in the company of Johan Thorn-Prikker, who was involved in

69

70

71

69. *Interior with a Top Hat,* 1896. Oil, 31½ x 37⅜ in. Private collection, Paris

70. *The Green Pumpkin,* 1911. Oil, 30½ x 24½ in. Museum of Art, Rhode Island School of Design, Providence, anonymous gift

71. *Portrait of Mme Matisse.* 1913. Oil, 57⅞ x 38¼ in. The Hermitage Museum, Leningrad

72

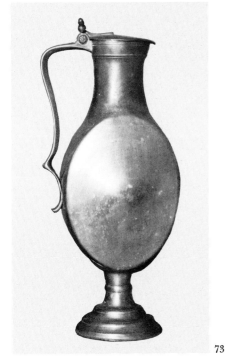

73

72. *Still Life with Lemons*, 1914. Oil, 27¾ x 21¾ in. Museum of Art, Rhode Island School of Design, Providence, gift of Miss Edith Wetmore

73. Vase depicted in *Still Life with Lemons* (fig. 72) and *Woman on a High Stool* (p. 93)

Osthaus's stained-glass projects (Neff, "Matisse's Forgotten Stained Glass Commission," p. 869).

17. The remaining works are described as follows: "Les tulipes, 1914" (whereabouts unknown); "La femme assise, 1914" (*Woman on a High Stool,* p. 93); "Les Poissons, 1914" (*Interior with Goldfish,* fig. 78); "Les citron, 1914" (*Still Life with Lemons,* fig. 72); "Dessin" (whereabouts unknown); "Dessin" (whereabouts unknown). It seems inconceivable that Matisse or his dealers could have been mistaken about these dates, given the May 1914 publication date of the magazine.

18. Barr, p. 147. Shchukin refers to this work as if it had still been in progress when he visited Matisse.

19. Ibid.

20. Shchukin wrote to Matisse on August 22, 1912, discussing the paintings he had chosen from that summer's output (Barr, p. 555). He would hardly have included among the "recent works" mentioned in the letter of October 19, 1913, paintings dating from the previous year. Matisse was in Morocco on his second visit there from December 1912 through February 1913 (Matisse-Camoin, pp. 13, 14), returning in time for his April 1913 Bernheim-Jeune exhibition of the Moroccan paintings. *The Blue Window* was therefore presumably painted between April and late September 1913.

21. See Neff, "Matisse and Decoration," pp. 192, 198, who convincingly demonstrates that this must have been the painting sent on this date. It should finally be noted that Osthaus's exhibition "Moderne Kunst: Plastik, Malerei, Graphik" (Hagen: Museum Folkwang, July 1912) included his Matisses, but not the *Blue Window.*

Woman on a High Stool
Paris, (early 1914)
Oil on canvas, 57⅞ x 37⅝ in (147 x 95.5 cm)
Signed L.L.: "Henri Matisse"
Given anonymously, donor retaining life interest
Acq. no. 506.64
Ill. p. 93

1. Barr, p. 158.

2. Barr, p. 183; Matisse-Camoin, p. 15, letter of [Nov. 1913].

3. Matisse-Camoin, p. 15, letter of [Nov. 1913].

4. Ibid. Matisse had taken a studio in Paris in autumn 1913. See n. 1 to *View of Notre Dame,* p. 203.

5. It was reproduced in *Les Soirées de Paris,* no. 24, May 15, 1914. It was the last of the paintings by Matisse to be purchased by Shchukin, but was never delivered to him because of the outbreak of World War I.

6. See John Golding, *Cubism: A History and an Analysis, 1907–1914,* 2nd ed. (New York: Harper & Row, 1968), p. 100.

7. Schapiro, "Matisse and Impressionism," p. 33; Gowing, *64 Paintings,* p. 19.

8. E.g., Barr, pp. 392, 395, 403–5.

9. Barr, p. 184. In view of the formal analogy here, it is interesting to note that the vase reappears (this time complete with its handle) in another drawing within a painting, entitled *Still Life with Lemons Which Correspond in their Forms to a Drawing of a Black Vase upon the Wall* (fig. 72). This is contemporaneous with *Woman on a High Stool*, being also illustrated in *Les Soirées de Paris* in May 1914. The vase itself is shown here as fig. 73. It also appears in *Vase of Anemones*, 1918 (San Francisco Museum of Art).

10. Barr, p. 184.

View of Notre Dame
Paris, (spring 1914)
Oil on canvas, 58 x 37⅛ in (147.3 x 94.3 cm)
Signed L.L. corner: "H. Matisse"
Provenance: Pierre Matisse Gallery, New York
Purchase
Acq. no. 116.75
Ill. p. 95

1. When Matisse lived and worked in Paris in this period, he would spend the entire winter season there without returning to Issy to paint, although it was only on the outskirts of the city. (Conversation with Pierre Matisse, June 1978.) His practice of dividing the year between two principal places of work (characteristic of the earlier years divided between Issy and Collioure) thus continued through the period of World War I. Since knowledge of Matisse's movements helps us to accurately date his paintings, a chronology for the years 1913 through 1917 is given here:

Matisse was back in France after his second trip to Morocco on February 27, 1913 (Matisse-Camoin, p. 14). He worked in Issy until around the end of October (Matisse-Camoin, pp. 15–16; Barr, p. 147), when he paid a short visit to Collioure (Matisse-Camoin, p. 16). By November 1913 he had established his Paris studio and worked there through to July or August 1914 (Matisse-Camoin, p. 15; *Henri Matisse: Dessins et sculpture*, cat. 45). He then returned to Issy until September 1, when he traveled to Bordeaux, Toulouse, and Collioure, arriving there September 10 (Barr, p. 178). In October he returned to Paris (Matisse-Camoin, p. 17; Barr, pp. 178–79) and remained there through the spring of 1915 except for a short visit to Arcachon (Barr, p. 181). The summer and autumn of 1915 were spent at Issy, and Matisse was still there on November 22 but shortly afterward left for Marseilles for a week there with Marquet (Matisse-Camoin, pp. 18–19). January 1916 was spent in Paris (Escholier, *Matisse ce vivant*, pp. 112–13), and Matisse remained there through to the spring. He was at Issy no later than June 1 and probably a month earlier (Barr, p. 181) and stayed there through to the autumn except for a visit to L'Estaque (Matisse-Camoin, p. 19; *Henri Matisse: Dessins et sculpture*, cat. 48) and (in August or September) to Marseilles with Marquet (Matisse-Camoin, p. 19). The autumn was spent in Paris. Toward the end of the year, Matisse went to L'Estaque and from there traveled to Nice for the months of January through May 1917 (Barr, pp. 183, 195; Flam, p. 134). June

74

75

76

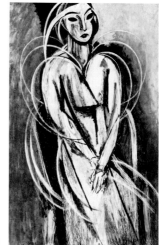

77

74. View of Notre Dame from the window of Matisse's studio on the Quai Saint-Michel, Paris

75. *Notre Dame in the Late Afternoon*, 1902. Oil, 28½ x 21½ in. Albright-Knox Art Gallery, Buffalo, gift of Seymour H. Knox

76. *Notre Dame*, 1914. Oil, 57⅞ x 37 in. Private collection, Switzerland

77. *Portrait of Mlle Yvonne Landsberg*, 1914. Oil, 57¼ x 42 in. Philadelphia Museum of Art, Louise and Walter Arensberg Collection

through August 1917 was spent at Issy (Barr, p. 543) and September through November in Paris. In December, Matisse went with Marquet to Marseilles, from where he went on to Nice, staying there through the spring of 1918 (Matisse-Camoin, pp. 20–22; Barr, p. 196).

2. This particular Paris sojourn stretched from November 1913 to at least July 1914 (see above, n. 1). It is unlikely that *View of Notre Dame* predates any of the works published in *Les Soirées de Paris* in May 1914 (see n. 17 to *The Blue Window*, p. 202). The level of abstraction and the technique of the painting relate it to *Mlle Yvonne Landsberg* (fig. 77), for which at least one drawing dates to Paris, July 1914 (p. 97). Given the juxtaposition of rectilinear grid and diagonals in *View of Notre Dame*, it is interesting to note that Matisse wrote to André Rouveyre on October 18, 1947: "Je suis arrivé à posséder le sentiment de l'horizontale et de la verticale de façon à rendre expressives les obliques qui en résultent, ce qui n'est pas facile..." (Paris 1970, p. 39).

3. The close proximity of the two works was emphasized by Mme Marguerite Duthuit (conversation with the author, Mar. 1978).

4. See above, n. 2.

5. In particular, it anticipates Robert Motherwell's "Open" series of paintings of 1967 ff.

Yvonne Landsberg
Paris, July 1914
Pen and ink, 25⅝ x 17⅞ in (65 x 50.2 cm)
Signed L.R.: "Henri-Matisse/Juillet 1914"
Provenance: Frank Perls, Beverly Hills, Cal.
Alva Gimbel Fund
Acq. no. 1576.68
Ill. p. 97

Yvonne Landsberg
Paris, August 1914
Pencil on tracing paper, 11⅛ x 8½ in (28.2 x 21.7 cm)
Signed L.R.: "Henri-Matisse Aout 1914"
Provenance: Albert Clinton Landsberg; Mr. and Mrs.
 Gray Taylor, Greenwich, Conn.; Stephen Hahn, New York
Gift of The Lauder Foundation, Inc.
Acq. no. 436.74
Ill. p. 97

1. Barr, p. 184.

Woman in a Kimono (The Artist's Wife)
(1914)
Etching, 6⁵⁄₁₆ x 2⅜ in (16 x 6 cm) (Pl. E.13)
Abby Aldrich Rockefeller Fund
Acq. no. 503.49
Ill. p. 98

Marguerite in a Kimono
(1915)
Etching, 7¹¹⁄₁₆ x 4¼ in (19.6 x 10.7 cm) (Pl. E.43)
Purchase
Acq. no. 349.51
Ill. p. 98

Walter Pach
(1914)
Etching, 6⅜ x 2⅜ in (16.1 x 6.1 cm) (Pl. E.33)
Purchase
Acq. no. 43.51
Ill. p. 98

Double Portrait: Mme Juan Gris
(1915–16)
Etching, 5¹⁄₁₆ x 7¹⁄₁₆ in (12.9 x 17.9 cm) (Pl. E.32)
Abby Aldrich Rockefeller Fund
Acq. no. 504.49
Ill. p. 99

Yvonne Landsberg
(1914)
Etching, 7⅞ x 4⁵⁄₁₆ in (20 x 11 cm) (Pl. E.16)
Gift of Mr. and Mrs. E. Powis Jones
Acq. no. 111.56
Ill. p. 99

Charles Bourgeat
(1914)
Etching, 7⅛ x 5¹⁄₁₆ in (18 x 12.8 cm) (Pl. E.23)
Acquired through the Lillie P. Bliss Bequest
Acq. no. 30.48
Ill. p. 99

1. For additional information on the etchings as well as on Matisse as a printmaker and illustrator of books, see William S. Lieberman, *Henri Matisse: Fifty Years of His Graphic Art* (New York: Braziller, 1956).

2. Walter Pach, *Queer Thing, Painting* (New York: Harper, 1938), pp. 219–20.

Goldfish
Paris, (winter, 1914–15)
Oil on canvas, 57¾ x 44¼ in (146.5 x 112.4 cm)
Signed L.R.: "Henri Matisse"
Provenance: Jacques Doucet, Paris; César M. de Hauke;
 Pierre Matisse Gallery, New York
Given anonymously, donor retaining life interest
Acq. no. 507.64
Ill. p. 101

1. See n. 4 to *Goldfish and Sculpture*, pp. 197–98, for details of the earlier works in the series.

2. They were illustrated together in *Les Soirées de Paris* in May 1914. See n. 17 to *The Blue Window*, p. 202.

3. Daniel-Henry Kahnweiler, *Juan Gris: His Life and Work* (New York: Abrams, n.d.), p. 26.

4. Barr, p. 178; Lisa Lyons, "Matisse: Work, 1914–1917," *Arts Magazine*, IL, no. 9, May 1975, p. 74.

5. *Les Soirées de Paris*, no. 18, Nov. 1913; ibid., no. 19, Dec. 1913.

6. See n. 17 to *The Blue Window*, p. 202

7. Barr, p. 187, describes the visit by Metzinger and Severini, which was made shortly after the completion of *Still Life with Lemons*, now known to date from spring 1914 (see n. 17 to *The Blue Window*, p. 202). For Raynal and Gris, see n. 6 to *Woman on a High Stool*, p. 202.

8. Barr, p. 179.

9. Matisse-Camoin, p. 19 (erroneously dated [1916–Paris]).

10. I am grateful to Mme Camoin, who, through the good offices of Pierre Schneider, supplied me with a copy of this postcard.

11. A photograph of the work was registered with Matisse's dealer, Bernheim-Jeune, in June 1915 (Mme Marguerite Duthuit, letter to the author, Mar. 30, 1978). This clearly disproves a 1916 date for the postcard to Camoin

12. E.g., Lyons, "Matisse: Work, 1914–1917," p. 74.

13. Five collages by Picasso were illustrated in *Les Soirées de Paris*, no. 18, Nov. 1913 (the issue in which Matisse's *Mme Matisse* was praised), and eight works by Braque, including *papiers collés*, in no. 23, Apr. 15, 1914. Gleizes's *Les Bateaux de pêche* (in no. 19, Dec. 1913) is an equally relevant precedent for Matisse's work as the often-cited Gris.

14. Again, a group of Léger illustrations in *Soirées de Paris* (no. 26–27, July–Aug. 1914) may well have been known to Matisse. In any case, he could hardly have missed Cubist work in Paris exhibitions. In November 1913, he referred to the Cubists' presence at the Salon d'Automne of that year (Matisse-Camoin, p. 15).

15. Reff, "Meditations," p. 113.

Seated Nude
(1913–14)
Drypoint, $5^{11}/_{16}$ x $3^{15}/_{16}$ in (14.5 x 10 cm) (Pl. E.48)
Purchase
Acq. no. 50.51
Ill. p. 102

Black Eyes
(1914)
Transfer lithograph, $17^{7}/_{8}$ x $12^{3}/_{4}$ in (45.3 x 32.6 cm) (Pl. L.18)
Gift of Mrs. Saidie A. May
Acq. no. 39.32
Ill. p. 103

78

79

78. *Interior with Goldfish*, 1914. Oil, $56^{3}/_{4}$ x $38^{5}/_{8}$ in. Musée National d'Art Moderne, Paris

79. Compositional sketch for *Goldfish* (p. 101), 1914

80

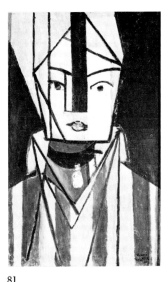

81

82

83

80. Dürer, *St. Jerome in His Study*, reproduced on postcard to Camoin, 1914

81. *Head, White and Rose*, 1915. Oil, 29 x 17⅜ in. Musée National d'Art Moderne, Paris

82. Gris, *Glass of Beer and Playing Cards*, 1913. Oil and cut paper on canvas, 20⅝ x 14¼ in. Columbus (Ohio) Gallery of Fine Arts, Ferdinand Howald Collection

83. Gris, *Man in the Café*, 1912. Oil, 50½ x 35⅝ in. Philadelphia Museum of Art, Louise and Walter Arensberg Collection

Seated Nude, Seen from the Back
(1914)
Transfer lithograph, 16⅝ x 10⅜ in (42.3 x 26.4 cm) (Pl. L.19)
Gift of Abby Aldrich Rockefeller
Acq. no. 458.61
Ill. p. 103

Torso
(1915–17)
Monotype, 6¹⁵⁄₁₆ x 5¹⁄₁₆ in (17.6 x 12.8 cm)
Frank Crowninshield Fund
Acq. no. 5.45
Ill. p. 104

Standing Nude, Face Half-Hidden
(1914)
Transfer lithograph, 19¾ x 12 in (50.3 x 30.5 cm) (Pl. L.15)
Frank Crowninshield Fund
Acq. no. 6.45
Ill. p. 104

1. *Gray Nude with Bracelet*, 1913, M. J. Muller collection, Soleure, reprod. Paris 1970, cat. 120. The drypoints are: *Nude with Bracelet, Seated upon a Cane Chair, Legs Crossed* (Pl. E.46, Pully 24), *Standing Nude* (Pl. E.47), and *Seated Nude* (Pl. E.48).

2. Henri Matisse, "Notes d'un peintre sur son dessin," *Le Point,* no. 21, July 1939, pp. 104–10; trans. Flam, p. 81.

3. Letter to the author from Mme Marguerite G. Duthuit, Mar. 7, 1978.

4. Albert Clinton Landsberg, quoted in Barr, p. 541, n. 4.

Variation on a Still Life by de Heem
Issy-les-Moulineaux, (late 1915)
Oil on canvas, 71¼ in x 7 ft 3 in (180.9 x 220.8 cm)
Signed L.R.: "Henri Matisse"
Provenance: Léonce Rosenberg; Henri Matisse; Georges Bernheim; John Quinn; Mrs. John Alden Carpenter, Chicago
Given anonymously, donor retaining life interest
Acq. no. 508.64
Ill. p. 105

1. Greenberg, "Matisse in 1966," p. 67.

2. Ibid.

3. The *Head, White and Rose* of 1915 (fig. 81) also falls into this category.

4. Jacobus, *Henri Matisse,* p. 36.

5. E. Tériade, "Matisse Speaks," 1951, Flam, p. 132.

6. Barr, p. 33, reports that Matisse bought back his 1893 copy from the Louvre in this period. His informant was Pierre Matisse. However, Pierre Matisse recently told the author that Barr misunderstood what he told him, which was that Matisse was forced to buy back the 1915 de Heem variation from Léonce Rosenberg in 1916 because Rosenberg decided he did not like

the painting after all. The 1893 copy was never sold to the Louvre, but remained in Matisse's possession.

7. Matisse-Camoin, p. 18. Letter of Nov. 22, 1915; letter to André Derain, late Jan. or early Feb. 1916, in Escholier, *Matisse ce vivant*, pp. 112–13. For the importance of the Galerie de l'Effort Moderne see Christopher Green, *Léger and the Avant-Garde* (New Haven and London: Yale University Press, 1976), pp. 130–31, 135 ff. In Rosenberg's "Curriculum vitae de l'Effort Moderne" (*Bulletin de l'Effort Moderne*, no. 1, Jan. 1924), he lists Matisse as associated with him in 1912. This, however, may well mean no more than that he purchased a work from Matisse that year.

8. Letter to André Derain, late Jan. or early Feb. 1916, in Escholier, *Matisse ce vivant*, p. 113.

9. It is interesting to note in this context that *Les Soirées de Paris*, no. 22, Mar. 15, 1914, ran an article by Giovanni Papini on "Deux Philosophes" dealing with Bergson and Croce.

10. See Elderfield, *Fauvism*, p. 124.

11. E. Tériade, "Matisse Speaks," 1951, Flam, p. 134.

12. Sembat, *Matisse et son oeuvre*, p. 11. Sembat also notes (p. 10): "Il regarda les toiles cubistes avec une sympathie qu'il ne cacha pas. Il aima leur effort, les accueillit, les écouta."

13. See above, n. 11.

14. Elizabeth Kahn Baldewicz, "Making Art at the Front: Cubism and the First World War in France." Paper delivered at the 20th Century Session of the 1978 College Art Association Meeting, New York.

15. See Matisse-Camoin, pp. 17–22.

16. Matisse-Camoin, p. 17. Letter of [autumn 1914].

17. See Golding, *Cubism*, p. 100–1.

18. The treatment of drapery also bears comparison with Gris's 1912 painting, *Le Lavabo* (Golding, *Cubism*, pl. 55A).

19. See Golding, *Cubism*, pp. 130–31; William Camfield, "Juan Gris and the Golden Section," *Art Bulletin*, XLVIII, no. 1, Mar. 1965, pp. 128–34.

20. These drawings (one inscribed "1915") are discussed by Victor Carlson in *Matisse as a Draughtsman*, cat. 28, 29, and in his "Some Cubist Drawings by Matisse," *Arts Magazine*, XLV, no. 5, Mar. 1971, pp. 37–39.

21. Matisse, "Jazz," 1947, Fourcade, p. 237; trans. Flam, p. 112.

22. Quoted by Escholier, *Matisse ce vivant*, pp. 80–81.

23. Escholier, *Matisse ce vivant*, p. 106, quoting from Lhote's *La Peinture* (1933). Matisse himself made a similar statement in 1949. See R. W. Howe, "Half-an-Hour with Matisse," 1949, Flam, p. 123.

24. R. W. Howe, "Half-an-Hour with Matisse," Flam, p. 123.

84

85

86

84. Jan Davidsz de Heem, *The Dessert*, 1640. Oil, 58⅝ in x 6 ft 8 in. Musée du Louvre, Paris

85. Copy after *The Dessert* by de Heem (fig. 84), 1893. Oil, 28⅞ x 39½ in. Musée Matisse, Nice-Cimiez

86. Gris, *Composition with Watch*, 1912. Oil, 25⅝ x 36¼ in. Private collection, Basel

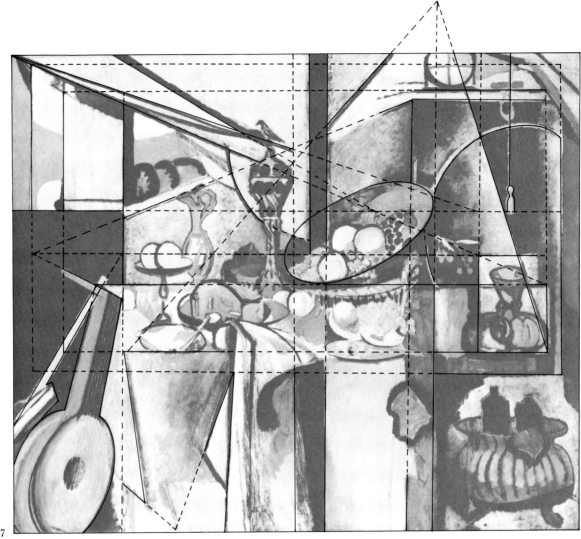

87

88

89

87. Compositional analysis of *Variation on a Still Life by de Heem* (p. 105)

88. *Still Life,* 1915. Pencil on paper, 20⅝ x 21¾ in. Philadelphia Museum of Art, Louise and Walter Arensberg Collection

89. *Still Life after de Heem,* 1915. Pencil on paper, 14¾ x 11 in. Musée Matisse, Nice-Cimiez

The Italian Woman
Paris, (early 1916)
Oil on canvas, 46 x 35¼ in (116.6 x 89.6 cm)
Signed L.R.: "Henri Matisse"
Provenance: John Quinn; Earl Horter, Philadelphia;
 Dr. and Mrs. L. M. Maitland, Beverly Hills;
 Ruth McC. Maitland, Santa Barbara
Gift of Nelson A. Rockefeller
Acq. no. 635.77
Ill. p. 109

1. These include Barr, pp. 227, 412–17; Paris 1970, cat. 133, 146, 149.

2. These works are illustrated in Barr, pp. 404–5. The photograph, which appeared originally in *Le Point*, XXI, July 1939, p. 38, also shows, on the wall to the right, a portrait of Marguerite Matisse.

3. Figure-ground interchanges in Matisse's work are stressed by Pierre Schneider in *Henri Matisse*, forthcoming.

4. Schneider, op. cit., who refers especially to *Still Life in Venetian Red*, 1908, and *Coffee Pot, Carafe, and Fruit Dish*, 1909 (Barr, pp. 343, 346).

5. Schapiro, "Matisse and Impressionism," p. 33.

6. Flam, "Matisse in 1911," p. 426. Elsen, p. 113, suggests the additional possibility that Matisse's experience of segmenting figures in his sculptures may have had some influence on paintings of this kind.

The Moroccans
Issy-les-Moulineaux, (November 1915 and summer 1916)
Oil on canvas, 71⅜ in x 9 ft 2 in (181.3 x 279.4 cm)
Signed L.R.: "Henri Matisse"
Gift of Mr. and Mrs. Samuel A. Marx
Acq. no. 386.55
Ill. p. 111

Gourds
Issy-les-Moulineaux, (summer) 1916
Oil on canvas, 25⅝ x 31⅞ in (65.1 x 80.9 cm)
Signed L.L.: "Henri Matisse 1916"
Provenance: Paul Guillaume; Léonide Massine
Mrs. Simon Guggenheim Fund
Acq. no. 109.35
Ill. p. 113

1. See Barr, pp. 145, 160.

2. Writing from Cassis in the summer of 1913, Camoin asks Matisse about his "motif de la plage à Tanger," which was possibly Matisse's first conception of this painting. (Matisse-Camoin, p. 16.)

3. Matisse-Camoin, p. 16, letter of Sept. 15, 1913.

4. Matisse-Camoin, p. 18. I am grateful to Mme Camoin who, through the good offices of Pierre Schneider, supplied me with a copy of this letter. It contains an additional sketch to that shown

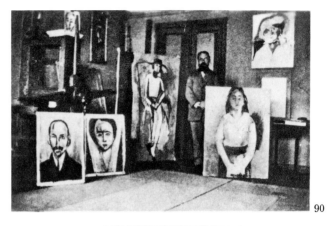

90

91

92

90. Matisse in his studio, Paris, 1916

91. *Arab Café*, 1912–13. Oil, 69¼ in x 6 ft 10¾ in. The Hermitage Museum, Leningrad

92. Sketch for *The Moroccans* (p. 111) in Matisse letter to Camoin dated November 1915

209

93

94 95 96

93. X-ray photograph of *The Moroccans* (p. 111)

94. *Still Life with Oriental Bowl*, 1915. Pencil on paper, 29⅛ x 21¼ in. Private collection

95. Picasso, *Harlequin*, 1915. Oil, 72¼ x 41⅜ in. The Museum of Modern Art, New York, acquired through the Lillie P. Bliss Bequest

96. Charles Dufresne, *Moroccan Scene*, c. 1910–12 (?). Oil, 24½ x 31¾ in. Whereabouts unknown

in fig. 92, a detail of the reclining Arab at the center of the composition.

5. It is difficult to be sure whether or not the dark circular forms visible below the shoulders of the figure on the X-ray photograph indicate the presence of breasts in an early state of this figure. If so, the figure was clearly shown facing front at first.

6. Matisse, Questionnaire I to Alfred Barr, 1945, Archives of The Museum of Modern Art.

7. Barr, p. 173.

8. The X-ray also shows a sequence of vertical forms (possibly indicating windows) along the top of the painting similar to those visible in the sketch.

9. Barr, p. 173.

10. Reprod. Barr, p. 386.

11. Memorandum by Alfred Barr, Archives of The Museum of Modern Art.

12. Barr, p. 173.

13. Ibid.

14. Matisse-Camoin, p. 18.

15. Barr, pp. 181–82.

16. Barr, p. 406.

17. Barr, p. 411. Matisse included a sketch of this painting in the letter to Purrmann (see Barr, p. 182).

18. Matisse-Camoin, p. 16.

19. This date was provided by Matisse, Questionnaire I from Alfred Barr, 1945, Archives of The Museum of Modern Art. A drawing possibly related to this work is shown as fig. 94.

20. Questionnaire I, 1945.

21. Barr, p. 190.

22. Hilton Kramer, *The Age of the Avant-Garde* (New York: Farrar, Straus & Giroux, 1973), p. 181.

23. Trapp, "The Paintings of Henri Matisse," p. 212.

24. Letter to André Derain, late Jan. or early Feb. 1916. In Escholier, *Matisse ce vivant*, pp. 112–13.

25. "The Relevance of Matisse," p. 10.

26. Matisse-Camoin, p. 15, letter of [Nov. 1913]. Matisse specifically refers to "un tableau de 15 m au moins de Odler [*sic*]" as being "la chose la plus grande" in the Salon d'Automne. He must be referring to Hodler's *Unanimité*, which Apollinaire also picked out for special (but unfavorable) mention in his review of the exhibition (Breunig, *Apollinaire on Art*, p. 324).

27. Jack Flam has compared *Back III*, made at the same time as *The Moroccans*, both to the lower right figure in *The Moroccans* and to a Gauguin Tahitian painting shown here as fig. 53 (Flam, "Matisse's *Backs*," p. 356).

28. Matisse, "On Modernism and Tradition," 1935, Flam, p. 72.

See also Matisse-Camoin, pp. 17–18, letter of [autumn 1914], where Matisse discusses at length a Seurat he had just seen at Bernheim-Jeune.

29. Matisse-Camoin, p. 19. (There erroneously dated "19–1–1916"; inspection of a copy of the original letter shows this to be a misreading of "19–7–1916.")

30. See Matisse-Camoin, pp. 14–16.

31. I am indebted to John Golding for bringing the Dufresne to my attention.

32. Matisse, "Le Noir est une couleur," 1946, Fourcade, p. 203; trans. Flam, p. 107.

33. Ibid.; trans. Flam, p. 106.

34. Ibid.

Piano Lesson
Issy-les-Moulineaux, (late summer 1916)
Oil on canvas, 8 ft ½ in x 6 ft 11¾ in (245.1 x 212.7 cm)
Signed L.L.: "Henri Matisse"
Provenance: Paul Guillaume, Paris; Walter P. Chrysler, Jr.,
 New York
Mrs. Simon Guggenheim Fund
Acq. no. 125.46
Ill. p. 115

1. The date of this painting, as well as its relation to that of the *Music Lesson* (fig. 97), has been the subject of much discussion. Barr, pp. 174, 193, reviews the conflicting statements made by members of the Matisse family. A 1917 postcard from Matisse to Camoin (Matisse-Camoin, p. 20) conclusively shows that the *Piano Lesson* was painted first. This postcard was written shortly after Matisse had completed the *Music Lesson* and just before Jean Matisse was inducted into the army. Mme Marguerite Duthuit is sure that the latter event took place in August 1917 (conversation with the author, Mar. 1978). Moreover, she confirms Pierre Matisse's statement (Barr, p. 193) that the *Piano Lesson* was painted late in 1916 (letter to the author, Mar. 30, 1978). However, the *Piano Lesson* was clearly painted at Issy. If it was painted in 1916, it can date no later than the late summer of that year before Matisse moved to Paris for the winter and then traveled to Nice, returning to Issy in June 1917. (See n. 1 to *View of Notre Dame*, p. 203, for details of his travels in this period.) Since part of the postcard to Camoin is mistranscribed in Matisse-Camoin, p. 20, the relevant passage is given here from a copy of the original, exactly as Matisse wrote it: "Je viens de faire une grande toile de plus de 2 m sur 2 m c'est celle qui était dans mon salon avec Pierre au piano—que j'ai reprise sur une autre toile en y joignant son frère, sa soeur et sa mère—" The reverse of the postcard shows a detail from Rubens' *The Landing of Marie de Médicis* in the Louvre (fig. 98), which may be relevant to the appearance of the enlarged version of *Reclining Nude I* beside the pool in the *Music Lesson*.

2. This point is often made, but never better than in Jack D. Flam, "Matisse in Two Keys," *Art in America*, LXIII, no. 4, July–Aug. 1975, pp. 83–86, to which I am indebted here.

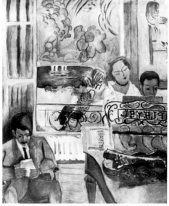

97

98

99

97. *The Music Lesson,* 1917. Oil, 8 ft x 6 ft 10½ in. © The Barnes Foundation, Merion, Pa.

98. Detail from Rubens, *Landing of Marie de Médicis,* reproduced on postcard to Camoin, 1917

99. Copy after *The Music Lesson* by Fragonard, 1893. Oil, 33⅛ x 41 in. Collection Mme Andrée Legrand and Suzanne Lefour, M. Louis Lefour

3. Reff, "Meditations," p. 115.

4. Marcelin Pleynet draws attention to these misreadings in "Le Système de Matisse," pp. 83 and 97, n. 120.

5. Reff, "Meditations," p. 115.

6. Escholier surprisingly questions the date of the painting for this reason (*Matisse ce vivant,* p. 175).

7. Reff, "Meditations," p. 115.

8. Judging from pentimenti in the shape of a grid in the window area, the window was probably shown closed in an earlier state. The right half of the window (marked by the vertical division of green and gray in the balustrade section) was originally the same salmon pink as the vertical band above the pianist's head, as was much of the right-hand section of the work. The left edge of the piano originally extended farther toward the center of the work. Pierre Matisse has confirmed that Matisse scraped out large areas of the picture two or three times before arriving at the final composition (conversation with the author, June 1978).

9. Barr, p. 174.

10. E.g., *The Open Window, Collioure* (Barr, p. 73). See also the ivy that crosses the doorway in *Goldfish and Sculpture* (p. 85).

11. Flam, "Matisse in Two Keys," p. 83, who points out that continuous arabesque patterns often have this function in Matisse's art.

12. Ibid.

13. See above, n. 1.

14. Jacobus, *Henri Matisse,* p. 150.

15. Flam, "Matisse in Two Keys," p. 85.

16. Guichard-Meili, *Henri Matisse,* p. 86.

17. Gowing, *Matisse, 1869–1954,* p. 36.

18. Although the casual, relaxed mood of the *Music Lesson* speaks more explicitly of domestic contentment, its "illustrative" presentation expresses the artist's estrangement from what he pictures. He is absent from the family group, outside the space of the painting—and therefore distanced from it—setting down the scene in a detached, realistic way. What is more, the family seems quite oblivious of the Matissean pastoral garden, complete with voluptuous nymph (an enlarged version of *Reclining Nude I* of 1906–07), that can be seen through the window. Whether this expresses, as Pierre Schneider suggests (*Henri Matisse,* forthcoming), Matisse's anticipation of the imminent breakup of the close-knit family (the picture had to be painted quickly before the elder son, Jean, left for the army, soon to be joined by his brother) or even, as Jack Flam suggests ("Matisse in Two Keys," pp. 83, 86), Matisse's sense of alienation from his family (when he moved to Nice that winter, he moved there alone), it certainly reflects personal as well as artistic change.

The Rose Marble Table
Issy-les-Moulineaux, (summer 1917)
Oil on canvas, 57½ x 38¼ in (146 x 97 cm)
Signed L.R.: "Henri Matisse"
Provenance: Alphonse Kann
Mrs. Simon Guggenheim Fund
Acq. no. 554.56
Ill. p. 117

1. E.g., Barr, p. 406; Paris 1970, cat. 138, 141, 142.

2. Barr, p. 194.

3. The term is Jane Livingston's in her "Matisse's 'Tea,'" *Los Angeles County Museum of Art Bulletin*, XX, no. 2, 1974, p. 51.

4. Matisse was later to develop this effect in some of his paper cutouts. See p. 167.

5. See Livingston, "Matisse's 'Tea,'" p. 50, quoting Jean Matisse on the topography of the Issy garden.

6. This comparison was pointed out by Helmut Ripperger in a letter to Alfred Barr, May 25, 1959, Archives of The Museum of Modern Art.

7. Notably in *Tea*, 1919 (fig. 101), and *A Summer Afternoon*, 1919 (*Matisse, 1869–1954*, cat. 81). Mme Marguerite Duthuit implies that there are other studies of this table (Livingston, "Matisse's 'Tea,'" p. 50). The *Rose Marble Table* itself is pictured in the right panel of the *Three Sisters* triptych, completed autumn 1917 (fig. 102).

8. Kenneth Clark, *Landscape Painting* (New York: Scribner's, 1950), p. 9, discussing the Cologne School work.

Interior with a Violin Case
Nice, (winter 1918–19)
Oil on canvas, 28¾ x 23⅝ in (73 x 60 cm)
Signed L.R.: "Henri Matisse"
Provenance: Etienne Bignou, Paris
Lillie P. Bliss Collection
Acq. no. 86.34
Ill. p. 119

1. Barr, p. 544 (n. 3 to p. 204).

2. Barr, p. 205, comparing this work with the Copenhagen *Interior with a Violin* (Barr, p. 421), which he dates to winter 1917–18, Hôtel Beau Rivage, Nice. It seems likely, however, that the Copenhagen painting was made in the early summer of 1918 (see Fourcade, "Autres Propos," p. 94) and therefore shows a room at the Villa des Alliés in Nice, where Matisse was living at that time (Barr, p. 196).

3. Matisse, Questionnaire I from Alfred Barr, 1945, Archives of The Museum of Modern Art.

4. Matisse-Camoin, p. 22, letter of May 23, 1918.

5. Matisse-Camoin, p. 21, letter of May 2, 1918.

6. Ragnar Hoppe, "På visit hos Matisse," 1931 (interview of June 1919), Fourcade, "Autres Propos," p. 94.

100

101

102

100. Cologne School, *Paradise Garden*, c. 1410. Oil. From Kenneth Clark, *Landscape Painting* (New York: Scribner's, 1950)

101. *Tea*, 1919. Oil, 55³⁄₁₆ x 6 ft 11¾₁₆ in. The Los Angeles County Museum of Art, bequest by David L. Loew in memory of his father, Marcus Loew

102. *Three Sisters and The Rose Marble Table*, 1917 (right panel of the Three Sisters triptych). Oil, 38 x 77 in. © The Barnes Foundation, Merion, Pa.

7. Dominique Fourcade, "Something Else," *Paper Cut-Outs*, p. 54.

8. Schneider, *Henri Matisse*, forthcoming, makes this comparison.

9. Francis Carco, "Conversation avec Matisse," 1941, trans. Flam, pp. 85–86.

The Plumed Hat
Nice, (1919)
Pen and ink, 14¾ x 19½ in (37.2 x 49.4 cm)
Signed L.R.: "Henri-Matisse"
Provenance: Kraushaar Gallery, New York;
 Abby Aldrich Rockefeller
Gift of Abby Aldrich Rockefeller
Acq. no. 110.35
Ill. p. 121

The Plumed Hat
Nice, (1919)
Pencil, 21¼ x 14⅜ in (54 x 36.5 cm)
Signed L.R.: "Henri Matisse"
Provenance: Pierre Matisse, New York; Hildegarde Ault Tjader
 (Mrs. George Helm), East Hampton, N.Y.;
 Lee Ault, New York
Gift of The Lauder Foundation, Inc.
Acq. no. 422.75
Ill. p. 121

1. In *Henri Matisse: Dessins et sculpture*, p. 102.

2. William S. Lieberman, *Henri Matisse* (Berkeley and Los Angeles: University of California Press, 1966), p. 26.

3. Barr, p. 206.

4. Letter to Alfred H. Barr, Jr., Archives of The Museum of Modern Art.

5. Ragnar Hoppe, *Stader och konstnarer: Resebrev och essaer om konst* (Stockholm: Bonnier, 1931), p. 196.

Girl with Bouquet of Flowers
(1923)
Lithograph, 7¹/₁₆ x 10⁵/₁₆ in (17.8 x 26 cm) (Pl. L.50)
Lillie P. Bliss Collection
Acq. no. 84.34
Ill. p. 122

The Pink Blouse
Nice, (1922)
Oil on canvas, 22 x 18⅜ in (55.9 x 46.7 cm)
Signed L.R.: "Henri Matisse"
Given anonymously, the donors retaining life interest
Acq. no. 781.63
Ill. p. 123

1. *Matisse, 1869–1954*, p. 36.

2. The painting has frequently been dated to 1923 and 1924. In a note to the present owner of the work, Mme Duthuit sug-

103

103. *Figure au tapis de Scutari*, 1922. Charcoal on paper, 20⅛ x 15⅞ in. Private collection

gested 1923. However, the 1922 date of the drawing seems to be the best guide in this case.

3. See Clement Greenberg, "Detached Observations," *Arts Magazine*, LI, no. 4, Dec. 1976, pp. 86–89, for a discussion of "light" and "heavy" modeling.

4. Greenberg, *Henri Matisse*, n.p. (pl. 16).

Arabesque I
(1924)
Transfer lithograph, 19¹/₁₆ x 12⅝ in (48.5 x 32.2 cm) (Pl. L.58)
Lillie P. Bliss Collection
Acq. no. 82.34
Ill. p. 124

Seated Nude with Arms Raised
(1924)
Transfer lithograph, 24¼ x 18¹³/₁₆ in (61.7 x 47.8 cm) (Pl. L.55)
Gift of Abby Aldrich Rockefeller
Acq. no. 252.55
Ill. p. 124

Seated Nude with Arms Raised before a Mantelpiece
(1925)
Transfer lithograph, 25⅛ x 18⅞ in (63.8 x 48 cm) (Pl. L.63)
Gift of Abby Aldrich Rockefeller
Acq. no. 41.53
Ill. p. 125

Odalisque in Striped Pantaloons
(1925)
Transfer lithograph, 21½ x 17⅜ in (54.6 x 44.2 cm) (Pl. L.64)
Promised gift of Governor Nelson A. Rockefeller, New York
Ill. p. 125

Reclining Odalisque with Basket of Fruit
(1925)
Lithograph, 7½ x 10⅝ in (19 x 27 cm) (Pl. L.66)
Gift of Abby Aldrich Rockefeller
Acq. no. 430.40
Ill. p. 126

Sleeping Dancer on a Couch
(1927)
Transfer lithograph, 10¹⁵⁄₁₆ x 18 in (27.8 x 45.7 cm) (Pl. L.92)
Gift of Mrs. Saidie A. May
Acq. no. 19.32.5
Ill. p. 126

Odalisque in a Tulle Skirt
(1929)
Lithograph, 11¼ x 15 in (28.6 x 38.1 cm) (Pl. L.107)
Gift of M. Knoedler and Company, Inc.
Acq. no. 186.57
Ill. p. 127

Reclining Nude
Nice, 1927
Pen and ink, 10⅞ x 15 in (27.7 x 32 cm)
Signed L.L.: "H. Matisse"
Provenance: Galerie Beyeler, Basel
The Tisch Foundation, Inc., Fund
Acq. no. 297.74
Ill. p. 128

Odalisque with a Moorish Chair
Nice, 1928
Pen and ink, 25¾ x 19⅞ in (65.4 x 50.5 cm)
Signed L.R.: "1928 Henri-Matisse"
Provenance: Galerie Thannhauser, Lucerne; Mr. and Mrs.
 Paul Lamb, Shaker Heights, Ohio
Acquired through the Lillie P. Bliss Bequest
Acq. no. 31.42
Ill. p. 129

1. Françoise Woimant, *Matisse, L'Oeuvre gravé* (Paris: Bibliothèque Nationale, 1970), p. 53.

2. The oil *Nude with Blue Cushion*, 1924, Mr. and Mrs. Sidney F. Brody collection, is the most exact counterpart to *Seated Nude with Arms Raised* (also known by the former title, though in fact the cushion has been eliminated). A drawing in the Art Institute of Chicago, *Seated Nude with Arms Raised* of c. 1920 (reprod. Carlson, *Matisse as a Draughtsman*, p. 96), is an early rendering of this popular pose. The linear lithograph *Day* of 1922 (Pl. L.33) is the precursor of the eventual pose of the 1925 sculpture. There are two other lithographs that repeat the *Seated Nude with Arms Raised before a Mantelpiece* composition (Pl. L.54 and L.77), the first a three-quarter-length figure published in a large edition of 250 and the second in a smaller size and in an edition of 25 printed in bister. The painting *Odalisque with Tulle Skirt* of 1923 from the Chester Dale Col-

lection in the National Gallery of Art, Washington, D.C., has a composition similar to the 1924 painting, but was translated almost exactly onto stone in 1924 (Pl. L.52, reprod. in Susan Lambert, *Matisse Lithographs* [London: Victoria and Albert Museum, 1972], no. 19, p. 44), thus directly anticipating the more imposing 1924 transfer lithographs.

3. E. Tériade, "Visite à Henri Matisse," *L'Intransigeant*, Jan. 14 and 22, 1922, trans. Flam, p. 59.

4. Matisse, "Notes d'un peintre sur son dessin," Flam, p. 81.

5. Lieberman, *Matisse: Fifty Years of His Graphic Art*, p. 11.

6. Barr, p. 216.

7. Matisse, *Jazz* (Paris: Tériade, 1947), p. 57; Flam, p. 112.

Girl Looking at Goldfish Bowl
(1929)
Etching, 3⅝ x 4⅞ in (9.2 x 12.4 cm) (Pl. E.156)
Purchase
Acq. no. 126.51
Ill. p. 131

Reclining Nude, Upside-Down Head, with Goldfish Bowl
(1929)
Etching, 6⅝ x 9⅜ in (16.8 x 23.8 cm) (Pl. E.155)
Gift of Mr. and Mrs. E. Powis Jones
Acq. no. 112.56
Ill. p. 132

Reclining Nude, Upside-Down Head
(1929)
Etching, 4⅜ x 5⅞ in (11.1 x 14.9 cm) (Pl. E.138)
Purchase
Acq. no. 113.51
Ill. p. 133

Seated Nude with Bracelets
(1929)
Drypoint, 5¹³⁄₁₆ x 3¹⁵⁄₁₆ in (14.7 x 10 cm) (Pl. E.116)
Purchase
Acq. no. 94.51
Ill. p. 134

Head, Fingers Touching Lips
(1929)
Etching, 3¹⁵⁄₁₆ x 5⅞ in (10 x 15 cm) (Pl. E.118)
Purchase
Acq. no. 96.51
Ill. p. 134

Seated Hindu I
(1929)
Drypoint, 6¹⁄₁₆ x 4⁵⁄₁₆ in (15.4 x 11 cm) (Pl. E.119)
Purchase
Acq. no. 97.51
Ill. p. 134

104

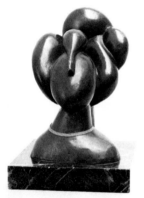

105

106

104. A tiari, or Tahitian gardenia. From Loraine E. Kuck and Richard C. Tongg, *Hawaiian Flowers and Flowering Trees* (Rutland, Vt., and Tokyo: Charles E. Tuttle Co.)

105. *Tiari (with Necklace)*, 1930. Bronze, 8 in h. The Baltimore Museum of Art, Cone Collection

106. *Tiari*, 1930 (?). Marble, 7⅞ in h. Musée Matisse, Nice-Cimiez

Woman in a Peignoir Reflected in the Mirror
(1929)
Etching, 10 x 16 in (25.4 x 15.2 cm) (Pl. E.86)
Anonymous promised gift
Ill. p. 135

1. *Woman before an Aquarium,* 1921, Helen Birch Bartlett Memorial, Art Institute of Chicago, is the painted antecedent of the several etched versions of 1929 (reprod. Barr, p. 436).

2. An unsigned *Nude in the Studio,* 1928, includes a similarly placed draped model in front of the tall mirror (reprod. Paris 1970, cat. 180).

Alfred Cortot
(1926)
Transfer lithograph, 15 x 15⅛ in (38.1 x 38.5 cm) (Pl. L.82)
Acquired through the Lillie P. Bliss Bequest
Acq. no. 31.48
Ill. p. 136

John Dewey
New York, 1930
Charcoal, 24⅜ x 19 in (61.9 x 48.4 cm)
Signed L.R.: "Henri Matisse 30"
Provenance: Estate of the artist; Pierre Matisse, New York
Gift of Pierre Matisse
Acq. no. 149.62
Ill. p. 136

1. Reprod. Douglas Cooper, *The Cubist Epoch* (London: Phaidon, 1970), p. 51.

2. Letter of May 11, 1962, Archives of The Museum of Modern Art.

Tiari
(Summer 1930)
Bronze, cast no. 2 in an edition of 10; 8 in (20.3 cm) h.,
 at base 5½ x 5⅛ in (14 x 13 cm)
Signed L.side, bottom, in black: "2/10/HM"
Provenance: Curt Valentin Gallery, New York
A. Conger Goodyear Fund
Acq. 154.55
Ill. pp. 137, 138

1. Aragon, *Henri Matisse,* I, p. 9.

2. Pierre Schneider points out that this flower is worn by the Tahitian in the painting Matisse purchased from Vollard ("Matisse's Sculpture," p. 24). The painting in question is *Jeune Homme à la fleur,* 1891 (Georges Wildenstein, *Gauguin* [Paris: Les Beaux Arts, 1964], I, cat. 422) and was in fact obtained by exchanging one of his own works. (Matisse, Questionnaire II from Alfred Barr, Mar. 1950, Archives of The Museum of Modern Art.)

3. Barr, p. 218.

4. See above, p. 173, n. 4.

5. See Aragon, *Henri Matisse,* I, pp. 101–3; Dore Ashton, "Matisse and Symbolism," *Arts Magazine,* IL, no. 9, May 1975, pp. 70–71.

6. Flam, "Recurrent Themes in the Art of Matisse," emphasizes Matisse's persistent use of formal analogy.

7. William S. Rubin, *Dada, Surrealism, and Their Heritage* (New York: The Museum of Modern Art, 1968), p. 120.

8. See fig. 105.

9. Jacques Lipchitz, "Notes on Matisse as a Sculptor," *The Yale Literary Magazine,* Fall 1955, p. 12.

10. E.g., *Henriette II,* 1927; *Upright Nude, Arms over Her Head,* 1927; the heads of *Reclining Nude II,* 1927, and *Reclining Nude III,* 1929; and the two *Small Torso* sculptures of 1929 (Elsen, pp. 164, 154, 156, 158, 160).

11. Elsen, p. 174. See fig. 106.

12. Guichard-Meili, *Henri Matisse,* p. 170.

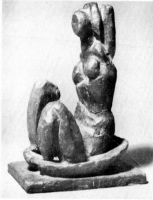

107

Venus in a Shell
(Summer 1930)
Bronze, cast no. 2 in an edition of 10; 12¼ in (31 cm) h.,
　at base 7¼ x 8⅛ in (18.3 x 20.6 cm)
Signed, incised L side of shell: "2/10 HM"
Gift of Pat and Charles Simon
Acq. no. 417.60
Ill. p. 139

1. Matisse-Camoin, p. 21, letter of Apr. 10, 1918; Escholier, *Matisse ce vivant,* p. 118.

2. See Elsen, pp. 144–53.

3. Elsen, pp. 197–98.

4. Reprod. Elsen, pp. 154, 160.

5. See Elsen, pp. 197–201.

6. See Elderfield, "Matisse Drawings and Sculpture," p. 83.

7. Aragon, *Henri Matisse,* I, p. 10.

8. Ibid., I, p. 102.

9. Ibid., I, pp. 102–3. Aragon also states that in the Mallarmé prints Matisse used images of "this *Woman* and this *Shell,* because they suggest Tahiti although they are not in fact Tahitian." (Ibid., I, p. 7.)

10. The 1930 drawing illustrated by Legg, *The Sculpture of Matisse,* p. 43, is especially instructive in this regard in that it relates very specifically both to the sculpture and to the drawings for the illustration to "Le Guignon" in the Mallarmé suite (reprod. Carlson, *Matisse as a Draughtsman,* p. 117).

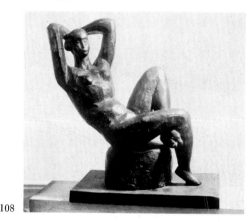

108

109

Poésies by Stéphane Mallarmé
Lausanne, Albert Skira & Cie, 1932
29 etchings, 13¹⁄₁₆ x 9¹⁵⁄₁₆ in (33.2 x 25.3 cm)
The Louis E. Stern Collection
Acq. no. 923.64
Ill. pp. 139, 141

107. *Venus in a Shell II,* 1932. Bronze, 13⅜ in h. Hirshhorn Museum and Sculpture Garden, Washington

108. *Large Seated Nude,* 1923–25. Bronze, 33 in h. Collection Nelson A. Rockefeller

109. Matisse working on a later-destroyed sculpture of *Venus in a Shell,* 1929 (?)

Ulysses by James Joyce
New York, The Limited Editions Club, 1935
6 soft-ground etchings and 20 reproductions of preliminary
drawings, 11¾ x 9 in (29.8 x 22.9 cm)
The Louis E. Stern Collection
Acq. no. 935.64
Ill. p. 142

Blinding of Polyphemus, rejected plate for *Ulysses*
by James Joyce (1935)
Soft-ground etching, 10⅝ x 8½ in (27 x 21.6 cm)
Derald and Janet Ruttenberg Foundation Fund
Acq. no. 503.71
Ill. p. 142

Pasiphaé, Chant de Minos (Les Crétois) by Henri de Monther-
lant, Paris, Martin Fabiani, 1944
148 linoleum cuts: 18 full-page plates, cover, 45 decorative
elements, 84 initials; 12⅞ x 9¾ in (32.7 x 24.8 cm)
The Louis E. Stern Collection
Acq. no. 926.64
Ill. p. 143

Florilège des Amours by Pierre de Ronsard
Paris, Albert Skira, 1948
135 lithographs: 69 full-page plates, cover, 57 decorative
elements, suite of 8 variations on one plate;
15 x 11¹¹⁄₁₆ in (38.1 x 28.1 cm)
The Louis E. Stern Collection
Acq. no. 933.64
Ill. p. 144

Lettres portugaises by Marianna Alcaforado
Paris, Tériade, 1946
106 lithographs: 19 full-page plates, cover, 51 decorative
elements, 35 initials; 10⅝ x 8¼ in (27 x 21 cm)
The Louis E. Stern Collection
Acq. no. 936.64
Ill. pp. 144, 145

Poèmes de Charles d'Orléans
Paris, Tériade, 1950
101 lithographs: 54 full-page plates, cover, 46 decorated pages
of text in artist's hand; 16⅛ x 10⅜ in (41 x 26.3 cm)
The Louis E. Stern Collection
Acq. no. 934.64
Ill. p. 146

1. Henri Matisse, "Comment j'ai fait mes livres," in *Anthologie du livre illustré par les peintres et sculpteurs de l'école de Paris* (Geneva: Skira, 1946), p. 21.

2. Barr, p. 249; George Macy et al., *Quarto-Millenary: The First 250 Publications . . . of The Limited Editions Club* (New York: Limited Editions Club, 1959), cat. 71, p. 247. Macy's role as publisher of *Ulysses* is explained by James Laver (p. 29), while Thomas Craven delivers perhaps the harshest judgment of any

Matisse enterprise: ". . . as it turned out, Matisse delivered to Mr. Macy a bunch of studio sweepings having no discoverable connection with anything in Homer or Joyce" (p. 36). Aragon writes: "In fact Macy's *Ulysses* is *not* 'one of Matisse's books,' and he never considered it as such, never mentioned it among *his* books" *(Henri Matisse,* I, p. 194).

3. Matisse, in two autograph notes to Raymond Escholier, 1946, lists *Ulysses* among his completed books. (Collection Bignou, sale Paris, Hôtel Drouot, June 6, 1975, cat. 36, 38.)

4. Matisse, letter to Simon Bussy, Aug. 24, 1934 (Fourcade, p. 217): "I telephoned Joyce and spoke to him about what his representative in Paris had told him about what he had seen. We are in complete agreement regarding the character that I want to give to the illustration."

5. Matisse, letter to Simon Bussy, Aug. 11, 1934 (Fourcade, p. 216): "I have then abandoned the stone for the copper plate and have made the soft-ground etching of which you have a proof in sanguine—in black is better . . ."

6. A large charcoal on canvas begun in 1935, *Nymph Resting and Faun Playing the Flute,* is the largest of several drawings related to the *Ulysses* plate illustrating *Calypso;* it was photographed on the wall in Matisse's room in the Hôtel Régina. See Barr, p. 30; Cowart et al., *Henri Matisse: Paper Cut-Outs* (The St. Louis Art Museum and The Detroit Institute of Arts, 1977), figs. 65, 66. Barr, p. 475, illustrates one preliminary drawing for *The Blinding of Polyphemus* (while five more are reproduced in conjunction with the print in *Ulysses*).

7. Aragon, *Henri Matisse,* I, p. 198: ". . . the only true image of pain in Matisse's work . . ."

8. See above, n. 1. "My second book: *Pasiphäe* by Montherlant." Matisse lists also the books awaiting publication (1946): *Visages, Poésies de Ronsard,* and *Lettres portugaises,* omitting Baudelaire's *Fleurs du mal, Jazz,* and *Poèmes de Charles d'Orléans,* which were also nearly ready for publication.

9. Martin Fabiani, *Quand j'étais marchand de tableaux* (Paris: Julliard, 1976), pp. 117–21.

10. Matisse, letter to André Rouveyre, Oct. 30, 1941 (Fourcade, p. 218).

11. Skira, *Vingt Ans d'activité* (Geneva: Skira, 1948), pp. 10–14.

12. Barr, p. 272.

13. Aragon, *Henri Matisse,* II, p. 307.

14. Matisse, letter to Camoin, Vence, Sept. 6, 1944 (Matisse-Camoin, p. 32).

15. Matisse, autograph note to Escholier (see above, n. 3) lists Nau's book as "en préparation" in 1946.

Lemons against a Fleur-de-lis Background
Nice, March 1943
Oil on canvas, 28⅞ x 24⅛ in (73.4 x 61.3 cm)
Signed L.L. corner: "Henri Matisse 3/43"

Loula D. Lasker Bequest
Acq. no. 382.61
Ill. p. 147

1. Aragon, *Henri Matisse,* I, pp. 242–44.

2. Ibid., I, p. 240.

Self-Portrait
Vence, 1945
Crayon, 16 x 20¾ in (40.5 x 52.5 cm)
Signed L.L.: "45 HM"
Provenance: Peter N. Matisse Gallery, Beverly Hills, Cal.
John S. Newberry Fund
Acq. no. 634.65
Ill. p. 148

Self-Portrait
Vence, June 1945
Pen and ink, 20½ x 15¾ in (52 x 40 cm)
Signed L.L.: "H Matisse 11 Juin 45"
Provenance: Mrs. Stephen Hahn, New York
Gift of Philip Johnson (by exchange)
Acq. no. 837.69
Ill. p. 149

1. Alexander Liberman, *The Artist in His Studio* (New York: Viking, 1960), pp. 21–22.

2. Matisse wrote a brief series of notes, "Exactitude Is Not Truth," published in the catalog of his retrospective organized by the Philadelphia Museum of Art in 1948.

3. Collection of the Tate Gallery, London; reprod. in William S. Lieberman, ed., *Modern Masters: Manet to Matisse* (New York: The Museum of Modern Art, 1975), pp. 21, 109.

4. Barr, p. 551.

Jazz by Henri Matisse
Paris, Tériade, 1947
20 pochoir plates, sheet 16⅝ x 25⅝ in (42.2 x 65.1 cm)
Book: Louis E. Stern Collection
Acq. no. 930.64
Ill. p. 151
Portfolio: Gift of the artist
Acq. no. 291.48
Ill. p. 150

1. Matisse, in a conversation of July 1948 reported by Father Marie-Alain Conturier: "I have been led to make cut-out papers in order to associate color and drawing in the same movement." (Quoted in *Se garder libre: Journal 1947–54* [Paris: Editions du Cerf, 1962].) Also: "The cut-out paper allows me to draw in color. It is a simplification. Instead of drawing an outline and filling in the color—in which case one modifies the other—I am drawing directly in color, which will be the more measured as it will not be transposed. . . . It is not a starting point but a culmination." (From *Les Amis de l'art* [Paris], n.s., no. 2, Oct. 1951; trans. by Avigdor Arikha in "Henri Matisse—Jazz," *Two Books,* Los Angeles County Museum of Art, 1972, n.p.)

110

111

110. *Still Life against a Fleur-de-lis Background,* 1943. Oil, whereabouts unknown

111. Diagram of *Lemons against a Fleur-de-lis Background* (p. 147) from *Verve,* vol. IV, no. 13 (1945)

2. A remark in Matisse's letter to Angèle Lamotte, Vence, Mar. 7, 1944 (Archives of The Museum of Modern Art), suggests that the *découpages* were first planned to be reproduced as woodcuts: "Could you please tell the good Monsieur Tériade that I am short of the paper I need for my Jazz or his Jazz (depending on the success of the woodcuts) (which we will soon judge)."

3. Matisse, letter to André Rouveyre, Dec. 25, 1947: "C'est absolument un raté. Et pourquoi ces découpés lorsque je les fais, que je les vois au mur me sont-ils sympathiques et sans le caractère de puzzle que je leur trouve dans *Jazz*." (Fourcade, p. 240.)

4. Matisse, letter to André Rouveyre, Feb. 22, 1948. (Fourcade, pp. 241–42.)

5. Matisse, *Jazz*, p. 17.

6. Matisse, letter to Angèle Lamotte and Tériade, Mar. 7, 1944.

7. Ibid.

8. Barr, pp. 249, 474, regarded Matisse's study of the bronze group of *Hercules and Antaeus* by Antonio del Pollaiuolo to be the genesis of the opposing and tumbling figures as composed in the plate for *Ulysses* entitled *The Blinding of Polyphemus*. However, the falling figures from the Barnes mural and *Toboggan* are even more closely related to the famous Lucas van Leyden engraving of *Cain Killing Abel* of 1529 (fig. 112).

9. Cf. *Elena*, 1937, Mr. and Mrs. Sydney R. Barlow Collection (reprod. *Henri Matisse* [New York: Acquavella Galleries, 1973], cat. 75), and *Music*, 1939, Buffalo, Albright Knox Gallery (reprod. Barr, pp. 480–81).

Dahlias and Pomegranates
Vence, 1947
Brush and ink, 30⅛ x 22¼ in (76.4 x 56.5 cm)
Signed L.L.: "H. Matisse/47"
Provenance: Pierre Matisse Gallery, New York
Abby Aldrich Rockefeller Fund
Acq. no. 12.50
Ill. p. 152

1. Barr, p. 276.

The Necklace
Nice, May 1950
Brush and ink, 20⅞ x 16⅛ in (52.8 x 40.7 cm)
Signed L.L.: "H. Matisse/ Mai 50"
Provenance: Theodor Ahrenberg Collection, Stockholm; Berggruen & Cie, Paris
The Joan and Lester Avnet Collection
Acq. no. 131.78
Ill. p. 153

Maquettes for a set of **red liturgical vestments** designed for the Chapel of the Rosary of the Dominican Nuns of Vence
Nice, (1950–52)
Gouache on cut-and-pasted paper
Chasuble, front: 52½ in x 6 ft 6⅛ in (133.3 x 198.4 cm)
 back: 50½ in x 6 ft 6½ in (128.2 x 199.4 cm)

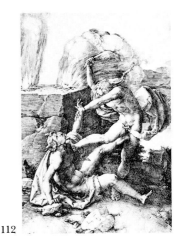

112

112. Lucas van Leyden, *Cain Killing Abel*, 1529. Engraving, 6⅜ x 4½ in

Stole: 49 x 7½ in (124.5 x 19 cm) (design)
Maniple: 17 x 8⅜ in (43.2 x 21.2 cm)
Chalice veil: 20¼ x 20¼ in (51.5 x 51.5 cm)
Burse: 10 x 8¾ in (25.4 x 22.2 cm)
Acquired through the Lillie P. Bliss Bequest
Acq. no. 176.53.1–6
Ill. pp. 154, 155, and fig. 115

White liturgical vestments
Designed Nice, 1950–51; executed 1951
White silk with yellow and green silk appliqué
Chasuble, front: 49 in x 6 ft 6½ in (124.4 x 199.4 cm)
 back: 50 in x 6 ft 6½ in (127 x 199.4 cm)
 Stole: 8 ft 8 in x 3¾ in (264.1 x 9.5 cm)
 Maniple: 43 x 3¾ in (109.2 x 9.5 cm)
 Chalice veil: 21 x 21 in (53.3 x 53.3 cm)
 Burse: 9¼ x 9¼ in (23.5 x 23.5 cm)
Manufactured by Atelier d'Arts Appliqués, Cannes, France, Craftsman, Gustav Pederson
Acquired through the Lillie P. Bliss Bequest
Acq. no. 484.53.1–5
Ill. p. 156 and figs. 116, 119

Black chasuble
Designed Nice, 1950–52; executed 1955
Black crepe with white crepe appliqué, 6 ft 4 in w. across top; 47¾ in l., front; 48 in l., back (193 cm; 121.3 cm; 121.9 cm)
Manufactured by Atelier d'Arts Appliqués, Cannes, France
Gift of Philip C. Johnson
Acq. no. 375.55
Ill. p. 156 and fig. 122

Green chasuble

Designed Nice, 1950–51; executed 1955
Green silk with black velvet, white and yellow silk appliqué,
 6 ft ¼ in w. across top; 50¼ in l., front; 50⅛ in l., back
 (187.4 cm; 127.7 cm; 127.4 cm)
Manufactured by Atelier d'Arts Appliqués, Cannes, France
Gift of William V. Griffin in memory of his wife
Acq. no. 164.55
Ill. p. 157 and fig. 120

Violet chasuble

Designed Nice, 1950–52; executed 1955
Violet silk in two shades with green and blue silk appliqué,
 6 ft 1¾ in w. across top; 52⅛ in l., front; 48¼ in l., back
 (187.4 cm; 132.4 cm; 122.6 cm)
Manufactured by Atelier d'Arts Appliqués, Cannes, France
Gift of Mrs. Gertrud A. Mellon
Acq. no. 163.55
Ill. p. 157 and fig. 121

Red chasuble

Designed Nice, 1950–52; executed 1955
Red satin with yellow silk and black velvet ribbon appliqué,
 6 ft 4 in w. across top; 51 in l., front; 46 in l., back
 (193 cm; 129.5 cm; 116.8 cm)
Manufactured by Atelier d'Arts Appliqués, Cannes, France
Gift of Mrs. Charles Suydam Cutting
Acq. no. 374.55
Ill. figs. 117, 118

Rose chasuble

Designed Nice, 1950–52; executed 1955
Rose silk with blue, green, and white silk appliqué,
 51 in x 6 ft 2⅛ in (129.6 x 188.3 cm)
Manufactured by Atelier d'Arts Appliqués, Cannes, France
Gift of Mrs. Gertrud A. Mellon
Acq. no. 162.55
Ill. fig. 123

1. Memorandum of 1955, Archives of The Museum of Modern Art. Barr additionally noted that when Picasso saw the chasuble designs he was so enthusiastic that he apparently tried his hand at designing a matador's cape but found the problem too difficult and gave it up.

2. Barr, pp. 279–88, summarizes the history of the chapel.

3. Fourcade, p. 257; trans. Barr, p. 287.

4. Matisse, "Chapelle du rosaire des Dominicaines de Vence," 1951, trans. Flam, p. 129.

5. See William S. Rubin, *Modern Sacred Art and the Church of Assy* (New York and London: Columbia University Press, 1961), p. 157.

6. André Verdet, "Entretiens avec Henri Matisse," 1952, trans. Flam, p. 144.

113

114

113. Matisse's studio, Hôtel Régina, Nice, c. 1951. On wall, clockwise from upper left: preliminary maquette for black chasuble; preliminary maquette for rose chasuble; another preliminary maquette for black chasuble; maquette for rose chasuble (front)

114. Attributed to Matisse (see n. 21, p. 222), Printed fabric, c. 1912–13. Japanese silk, on a green field, pink and orange flowers with purple stalks and leaves 24¾ x 49¾ in (irreg.). The Museum of Modern Art, New York

115

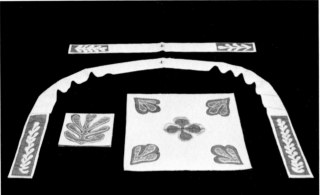

116

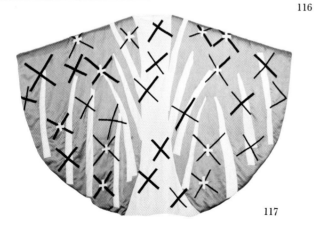

117

115. Maquettes for red chasuble accouterments, 1950–52
116. White chasuble accouterments, designed 1950–51; executed 1951
117. Front of red chasuble, designed 1950–52; executed 1955

7. Matisse, "Notes d'un peintre," 1908, Fourcade, p. 49; trans. Flam, p. 38.

8. E.g., Matisse, "Jazz," 1947, Fourcade, p. 238; trans. Flam, pp. 112–13; Matisse, "Chapelle du rosaire des Dominicaines de Vence," 1951, Fourcade, p. 260; trans. Flam, p. 130.

9. Quoted by Rubin, *Modern Sacred Art*, p. 158.

10. Georges Charbonnier, "Entretien avec Henri Matisse," 1960, Fourcade, p. 266; trans. Flam, p. 139.

11. Letter to Alexander Romm, Feb. 14, 1934, Fourcade, p. 147; trans. Flam, p. 69.

12. Georges Charbonnier, "Entretien avec Henri Matisse," 1960, Fourcade, p. 267; trans. Flam, p. 140.

13. Gowing, *64 Paintings*, p. 17.

14. Matisse, "La Chapelle du Rosaire," 1951, Fourcade, p. 258; trans. Flam, p. 128.

15. Aragon, *Henri Matisse*, II, p. 207.

16. See above, n. 14; cf. "They [the chapel walls] are the visual equivalent of a large open book where the white pages carry the signs explaining the musical part composed by the stained-glass windows." (Matisse, "Chapelle du rosaire des Dominicaines de Vence," 1951, Fourcade, p. 260; trans. Flam, p. 130.)

17. John Haletsky in *Paper Cut-Outs*, p. 181.

18. Ibid., p. 182. Details of the symbolism of the chasubles are given in *Paper Cut-Outs*, cat. 128–55.

19. *Paper Cut-Outs*, p. 182.

20. Matisse, "Témoignage," 1951, Fourcade, p. 248; trans. Flam, p. 137.

21. E.g., *Paper Cut-Outs*, cat. 13, 14, 17. It should also be noted here that Matisse was no novice to fabric design (see Barr, pp. 207, 254). Although he did not study tapestry and textile design at the Ecole Quentin de La Tour in 1899 as is sometimes claimed (Matisse, Questionnaire II from Alfred Barr, Mar. 1950, Archives of The Museum of Modern Art), a textile design (fig. 114) has been attributed to him. Of uncertain date, it was originally purchased from the couturier Paul Poiret in 1912 or 1913 as a work by Matisse. However, neither Pierre Matisse nor Mme Duthuit has any record of Matisse having designed it.

22. *Paper Cut-Outs*, cat. 157.

23. See *Paper Cut-Outs*, cat. 128–55.

24. Guillaume Apollinaire, "Henri Matisse," 1907, Fourcade, p. 55; trans. Flam, p. 32; also Matisse, "Notes d'un peintre," 1908, Fourcade, p. 45; trans. Flam, p. 37.

25. See above, n. 20.

26. Verdet, "Entretiens avec Henri Matisse," 1952, Fourcade, p. 250; trans. Flam, p. 147.

27. Letter to André Rouveyre, Feb. 22, 1948, Fourcade, p. 243.

28. See above, n. 20.

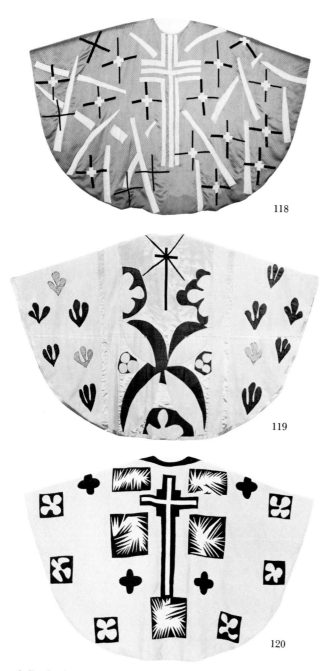

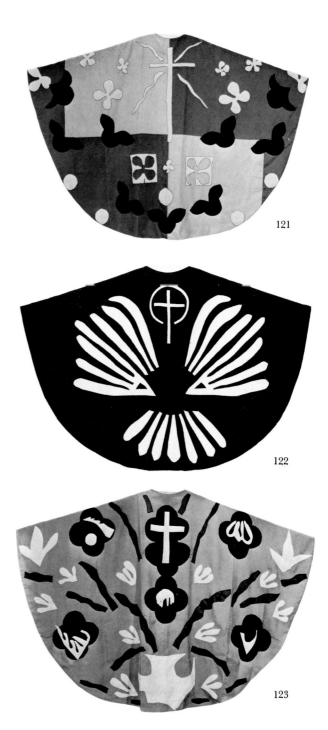

118. Back of red chasuble, designed 1950–52; executed 1955
119. Back of white chasuble, designed 1950–51; executed 1951
120. Back of green chasuble, designed 1950–51; executed 1955
121. Back of violet chasuble, designed 1950–52; executed 1955
122. Back of black chasuble, designed 1950–52; executed 1955
123. Rose chasuble, designed 1950–52; executed 1955

29. *Paper Cut-Outs,* p. 181.

30. The design of only one side of this chasuble was realized. The designs finally established for the rose chasuble are illustrated and described in *Paper Cut-Outs,* cat. 138, 139.

Nuit de Noël
Paris, (summer–autumn) 1952
Stained-glass window, commissioned by *Life*
Metal framework: 11 ft ¾ in x 54¾ in x ⅜ in
 (332.5 x 139 x 1 cm)
Fabricated in the workshop of Paul and Adeline Bony, Paris, under the artist's supervision
Signed, lower pane of glass, L.R.: "Matisse 52"
Gift of Time, Inc.
Acq. no. 420.53.1–4
Ill. p. 158

Maquette for **Nuit de Noël**
Nice, (January–February) 1952
Gouache on cut-and-pasted paper, 10 ft 3 in x 53½ in
 (312.8 x 135.9 cm)
Signed, lower section of window, L.R., on pasted strip: "Matisse 52"
Gift of Time, Inc.
Acq. no. 421.53.1–5
Ill. p. 159

Design for jacket of **Matisse: His Art and His Public**
 by Alfred H. Barr, Jr. (New York: The Museum of Modern Art, 1951)
Paris, (September 1951)
Gouache on cut-and-pasted paper, 10⅝ x 16⅞ in (27 x 42.9 cm)
Signed L.L.: "H.M.," and L.R., across front of jacket design: "H. Matisse"
Commissioned by the Museum
Acq. no. 418.53
Ill. p. 160

Design for cover of **Exhibition: H. Matisse,** introduction
 by Alfred H. Barr, Jr. (New York: The Museum of Modern Art, 1951)
Paris, (September 1951)
Gouache on cut-and-pasted paper, 10⅝ x 15¾ in (27 x 40 cm)
Signed, L.R.: "HM"
Commissioned by the Museum
Acq. no. 419.53
Ill. p. 161

1. See *Paper Cut-Outs,* cat. 122, 123, 158.

2. Matisse's final work, the rose window of 1954 (*Paper Cut-Outs,* cat. 218), is exceptional in falling outside either of these groups.

3. Details of the commission presented here derive from information from *Life* magazine in the Archives of The Museum of Modern Art, where the Matisse-Barr letters quoted below are also lodged. I am particularly indebted to Richard Gangel, the initiator of the project, for recently providing me with new information on the commission. Mr. Gangel writes (letter to the author, May 18, 1978) that it was commissioned in order to be reproduced in miniature as a gift-subscription announcement, but when the window arrived it was thought by the publisher to be "too modern and abstract" for that purpose. Matisse's commission was to design a window "on the general subject of Christmas"; the choice of specific theme was his. He accepted on the condition that the cut-out design be donated to a Museum.

4. From documentary photographs of Matisse's apartment in 1952, it is clear that *Nuit de Noël* was made in his bedroom, on the wall facing the end of Matisse's bed, where a number of important cutouts were created that year. For a collection of these photographs, see John Elderfield, *The Cut-Outs of Henri Matisse* (New York: Braziller, 1978).

5. The dimensions of works that were not commissioned frequently changed as the works developed. E.g., *Paper Cut-Outs,* cat. 111, 114.

6. The main color changes as the work developed involved the removal of white, gray, and viridian green compositional rectangles. The color photographs documenting the changes are on file in the Archives of The Museum of Modern Art.

7. See *Paper Cut-Outs,* cat. 159, 160.

8. See *Paper Cut-Outs,* cat. 161.

9. It may also be noted that it was at this point that Matisse weighted the lower area by introducing the green stripes around and within the wave forms.

10. See *Paper Cut-Outs,* cat. 55, 56, 59, 60.

11. See *Paper Cut-Outs,* cat. 114.

12. See John Hallmark Neff, "Matisse, His Cut-Outs and the Ultimate Method," *Paper Cut-Outs,* pp. 32–33.

13. *Paper Cut-Outs,* cat. 95.

14. Matisse discussed the work in an interview with Gotthard Jedlicka on that date. See Fourcade, "Autres Propos," p. 114.

15. Matisse, "Le Chemin de la couleur," 1947, Fourcade, p. 203; trans. Flam, p. 116.

16. André Verdet, "Entretiens avec Henri Matisse," 1952, trans. Flam, pp. 143, 144.

17. Fourcade, "Autres Propos," p. 114.

The Swimming Pool [La Piscine]
Nice, (summer 1952)
Mural in two parts. Gouache on cut-and-pasted paper mounted on burlap, 7 ft 6⅝ in x 27 ft 9½ in (230.1 x 847.8 cm) and 7 ft 6⅝ in x 26 ft 1½ in (230.1 x 796.1 cm)
Provenance: Pierre Matisse Gallery, New York
Mrs. Bernard F. Gimbel Fund
Acq. no. 302.75.a–i
Ill. p. 163–66

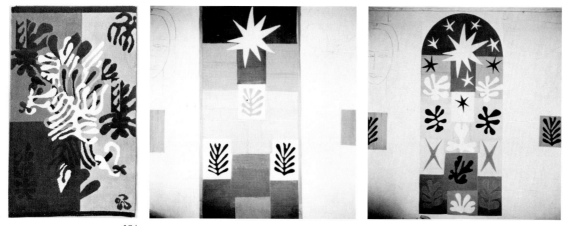

124

125

126

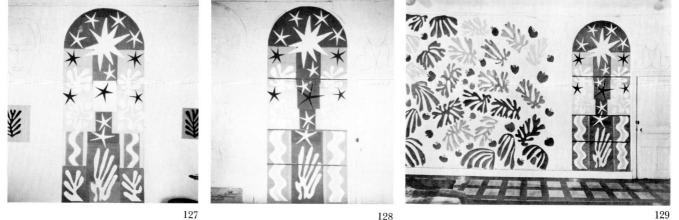

127

128

129

124. *Mimosa,* designed 1949; final version approved by artist 1951. Wool rug, deep pile, 36 x 59 in. The Museum of Modern Art, New York, gift of Alexander Smith, Inc.

125. Maquette for *Nuit de Noël* on January 17, 1952, Nice

126. Maquette for *Nuit de Noël* on January 30, 1952, Nice

127. Maquette for *Nuit de Noël* in February 1952, Nice

128. Maquette for *Nuit de Noël* on February 27, 1952, Nice

129. Matisse's studio, Hôtel Régina, Nice, 1952. On wall: left, *The Parakeet and the Mermaid* (fig. 135), early state; right, *Nuit de Noël* (p. 159)

130. Matisse beside completed *Nuit de Noël* window (p. 158), Nice, 1952

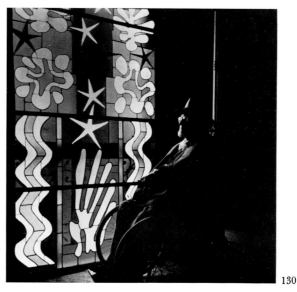

130

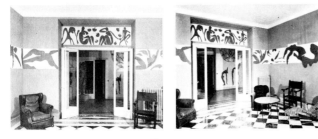

131 132

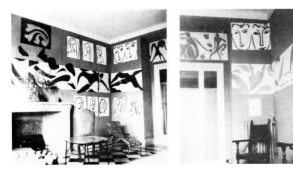

133 134

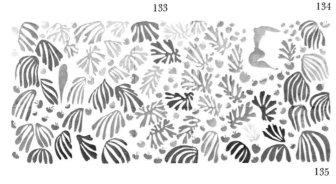

135

131–34. *The Swimming Pool* in the dining room of Matisse's apartment in the Hôtel Régina, Nice

135. *The Parakeet and the Mermaid,* 1952. Gouache on cut-and-pasted paper, 11 ft 11/16 in x 25 ft 4 in. Stedelijk Museum, Amsterdam

1. The work has a number of times been erroneously described as a project for a ceramic intended to decorate a swimming pool. Both Mme Marguerite Duthuit and Pierre Matisse have confirmed that it was created as an independent work.

2. André Verdet, *Prestiges de Matisse* (Paris: Editions Emile-Paul, 1952), p. 20.

3. Statement recorded by Mrs. Alfred Barr, Sept. 1952, Archives of The Museum of Modern Art.

4. The following description of Matisse's development in 1952 is condensed from Elderfield, *The Cut-Outs of Henri Matisse,* pp. 26–30.

5. Reprod. *Paper Cut-Outs,* cat. 166.

6. Matisse refers to it as a unique work in his March 19, 1952, interview with Jedlicka (Fourcade, "Autres Propos," p. 114).

7. It was subsequently completed early in 1953. See Elderfield, *The Cut-Outs of Henri Matisse,* p. 43.

8. *Paper Cut-Outs,* cat. 167–70.

9. See Tucker, "Four Sculptors," p. 87; John Hallmark Neff, "Matisse: His Cut-Outs and the Ultimate Method," *Paper Cut-Outs,* pp. 26–28.

10. Guichard-Meili, *Henri Matisse,* p. 170.

11. *Paper Cut-Outs,* p. 211; Elderfield, *The Cut-Outs of Henri Matisse,* p. 28.

12. John Neff, conversation with Mme Lydia Delectorskaya, Matisse's secretary.

13. Mme Marguerite Duthuit. Notes on the technique of The Swimming Pool, Oct. 8, 1975, Archives of The Museum of Modern Art.

14. André Verdet, "Entretiens avec Henri Matisse," 1952, trans. Flam, p. 143.

15. *Paper Cut-Outs,* cat. 177.

16. See Elderfield, *The Cut-Outs of Henri Matisse,* p. 37–38.

17. Verdet, *Prestiges de Matisse,* pp. 97–98. In his discussion of this work, which he calls *La Plongeuse,* he makes no reference to its having any companions.

18. An opposite reading to the one proposed here has been suggested by Jack Flam, who sees a left-to-right development from broken to whole images across the work (conversation with the author, May 1978).

19. A similar image occurs in *The Beasts of the Sea,* 1950 (*Paper Cut-Outs,* cat. 114).

20. *Paper Cut-Outs,* cat. 30.

21. Ibid., cat. 56.

22. Ibid., cat. 177.

23. See Elderfield, *The Cut-Outs of Henri Matisse,* pp. 28–29.

24. Ibid., p. 43.

25. *Paper Cut-Outs,* p. 168.

26. Fourcade, p. 168.

27. "Entretien avec Henri Matisse," 1952, trans. Flam, p. 144.

28. Mallarmé, letter to Charles Morice, n.d., in *Mallarmé: Selected Prose Poems, Essays, and Letters,* trans. Bradford Cook (Baltimore: The Johns Hopkins Press, 1956), p. 105.

29. Charles W. Millard, "Matisse in Paris," *Hudson Review,* XXIII, no. 3, Autumn 1970, p. 545.

30. Thomas B. Hess, "Blue Nymphs and White Water," *New York Magazine,* May 2, 1977, p. 72.

31. *Paper Cut-Outs,* cat. 61.

32. Matisse, "Témoignage," 1951, Fourcade, p. 246; trans. Flam, p. 136.

Memory of Oceania [Souvenir d'Océanie]
Nice, (summer 1952–early) 1953
Gouache and crayon on cut-and-pasted paper over canvas,
 9 ft 4 in x 9 ft 4⅞ in (284.4 x 286.4 cm)
Signed L.L.: "H. Matisse/53"
Provenance: Pierre Matisse Gallery, New York
Mrs. Simon Guggenheim Fund
Acq. no. 224.68
Ill. p. 168

1. The dates on both of these works were probably inscribed when the cutouts were fastened down upon their supports. *Paper Cut-Outs,* cat. 198, erroneously states that *The Snail* was published by Verdet in 1952. The work published by Verdet (*Prestiges de Matisse,* p. 64) is another work of the same title (*Paper Cut-Outs,* cat. 182).

2. See *Paper Cut-Outs,* cat. 203.

3. Ibid., cat. 247.

4. Jacobus, *Henri Matisse,* p. 180.

5. See Elderfield, *The Cut-Outs of Henri Matisse,* p. 36.

6. *Paper Cut-Outs,* cat. 198.

7. André Verdet, "Entretiens avec Henri Matisse," 1952, trans. Flam, p. 145.

8. Matisse, "Entretien avec Tériade," 1930, Fourcade, pp. 102–3; trans. Flam, p. 60.

9. E. Tériade, "Matisse Speaks," 1951, Flam, p. 135.

10. Matisse, "Entretien avec Tériade," 1930, Fourcade, p. 107; trans. Flam, p. 62.

11. Aragon, *Henri Matisse,* I, p. 208.

12. Fourcade, p. 105.

13. Aragon, *Henri Matisse,* I, p. 8; André Verdet, "Entretien avec Henri Matisse," 1952, trans. Flam, p. 145.

14. Aragon, *Henri Matisse,* I, p. 9.

15. *Paper Cut-Outs,* cat. 33–35.

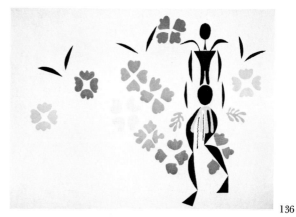

136

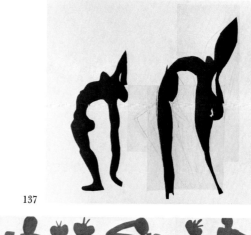

137

138

136. *The Negress,* 1952–53. Gouache on cut-and-pasted paper, 14 ft 10¾ in x 20 ft 5½ in. National Gallery of Art, Washington, Alisa Mellon Bruce Fund

137. *Acrobats,* 1952. Gouache on cut-and-pasted paper, 6 ft 11¹³⁄₁₆ in x 6 ft 10½ in. Sheldon H. Solow, New York

138. *Women and Monkeys,* 1952. Gouache on cut-and-pasted paper, 28¼ in x 9 ft 4¾ in. Galerie Beyeler, Basel

139

140

141

16. See ibid., cat. 199, for Matisse's different versions of this subject.

17. Ibid.

18. Ibid. The drawing is illustrated in *Cahiers d'art*, XI, no. 3–5 (1936), p. 77.

19. Helen Franc, *An Invitation to See* (New York: The Museum of Modern Art, 1973), p. 132.

20. E.g., Aragon, *Henri Matisse*, II, p. 97.

21. Reprod. Barr, p. 467.

22. Aragon, *Henri Matisse*, I, p. 6.

23. *Paper Cut-Outs*, cat. 199.

24. *Paper Cut-Outs*, cat. 181.

25. This area also recalls the standing figure in Gauguin's *Tahitian Women on Beach* (fig. 53), which may have influenced the form of the Backs.

26. Aragon, *Henri Matisse*, I, p. 10.

27. Ibid., I, pp. 102–3.

28. Ibid., I, p. 7.

29. For Matisse's use of framing devices see Fourcade, "Rêver à trois aubergines...," p. 485.

30. It particularly recalls *The Yellow Curtain* of 1915 (Paris 1970, cat. 128).

139. *Women and Monkeys*, early state, 1952

140. *Swimmer in the Aquarium*, 1947. Pochoir, 16 x 24¾ in (composition). The Museum of Modern Art, New York, gift of the artist

141. Detail from *Dance*, 1932–33. Oil, 11 ft 8½ in x approx. 47 ft. © The Barnes Foundation, Merion, Pa.

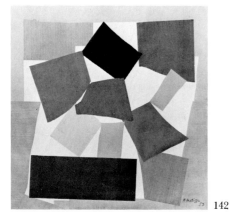

142

143

144

142. *The Snail,* 1952. Gouache on cut-and-pasted paper, 9 ft
4⅝ in x 9 ft 5 in. The Tate Gallery, London

143. View from Matisse's window in Tahiti, 1931

144. *Window in Tahiti,* 1936. Tapestry, approx. 89 x 68 in.
Whereabouts unknown

REFERENCE ILLUSTRATIONS

Photograph Credits

Photographs of the works of art reproduced as reference illustrations have been supplied, in the majority of cases, by the owners or custodians of the works. The following list applies to photographs for which a separate acknowledgment is due.

Hélène Adant, Paris, 20, 179 (fig. 18), 203 (fig. 74), 221 (fig. 113), 225 (figs. 125–28), 228 (fig. 139); David Allison, New York, 101, 105; Oliver Baker, 125; Photo Bulloz, Paris, 174 (fig. 4); Rudolph Burckhardt, New York, 139 right; Alexandre Georges, 156; Courtesy Lucien Goldschmidt, New York, 220 (fig. 112); Foto Heri, Solothurn, 203 (fig. 76); Kate Keller,* 25, 29, 32 right, 40, 53, 59, 87, 93, 95, 97 right, 109, 111, 115, 117, 121, 128, 143, 144, 145, 199 (fig. 65), 222 (fig. 117), 223 (fig. 118); Peter Juley, New York, 104 left, 122, 127; James Mathews, New York, 35, 61, 62, 65, 99 top right, 103 right, 126 (both), 131, 133, 134, 149; *Matisse,* a film produced by Comptoir Général Cinématographique, directed by François Campaux, 1945, 199 (figs. 63, 64); Pierre Matisse, New York, 6; Novosti Press Agency, Moscow, 194 (fig. 56) (copy negative); Mali Olatunji,* 99 top left, 151, 154, 155, 159, 222 (fig. 116), 228 (fig. 140); Rolf Peterson, 148; Eric Pollitzer, New York, 57, 72; Hans Purrmann, 174 (fig. 5) (copy negative), 175 (fig. 8) (copy negative); San Francisco Museum of Modern Art Photo Archive, 180 (fig. 20); Edward Steichen, 2; Adolph Studly, New York, 75; Soichi Sunami, 30, 31, 33, 34, 36, 43, 46, 48 (both), 49 (both), 50, 63, 66, 67, 69, 70, 71, 73, 77, 79, 98 bottom, 99 bottom, 102, 104 right, 124, 129, 132, 134 top left, 134 bottom, 136, 137, 138, 139 left, 141, 142 (both), 144, 146, 150, 152, 156, 157, 158, 160, 223 (fig. 120), 224 (figs. 121, 123); Charles Uht, New York, 81; Malcolm Varon, New York, 41, 83, 85, 91, 123, 150, 161, 163–66; *Verve* (vol. IV, no. 13), 219 (fig. 111) (copy negative); Jean Volkmer, New York, 210 (fig. 93); P. Willi, Paris, 185 (fig. 30)

*Currently staff photographer, The Museum of Modern Art